Lucius Grisebach

ERNST LUDWIG KIRCHNER

1880–1938

TASCHEN

KÖLN LONDON MADRID NEW YORK PARIS TOKYO

PAGE 2:
Self-Portrait with a Cat, 1919–1920
Selbstporträt mit Katze
Oil on canvas, 120 x 85 cm
Gordon 621; Cambridge (MA), Courtesy of The Busch-Reisinger
Harvard University Art Museums, Museum's Purchase

Edited and produced by Simone Philippi, Cologne
English translation by Michael Hulse, Cologne
Cover design by Angelika Taschen, Cologne

Printed in Italy
ISBN 3-8228-6521-4

Ernst Ludwig Kirchner

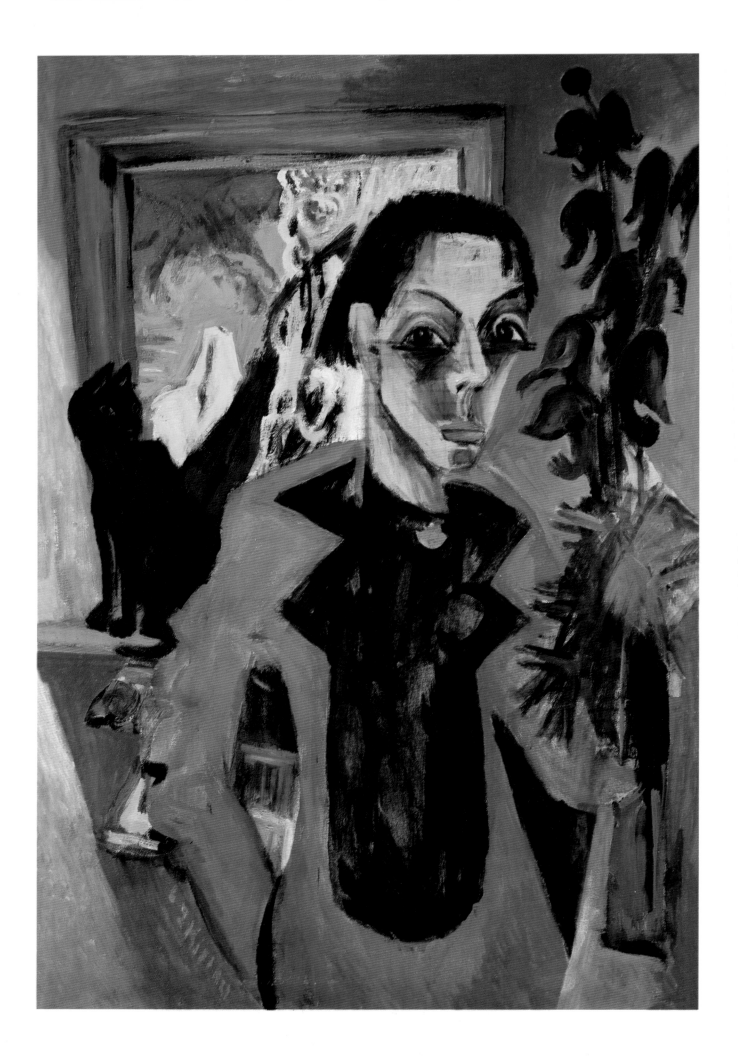

Contents

The Early Years

When Ernst Ludwig Kirchner, a young man of good middle class family, passed his school-leaving exams in the spring of 1901 and left Chemnitz for Dresden to study architecture there, he seems to have been very sure of what he wanted. He planned to be a painter, regardless of whether his family approved. His architectural studies were no more than a pretext from the start. Not that Kirchner would have been considered unsuitable for a career in art; his parents had recognised and encouraged their son's talent, had preserved his childhood drawings, and for a time, as he himself liked to emphasize later in life, they had hired an English watercolourist to teach him drawing skills. But having a gifted son with an interest in art is by no means the same as seeing that son adopt the uncertain life of an artist, least of all in middle class families with a high opinion of their own cultural traditions.

The father, Ernst Kirchner (1847–1921), and the mother, Maria Elise Kirchner, née Francke (1851–1928), were both from the Brandenburg Marches north of Berlin, where the paternal grandfather, Ernst Daniel Kirchner (1802–1879), had been a Protestant minister. Novelist Theodor Fontane, the great chronicler of 19th century Prussia, left a description of the vicar in his book on the Marches; Ernst Daniel Kirchner was something of an amateur palaeontologist, and in 1853 had published a study of stone sacrificial vessels of the northern Germanic tribes in pagan antiquity – his major publication. The scholarly climate of Protestant vicarages was the cradle of many an intellectual or artistic career in Germany, be it revolutionary or conservative in tenor, and Kirchner's was no exception.

Ernst Kirchner *père* was a chemist, and in his day one of the foremost experts on the industrial manufacture of paper, with professional contacts throughout the various branches of the industry. When his first son Ernst Ludwig was born on 6 May 1880, the Kirchners were living in Aschaffenburg. Subsequently their home was in Frankfurt am Main and near Lucerne in Switzerland, till in 1890 Ernst Kirchner was appointed to Germany's first chair of paper research at the Technical Academy of Chemnitz. A family photograph (p. 194), probably taken in 1904 when Ernst Ludwig was already studying in Dresden, nicely shows the unbending air of orderly severity typical of the upwardly-mobile in turn-of-the-century Germany. This was the atmosphere in which Ernst Ludwig Kirchner grew up. And this was the milieu he was quitting when in 1901 he left for Dresden.

When we examine the background and development of Ernst Ludwig Kirchner the artist it is important to begin with various corrections – for he himself told a number of tall or at least inexact tales in the course of his career, legends of the artist's life that distorted his own image and that of his art. He set himself high standards and set out to revitalize art radically; at the

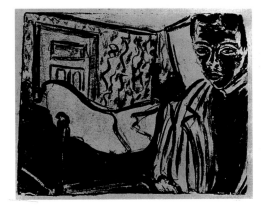

Self-Portrait in a Room, 1907
Selbstporträt in Kammer
Lithograph, 35 x 40.5 cm
Dube 41; Saarbrücken, Saarland Museum in der Stiftung Saarländischer Kulturbesitz

At this time the twenty-seven-year-old Kirchner was still leading a student style of life in a furnished rented room; but he was certain of his calling.

PAGE 6:
Female Nude with Foliage Shadows, 1905
Nacktes Mädchen mit Zweigschatten
Oil on card, 37 x 30 cm
Gordon 5; Davos, Kirchner Museum

"I visited his studio. There were pictures there brighter and more daubed than anything I have seen from the most audacious French Impressionists. The body of one nude was ashimmer with green and red patches, impasto patches of paint thick as a finger […]." Thus one contemporary, Dresden art critic F. Ernst Köhler-Haußen, after his first visit to Kirchner's studio in 1907. He may have seen this picture, which had been painted in 1905 and was typical of Kirchner's art shortly after Die Brücke was founded. The light and shadow on the woman's body are handled in a Post-Impressionist manner.

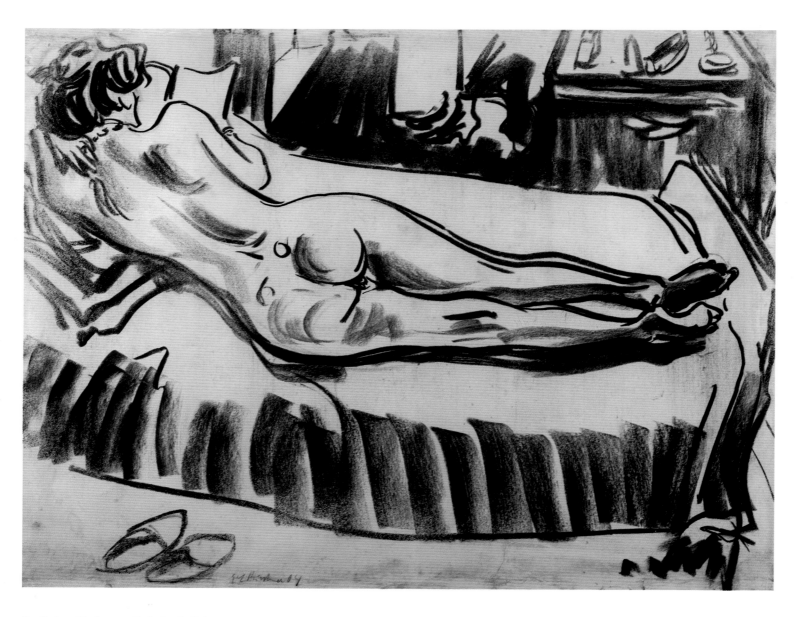

Reclining Nude on a Sofa (Isabella),
1906–1907
Liegender Rückenakt auf Sofa (Isabella)
Charcoal over pencil, 68.5 x 89 cm
Private collection

same time, he was extraordinarily sensitive his whole life long to the public and to criticism. He was always out to steer the reception of his art, and to establish an image of himself as artist that was to his taste. On various occasions, sometimes under a pseudonym, he wrote about himself and his art, and in the process his abiding concern was to date decisive moments in his life (such as the foundation of the Brücke movement) to an earlier time than had in fact been the case. In his personal writings too, such as the Davos journal which he kept from 1919 to 1928, as well as in letters to friends and patrons, he consistently worked to create an image. In later years he took systematically to assigning earlier dates – by several years – to his early works, in order to establish the priority of his claims over other artists. Critics writing on Kirchner during the artist's lifetime were obliged to adopt these falsified dates, and it was left to subsequent art historians to reconstruct the actual course of his artistic evolution, in the teeth of Kirchner's own statements.

From 1901 till 1905, his life was dominated by the architectural studies for which he had so little affection. On 30 April 1903 Kirchner passed his preliminaries and in summer 1905 he completed his diploma, graduating as an engineer on 1 July 1905. At that date, he was not yet appearing before the public as an artist, even if he saw himself as one, and spent all his spare time

painting and drawing. We have no record of his exhibiting, and only a very few works have survived from that time. For this reason, the presentation of Kirchner the artist in this book begins in the year 1905.

That said, though, we must not overlook the winter semester of 1903 to 1904, which Kirchner (having passed his Dresden preliminaries) spent in Munich. Officially he was studying architecture, though in reality he was pursuing art to the exclusion of all else. He attended a private teaching studio run by Wilhelm von Debschitz (1871–1948) and Hermann Obrist (1862–1927) and frequented artistic circles. In later years Kirchner availed himself of every opportunity to stress that Munich sojourn. But it seems that he was less interested in the tuition available than in the art he could see in museums and exhibitions: "There was little of interest in the schools. I learnt far more in the museums. The drawings of Dürer, and principally those of Rembrandt, made a powerful impression on me. I attempted to paint scenes of everyday life, and to that end drew everywhere, in the street, in bars, in theatres and so forth. The freedom of Rembrandt's approach to the figure

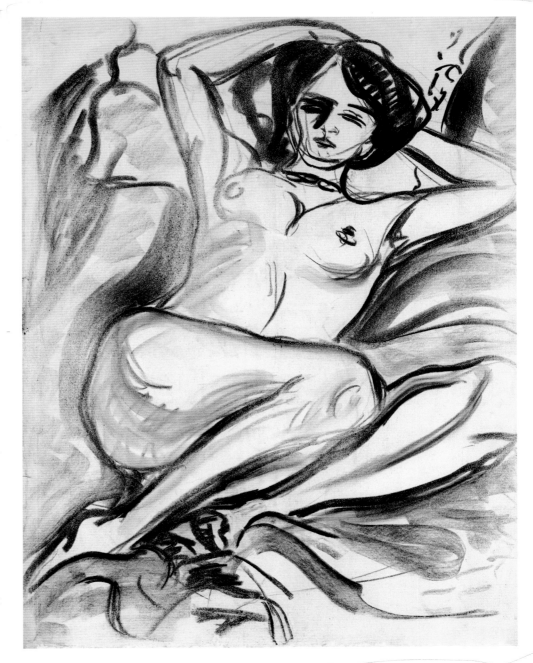

Reclining Nude (Isabella), 1906
Liegender Akt (Isabella)
Charcoal, 90 x 69 cm
Kassel, Staatliche Museen Kassel, Graphische Sammlung

"I spent my student allowance on painting and on girls I undressed in order to draw them. At the Academy I learned how to dispense with life drawing in the academic manner. It was only at home that I had complete freedom in my work. Often I would get up in the middle of the sexual act in order to sketch a movement or expression." Thus Kirchner in 1923, in his Davos journal, remembering the early years. Isabella was one of his first girlfriends we can identify in his works. The large-format charcoal drawings can be dated on stylistic grounds to 1906 and 1907, and constitute a well-defined and important group of works.

showed me the way to a reduced style of drawing…" Following that semester of art in Munich, Kirchner returned to Dresden in early 1904, and there, as we have seen, he completed his diploma in July 1905.

Kirchner's uncompromising commitment to art, to the artist's life, and to the independence and sense of vocation that went with it, can be effectively dated from the completion of his studies. The spectacular point of departure (three weeks before he finished his diploma) was the establishment of Die Brücke (literally, The Bridge) on 7 June 1905. The date on which the group was founded was long uncertain, partly because Kirchner himself liked to put it at 1902 or 1903, until a document including the date came to light. Clearly the twenty-five-year-old had been waiting for the right moment to set architecture aside; art, which had hitherto occupied him on the side, was henceforth to be the sole content of his life.

In his very first semester in Dresden, Kirchner had made a friend of like-minded Fritz Bleyl (1880–1960) from Zwickau. They pursued art together during their student years, and Bleyl, who later became a teacher, later recalled that time with palpable fondness: "One day in the first semester I was in the Rohn study room, working on projective geometry, grappling with all manner of childish exercises, when a former schoolfriend and classmate came over and suggested I come over to where he was working. He said a student, clearly an artist, had been drawing all kinds of things in the margins of his Rohn paper; I had to have a look. I hurried over and took a look at the drawings, which had evidently been done to fill in time spent waiting for the professor or one of his assistants. The student who had drawn them was Ernst Ludwig Kirchner, whom I shortly made a point of getting to know, and from that first acquaintance there quickly evolved a rare friendship [...]."

"Kirchner, who for some idiosyncratic reason preferred to be addressed not by his own name but as Gustav, had come to be studying architecture

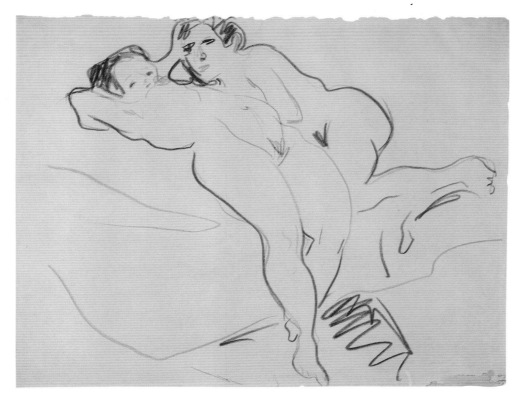

Couple Resting, 1907–1908
Ruhendes Paar
Red and blue crayon, 34.5 x 44 cm
Private collection

10

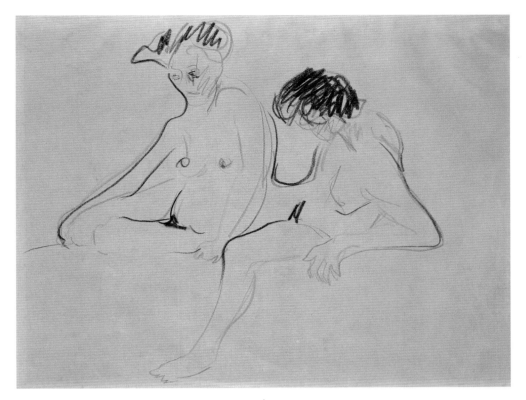

in much the same way as I had. That is to say, he was doing so because
of pressure exerted by his family, rather than studying painting at the
Academy [...]."

"He was a well-built, upright youth possessed of the greatest self-assur-
ance and a powerfully passionate nature. He had a lordly ease in his ways,
and an infectious, unrestrained laugh. And he was obsessed with drawing
and painting, with all things artistic, and with aesthetic thought and debate
[...]."

"We were meant for each other, and for the rest of our student years we
clung together like burrs. We were inseparable [...]. Every day we spent
together, meeting at college and eating together [...] or seeking each other
out very late in the evening, to look at new work we had done and assess
it [...]."

In early 1904, shortly after Kirchner's return from Munich, he met a sec-
ond artistic friend in Dresden, Erich Heckel (1883–1970). Like Kirchner,
Heckel came from Chemnitz. His elder brother had been at school with
Kirchner, and it was through that connection that the two men met. Heckel
was very interested in philosophy and poetry, and Kirchner sometimes
referred to him as a poet; at grammar school in Chemnitz, Heckel had been a
member of a literary group that called itself the Volcano. The story goes that,
when he first called on Kirchner in Dresden, he mounted the stairs "declaim-
ing passages from Nietzsche's 'Zarathustra'". But now Heckel planned to be
a painter. In summer 1904 he began studying architecture in Dresden, and he
too saw these studies as a substitute for the art studies his parents would not
approve of.

A year later, Heckel introduced a former Chemnitz schoolfriend to Dres-
den: Karl Schmidt, from Rottluff. Schmidt shared Heckel's interests, had
been a member of the Volcano group, and now began studying architecture
too, as a way of pursuing his interest in art. And it was these four students of

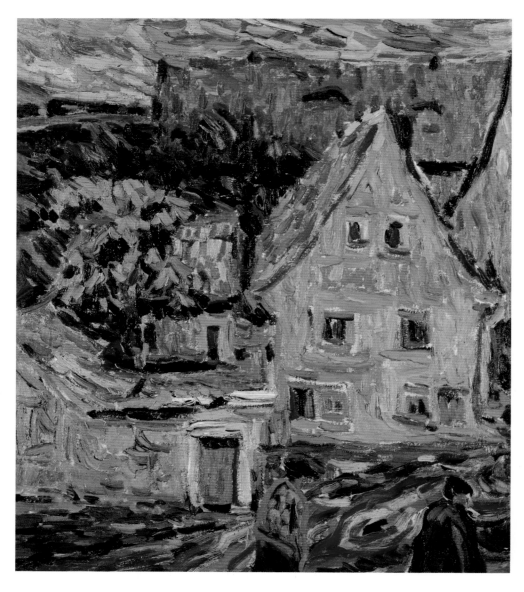

The Green House, 1907
Grünes Haus
Oil on canvas, 70 x 59 cm
Gordon 26; Vienna, Museum moderner Kunst,
Stiftung Ludwig

Two influences are apparent in this early oil:
the Pointillism of French artists Georges Seu-
rat and Paul Signac, and the direct and ex-
pressive approach of Vincent van Gogh. The
latter was always the more powerful influence
on Kirchner. The German used his French in-
fluences in so brusque a manner that there
was no room for grace or beauty. He was after
the vigour of unfaked directness.

architecture – Ernst Ludwig Kirchner, Fritz Bleyl, Erich Heckel and Karl
Schmidt-Rottluff – who founded Die Brücke on 7 June 1905.

The following year, the four published their ambitious manifesto, which
included this appeal: "Sharing a belief in development and in a new gener-
ation of creators and lovers of art, we call upon the young to come together.
As young people who will bear the future, we want freedom in our work and
in our lives, independence of older, established forces. Anyone who conveys
directly and without falsification the powers that compel him to create is one
of us."

It seems undisputed that Kirchner was the driving force in the foundation
of the group. His motivation was the strongest, and, on completing the archi-
tecture studies he had so little enthusiasm for, he was the first who had to
take decisions. Bleyl, who was the same age, would not have mustered the
energy on his own (and indeed left the group in 1907), and the two younger
members had not yet reached a point where they felt ready. But Kirchner, of
course, needed friends in his position. Without them he would not have
braved the vagaries of the artist's life. If we furthermore consider the fact
that, in the years ahead, anything that helped consolidate and expand Die
Brücke was initiated by Heckel or by Schmidt-Rottluff (approaching other
artists, recruiting them as members, and so forth), then it becomes clear that

Karl Schmidt-Rottluff:
Village House with Willow Trees, 1907
Dorfhaus mit Weiden
Oil on canvas, 85 x 75 cm
Berlin, Staatliche Museen zu Berlin –
Preußischer Kulturbesitz, Nationalgalerie

Jointly, the Dresden Brücke artists absorbed
new influences from Paris. They would go out
to paint landscapes in twos or threes, which is
why many of their pictures dating from the
early years are strikingly similar in subject
and style.

Erich Heckel:
Marshland (Dangast), 1907
Marschland (Dangast)
Oil on canvas, 48 x 77 cm
Berlin, Brücke-Museum

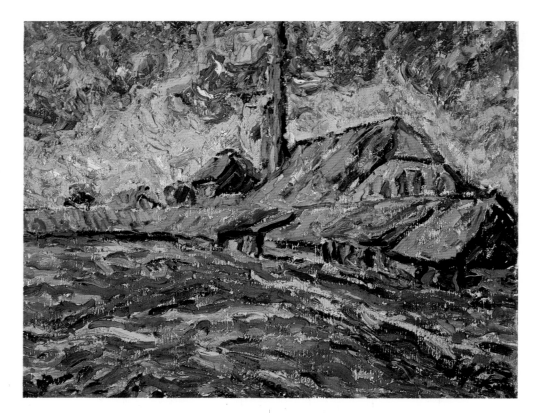

Erich Heckel:
Brickworks (Dangast), 1907
Ziegelei (Dangast)
Oil on canvas, 68 x 86 cm
Madrid, Fundación Colección Thyssen-
Bornemisza

the founder members complemented each other nicely in terms of their art-
istic and organizational skills.

The name of the group was thought up by Schmidt-Rottluff. The philo-
sophy of Nietzsche coloured the spirit of the age, and the image of the
bridge occurred, for example, in *Thus Spake Zarathustra* (1883–1885): "The
greatness of Man is that he is a bridge and not an end: what can be loved in
Man is the fact that he is a crossing and a decline." Heckel acted as a kind of
manager, developing the group's infrastructure. It may have been that the
most significant motive for the establishment of the group was that, unlike
other young artists, these four were not studying at an art college from
which they could graduate almost imperceptibly into a life in art – and for
any single one of them, the road of the autodidact would have been a diffi-
cult one to travel. The group gave each the support he needed, and gave
them courage as they forged ahead into a field where the stakes were formid-
ably high. That they were aware of this is evidenced by the terms of their
1906 programme.

Thus it is essentially *de trop* to enquire whether Kirchner was the leader
of Die Brücke. Yet the question still needs raising, if only because Kirchner
himself was so insistent on raising it. Eight years later, Die Brücke pub-
lished a retrospective chronicle, and Kirchner was entrusted with writing it.
It was Kirchner's problematic emphasis on his own role as the presiding
governance in the group's development, a view the others disagreed with,
that led to a break and to the formal dissolution of Die Brücke in May
1913. Kirchner, indeed, subsequently went even further, downplaying his in-
volvement with the group and its significance for his own evolution as an
artist. This went so far that he even preferred critics who wrote about him
not to mention the group at all. But the truth is, of course, that Kirchner and
Die Brücke remain inseparable, and the Brücke years were crucial in his
life as an artist.

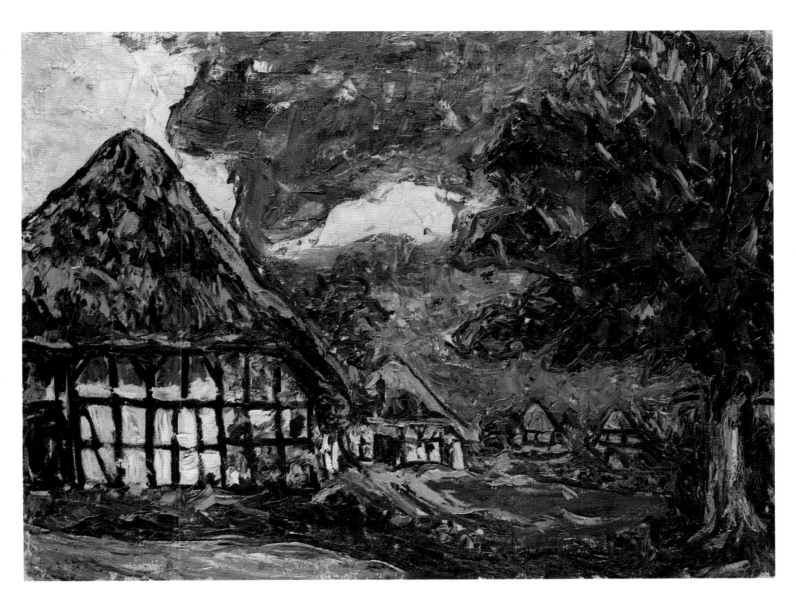

Fehmarn Houses, 1908
Häuser auf Fehmarn
Oil on canvas, 75 x 98 cm
Gordon 37; Frankfurt am Main, Städelsches
Kunstinstitut
On loan from a private collection

Kirchner's style of 1906–1907, influenced by
Post-Impressionism and van Gogh, was fol-
lowed from 1907 to late 1908 by a more
lively but also heavier approach to applying
the paint (often using a spatula). Kirchner first
visited the Baltic island of Fehmarn in sum-
mer 1908, renting the top floor of a farmhouse
in the town of Burg together with his girl-
friend. Meanwhile, Erich Heckel and Karl
Schmidt-Rottluff regularly visited the Olden-
burg district near the North Sea.

Karl Schmidt-Rottluff:
Windy Day, 1907
Windiger Tag
Oil on canvas, 71 x 91 cm
Hamburg, Hamburger Kunsthalle
On loan from a private collection

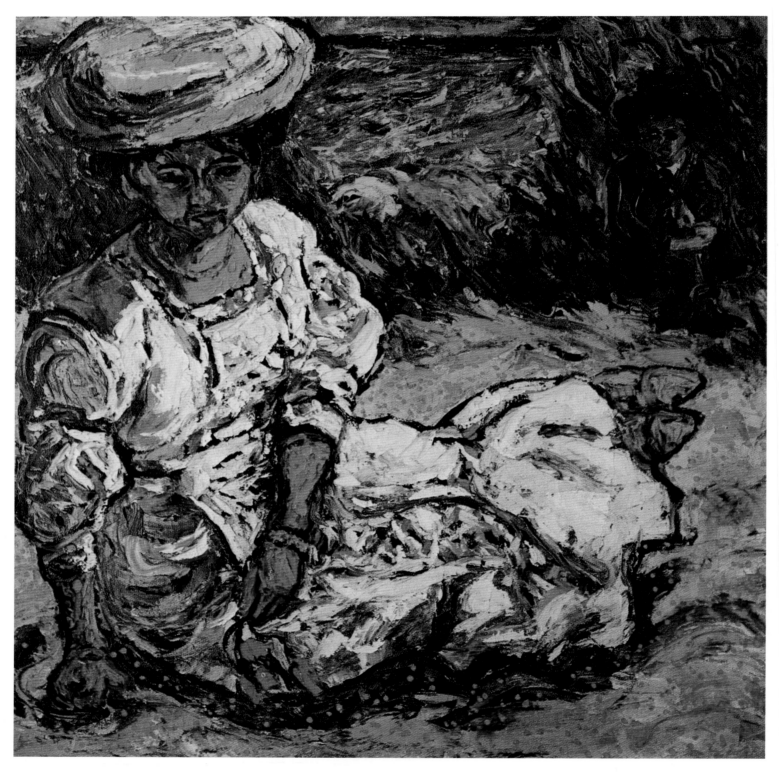

Portrait of a Woman in White, 1908
Frauenbildnis in weißem Kleid (Emmy Frisch)
Oil on canvas, 113.5 x 114.5 cm
Gordon 39; private collection

Photographer Emmy Frisch (1884–1975) was Kirchner's companion on his first visit to Fehmarn in summer 1908. She later married Karl Schmidt-Rottluff. Kirchner painted her on the beach wearing a white summer dress and a straw hat. A young man is sitting in the background (upper right), probably Emmy's brother Hans, who was on Fehmarn with her and Kirchner. There is an Impressionist lightness in Kirchner's touch here, while the compositional placing of the male figure, and the ornamental use of red dabs across the entire canvas, recall the Art Nouveau of a Klimt – though once again the impasto vehemence of the brushwork lacks the grace of Art Nouveau. This was painting of a radically new order.

Portrait of a Man; Hans Frisch, 1907
Herrenbildnis; Hans Frisch
Oil on canvas, 115 x 115 cm
Gordon 33; San Antonio (TX), Marion
Koogler McNay Art Museum

Hans Frisch, Emmy's younger brother, was a friend from Kirchner's youth. The artist had known him and his sister since school days in Chemnitz. In 1905 Hans Frisch was working in the Dresden Ethnological Museum. He painted and wrote himself, and was a passive member of Die Brücke. At the time when this portrait was painted he was seen as a poet; we no longer know what profession he had actually trained for. In later years he was a farmer in Saxony. This picture was painted before the first visit to Fehmarn in 1908, probably during the preceding winter. The in-

fluence of Klimt is more readily apparent here than in the later portrait of Emmy Frisch; but here too the painting technique is in fact fundamentally different from that of Klimt.

Cabaret Dancer, 1908–1909
Kabarettänzerin
Pastel on coloured chalk, 43 x 34.5 cm
Private collection, courtesy of Galerie Gunzen-hauser, Munich

Dancer in a Blue Skirt, 1908–1909
Tänzerin mit blauem Rock
Pastel, 42.5 x 34.5 cm
Stuttgart, Staatsgalerie Stuttgart

We do not know whether these two pastels of a single dancer were done on the same occasion as the big oil *Czardas Dancers*. Early dates assigned to the pastels suggest not. The theme of cabarets and dancers was one to which Kirchner frequently returned.

They were a close-knit group of friends, and the Brücke members had a forum within which to work, develop, and enjoy support. They were also something of an association for practical purposes. They canvassed for exhibitions in Dresden and elsewhere, collected print graphics and exhibited them in travelling shows around Germany, and, to strengthen their own position, they recruited other artists. Along with active members (artists), Die Brücke also numbered passive members in its ranks, friends and patrons to whom a graphic portfolio was offered annually. Among them were Harry, Count Kessler, the great Weimar aesthete and bibliophile; Hans Fehr, a Swiss friend of Emil Nolde's, who was professor of law at the university of Jena; Rosa Schapire, a Hamburg art historian and critic; Gustav Schiefler, the Hamburg graphics collector who compiled catalogues of the graphic works of Max Liebermann, Edvard Munch and Emil Nolde; and Martha Rauert, wife of one of the leading collectors of new art in Hamburg. Names such as these suggest that the group rapidly won recognition and support in pro-Modernist circles in Germany.

In 1906 Max Pechstein (1881–1955) joined the Dresden core members. He had completed an apprenticeship as an interior decorator and was now studying at the Dresden Academy of Art. Another newcomer was the somewhat older Emil Nolde (1867–1956), though he was to find the collective spirit of the group uncongenial and left eighteen months later. Another important artist, Otto Mueller (1874–1930), did not join until 1910. Mueller was to be an important friend to Kirchner in particular; but in Die Brücke's Dresden years he had no part to play in developments. Of the artists elsewhere who were invited to join, the Swiss Cuno Amiet (1868–1961)

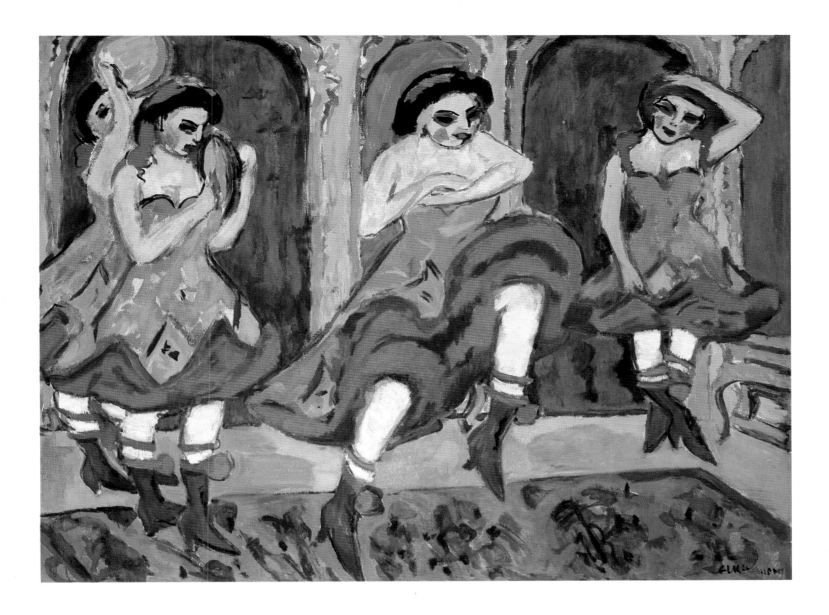

deserves mention since he was Die Brücke's link to French art. Others such as the major Finnish artist Axel Gallén-Kallela (1865–1931) or the Dutch painter Lambertus Zijl (1866–1947), whose names feature in the group's records, were only nominally members and played no part in Die Brücke's ventures. The great Norwegian Edvard Munch (1863–1944), whose art was extremely influential in Germany at that period, did not even reply to his invitation.

From 1905 to 1908, the members of Die Brücke engaged with international Modernism, which meant first and foremost – in Dresden as elsewhere throughout Europe – the latest French work and aesthetic positions. The group lost no opportunity to see exhibitions in Dresden or Berlin. The impact of the Fauves, which we shall be describing in the next chapter, was preceded by that of two very different kinds of art: on the one hand, the Pointillism of Georges Seurat (1859–1891) and Paul Signac (1863–1935), whose colourism was highly systematized, and on the other the expressive vigour of Vincent van Gogh (1853–1890). Van Gogh, whose work was repeatedly exhibited in Dresden, was the stronger of these influences. In November 1905 there was a solo exhibition of fifty of his paintings at the Arnold Gallery, and a year later the same space put on a show of French Post-Impressionists. In May 1908 the next solo show followed, in the Emil Richter Art

Czardas Dancers, 1908/1920
Czardastänzerinnen
Oil on canvas, 151 x 199 cm
Gordon 49; The Hague, Collection Haags Gemeentemuseum

Kirchner saw Czardas dancers in Dresden in November 1909, as we know from a dated postcard he sent Erich Heckel, on which he drew the same group of dancers. In 1920 he reworked the oil; in its original state, the brushwork was more relaxed.

19

The Church of Our Lady in Dresden, 1908
Frauenkirche Dresden
Charcoal on wrapping paper, 41 x 37 cm
Private collection

The baroque church is one of Dresden's famed assets, and the Venetian Bernardo Belotto had taken it as a subject in the 18th century. In Kirchner's approach to the city, though, choosing a "sight" was untypical – he generally preferred the everyday scene, regardless of its suitability for postcards.

Salon. Pointillist paintings were on view at the second of these Arnold exhibitions in November 1906. Other key shows that fired the imaginations of the Brücke artists were Emil Nolde at Arnold in January 1906, and Cuno Amiet at the same venue that summer; Munch, at the "Sächsischer Kunstverein" (Art Association of Saxony) in February 1906; a show of Viennese art at Richter's in October 1907, which included paintings and drawings by Gustav Klimt (1862–1918); and works by the Fauves, also at Richter's, in September 1908, alongside a Brücke exhibition there.

In 1907, clearly inspired by the Pointillist pictures of Signac and Seurat, the Brücke artists adopted a manner of painting that was divisionist in tendency, using regular brushstrokes and unmixed colours. The influence of van Gogh was so great, however, that the divisionist element in their approach never emerged dominant. The work they produced remained powerfully expressive, and the visual effect of their brushwork was not to produce a single impression such as the Pointillists aspired to, but rather to emphasize the discreteness of the visual components. By 1908 they had abandoned the use of even brushstrokes and had turned to a more impasto style, Kirchner even using a spatula (cf. pp. 15–17).

While Die Brücke was evolving aesthetically, it was also developing its presence in the art world. We are now in a position to see the group's tremendous exhibition presence: as early as November 1905 they were holding their first joint show at a Leipzig dealer's, their graphics were seen throughout Germany, and from 1905 to 1913 a total of seventy group exhibitions are recorded – following that first in 1905 there were eight in 1906, eighteen in 1907 and thirteen in 1908, and their activity in this sector continued with a vigour that shows there was no lack of a market for their work. The Dresden shows were naturally the heart of the matter. Die Brücke exhibited there at least once a year, and they clearly won rapid recognition and were soon accepted in the upper echelons of the Dresden art scene.

The first of these Dresden exhibitions, in September 1906, was held – somewhat unusually – in the showrooms of a lamp factory (p. 195). Erich Heckel, working for the architect Wilhelm Kreis, had been partly responsible for the construction of the showrooms, and talked the owner of the factory, Karl-Max Seifert, into patron membership of Die Brücke. Seifert made the space available a second time later the same year, for an exhibition of print graphics in December.

But their next show, in September 1907, was held in a proper gallery, the Emil Richter Art Salon in Prager Strasse. There the artists were able to exhibit in 1908 and 1909 too, before their group activity peaked in 1910 with a show at the Arnold Gallery in Schlossstrasse. Run by Ludwig Gutbier, it was the foremost venue for contemporary art in Dresden. It was in the Arnold that the Brücke artists had seen much of the modern art that had inspired their own creative endeavours.

Following the first exhibition at Richter's, a long article appeared from the pen of a Dresden art critic by the name of F. Ernst Köhler-Haußen (1872–1946). This is one of the few genuinely contemporary critiques, an enthusiastic piece which is worth quoting at some length:

"Die Brücke have recently exhibited at Richter's Art Salon. This indefatigable gallery deserves unqualified praise for its commitment to giving space to new and evolving talent such as that of the Brücke artists, to giving them the opportunity to develop, to attract attention, and to show to a public that takes as wide an interest in art as the Dresden public does that

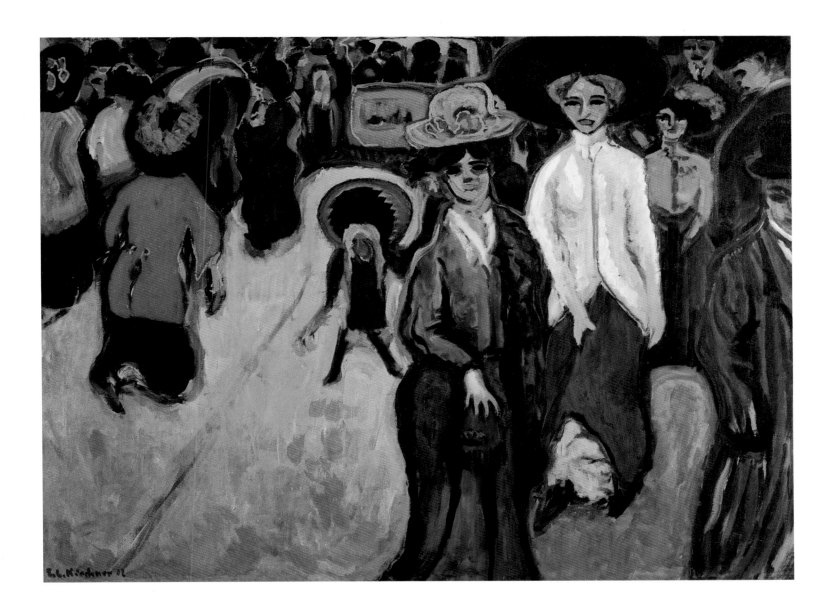

even the most venturesome extremes of Impressionism in painting do not need importing from abroad. No, not at all – that breathtaking audacity, that loud call for absolute freedom from convention and from academic tradition, is alive in our midst here in Dresden. It remained for Richter's Art Salon to demonstrate to us that art is alive not only in the fine, large studios of the successful. The passionate blood of the desire to present what the artist has seen, entire and without reservation, flows in local veins, even in the humblest of studios – indeed, I found one young hopeful had set up his studio out in the Friedrichstadt suburb... in a shop. It was cold and rather uncomfortable, but the young artist's heart was beating with resolve and hope, and his ideals meant more to him than anything else. His work was all of a piece, determined and consistent, and spoke eloquently to me of resolution, altruism, and the blissful one-sidedness of an artistic temperament that so buoyed up this young man that even in his grey shop in that grey suburb he was indifferent to his surroundings and saw only the colourful waves of his bright dreams rolling towards him. That artistic temperament is his, the fine youngster who deep within himself feels so utterly a man, and is so wretched when the hour of doubt arrives and his dreams of success and recognition prove to have been premature. How many there are who persist, and how few are crowned!"

Street, 1908/1919
Straße
Oil on canvas, 150.5 x 200.4 cm
Gordon 53; New York, The Museum of Modern Art, Purchase

Kirchner presented the city in two modes in his art: as urban landscapes of streets and buildings, or as street scenes showing passers-by at night, the type he later perfected in Berlin. This first street scene done in Dresden, an isolated case at the time, sets out to be a major work even by virtue of its sheer size. It was influenced by Edvard Munch, the seminal Norwegian artist whose work was at the forefront of Modernism as received in Germany around the turn of the century. Unlike Munch, however, whose people are always faceless ciphers in a staged action, Kirchner was portraying a throng he had seen in a modern city street.

Two Female Nudes on a Divan, 1908–1909
Zwei weibliche Akte auf der Liege
Pastel chalk, 34.5 x 43 cm
Kassel, Staatliche Museen Kassel, Graphische
Sammlung

Two Women Sitting on a Sofa, 1908–1909
Zwei Frauen auf einem Sofa sitzend
Pastel on chalk, 35 x 48 cm
Private collection

"Die Brücke is an association of young up-and-coming artists in the making. It is a product of ferment and unrest, a cry for barriers to be broken down, a trembling wish for what has hitherto lain beyond the permissible, beyond what was possible to art."

"The association's manifesto is a stout piece of work, perhaps a little too portentous, yet plucky and full of that daredevil assurance that better becomes ambitious men who aim to gain control and believe they have the ability to do so than any cool, calculating ingratiation could. Quite right, too. The crown of art and of life is not to be had by currying favour. It must be seized, won by defiance and conquest. The brief programme […] strikes a proud note, but it is right and wins assent, not least because the members of Die Brücke practise what they preach. In their exhibition they have given of themselves, entire and unfaked."

"Admittedly they have influenced each other, have borrowed technique and manner freely. But what of it? They are young, and young men readily think of each other as friends and brothers, if their feelings are at all similar […]. And the cameraderie of these Brücke artists will one day be a thing of the past too, for even now they all have minds of their own, even if they are wearing the brightly-coloured apparel of Neo-Impressionism. Their names

Two Female Nudes, 1908
Zwei weibliche Akte
Pastel, 69 x 90 cm
Cologne, Museum Ludwig

Nudes in movement were a major subject for the Brücke artists. They were not interested in academic study of a classical ideal. Rather, they were out to show life as it was, which they felt could best be done through nudes moving in a natural manner. They and their girlfriends would meet in their studio apartments, and their personal and artistic lives were inseparably fused. Scenes featuring a number of nudes, both women and men, constitute a major thematic group among Kirchner's drawings from 1908 to 1911.

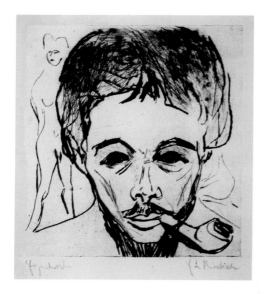

Self-Portrait with a Pipe, 1908
Selbstbildnis mit Pfeife
Drypoint engraving, 22 x 20 cm
Dube 27; Essen, Museum Folkwang

Self-assuredly the twenty-eight-year-old artist confronts us head-on. He was living in modest circumstances, but he already had his first successes behind him. In the background is a female nude – lover, model, or personification of art, a motif that was to recur in self-portraits through the years.

Nudes in the Studio, 1908–1909
Akte im Atelier
Charcoal, 49 x 60 cm
Berne/Davos, Sammlung EWK

In November 1909 Kirchner moved into his second Dresden studio, at 85, Berliner Straße. He painted wall hangings himself and fitted it out with curtains, his own sculptures and hand-carved furniture to create an individual artistic home. There he painted *Bathing Nudes in a Room*, for which this drawing was one of many preliminary sketches.

are Cuno Amiet, Fritz Bleyl, E. Heckel, E. L. Kirchner, E. Nolde, M. Pechstein, K. Schmidt-Rottluff, Axel Gallén. Their names and manners unite a group scattered from Switzerland to Helsingfors in the north. A handful of well-wishers – a headmaster in Soest, a few people in Leipzig, Chemnitz and Dresden, a few in Hamburg – have joined the Brücke as 'passive' members. One of these is the German Book Trade Museum in Leipzig. Once a year the 'active' members publish a portfolio of their own etchings and woodcuts; these the 'inactive' receive."

"What we saw of the Brücke at Richter's was at the very least perplexing. Of some of the pictures one could make nothing whatsoever. Two children reading I initially took for a couple of cabbages, and a bouquet of flowers I saw as an old military overcoat. But in the dabs of paint, abruptly and daringly juxtaposed, there were fine effects. The colours in a bunch of roses by Nolde were most estimable, K. Schmidt-Rottluff's birches were finely and idiosyncratically done, and a woman smoking, by E. L. Kirchner, was surprisingly effective in its tonalities – qualities, then, in the draughtsmanship. And what I saw here encouraged me in expectations of the future, even if I was as amused in the gallery as most of the others who had gone to see the exhibition."

"As chance would have it, I made the personal acquaintance of one of the artists, E. L. Kirchner, whose absurd woodcuts had already struck me in the next room. They possessed a curious certainty of overall impact, despite the fact that individual pieces were wholly lacking in any draughtsmanly finesse, evidently by design. [...] I visited his studio. There were pictures there brighter and more daubed than anything I have seen from the most audacious French Impressionists. The body of one nude was ashimmer with green and red patches, impasto patches of paint thick as a finger [...]."

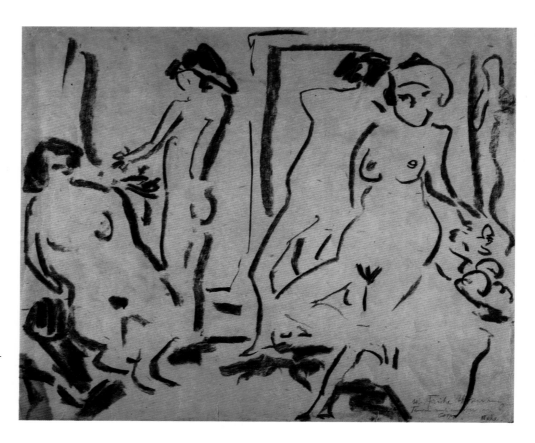

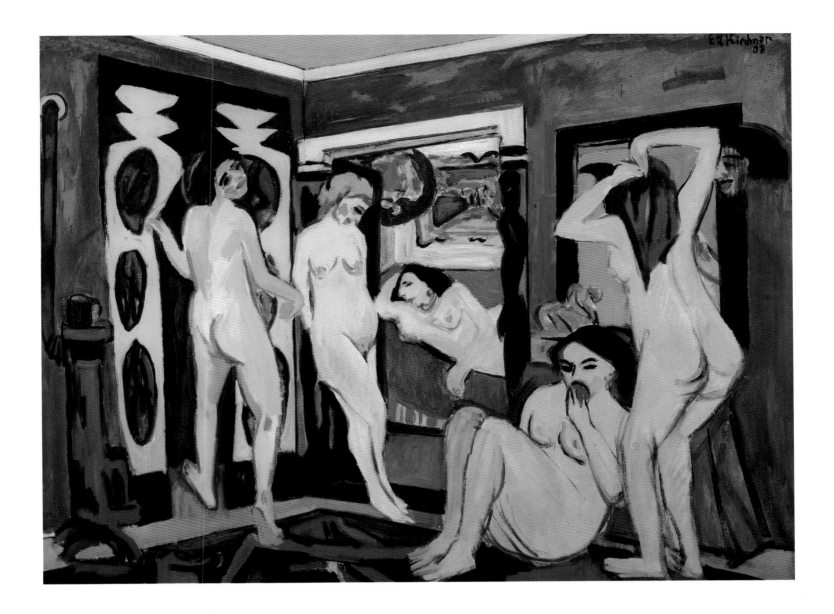

"In Kirchner's studio I also happened upon a great number of drawings and woodcuts. Among the drawings there is much that is delightful. These are works that despise finesse, refinement, anything subtle or squeamish in the technique. Using a brush (he has a predilection for Indian ink) or charcoal, he simply draws – until something results. There are no half-tones – black alternates with white, and then it is back to black […]."

"The originality and independence of Kirchner appeal to me especially. His subjects are new and strange, and his technique without antecedent. When a man is already capable of so much, one can safely say that in times to come he will always go his own way. And that, in art, is everything. Anyone who has learnt so early to avoid the slither of conventional ink drawings will go his own way. The question is: will it lead him to salvation?"

"I left the artist's studio with the pictures reproduced here under my arm. I shall give my wife a woodcut portrait by Kirchner for Christmas. I too am becoming a 'passive' member."

Bathing Nudes in a Room, 1909/1926
Badende im Raum
Oil on canvas, 151 x 198 cm
Gordon 108; Saarbrücken, Saarland Museum
in der Stiftung Saarländischer Kulturbesitz

This major nude composition was painted in Kirchner's new studio in the winter of 1909 and shows five naked women in the artist's colourful apartment. To the right the remains of a male figure can be seen – probably a self-portrait. Kirchner first titled the painting *Bacchanal in a Room*, which implied an erotic content. When he overpainted it in 1926, almost completing deleting the male figure and establishing a greater unity, he also gave the picture its present more neutral title.

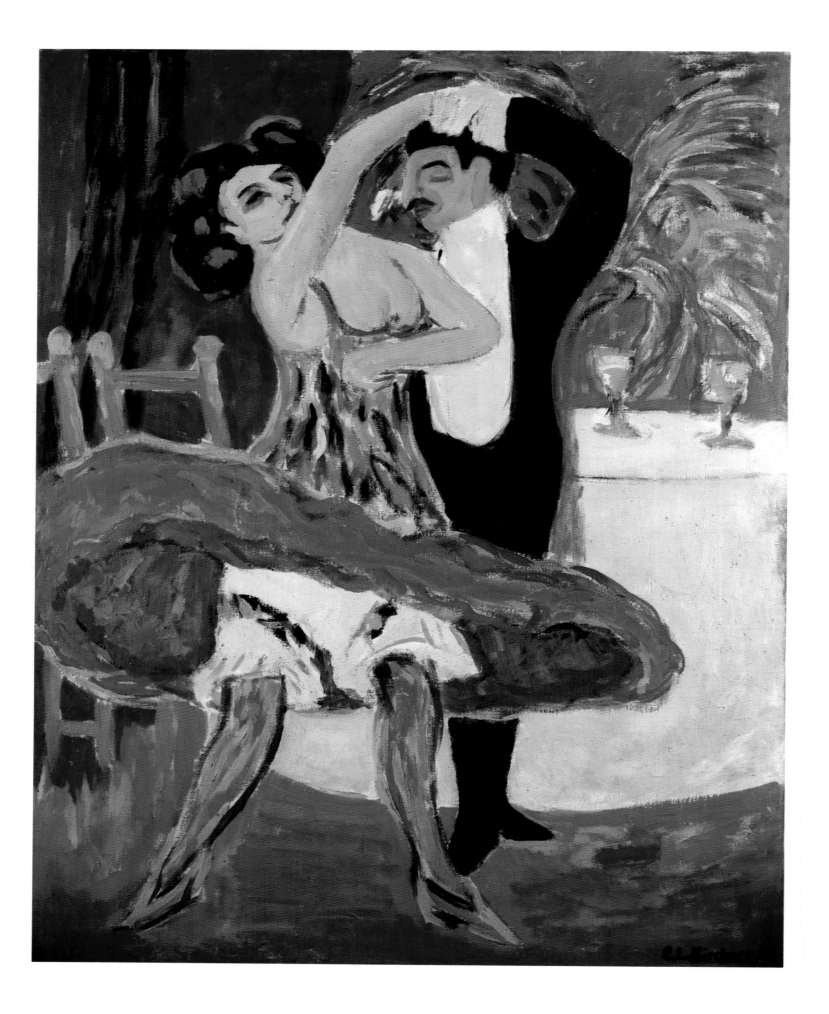

Unfaked, Direct, Real

For the group as a whole and for every artist in it, the first three and a half years of Die Brücke, from its foundation in June 1905 until the end of 1908, were a time for taking stylistic bearings, finding a place within the art of their generation, and getting established on the art scene. Their rise was swift, from the first two shows at Karl-Max Seifert's suburban lamp factory in Dresden (what would today be described as an alternative space) to exhibiting at the Emil Richter Art Salon in Prager Straße, very nearly the city's top venue, in 1907 – rapid success indeed. Those were years of mutual endeavour and development, and their art, though not yet matured, was already heady with revolutionary vigour, its energy and power palpable. The article we have quoted by Köhler-Haußen has a spontaneity which catches that energy better than many more recent definitions, when he describes their art as "a product of ferment and unrest, a cry for barriers to be broken down", and praises their "daredevil assurance".

And when the same critic, writing of Kirchner, wrote of "the colourful waves of his bright dreams" and found his work more arresting "than anything I have seen from the most audacious French Impressionists", he not only struck the nerve of the age, but also raised a key issue – Die Brücke's relations with French art. For their generation, Impressionism and the styles that had followed it offered crucial bearings for any artist who hoped to make an international impact. Paris was the source of all things new, openminded, cosmopolitan. And the Paris art scene had been transformed by Impressionism and the subsequent movements. We have seen that the young Dresden artists assiduously visited exhibitions of French Post-Impressionism. It is worth stressing, however, that they did not wish to be seen as pupils or imitators of French Modernism, but rather as innovators within German art.

A letter written by Emil Nolde in 1908, in the somewhat inflated manner he affected, describes the relations between French and German art from the inside: "The great battles of any genuine significance have been fought in France, while here in Germany we have seen only the side-effects. The great French artists Manet, Cézanne, van Gogh, Gauguin and Signac broke up the ice. The French ruled out all the old constituents of affect, and only in that way is it possible to create an art worthy of a place alongside the great art of old. In Germany, if we are really to succeed in creating a second great period in German art (the first having been the age of Grünewald, Holbein and Dürer), the immense endeavour still lies before us. I myself feel that I am engaged in it, and I hope that this period of a high German art will indeed come. The artists must fight the good fight. And for that they need new, young people with untrammelled minds."

Dancers in Hamburg, 1910
Hamburger Tänzerinnen
Etching, 40 x 31 cm
Dube 100; Hanover, Sprengel Museum

Dance, especially of the cabaret kind, was a favourite subject with Kirchner. It expressed the vitality and energy as well as the freedom and expressiveness of humankind. It was movement that liberated – and an obvious source of fascination for an artist who saw mankind at its most natural in a state of movement.

PAGE 26:
Varieté; English Dancers, 1910/1926
Varité; Englisches Tanzpaar
Oil on canvas, 151 x 120 cm
Gordon 115; Frankfurt am Main, Städtische
Galerie im Städelschen Kunstinstitut

Highly though the young German artists valued French art, they had their reservations when it came to public admission of the debt they owed. And indeed, their rough and ready directness and their sturdy indifference to received ideas of beauty had little in common with most of the Post-Impressionist influences they had absorbed. The presence of van Gogh was a palpable one, it is true – but then, van Gogh too had little in common with mainstream French Post-Impressionism.

But before the final breakthrough could be made, the achievement of a mature style of Die Brücke's own – that style which can now, in retrospect, be seen as the true, major achievement of the Dresden movement – one more decisive Parisian influence had to make its impact. This was the influence of Henri Matisse (1869–1954) and the Fauves. Not until 1909 and 1910, after they had been exposed to Matisse, did the Brücke artists achieve a true peak of achievement, in terms of both quality and quantity. And it was then that they received the highest accolade Dresden could offer, an exhibition at Arnold's, the city's foremost gallery, in September 1910.

Needless to say, contemporaries were not slow to register the impact of Matisse on the Brücke artists, and it became a recurring issue in the reception. But Kirchner himself categorically denied having been aware of Matisse at all. As late as the mid-twenties, in an essay on his own work penned in 1925 or 1926, Kirchner wrote in extremely disparaging terms of his former friend Max Pechstein, who had been Die Brücke's contact with Matisse and the Fauves. "His new lack of bearings became particularly apparent, however, when he went to Paris and became an imitator of Matisse", asserted Kirchner – as if that were the gravest accusation that could be brought against an artist. And in a letter to Gustav Schiefler of 31 March 1919 we find Kirchner claiming that at that earlier period he him-

Still Life with Oranges and Tulips, 1909
Stilleben mit Orangen und Tulpen
Oil on canvas, 55 x 65 cm
Gordon 112; private collection

self had "never even heard of" Matisse (or indeed of Emil Nolde or Edvard Munch!) – a ludicrous assertion, not least because we know Kirchner to have been well-informed at all times. We now know that Kirchner's statements were all untrue. It seems fair to suppose that he was so vehement in his denials of any influence Matisse might have had on his own work towards the end of the first decade precisely because that influence was so important.

In January 1909, the Paul Cassirer gallery at 53, Viktoriastraße in Berlin held an exhibition of Matisse, the first anywhere in Germany, and there is evidence that Kirchner saw that show. On 12 January 1909, together with that same Max Pechstein of whom he later wrote so contemptuously, he penned a postcard to Erich Heckel in Dresden: "Best wishes, Ernst. Matisse in parts very chaotic. Regards, Max." Along with a great number of similar postcards, this card, bearing a crayon drawing by Kirchner, is now in the Altona Museum in Hamburg. These cards are an invaluable aid in dating, and we shall be referring to them more than once. From another source we even learn that, following that Berlin exhibition, Kirchner suggested recruiting Matisse as a member of Die Brücke. Cuno Amiet, the Swiss artist, who was more familiar with the Parisian art scene, was asked to make the approach, but nothing came of it.

Landscape in Spring, 1909
Frühlingslandschaft
Oil on canvas, 70.3 x 90.3 cm
Gordon 62; Kaiserslautern, Pfalzgalerie

The art of Henri Matisse and the Fauves liberated Kirchner's handling of colour and space. He saw the first Matisse exhibition at Paul Cassirer's gallery in Berlin in January 1909, and presently loosened up his technique in a more watercolourist, flowing manner that replaced his impasto predilections in earlier works. The *Landscape in Spring*, exhibited in the Brücke show at Emil Richter's in Dresden in June 1909, will have been painted at blossom time that year – April or May – and is thus the earliest painting that we can definitely date in which the new influence is apparent.

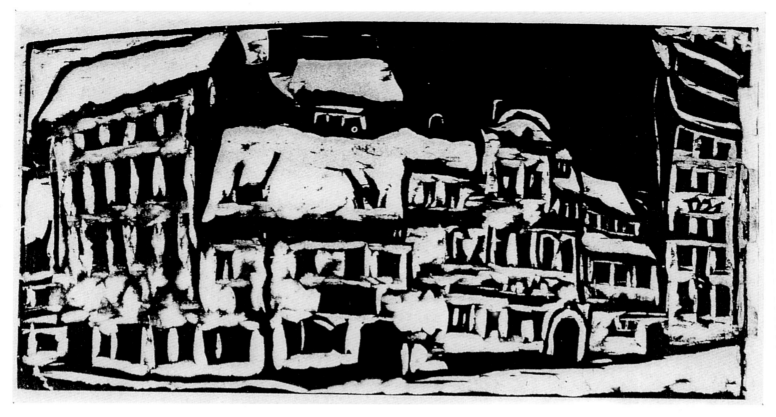

Houses, 1909
Häusergruppe
Woodcut, 42 x 76 cm
Dube 138; Cologne, Museum Ludwig

The liberated, gentler style prompted in Kirchner by the influence of Matisse was seen in his draughtsmanship in every medium – in his woodcuts (a difficult medium), charcoal drawings and etchings. They were all fluent; and so, most particularly, were his oils. The city was one of Kirchner's recurring motifs, especially the city he himself lived in, his own street and neighbourhood, or other unremarkable districts. The "Topflappenviertel" was a poor district of Dresden; the Blue House has been identified as a building near to the Church of the Three Kings in Rähnitzgasse, though a more recent theory places it at Wettiner Platz opposite the Church of St. James, in a different district closer to the Friedrichstadt suburb where Kirchner himself lived. Historical aerial photographs of Dresden support this theory – in which case the traditional titles of the two drawings below are inapt.

The Blue House in the Topflappenviertel, 1909
Das blaue Haus im Topflappenviertel
Charcoal, 31.5 x 44 cm
Private collection

The Blue House in the Topflappenviertel, 1909
Etching, 31 x 40 cm
Dube 57; Berlin, Staatliche Museen zu Berlin –
Preußischer Kulturbesitz, Kupferstichkabinett

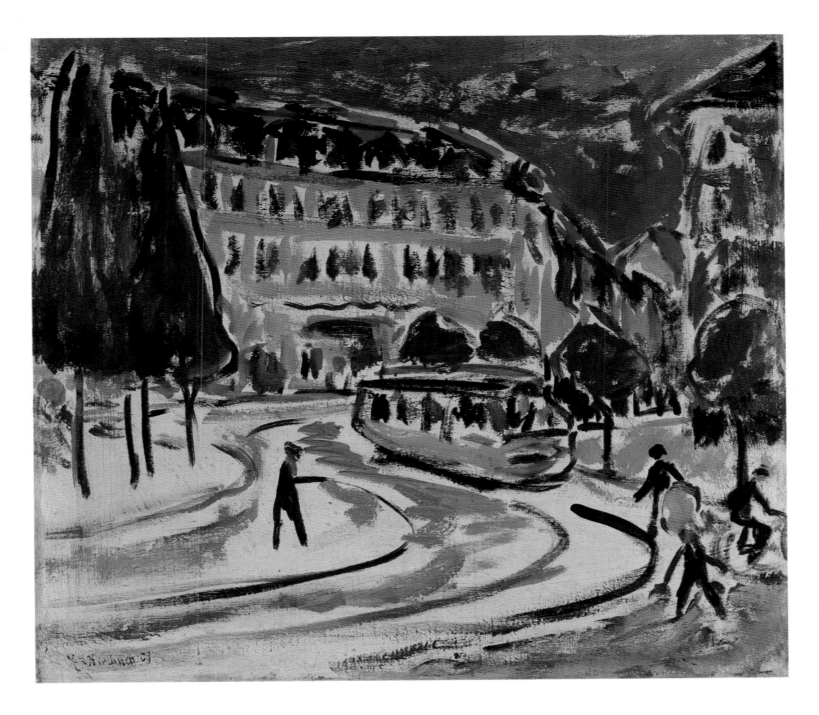

Streetcar in Dresden, 1909
Straßenbahn in Dresden
Oil on canvas, 70 x 78.5 cm
Gordon 99; private collection

Thus, contrary to Kirchner's own version, the facts appear to have been these: that Die Brücke's evolution from 1905 to 1908 moved towards a position that Henri Matisse had already reached in Paris around 1905. This involved using unmixed colours, dispensing with the traditional trappings of *peinture*, emphasizing large areas of single colour in the composition and at the same time stressing directness in the draughtsmanship and the application of paint. Familiarity with the work of Matisse gave Kirchner and the other Brücke artists the extra incentive they had apparently been in need of, and for Kirchner that familiarity dated from the Cassirer show in Berlin in January 1909.

Not that the Dresden artists might not theoretically have had contact with Matisse and other French contemporaries previously. In 1906 they had recruited Cuno Amiet as a member. The Swiss artist, then nearing forty and somewhat older than the Brücke artists, had been acquainted with the work of the Nabis – Maurice Denis (1870–1943), Pierre Bonnard

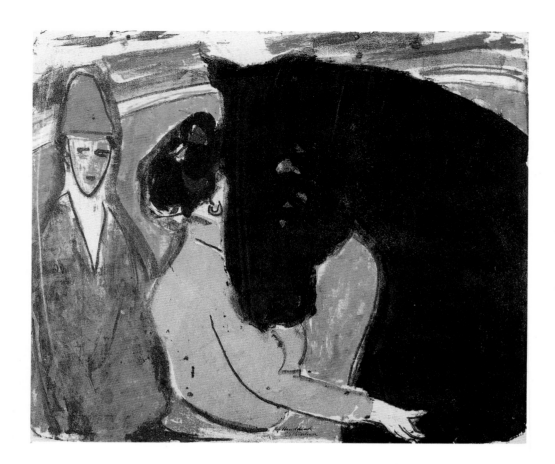

Black Stallion, Rider and Clown, 1909
Rapphengst, Reiterin und Clown
Coloured lithograph, 49 x 59 cm
Dube 128; private collection

Circus Rider, 1909
Zirkusreiterin
Woodcut, 37.5 x 47.5 cm
Dube 150; Karlsruhe, Staatliche Kunsthalle

(1867–1947), Edouard Vuillard (1868–1940) and others – at the close of the 19th century. He was also acquainted with Matisse and his painting. Max Pechstein, who graduated from the Dresden Academy of Art in 1906 and, with the State Prize of Saxony to his name, had the money to travel, went to Paris for some months in 1908, and on his return (this much was assuredly true in Kirchner's account) proved profoundly under the influence of Matisse. Pechstein recruited the Paris-based Dutch artist Kees van Dongen (1877–1968), one of the Fauves, as a member of Die Brücke. And it was at that period, in 1908, that Pechstein painted a picture that was manifestly indebted to Matisse, the *Portrait of a Woman* (now on loan from the Berlin National Gallery to the Brücke Museum in Berlin), which we now see as one of his finest works. In it, Pechstein has already attained that freedom in his style that Kirchner was not to achieve until some months later, after seeing the Berlin Matisse show.

One further point needs making, that in September 1908, parallel with the Brücke exhibition, the Emil Richter Art Salon in Dresden mounted a show that included at least sixty works by the Fauves. Thus all of the group had the best of opportunities to view art by the Matisse circle. The impact of these encounters on Kirchner's own painting is easy to see. Even without the input of Matisse, his pictures had come to emphasize large spaces and strong colours; but now his painting technique underwent a lasting change. Previously he had tended toward encrusted, impasto application (cf. pp. 15–17), but now he acquired a loose fluidity reminiscent of watercolour technique. His painting acquired a verve, freshness and directness that had not been seen in Germany before. Indeed, even among the French contemporaries grouped around Matisse an approach so radical could have been sought in vain. The earliest convincing work that documents the change is *Landscape*

in Spring (p. 29), painted in 1909 and exhibited that June in the Brücke show at Richter's in Dresden. To judge by the subject, trees in blossom, it will have been painted some weeks before, in May 1909 – despite Kirchner's own pretence, when he later compiled an album-cum-catalogue complete with titles and dates (now in the Kirchner Museum at Davos), that it dated from 1904. We can thus place the picture with some precision, and see it as a record of Kirchner's artistic response to Matisse following his exposure to the Frenchman's art in 1908 and 1909. Other works that clearly show the light and decoratively arabesque touch of Matisse include the *Still Life with Oranges and Tulips* (p. 28), *Streetcar in Dresden* (p. 31) and *Tavern* (p. 35), all painted in 1909, as well as the particularly fine coloured lithograph of the same year, *Dodo with a Japanese Umbrella* (p. 36), of which only a very few copies exist.

The question of inspiration or influence amongst artists, which is naturally an abiding concern of art historians, always remained taboo for Kirchner. He affected to have discovered or worked out everything for himself, and was deeply suspicious of comparative critiques of his art. The only names he himself cared to be linked with were those of the great – Dürer or Rembrandt, or perhaps Gauguin or van Gogh. His whole life long he denied any effective involvement with the work of contemporaries, even of elder living artists. Ironically, of course, it was for that very reason that critics have subsequently assigned too great a significance to this issue. Kirchner, needless to say, did follow the work of other artists closely, and like any artist he was continually absorbing new impulses. The influence of Munch, for example, who was very widely received in turn-of-the-century Germany and whom the Brücke artists would have liked to win for their cause, given his charismatic profile, can be clearly seen in Kirchner's first major street scene,

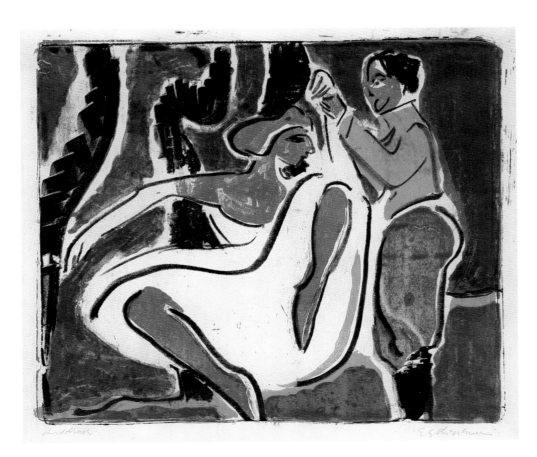

Two Russian Dancers, 1909
Russisches Tanzpaar
Coloured lithograph, 33.5 x 38.5 cm
Dube 130; Berne/Davos, Sammlung EWK

The dancers were Olga Preobrayensky and Georges Kiakscht, the prima ballerina and ballet master of the St. Petersburg Court Theatre. They performed at the Dresden Central Theatre in September 1909. Kirchner saw them and wrote to Heckel, who was at the North Sea: "Russian dancers at the Central very nice".

Street (p. 21), painted in 1908. Equally, in more general terms, the Expressionist colourism of Die Brücke would have been inconceivable without the colourist line that ran through French Post-Impressionism to Matisse. Cubism too, and the abstract styles that followed it, made an impression on Kirchner in due course.

To note and examine influences is, of course, not to denigrate the achievements of individual artists. Art cannot exist without prior art. The mark of excellence in art is established not merely by style and innovation but by the traits of individual character evolved and expressed within a given stylistic frame. And in these terms, Kirchner and the Brücke artists on the one hand, and Matisse and the Fauves on the other, were worlds apart. In their simplification of form, the use of large compositional zones, and the directness and force of their brushwork, the German artists went further than their French models or indeed any other contemporaries, to achieve a quality of radical simplicity that was wholly new to painting. Matisse once compared art to an armchair offering relaxation from the stresses of the day. Kirchner and his fellows, by contrast, sought to make core statements on life and truth.

Kirchner's art, even when he was painting landscapes or still lifes, always had people in eye. Humankind was invariably at the centre of his work, in both senses: in his choice of subjects and in his compositional strategies. His main concern was with the representation of the human figure, especially of modern people in modern contexts. This is true of everything he painted in the Dresden heyday of Die Brücke (and indeed, broadly speaking, of the other Brücke artists as well).

In their first few years, the Brücke artists concentrated on figural studies (notwithstanding the fact that several of the early oils reproduced in this

Hungarian Dancers, 1909
Ungarischer Tanz
Coloured lithograph, 33 x 38 cm
Dube 123; Saarbrücken, Saarland Museum in der Stiftung Saarländischer Kulturbesitz

Kirchner saw the Hungarian dancers two months later, in November 1909. Again he drew the scene on a card describing the performance for Heckel. In his relaxed style of 1909, Kirchner did a number of vivid, fresh coloured lithographs.

34

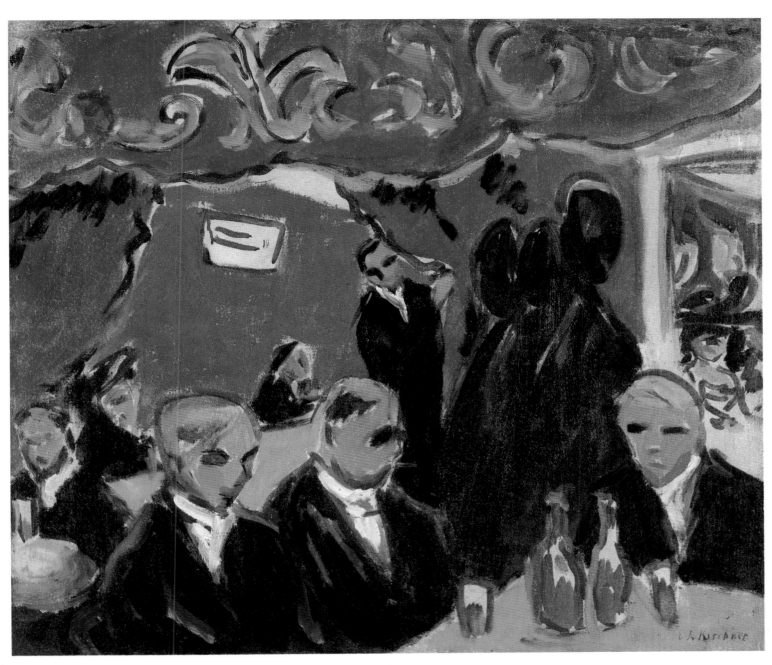

Tavern, 1909
Weinstube
Oil on canvas, 71 x 81 cm
Gordon 71; Saint Louis (MO), The Saint
Louis Art Museum, Morton D. May Collection

Of all Kirchner's coloured lithographs, this sheet, which so strikingly betrays the influence of Matisse in its radiant colours, is the freshest and most accomplished. The colours have a watercolour lustre. Only four copies are known today, and in their state and colouring they are so different that each can be considered a unique work. Kirchner made them himself, printing from five stones. Dodo was his Dresden lover from 1909 to 1911, and she is seen here in a white summer dress, holding a Japanese umbrella and sitting on a yellow blanket. Possibly it is the same umbrella or parasol as appears in studio nudes. In the background, part of a painted drape can be seen.

book are landscapes; cf. pp. 12–15). They met to draw together in their rooms or studios, and a key exercise regularly undertaken at these joint sessions was what they called the "fifteen minute nude" – rapidly drawing a figure in an attitude of movement. The model would hold a pose for just a quarter of an hour, and the artists had to capture the essentials in that time. Self-evidently, what was called for was not meticulousness and scruple in the study and sketching, such as were taught in traditional life classes at academies of art; in this exercise, what counted was spontaneity, and a compositional grasp of how to render the figure, the space and the stance. It was an exercise expressly designed to promote a style of drawing unimpeded by lengthy deliberation – a kind of drawing, in fact, that might almost be described as automatic. It was also intended to move art closer to life, by focussing not on supposed rules of drawing but on what was there to be seen. In 1919 in Davos, after the First World War, when Kirchner began to analyse and interpret his own work and to write about it, he penned an essay on the key subject of drawing, in which he was at pains to distinguish his own approach as artist and his treatment of the human figure (not least in the fifteen minute exercises) from traditional academic teachings. His own drawings aimed not at an ideal figure exemplary of

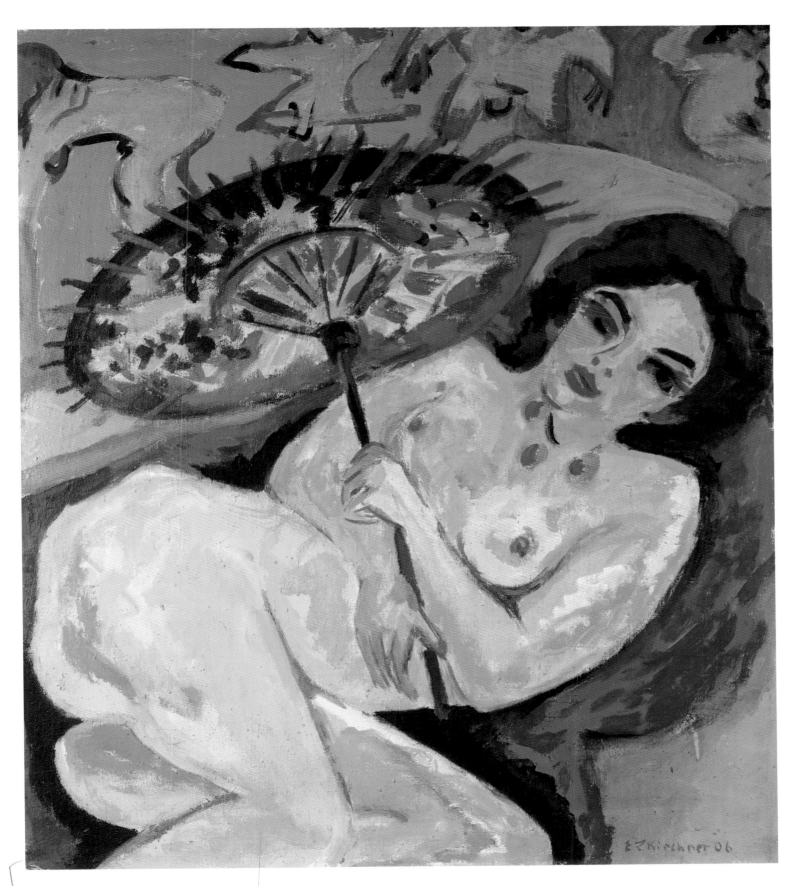

Girl under Japanese Umbrella, 1909
Mädchen unter Japanschirm
Oil on canvas, 92 x 80cm
Gordon 57; Düsseldorf, Kunstsammlung
Nordrhein-Westfalen

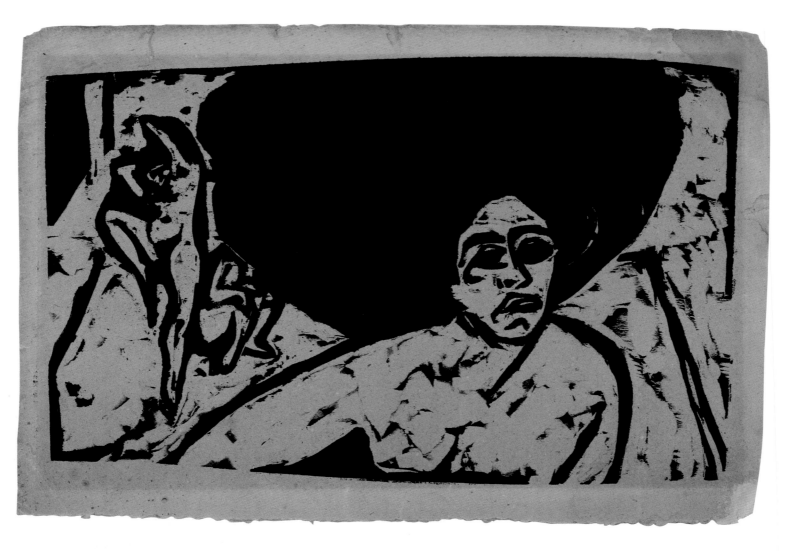

Nude Dancers, 1909
Nackte Tänzerinnen
Woodcut, 35 x 57.3 cm
Dube 140; Amsterdam, Stedelijk Museum

compositional principles, but at rendering ordinary people moving in natural, everyday ways. It was precisely these natural movements in unremarkable situations which, for Kirchner, truly articulated humankind's expressive power, and it was to them that he gave his attention – in the studio, in landscape settings, or in the city streets.

First we must turn to Kirchner's studio nudes. In their studios, the artists were able to marry art and life seamlessly. They lived in them, with their girlfriends. They worked there. And there too, humble though their circumstances were, they at least had privacy, away from the incomprehension of the world outside. Their girlfriends might be lovers or long-term partners, but either way they doubled as models, and the bohemian liberties the artists valued in their lives went hand in hand with their work as life artists. "It was only at home that I had complete freedom in my work", Kirchner wrote in his Davos journal in 1923, describing the intimacy, personal and aesthetic, that obtained between him and his girlfriends. "Often I would get up in the middle of the sexual act in order to sketch a movement or expression."

In a 1907 lithograph depicting the artist in his own room, *Self-Portrait in a Room* (p. 7), Kirchner is still dressed "respectably" and the room is conventionally furnished. It is thus that we must presumably imagine the early days of all the Brücke artists, the early years of their careers. But in the course of time they were able to fit out studios or apartments of their own, to suit their own tastes. Erich Heckel lived with his parents in 65, Berliner Straße in the

Friedrichstadt suburb of Dresden, near the railway tracks. His father, a senior railway official, had the use of a railwayman's apartment, and his son was able to use a top floor room as a studio. Heckel continued to live there until 1911, when the Brücke artists moved to Berlin, one after another. But from 1910 he had a studio elsewhere in Dresden. 65, Berliner Straße (1st floor) was used as the official business address of Die Brücke and appears as such in a large number of documents, including the 1906 manifesto. Karl Schmidt-Rottluff lived in Berliner Straße too, from 1906 on, on the third floor of number 60, and it was in that same building that Kirchner rented ground-floor shop premises to serve as both home and studio, probably some time in 1907. Heckel and Schmidt-Rottluff had apparently used the premises for storage until that point. And so it was that the nucleus of the

__Nude Couple on a Settee__, 1909
Nacktes Paar auf einem Kanapee
Woodcut, 65.5 x 48 cm
Dube 127; Stuttgart, Staatsgalerie Stuttgart

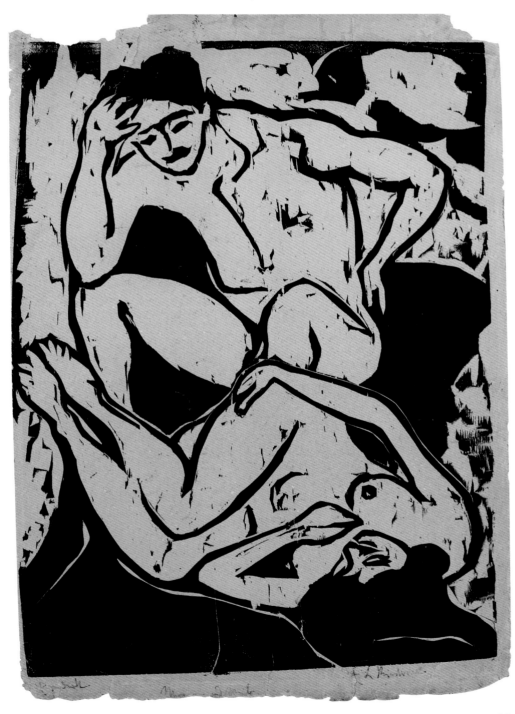

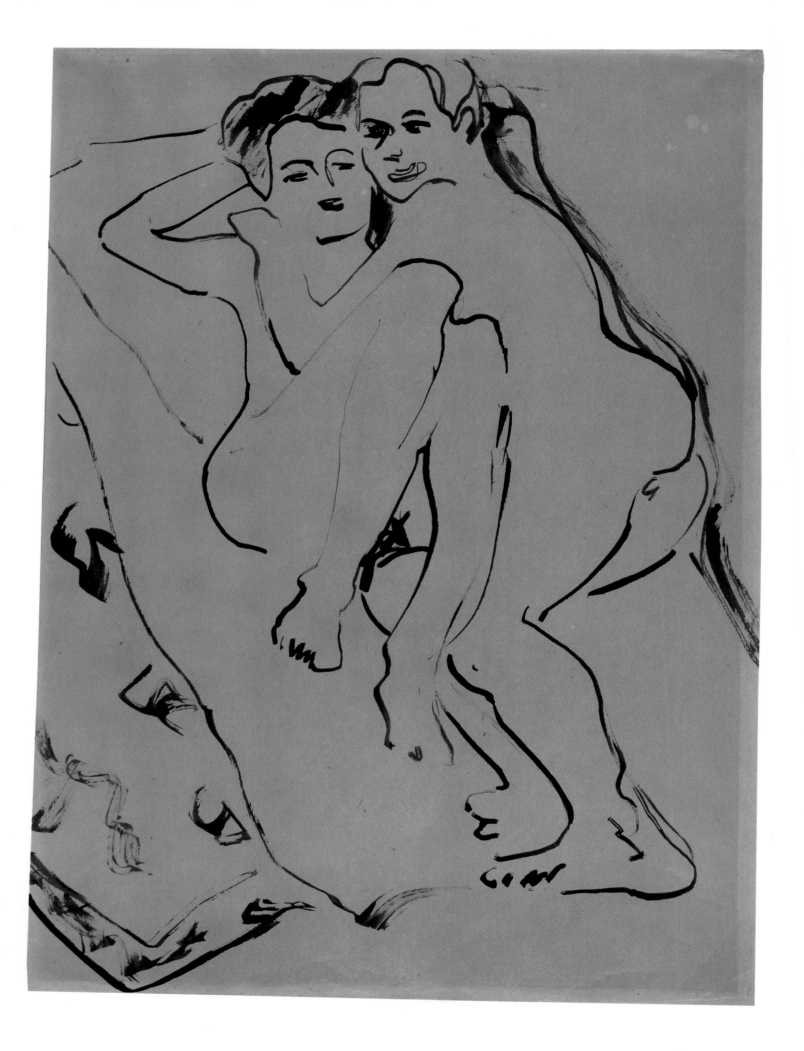

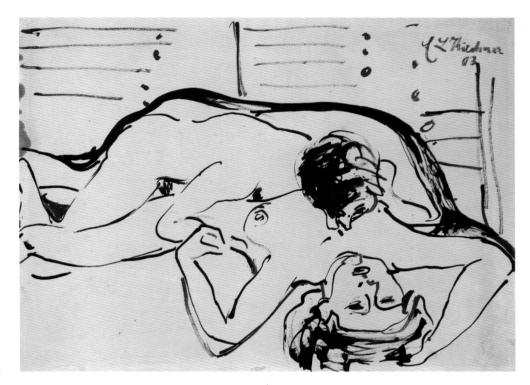

Couple, 1909
Liebespaar
Reed pen and Indian ink, 33 x 44.3 cm
Berlin, private collection

Nudes – in the open or in the studio – were
Kirchner's dominant subject in 1909 and 1910.

PAGE 40:
Couple, 1909
Liebespaar
Brush and Indian ink, 44 x 32 cm
Berlin, Brücke-Museum

Brücke artists was based in Berliner Straße, doubtless through the offices of
Heckel, who was the organizing power and business manager of the group
in the early years.

On 1 November 1909, Kirchner moved to another shop down the street,
at number 80, and the following day he wrote an enthusiastic card to Heckel,
who was out of town: "Am happy here, 80, Berliner Straße, ground floor."
There he created a living and studio space to suit his own tastes, a space
which has gone down in art history and which can be seen in various draw-
ings and paintings (pp. 24–25 and 62–64) as well as photographs. There
were at least three rooms. The pictures we have generally show a corner of
one room where two doorways open sightlines into two further rooms. Most
of the fittings – the painted wall coverings, the curtains, the carved furniture
and even the utility objects – were made by the artist himself. Some of the
sewing and embroidery was done by girlfriends. A large number of paintings
and drawings done from 1909 to 1911 enable us to trace the steps by which
these rooms were completed, with the gradual addition of further sculptures
and furniture. This studio apartment was not only a place for creative work
but also an environment, the world Kirchner inhabited – and it was of his
own making. And just as the life he led there with his friends and lovers en-
tered the annals of art, so too the art with which he adorned the rooms fed
back into his everyday life.

Kirchner and his Brücke friends were fortunate in knowing girls who
liked the idea of the artist's unrestricted life style. Men and women appear
naked in the paintings and drawings, singly, in couples or in groups, stand-
ing, sitting or reclining. The earliest works showing this reproduced in the
present study are large-format charcoal drawings of a woman customarily
identified as an early girlfriend of Kirchner's by the name of Isabella. We
see her from behind, lying on a bed and reading, in *Reclining Nude on a
Sofa (Isabella)* (1906–1907; p. 8), and frontally with her arms behind her
head in *Reclining Nude (Isabella)* (1906; p. 9) – drawings done at a time

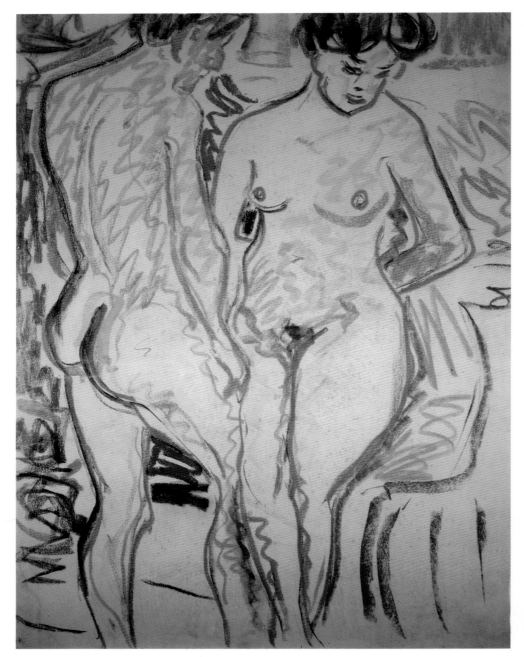

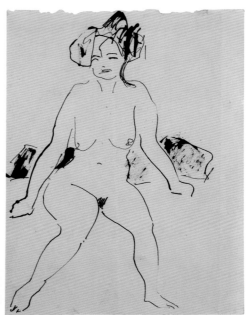

Couple, 1908
Paar
Black and coloured chalk, 88.5 x 68.5 cm
Berlin, Brücke-Museum

Seated Nude, 1909
Sitzender Akt
Reed pen and brush with Indian ink,
34 x 25.5 cm
Munich, Staatliche Graphische Sammlung

when Kirchner's life style was still that of a student. Items of furniture are sketched in; we are even shown slippers neatly placed by the bedside. This is probably the same room we have already noted in the lithograph self-portrait (p. 7), before Kirchner moved to his first Berliner Strasse premises. The drawings are generously, even exuberantly executed, as big as paintings, and eloquently bespeak the ambition and the physical energy Kirchner brought to his work. Two later drawings done in 1907 or 1908 (*Couple Resting*, p. 10, and *Two Seated Nudes*, p. 11) show nude couples, reclining or sitting on a bed or divan. The fluent lines emphasize outlines, and the body modelling done by using the charcoal lengthwise, so characteristic of the earlier nudes, has been abandoned. The distinctive combination of red and blue crayon in these drawings perhaps suggests the inspiration of the Viennese Art Nouveau master Gustav Klimt, too – only in Klimt do we encounter a comparable technique elsewhere. At the time these drawings were made there had been an exhibition of Austrian art at the Emil Richter Art Salon in

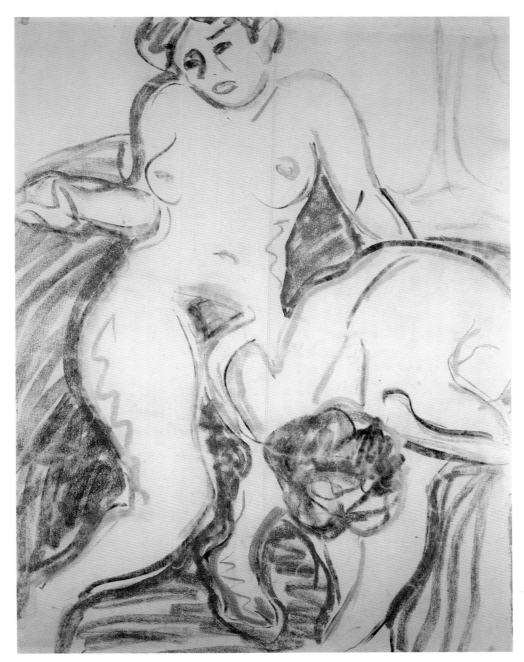

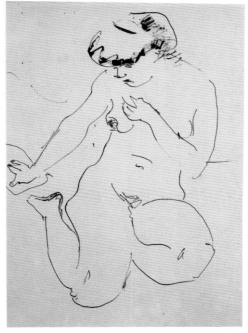

Two Nude Girls, 1909
Zwei nackte Mädchen
Chalk, 88.5 x 68.5 cm
Berlin, Brücke-Museum

Squatting Nude, 1909
Kauernder Akt
Pen, brush and Indian ink, 44.5 x 30.5 cm
Kassel, Staatliche Museen Kassel,
Graphische Sammlung

Dresden, including a substantial number of Klimts, and Kirchner might easily have seen two-colour drawings there.

The fact that the subjects were not restricted to single nude figures but also included couples and groups is indicative of the artists' habit of being naked with their girlfriends in the studio. That unconstrained nudity and naturalness of movement lay behind their figure work, as work done at various times indicates (pp. 22–23, 39–43). Indeed, the naked human figure, viewed in uninhibited movement, was at the heart of their art. Every change in their aesthetic approach can be traced through their handling of the nude – in the studio settings, where a philistine, conventional world without was unable to place restrictions on their freedom.

Unlike traditional single or group nudes, Kirchner's studio figures betray no allegorical or symbolic intent. He painted and drew his subjects in everyday attitudes, without troubling over deeper meanings. This much is crucial, and it underpins a number of other features equally central to the

Self-Portrait with Model, 1910
Selbstbildnis mit Modell
Coloured chalk, 60 x 49 cm
Private collection

Here we have two versions of the same motif of the artist in a colourful dressing gown and his semi-undressed lover on the bed: the relaxed pastel and the large oil. The pastel still has that freshness which was the hallmark of Kirchner's 1909 style. The oil was overpainted by the artist in the twenties and given the poster-like quality it now has, which is at odds with that freshness. The creamy later colours helped destroy the spontaneity and ease. In the pastel the man lacks any specific attributes, but in the oil his palette and brush declare him a painter. The lover on the bed might be seen as the personification of his art.

new art. In order to convey life "directly and without falsification", as the Brücke artists had proclaimed in their 1906 programme, they first had to live it as directly as they could. They avoided the kinds of subjects conventionally considered suitable for pictures, subjects that came complete with ready-made interpretations, and rejected any accommodation with tradition. The life they were interested in presenting was their own, as artists, and nowhere could they have found it more vividly available than in their own daily existence. Nor could they have portrayed it more credibly on any terms but their own.

The life they led was provocatively unconventional, profoundly at odds with the bourgeois milieu such as Kirchner and most of his fellows had grown up in. Kirchner's parents back in Chemnitz were appalled by their son's ways. His intransigence and their condemnation produced a climate anything but comfortable on those occasions when he was obliged to go cap in hand to his parents because he was out of funds. ("Had to go to Chemnitz recently, for money", we read in a letter he wrote to Heckel in 1910. "I have a few very disagreeable days behind me, and I accomplished very little.")

PAGE 45:
Self-Portrait with Model, 1910/1926
Selbstbildnis mit Modell
Oil on canvas, 150.5 x 100 cm
Gordon 121; Hamburg, Hamburger Kunsthalle

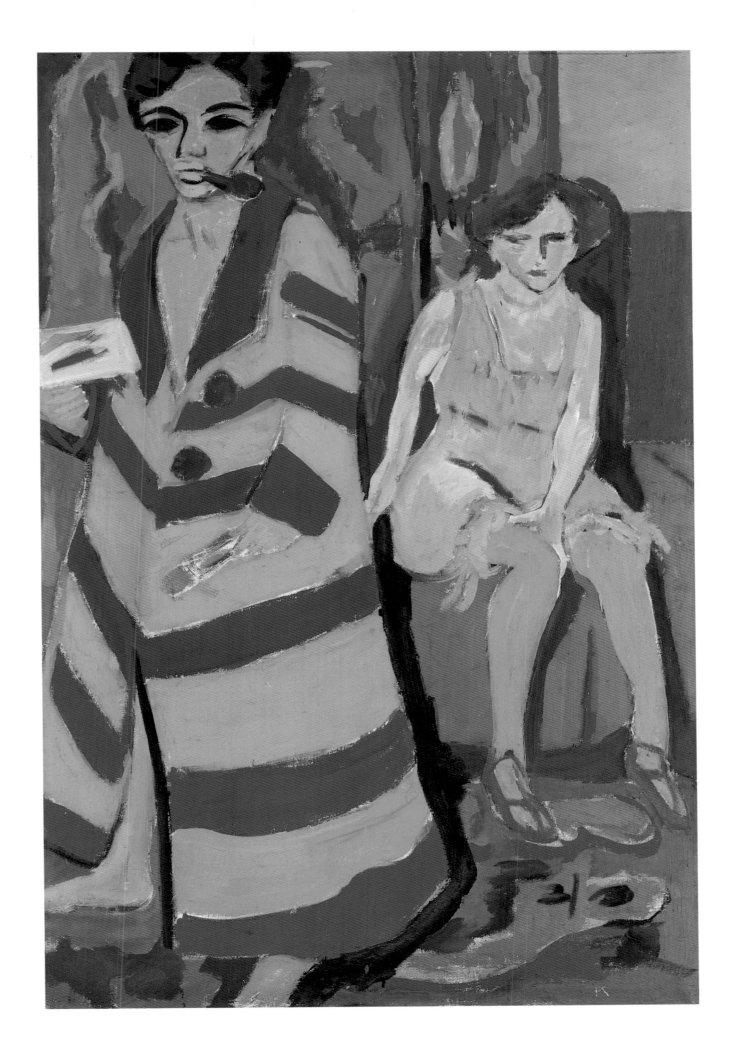

PAGE 46:
Dodo and Her Brother, 1908/1920
Dodo und ihr Bruder
Oil on canvas, 171 x 95 cm
Gordon 48; Northampton (MA)
Smith College Museum of Art,
Purchased 1955

Reclining Nude with Pipe, 1909–1910
Liegender Akt vor Spiegel
Oil on canvas, 83.5 x 95.5 cm
Gordon 56; Berlin, Brücke-Museum

Dodo's proper name was Doris Große. Kirch-
ner's Dresden lover was four years his junior,
had lost both parents as a girl, and lived with
her siblings. By profession she was probably a
milliner. In this picture she is seen with her
brother Alexander, who was nine years older
and the manager of a restaurant. They make a
stylish twosome – though the nude shows her
as we are used to seeing her.

Marzella with Her Hair Down, 1910
Marzella mit offenen Haaren
Pen, brush and Indian ink, 42.5 x 30 cm
Kassel, Staatliche Museen Kassel,
Graphische Sammlung

Marzella Seated, 1910
Sitzende Marzella
Pen and Indian ink, 43 x 30.5 cm
Berlin, Staatliche Museen zu Berlin –
Preußischer Kulturbesitz, Kupferstichkabinett

The Brücke artists were leading a life outside society's norms, an existence in which the demands of life and art could be harnessed together. But merely to be provocative is not in itself very interesting, and the point lay, of course, in their art, in its vitality and credibility. The directness and genuineness of that art was to be the foundation of that credibility. This principle applied as much to subject matter as to technique – and thus the pictures they produced could be as uncompromisingly radical as the life style of the artists. Ornamental artistry, including the fine decorative manner of Art Nouveau then in fashion, was banished from their work. Instead, Die Brücke espoused the rough and ready. Spontaneity of technique was valued – what counted was simplicity, fidelity to experience, and the expressive force and credibility that were felt to result from these. In later years, when Kirchner came to elaborate in theoretical terms the principles he had arrived at in practice, he described his method in drawings and paintings as hieroglyphic, by which he meant that, although his work possessed autonomous value as art, it was derived directly from things seen and experienced. We shall be returning to this term in due course.

Crucial to the Brücke artists' simplification of form, both in drawing and in painting, was the work they did in print graphics, particularly woodcuts. Wood, with its alternating smoothness and grain, can be an intractable or at least difficult material for the artist. The result is often simple, clear outlines. In this regard, woodcuts played a central part in the Dresden artists' evolution during the critical early years. We need only look at Kirchner's 1909 *Circus Rider* (p. 32), or the *Nude Dancers* (p. 38) and *Nude Couple on a Settee* (p. 39) done in the same year. Heckel and Schmidt-Rottluff also created important works in the same medium at that period – the group developed together.

The various aspects of the Brücke preoccupation with the nude seen in interior settings are all on display in Kirchner's outstanding work on the subject, his large oil *Bathing Nudes in a Room* (1909/1920; p. 25). Again the interior is that of the rooms he had moved into on 1 November 1909. The corner with the two doors, familiar from other drawings too (cf. pp. 62–63), is

PAGE 49:
Marzella, 1909–1910
Marzella
Oil on canvas, 75 x 59.5 cm
Gordon 113; Stockholm, Moderna Museet

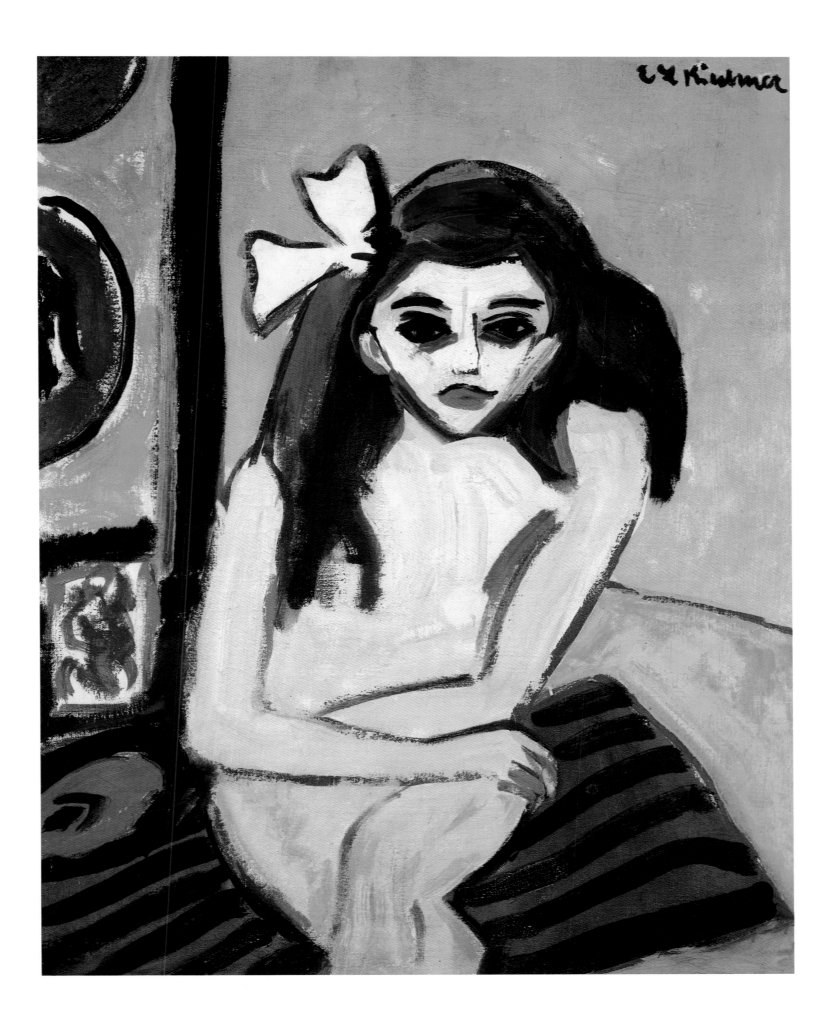

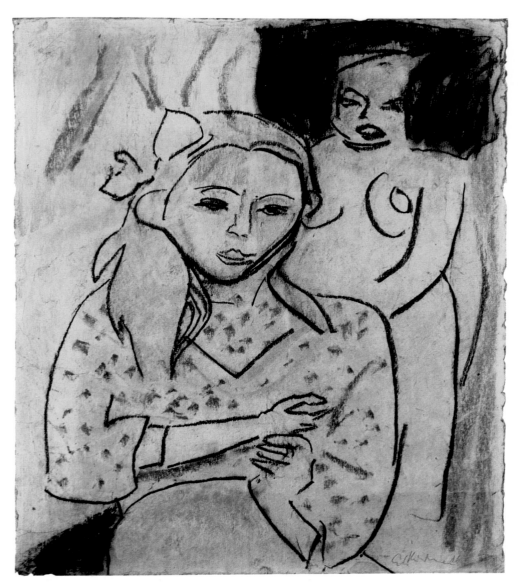

PAGE 51:
Fränzi in Carved Chair, 1910
Fränzi vor geschnitztem Stuhl
Oil on canvas, 70.5 x 50 cm
Gordon 122; Madrid, Fundación Colección
Thyssen-Bornemisza

The two young sisters, Marzella and Fränzi,
were apparently the daughters of an artist's
widow who lived near Kirchner. Erich Heckel
met them in early 1910 and recruited them as
models. In that and the following year they
were closely involved with Die Brücke, both
in the studios and on excursions to Moritzburg.

Fränzi in Carved Chair, 1910
Fränzi vor geschnitztem Stuhl
Chalk, 60 x 49.5 cm
Frankfurt am Main, Städtische Galerie im
Städelschen Kunstinstitut

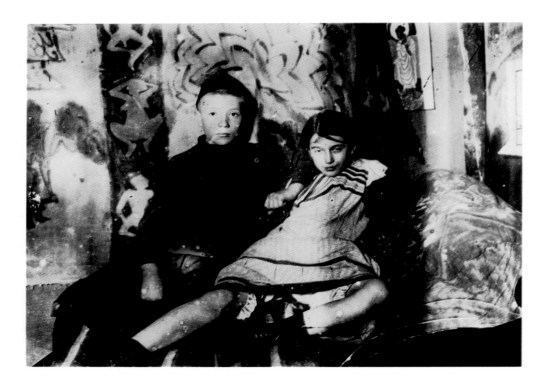

Fränzi and a boy in Kirchner's Dresden
studio, 1910
Photograph by Ernst Ludwig Kirchner
Wichtrach/Berne, Fotoarchiv Bollinger/Ketterer

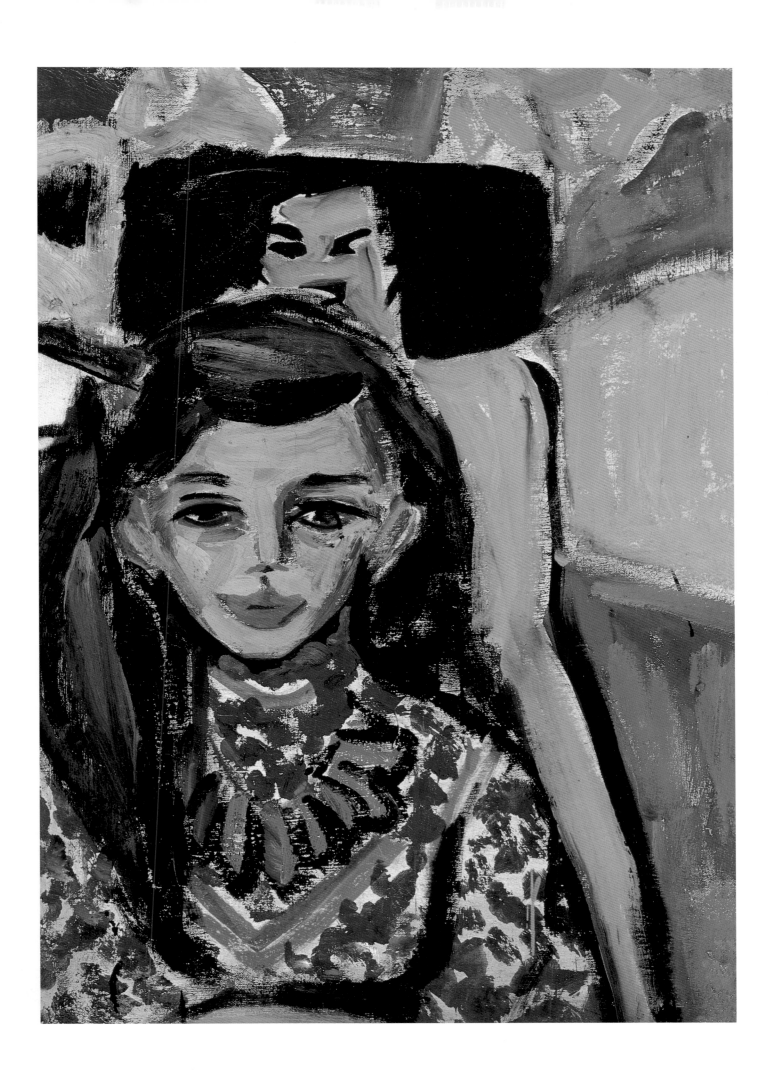

unmistakable. To describe this painting as Kirchner's major work on the subject is not only the critic's retrospective evaluation; it was also the express intention of the artist. It differs in format and in the number of figures from all his other variations on the theme. Almost two metres in width, it is more than twice the size of other comparable works. Time and again, as we shall see, it was Kirchner's practice to paint a monumental major work in this manner – and we have his own subsequent statements to confirm that this was what he had in mind.

The painting shows four nude women, three standing and one seated, in the foreground space, and a fifth reclining in the room seen to the rear. At the right margin are the head and adumbrated body of a man, possibly the artist himself. These people make a very relaxed impression, and the title suggests that they have just bathed together. As a large-format figure composition, the picture has its place in a tradition that runs from the Renaissance, though of course it does not invite comparison with the conventional nude compositions on Biblical or mythological subjects that constitute the substance of that tradition. This painting is no more than a picture of several naked women in an artist's studio. They are girlfriends relaxing after

Dresden-Friedrichstadt, 1910
Oil and tempera on canvas, 57 x 70 cm
Gordon 130; Hanover, Sprengel Museum

bathing, and that is all. The picture proposes no historical or metaphoric dimensions. Kirchner's studio was a place for painting from life, not for creating theatrical effects.

In 1920 Kirchner overpainted the picture. He did this repeatedly with various works, and these revisions are an important subject in Kirchner studies. By the twenties, when he was in Davos and had the time to attend to them once more, Kirchner had repeatedly moved house, and his paintings had often been in storage, so that they were in poor condition. Kirchner restored them, taking the opportunity to improve and revise. But of course restoration was not his profession, and the result was pictures altered in appearance, paintings that faithfully recorded his second thoughts and the changes in his style. In 1909 and 1910, for instance, he had applied the paint loosely and with a watercolourist's interest in translucence, but in the revision the painting is firmer and denser. In the twenties he mixed white into his colours, for a creamy effect, and these new shades tend to eliminate the colourful freshness of the original state. He firmed up the outlines of figures and objects – *Bathing Nudes in a Room* is an example of this. In overpainting this picture, Kirchner also very nearly eliminated the male figure at right. In the first major study of Kirchner,

Railway Underpass at Löbtauer Strasse, Dresden-Friedrichstadt. 1910/1926
Eisenbahnüberführung an der Löbtauer Straße in Dresden-Friedrichstadt
Oil on canvas, 68 x 89 cm
Gordon 171; Dresden, Staatliche Kunstsammlungen, Gemäldegalerie Neue Meister, on loan from a private collection

Two characteristic views of Dresden, one (facing page) in its original 1910 state, the other (above) overpainted by Kirchner in the twenties and heavily changed in texture in the process. The use of a sharp perspective together with a two-dimensional handling of spatial areas recalls the townscapes of van Gogh.

written by Will Grohmann and published in 1926, the painting was reproduced from a photograph taken by the artist which showed it in the earlier state, in which the entire male figure can be seen and not just the head we have now. The painting will presumably have made a softer, more open impression in its original state.

Not only the textures but also the title were changed in the overpainting. In Grohmann's study the picture was still identified as *Bacchanal in a Room* – in other words, an uninhibited erotic assembly of bacchantes, female followers of Bacchus, the Greek god of wine and – by extension – of debauchery. Whether the scene should really be read as an orgy is a moot point. What can be said is that Kirchner clearly had a taste, at least for a while, for giving mythological titles to the groups of naked persons in his Dresden studio – thus perhaps associating his own art with that of the Renaissance and the Baroque. The change of title to *Bathing Nudes in a Room* marked his later departure from what was a rather immature contrivance. At the same time, it substituted one allusion for another. The subject of bathing women had occupied Paul Cézanne in a considerable number of works both large and small, for several years. For Cézanne, the motif had become the very definition of ambitious figure composition in the line of the Renaissance, Baroque and Classicism – even if the nature of the subject really had little to do with that tradition. Kirchner, by describing the figures in this major product of his interest in the indoor nude not simply as nudes but as bathers, was unambiguously associating his own work with Cézanne's Modernist tradition. This is important, for it shows that Kirchner, despite his resolve to break with tradition and assert the freedom of the new and the young, was continuously aware of older artists at his shoulder, and by no means disinclined to place himself in their line. Indeed, as we shall see, Kirchner was much given to scrutinizing himself in the mirror of existing art.

In the summer months, the Brücke artists were able to transfer their interest in the nude outdoors. Since Die Brücke often tends to be viewed as an urban movement, it is worth emphasizing that they had a noticeable fondness for the countryside, and whenever they went out of town they would produce landscape as well as other work. But their chief interest seems to have been in bathers seen in landscape settings. The pools at Moritzburg castle, a hunting lodge not far from Dresden, were their preferred location. These ponds, thick with reeds, had been artificially created in the 18th century by King August of Saxony (known as August the Strong), apparently in order to re-enact naval battles in miniature, but by Kirchner's day they had become popular among bathers. The woods and bushes offered secluded spots to relax, and it was even possible to bathe in the nude. Kirchner and some of the other Brücke artists went there frequently in the summers of 1909, 1910 and 1911, putting up at country inns and spending the days swimming with their girlfriends and painting. It was an easy-going and uninhibited life, one that suited the programme of an art drawn directly from life ideally.

The Moritzburg nudes occupy a central position in the history of Die Brücke. As well as Kirchner, Heckel was a regular on these trips, and (at least in 1910) so was Pechstein. Schmidt-Rottluff, on the other hand, was a solitary kind of person and preferred not to join them. In the pictures painted at Moritzburg, the shared pleasure and experience spilled over into a shared style (pp. 56–59). What is more, within the œuvres of the individual artists the output of those three years stands out by the distinctiveness of the style,

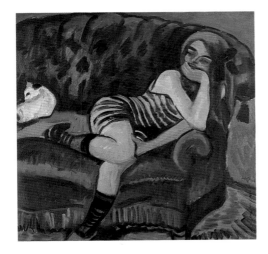

Max Pechstein:
Girl on a Green Sofa with a Cat, 1910
Mädchen auf grünem Sofa mit Katze
Oil on canvas, 96.5 x 97 cm
Cologne, Museum Ludwig

In summer 1910, Kirchner, Heckel and Pechstein spent several weeks at Moritzburg. From a postcard written by Erich Heckel on 11 August to his brother Manfred in Dresden we know that the three artists lived at house number 93 in Moritzburg, the Old Brewery. There Kirchner and Pechstein presumably painted their pictures of the girl (probably Fränzi) and a white cat on a green sofa. Kirchner's picture, one of the masterpieces of the Dresden Brücke period, is notable for its virtuoso handling of a difficult perspective.

PAGE 54:
Artiste, 1910
Artistin
Oil on canvas, 100 x 76 cm
Gordon 125; Berlin, Brücke-Museum

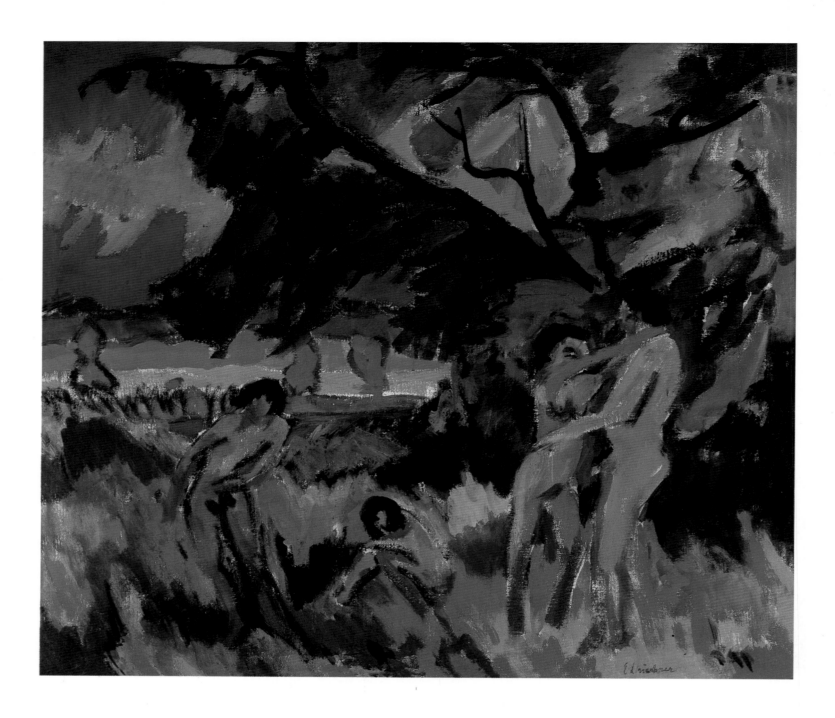

***Nudes Playing under Tree**, 1910*
Spielende nackte Menschen unter Baum
Oil on canvas, 77 x 89 cm
Gordon 141; Munich, Staatsgalerie für
moderne Kunst

a style that remained from start to finish. In the case of Kirchner it is often difficult to date the Moritzburg landscapes with nudes, at least on stylistic evidence. Other criteria have to be sought, such as the identities of the people portrayed, if we are to decide which of the three summers to assign a work to. Thus, for instance, the Wuppertal *Four Bathers* (p. 57) was long dated 1909 (this mistake even appears in Donald E. Gordon's catalogue), until it transpired that Fränzi, the girl at left, recognisable from her long black hair and her pose, had no connections with the Brücke artists till 1910 and did not join them at Moritzburg until the summer of that year. The stylistic willingness to re-think and change, which was a hallmark of the Brücke artists, seems to have been suspended at Moritzburg, doubtless because sheer enjoyment took priority.

The Brücke circle included a large number of girlfriends, only some of whom can be identified as partners of some duration and traced over a longer period. We have already noted an early girlfriend of Kirchner's,

Isabella, seen in the big charcoal drawings of 1906 and 1907 (pp. 8 and 9). Then there was Emmy Frisch (p. 16). We also know of a girlfriend called Line in 1907 – but other women came and went, their names unknown to us now. Some of them were very young girls indeed, and even there the relations seem by no means to have been platonic. The sisters Fränzi and Marzella, who figure so frequently in Kirchner's studio and Moritzburg pictures, have become so familiar to us that we might even classify an entire group as Fränzi and Marzella works. It appears that Erich Heckel met the girls in Dresden in 1910. "Here are two sisters I have just discovered", he wrote on 18 February 1910 on a postcard on which he had drawn Fränzi and Marzella with archers' bows, a card he sent to Rose Schapire, the art historian who supported Die Brücke. He described them as the daughters of an artist's widow who lived in Berliner Straße too. Kirchner seems to have been utterly captivated by the sisters, and it is they who appear in his most persuasive and mature works of the period. We see them in the studio (pp. 48–51) and also in Moritzburg paintings done in 1910 and 1911 (pp. 54–57).

One example (many might be described) of the artists' parallel work on the same subject is Kirchner's 1910 painting *Artiste* (p. 54) and Max Pechstein's *Girl on a Green Sofa with a Cat* (p. 55), done at the same time. The sitter appears to have been Fränzi, and the pictures were presumably painted

Four Bathers, 1910
Vier Badende
Oil on canvas, 75 x 100.5 cm
Gordon 95; Wuppertal, Von der Heydt-Museum

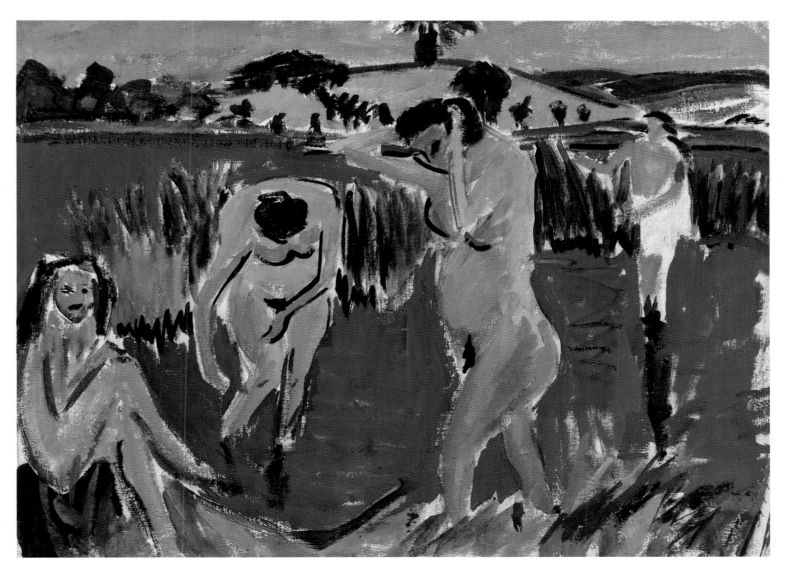

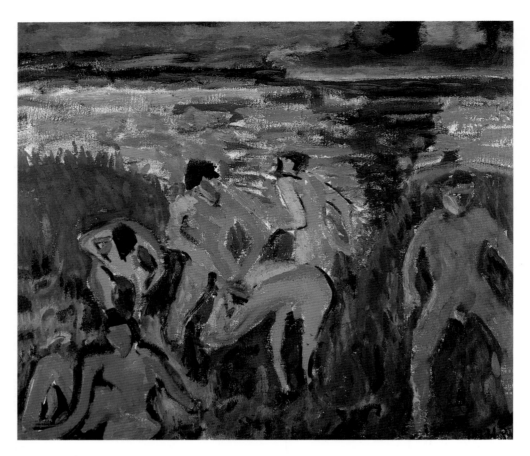

Erich Heckel:
Bathers in the Reeds, 1909
Badende im Schilf
Oil on canvas, 71 x 81 cm
Dube 148; Düsseldorf, Kunstmuseum Düsseldorf im Ehrenhof

Max Pechstein:
Bathers at Moritzburg, 1910
Badende in Moritzburg
Oil on canvas, 70 x 79.5 cm
Duisburg, Wilhelm Lehmbruck Museum

Working together *sur le motif* at Moritzburg in summer 1910 established a striking stylistic affinity between Kirchner, Heckel and Pechstein – just as Kirchner, Heckel and Schmidt-Rottluff had been close in 1907 and 1908 when working together. But generally speaking that affinity was an exception; usually the artists went their own ways. It was only one or two among the group that would work together at a particular time. At Moritzburg, Kirchner tended to work with Heckel; Pechstein joined them in 1910 only, and Schmidt-Rottluff never did so. Recalling that 1910 sojourn later in his memoirs, Max Pechstein remembered that one day the village policeman happened upon the artists and their models as they were all sitting around naked: "Quickly the girls slipped into their bathing robes, and there we stood, caught – in his eyes – in an act of gross indecency. Trying to explain that life drawing was part of our profession was of no avail, and our argument that not only ourselves but also the drawing class at the Royal Academy of Saxony required nude human beings in God's Nature for study purposes fell on deaf ears. He confiscated my painting – the *corpus delicti* – and assured us that charges would be brought." But thanks to Pechstein's former teacher, academician Otto Gussmann, and a public prosecutor with a taste for art, the charges were dropped.

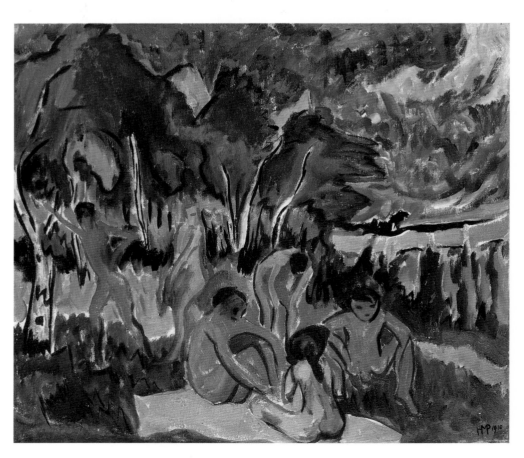

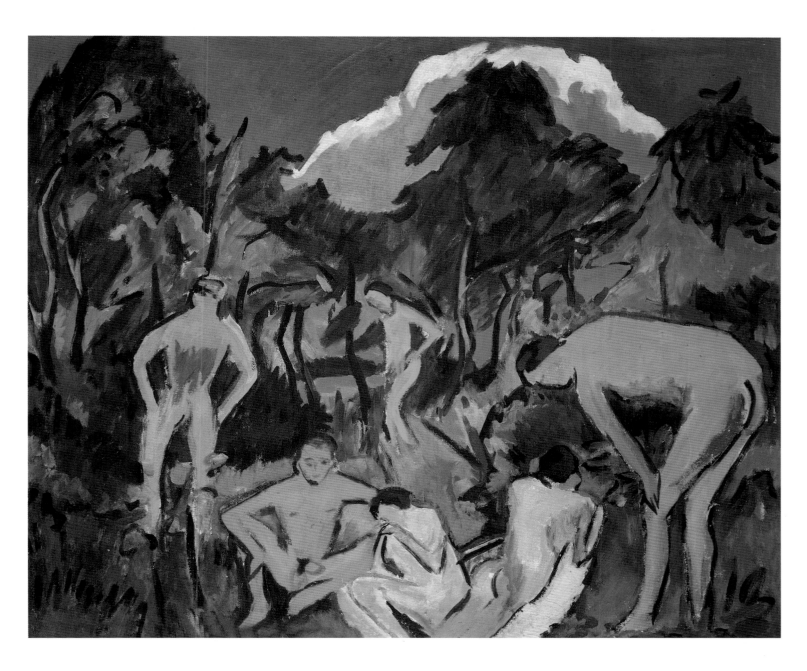

Nudes in the Sun, Moritzburg, 1910
Akte in der Sonne, Moritzburg
Oil on canvas, 100 x 120 cm
Gordon 144; private collection

Standing Nude with Hat, 1910/1920
Stehender Akt mit Hut
Oil on canvas, 205 x 65 cm
Gordon 163; Frankfurt am Main, Städtische
Galerie im Städelschen Kunstinstitut

Kirchner always described this nude of Dodo
in the studio as one of his major works, ex-
pressing his ideal of female beauty at the time.
"My wife always says I have never painted a
picture of a woman quite like it", he wrote to
collector Carl Hagemann in 1933 when the lat-
ter bought it; "she may be right, in so far as
my first deep love of the female body entered
into the painting, and that is unrepeatable."
We have Kirchner's testimony for it that this
nude was inspired by Lucas Cranach the El-
der's famous Venus of 1532, which is also in
the Städel in Frankfurt now. Kirchner always
had a reproduction on the wall of his Dresden
studio. Thus the personal and the historical al-
lusion are co-present in the work. The wood-
cut done after the painting was not made until
after Kirchner moved to Berlin, when he was
no longer together with Dodo. Later, in a
wooden sculpture, he gave the same body to a
statue bearing the facial features of his new
partner, Erna.

in a Moritzburg inn or pension in 1910. Certainly the setting, with the green sofa, is quite different from Kirchner's studio, where the picture of Marzella (p. 49), the elder of the sisters, was painted in 1909 or 1910. And we know that Kirchner was at Moritzburg in the summer of 1910 together with Heckel and Pechstein (who had been in Berlin since 1908). Kirchner chose to paint the girl from the side and slightly above, and this implied foreshortening and a somewhat cavalier handling of spatial actuality – the painting tends toward the two-dimensional. The outcome was a composition of monumental and unpretentious clarity. Stripped of all but essential detail, the picture is dominated by the figure. Pechstein's frontal treatment of the same subject makes an illustrative, even anecdotal impression in comparison, and is far more traditional and toothless.

The most important woman in Kirchner's life and art, from 1909 to 1911, was Doris Große, known as Dodo. "Dearest Dodo with those busy hands of yours. Quiet and delicate and so whitely beautiful. Your fine, free lovelust, I knew it entire with you, almost to the point of jeopardizing my calling. But you gave me the power to speak of your beauty, the purest image of woman, beside which Cranach's Venus is an old bag." In rapturous words such as these did Kirchner, on the first page of the Davos journal, penned in 1919, recall the woman who was his companion in his most fertile Dresden years. Their intimacy seems to have lasted from 1909 until Kirchner moved to Berlin in 1911, though they had met earlier. Doris Große, whose parents had kept a pub in Dresden and had died when she was very young, was a shopgirl, and perhaps worked in a fashion store. She had several sisters and a brother, some of whom make occasional appearances in Kirchner's work too (cf. *Dodo and Her Brother*, 1908/1920; p. 46).

Many of the major Dresden works are connected with Dodo, among them works that had an importance both artistic and personal for Kirchner. One of the first of these, done in 1909, is the wonderfully delicate lithograph *Dodo with a Japanese Umbrella* (p. 36) – not only one of the loveliest but also one of the rarest of Kirchner's print graphics, with only a few copies surviving, in various colourings. Related to it is the oil *Girl under Japanese Umbrella* (p. 37), painted the same year. These two pictures, works of great intimacy and radiance, show the onset of the evolution inspired in Kirchner by Matisse. Dodo may also feature in other single or group nudes (such as those on pp. 40–43 of this book), but we do not have any evidence either way.

One work in which Dodo undoubtedly appears is the famous oil *Self-Portrait with Model* (p. 45) of 1910, overpainted in 1926; in the present study a crayon drawing on the same theme is reproduced too (p. 44), a delightfully fresh and light piece with an altogether Fauvist mood. This self-portrait with his partner is one of the works in which Kirchner combined the autobiographical and the aesthetic veins in an exemplary, mutually enhancing manner. Robed in a colourful dressing gown, the artist is standing by the bed on which a lightly-clad Dodo is sitting. The atmosphere is elusively post-coital, yet the man is holding his palette and brush, which counters the first impression of an altogether private moment. Are we perhaps to imagine that the artist has quit the lovers' shared bed for his easel (as we have seen he was capable of doing), to record the moment in paint? Or is he simply getting on with his artistic work after the act of love? The painting is at once a personal record of a man and a woman, Kirchner and his partner Dodo, and also a near-allegorical painting on the time-honoured theme of the artist and

Nude with a Black Hat. 1911–1912
Akt mit schwarzem Hut
Woodcut, 66 x 21.5 cm
Dube 207; Frankfurt am Main, Städtische
Galerie im Städelschen Kunstinstitut

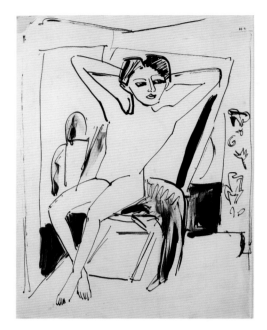

Nude Girl Sitting in the Studio, 1910
Sitzender Mädchenakt im Atelier
Pen, brush and Indian ink, 44 x 33 cm
Hamburg, private collection

his art. The woman might be taken as a personification of the art to which the artist is wed by Fate. Self-presentations such as this recur in Kirchner's work, and often he portrays himself together with a naked woman (cf. pp. 24, 123, 128). What varies is the situation he finds himself in, and the image he offers of the artist's vocation.

Other Dodo pictures include the full-length portrait with her brother (p. 46), the *Reclining Nude with Pipe* (p. 47) and two paintings showing her wearing hats, *Dodo with Feather Hat* (p. 65) and *Half-Length Nude with Hat* (p. 67), to which we shall be returning in a different context. The undisputed crowning achievement among the Dodo pictures, though, and a typical major Kirchner, is the *Standing Nude with Hat* (p. 60), begun in 1910, now in the Städel in Frankfurt. Kirchner always considered this as one of his most important works. Like the other major pieces we have mentioned, it is exceptionally large (more than two metres in height). Again the personal is intertwined with the aesthetically allusive in the manner we have seen in *Bathing Nudes in a Room* (p. 25). A naked woman in the intimacy of one's

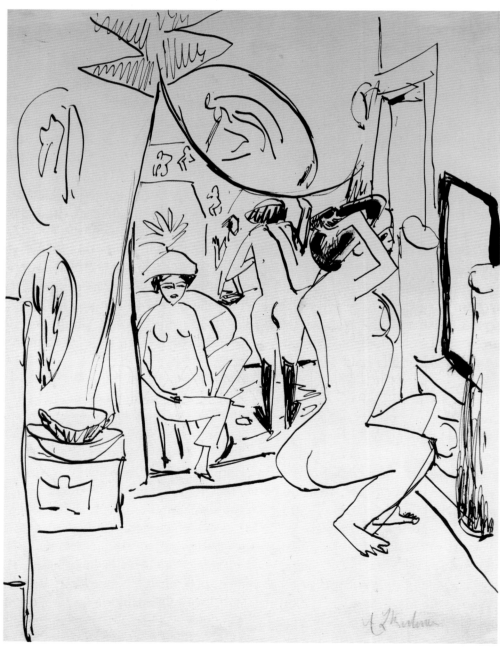

Interior with Nudes, 1910–1911
Interieur mit Akten
Pen and Indian ink, 45.5 x 34 cm
Saarbrücken, Saarland Museum in der
Stiftung Saarländischer Kulturbesitz

Studio Scene, 1910–1911
Atelierszene
Pen and Indian ink, 34.5 x 41.5 cm
Berlin, Staatliche Museen zu Berlin –
Preußischer Kulturbesitz, Kupferstichkabinett

Late in 1910, Kirchner's style became harder
and more graphic, probably under the in-
fluence of the Pacific sculptures he had found
in the Ethnological Museum. He carved in
wood and made sculptures for his studio in
this period. Numerous drawings and graphics
indicate what the studio looked like and the
life that was led in it. In this drawing, Dodo is
at left in the hat and at right is Kirchner with a
cigarette between his lips, while behind them,
naked, is one of the girls, Marzella or Fränzi.

**Bathing Girl in the Tub, with a Hand
Mirror**, 1911
Badende Mädchen im Tub mit Handspiegel
Etching, 32 x 25 cm
Dube 134; Essen, Museum Folkwang

own home (she is seen in front of the painted drape that masked a door in
Kirchner's apartment, beyond which were a divan and erotic paintings) is of
course an essentially private motif. Her wearing a stylish hat despite her
nudity is a gesture of almost fetishist eroticism, and as such likewise private
in origin. Dodo is often seen wearing hats in Kirchner's pictures, and some
critics have even concluded from her apparent taste for elegant headwear
that she may have been a milliner. In addition to this intimate dimension,
though, we must note that Kirchner liked to use his studio as the setting for
paintings that were richly allusive. And it is from the artist himself that we
learn that this nude was directly inspired by the famous Venus of Cranach
the Elder (also in the Städel now), and represented his own ideal of female
beauty. When Kirchner wrote "you gave me the power to speak of your
beauty, the purest image of woman, beside which Cranach's Venus is an old
bag", he was in all probability referring to this very painting, conceived in
homage to Cranach's. On the one hand, it was Kirchner's demonstrative way
of acknowledging and avowing the old tradition in German art as a histor-
ical line to which his own work pledged affinity. It is as if he was heeding
Nolde's comments above, that young German artists would have to take up
the struggle of the French Modernists if they wanted to initiate a new high
German art, or was following Wilhelm Worringer (1881–1965), an art histo-
rian contemporaneous with the Brücke artists, who wrote that German
painters should take their bearings from the great tradition in German art.
On the other hand, this historical homage was transformed by Kirchner into
a deeply personal homage to the woman he loved. A year or two later, when
he was living in Berlin and the liaison with Dodo was a thing of the past, he
returned to the painting in order to model a woodcut on it (p.61) – confirma-
tion of the importance it had in his eyes. And six or seven years later he used
it once more as the model for a sculpture in which he combined Dodo's long

torso and short legs, familiar from the painting, with the facial features of his new partner, Erna.

Alongside his concern with the nude, indoors or out, and with the human figure generally, Kirchner did turn to other subjects at times. As well as landscapes and still lifes he produced work on the more modern theme of the urban scene – not pictures of sights or popular views, of course, but townscapes such as the artist (or anyone) might see in his daily life (cf. pp. 52 and 53). The locations he chose were in the Friedrichstadt part of Dresden. These were streets Kirchner would have been very familiar with, and indeed their interest for him lay precisely in their being usual rather than unusual. Picture-postcard Dresden was not on his agenda.

Night life, the circus and the cabaret entertainment scene also figured prominently on Kirchner's list of subjects. A favourite Brücke alternative to the licensed life they led in the privacy of the studio was the uninhibited life of the shows; and dance held a particular appeal for Kirchner because of the complex movements involved. He produced a large number of pictures on these subjects (pp. 18–19, 26–27, 32–34, 38) and occasionally asked dancers or circus artistes to his studio. Three black artistes from Schumann's Circus – Milly, Nelly and Sam – appear in his work (cf. *Milly Sleeping*, 1911; p. 64), and there is a photograph taken by Kirchner which shows two of them naked in his studio.

The softened style he had adopted from Matisse dominated Kirchner's output from early 1909 until the latter half of 1910, after which his manner

Milly Sleeping, 1911
Schlafende Milly
Oil on canvas, 64 x 90.5 cm
Gordon 58; Bremen, Kunsthalle Bremen

Milly was one of a threesome of circus artistes – Milly, Nelly and Sam – whom Kirchner and Heckel used as models.

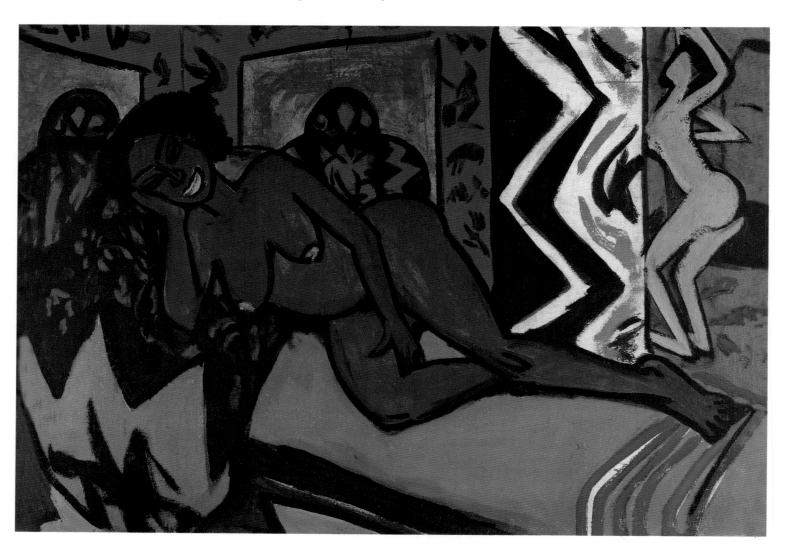

Dodo with Feather Hat, 1911
Dodo mit großem Federhut
Oil on canvas, 80 x 69 cm
Gordon 181; Milwaukee (WI), Milwaukee Art
Museum, Gift of Mrs. Harry Lynde Bradley

The graphic style of draughtsmanship Kirch-
ner developed in late 1910 was matched in his
oil work by angularity and strong black out-
lines. This phase lasted for only a few months.

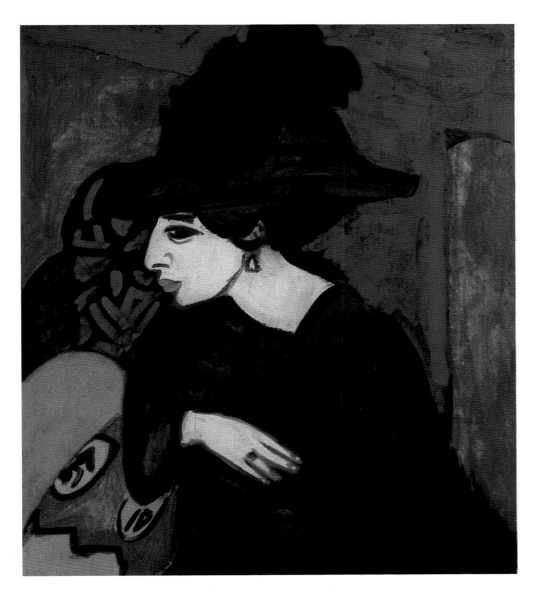

began to change once more (cf. pp. 62–65). The outlines became harder and
more angular, and his draughtsmanship more graphic, with black contour
lines defining powerfully coloured shapes. The soft colourism of the Brücke
style of 1909 and 1910 was complicated with a rigour like that of wood carv-
ings. This change of direction was evidently prompted by the widespread
contemporary interest in art that was thought "primitive" – that is to say, the
art of Africa or the South Seas, which Kirchner could view in Dresden's Eth-
nological Museum. A letter he wrote from Dresden on 31 March 1910 to
Heckel and Pechstein in Berlin reads, "The Ethnological Museum here has
re-opened, albeit only part of it, and it is a refreshing pleasure to look at the
wonderful bronzes from Benin. Various things from the Mexican Pueblos
are on show, and a number of Negro sculptures [...]." In this case it was
plainly Kirchner who was introducing the group to a new source of inspira-
tion. It was in his own art that the new interest made the most noticeable im-
pact, though; some of the objects and vessels he carved for his own apart-
ment might easily have come from Africa or the South Seas. He was particu-
larly influenced by carved and painted beams from the Palau Islands in the
Pacific, to which this letter makes no mention. He referred to them numer-
ous times elsewhere, and made sketches of them, clearly interested in the
simple, angular designs.

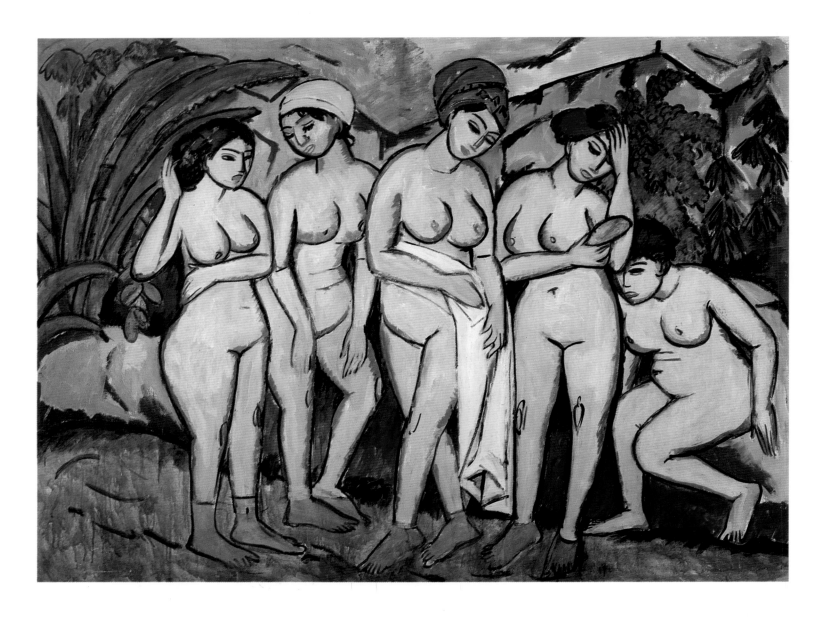

Five Bathers at the Lake, 1911
Fünf Badende am See
Oil on canvas, 150.5 x 200 cm
Gordon 194; Berlin, Brücke-Museum

Kirchner became interested in *The Paintings in the Buddhist Cave-Temples of Ajanta, Khandesh, India* (published 1896–1897) by the British archaeologist John Griffith, and under the influence of the reproductions in the book his painting style changed in the latter half of 1911. His shapes and contours became rounder, his colours more muted. This grand composition faithfully follows a mural in Cave II at Ajanta, illustrated in Griffith's study.

Milly Sleeping (p. 64) and the profile of *Dodo with Feather Hat* (p. 65), both painted in 1911, show the changes Kirchner's style was undergoing. The compositions use weighty blocks of colour, the outlines are hard and graphic, the shapes are forcefully set off from each other by strong colours. Kirchner's contrasts have become more powerful, and simpler too, like those of book illustrations or posters – possibly an effect of his interest in "primitive" art. Two ink drawings signed and dated by Kirchner at the time show that this mutation in his style had set in the year before, in 1910, and the transformation continued into 1911, initiating a further phase in his development which we can trace well beyond the Dresden years.

Let us turn once again to a large-scale work with several figures, the 1911 *Five Bathers at the Lake* (p. 66), now in the Brücke Museum in Berlin. We have already seen that the subject matter, with its allusion to Cézanne, has an import beyond the merely personal. In this case, the painting shows five female nudes, variously posed. The composition makes a more static, even monumental impression than the *Bathing Nudes in a Room* (p. 25) or Kirchner's Moritzburg pictures (pp. 57 and 59) – partly for stylistic reasons (the figures are more rounded and classical), partly because of the juxtaposed attitudes of the women. The effect is almost of five phases in the movements of one and the same model. Research has shown that the group composition

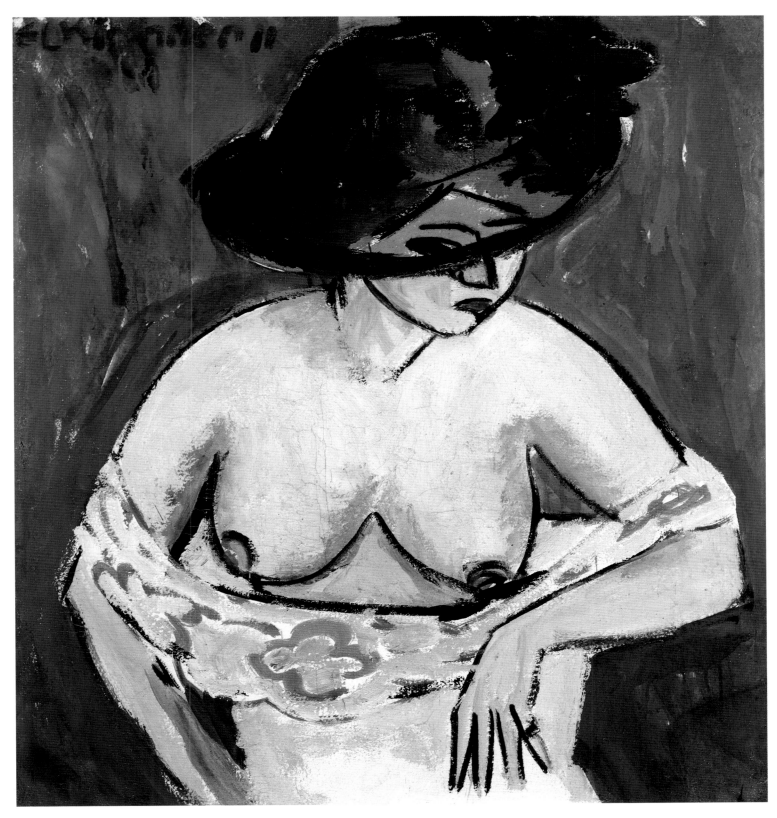

Half-Length Nude with Hat, 1911
Weiblicher Akt mit Hut
Oil on canvas, 76 x 70 cm
Gordon 180; Cologne, Museum Ludwig

was not of Kirchner's own devising but was borrowed from a historical original. As he pursued his interest in non-European art in the libraries of Dresden's museums, he came upon John Griffith's two-volume study *The Paintings in the Buddhist Cave-Temples of Ajanta, Khandesh, India*, published in London in 1896/97. The American Kirchner scholar Donald E. Gordon, preparing his landmark monograph of 1968, traced the very copy of Griffith's study that Kirchner had used in 1911. It included a colour reproduction which served the German artist as a compositional model for *Five Bathers at the Lake*. Kirchner himself, writing on his own work in the 1920s, noted: "By chance I came across Griffith's book on Indian cave paintings in a Dresden library. I was almost beside myself with delight. The compositions were utterly unique, and I was convinced that I could never achieve that immense quality of repose in the form. My every attempt seemed vapid and restless. I copied a good deal from the illustrations, in order to develop my own style, and began to paint large pictures measuring 150 by 200 centimetres […]."

That use of an Indian model for *Five Bathers at the Lake* in 1911 did indeed herald a thoroughgoing change in Kirchner's style, shifting his evolution away from the Dresden Brücke's use of large blocks of colour, in an al-

The Bosquet; Square in Dresden, 1911
Das Boskett; Platz in Dresden
Oil on canvas, 120 x 150 cm
Gordon 198; private collection

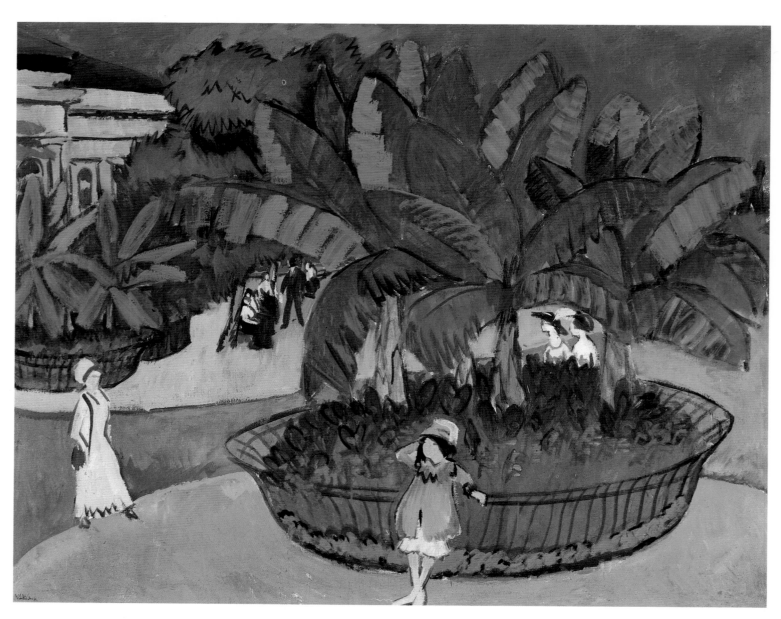

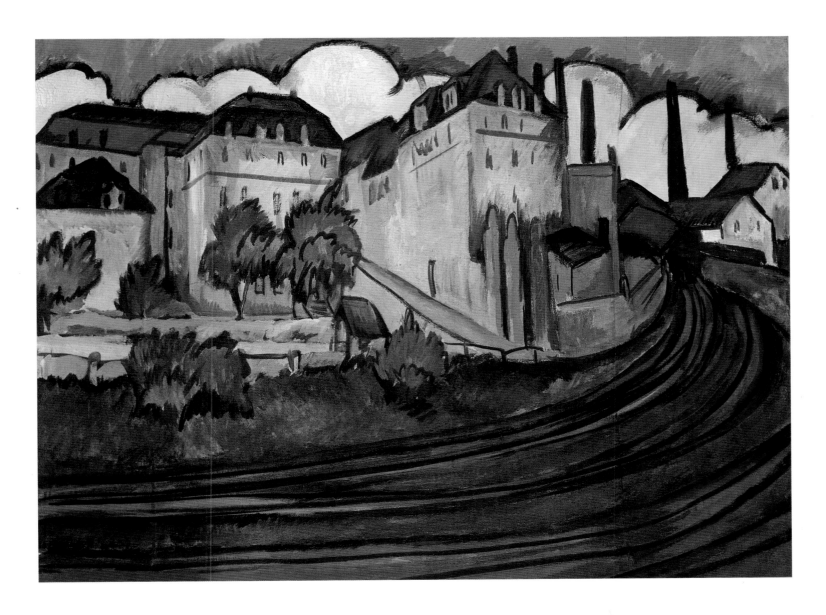

together new direction. This development continued in one last picture of Dodo in 1911, *Half-Length Nude with Hat* (p. 67), and two important Dresden city scenes, *The Bosquet; Square in Dresden* (p. 68) and *Approach to the Altstadt Goods Station, Dresden* (p. 69), also done in that year. And then, hard upon the heels of these new stylistic bearings, came a profound change in Kirchner's life. In October 1911 he moved to Berlin.

Approach to the Altstadt Goods Station, Dresden, 1911
Einfahrt zum Altstädter Güterbahnhof Dresden
Oil on canvas, 90 x 125 cm
Gordon 207; private collection

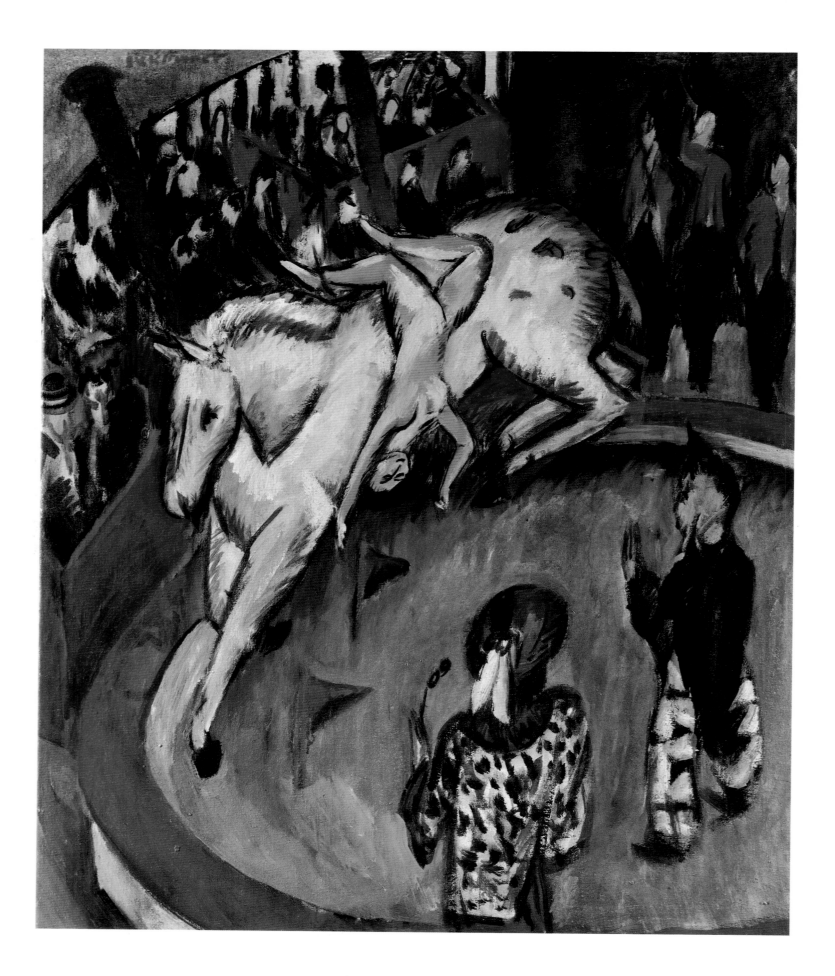

The Streets of Berlin

Berlin had long been a magnet. Assuredly Dresden was well disposed to art and artists, and Die Brücke had been fortunate in acquiring an audience quickly and scoring first successes beyond the city, in those middle-class circles that took an active interest in contemporary art. But Germany's most international-minded art centre, its most vibrant cultural metropolis, was unquestionably the capital. At that time, Berlin ranked third among European art centres, after Paris and London, and its importance was growing yearly. In 1889 Paul Cassirer had opened the commercial gallery we have already referred to, and in Kaiser Wilhelm's Berlin it became a forum of open-minded aesthetic cosmopolitanism, compensating for the stuffily historical fixation of official salon taste. Anything that had recently been exciting Paris was sure to be seen there. The Brücke artists visited Cassirer's time and again, and, as we have seen, it was there that they first encountered the work of Matisse, in January 1909. Furthermore, the Berlin Secession of 1898, led by Max Liebermann (and with Paul Cassirer as its business manager), had provided an umbrella under which outward-looking artists whose interest was in French Impressionism and what followed could congregate. Meanwhile, Hugo von Tschudi, appointed director of the Berlin National Gallery in 1896, had begun ahead of the curators of other major European collections to acquire Impressionist works by Edouard Manet and Claude Monet – though when, in 1909, he proposed purchasing paintings by Cézanne, he clashed head-on with Wilhelm II and was forced to resign.

For the generation to which the Brücke artists belonged, Paul Cassirer, the Berlin Secession and the National Gallery's holdings represented established modern art. This alone would not have sufficed to tempt them from Dresden to Berlin; after all, they could have seen the same kind of art at Dresden galleries such as Richter's or Arnold's. But Berlin was also the battleground on which the young generation was fighting for position – and the Brücke programme had expressly advanced the claims of youth. In 1910 Emil Nolde's famous *Pentecost*, painted the previous year, was turned down by the jury of the Berlin Secession's annual exhibition, at the instigation of Max Liebermann – and so was every other work submitted by the rising generation. The result was a secessional group within the existing Secession. At Max Pechstein's initiative, the New Secession was founded, pledged to assert the interests of an art genuinely representative of the young generation, and of course of the Brücke artists. It was at this point that the group met Otto Mueller, who presently joined them.

Also in 1910, the first number of a new periodical of literature and the arts appeared: *Der Sturm* (the storm), edited by Herwarth Walden. Two years later one of the most progressive galleries in Germany was opened under the

***Woman Fastening Her Shoe**, 1914*
Frau, Schuh zuknöpfend
Woodcut, 31 x 24.5 cm
Dube 206; Berlin, Staatliche Museen zu Berlin – Preußischer Kulturbesitz, Kupferstichkabinett

PAGE 70:
***Girl Circus Rider**, 1912*
Die Zirkusreiterin
Oil on canvas, 120 x 100 cm
Gordon 288; München, Staatsgalerie für moderne Kunst

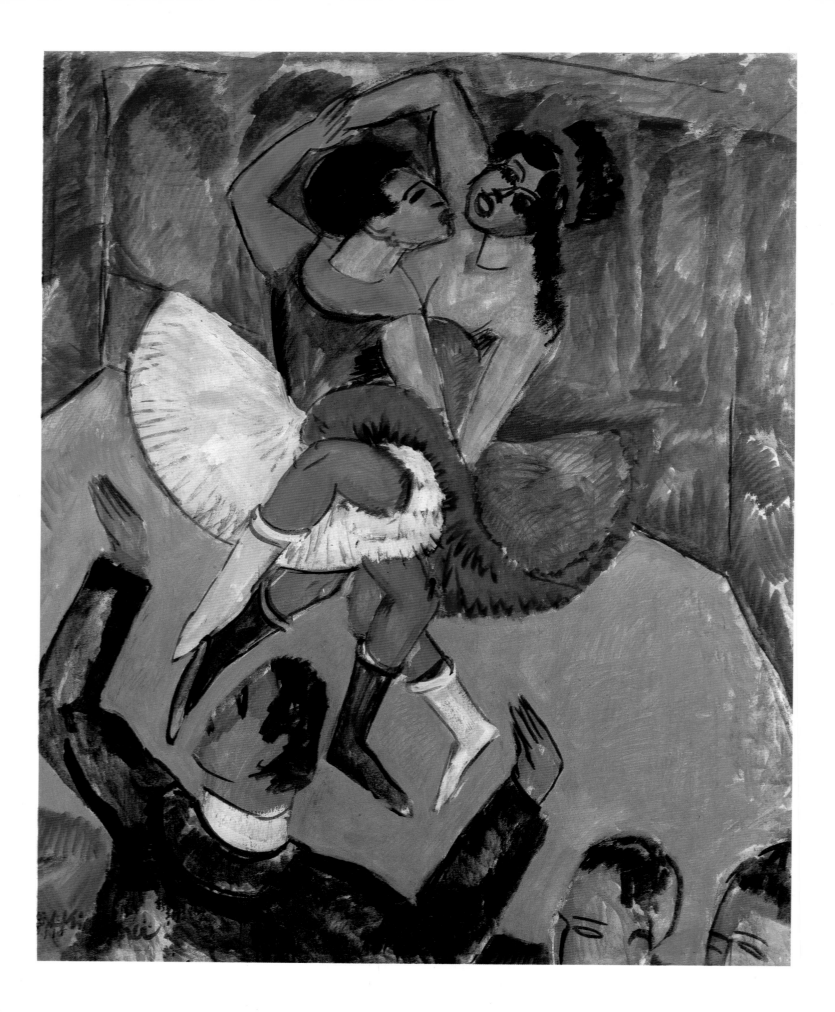

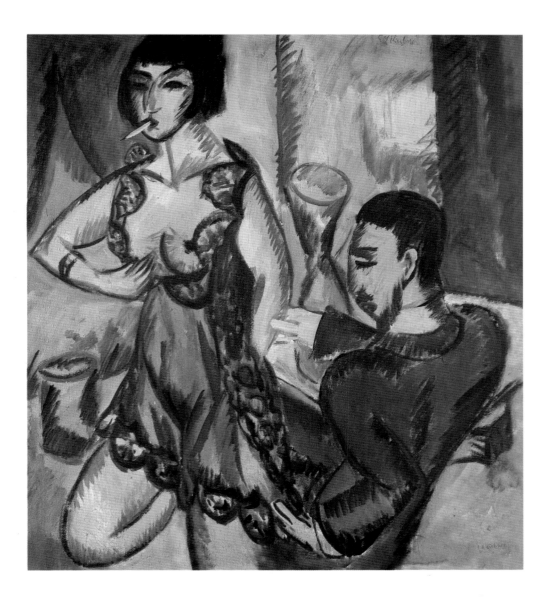

same name, a venture closely related to the magazine. "Der Sturm" quickly became a platform for the international avant-garde, a pioneering enterprise in Europe. It was owing to Walden and "Der Sturm" that Oskar Kokoschka moved from Vienna to Berlin in 1910, for instance. Though the Brücke artists were never represented by the Sturm gallery, its charismatic role was important for them too; and the periodical printed ten of Kirchner's woodcuts in 1911 and 1912, the first as early as April 1911, when he was still living in Dresden.

If we bear all of this in mind, it will seem that the move to Berlin was the logical next step for a group of artists who had achieved as much as they could expect to achieve in Dresden. Pechstein indeed, when he returned from his visits to Italy and Paris in 1908, had already decided at that date not to return to Dresden, and had settled in the capital. He had become the Brücke's man in Berlin, and the others all found his presence there useful and important. From the cards they regularly wrote to each other we know that they stayed ever more frequently, and often for lengthy periods, at Pechstein's home in Berlin, which they saw as their base there. When Kirchner later claimed to have had a Berlin studio as early as 1908, he was referring to Pechstein's place.

But the move to Berlin was not undertaken merely in order to be closer to an art scene that was up to date and international. The Brücke artists were

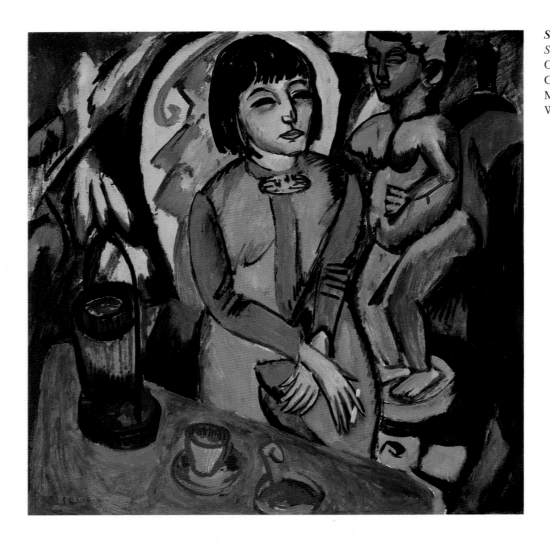

Seated Woman with Wood Sculpture, 1912
Sitzende Frau mit Holzplastik
Oil on canvas, 97 x 97 cm
Gordon 268; Richmond (VA), Virginia
Museum of Fine Arts, The Adolph D. and
Wilkins C. Williams Fund

Ernst Ludwig Kirchner and Erna Schilling in
the Berlin studio, 1911–1914
Photograph
Wichtrach/Berne, Fotoarchiv Bolliger/Ketterer

As in Dresden, Kirchner's Berlin studio was
richly decorated with painted wall hangings,
embroideries, and carved furniture, vessels
and sculptures. The picture above shows his
new partner Erna Schilling in the studio. The
large sculpture seen in both the painting and
the photo (right) was a copy of an African
piece made by Kirchner for practice exercises
at the drawing school he and Pechstein had set
up at the studio.

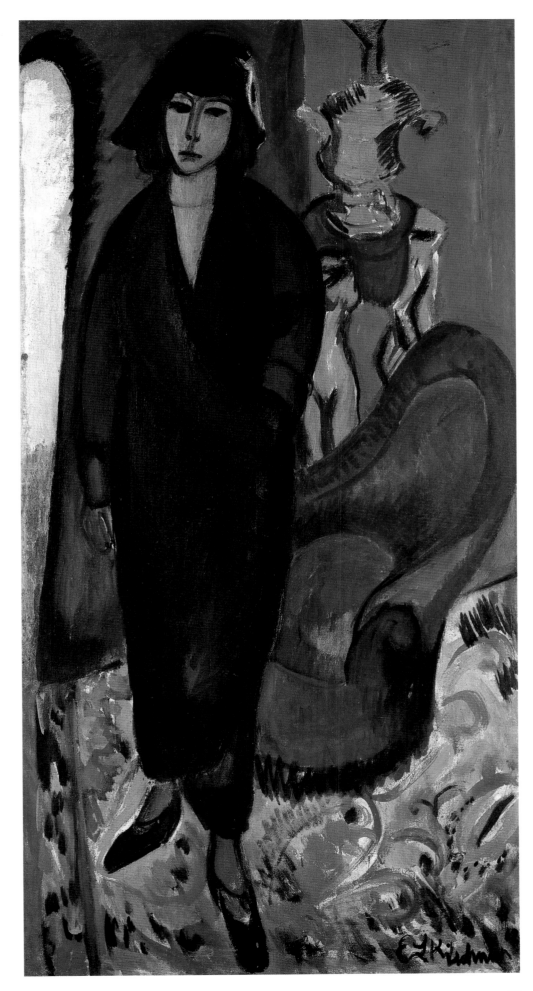

The Russian Girl, 1912
Die Russin
Oil on canvas, 150 x 75.5 cm
Gordon 228; Cologne, Museum Ludwig

Bathing Women with White Rocks, 1912
Badende Frauen zwischen weißen Steinen
Coloured woodcut, 28 x 27.5 cm
Dube 209; Hamburg, Hamburger Kunsthalle

From 1912, summers on the Baltic island of
Fehmarn took on the same significance as the
Moritzburg excursions in Dresden days.
Nudes in the open remained a favourite Kirch-
ner motif. He liked to put up at the lighthouse
keeper's house at Staberhuk on the southeast
tip of the island, and to spend the whole day
on the stony beach, bathing in the nude.

also in pursuit of greater success for themselves. Their next major exhibi-
tion, following the show at Arnold's in Dresden in 1910, was at the Fritz
Gurlitt gallery in Berlin in 1912 (from where it travelled to Commeter's in
Hamburg). They had been invited to show in the second Blauer Reiter ex-
hibition in Munich, an exhibition that was subsequently seen in the Sturm
gallery in Berlin as well. And above all, they were invited to show in the
Sonderbund exhibition in Cologne in 1912, an important honour. This key
exhibition, according to the catalogue, hoped to provide "an overview of the
latest movement in painting, which has followed atmospheric Naturalism
and dynamic Impressionism and aims for simplified and intensified forms of
expression, a new sense of rhythm and colour, structures that are decorative
or monumental – an overview of that movement that has been called Ex-
pressionism."

This marked Die Brücke's official entry into the art elite of Europe.
Their works hung alongside paintings by the very artists who had inspired
them: van Gogh, Cézanne, Gauguin, Signac and Munch, or others who
were their own contemporaries, such as Pablo Picasso, Georges Braque,
André Derain, Henri Matisse, Maurice de Vlaminck, Kees van Dongen,
Piet Mondrian and Oskar Kokoschka, to name but the most important. It
was at this time that Ernst Ludwig Kirchner had himself photographed,
dressed stylishly, and self-confidently wrote on the back of the picture,
"Expressionist, leader of the newest movement." That hubris may reflect
the new European status to which the Sonderbund exhibition had elevated

PAGE 77:
Brown Nude at the Window, 1912
Brauner Akt am Fenster
Oil on canvas, 125 x 90 cm
Gordon 260; private collection

The picture shows Kirchner's partner Erna at
the window of the room in the lighthouse
keeper's house which they rented at Staber-
huk on Fehmarn.

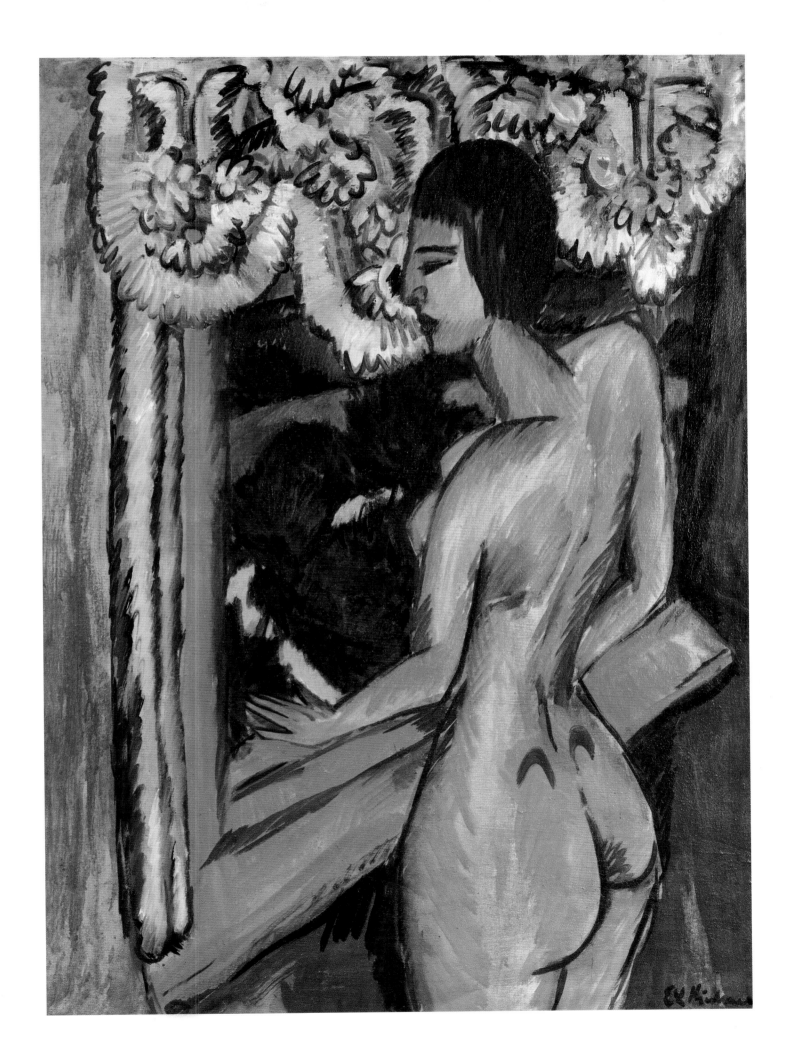

Seated Nude Woman, 1912
Sitzende nackte Frau
Pencil, 51 x 39.5 cm
Stuttgart, Staatsgalerie Stuttgart

Kirchner. He and Heckel had been additionally honoured with an invitation to decorate a chapel at the show. They had arrived. And Berlin was the better place for them.

Thus Kirchner, Heckel and Schmidt-Rottluff, one after another, gave up their Dresden studios in the autumn of 1911 and moved to Berlin. That October, Kirchner moved into 14, Durlacher Straße in the suburb of Wilmersdorf – the very building where Pechstein had been living for some time. There, together with Pechstein, he started up a school for modern drawing. Though young, they plainly felt mature and established enough to be offering tuition. "Pechstein and I hope that this will be useful to the new movement in art", Kirchner wrote to his Hamburg patrons, Luise and Gustav Schiefler, when announcing the project. He designed a poster to advertise the school, a fine two-coloured woodcut which is highly regarded now. But despite such efforts the school seems never to have attracted more than two students. These were men who subsequently became friends of Kirchner but have been largely forgotten as artists: Hans Gewecke and Werner Gothein.

At that date, Max Pechstein appears to have been very important for Kirchner still. Indeed, he may well have been his closest friend. Later, however, he inspired jealousy and anger in Kirchner, and contemptuously dismissive comments. This was partly because of events within Die Brücke, to which we shall be turning in due course, but chiefly because Pechstein had good friends and contacts in the art world (such as the Dresden art critic Paul Fechter, who had had distinct reservations about the earliest work of Die Brücke). These contacts spoke out in praise of Pechstein, and from 1912 essays on him were appearing in leading German periodicals such as *Deutsche Kunst und Dekoration*, *Cicerone* or *Kunst und Künstler*, to be followed in 1916 by the first book-length study, in which he was even hailed as "the Giotto of our time". Kirchner and the other Brücke art-

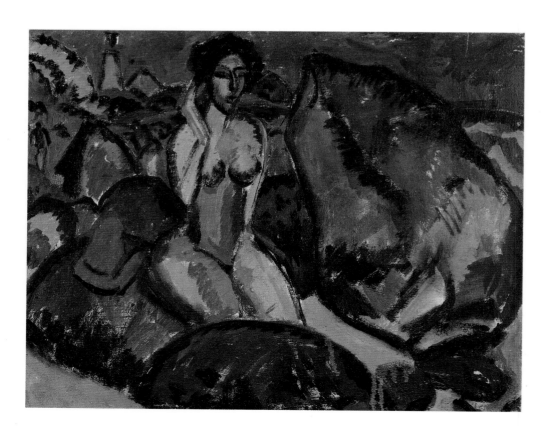

Bather between Rocks, 1912
Badende zwischen Steinen
Oil on canvas, 46 x 60.5 cm
Gordon 256; private collection

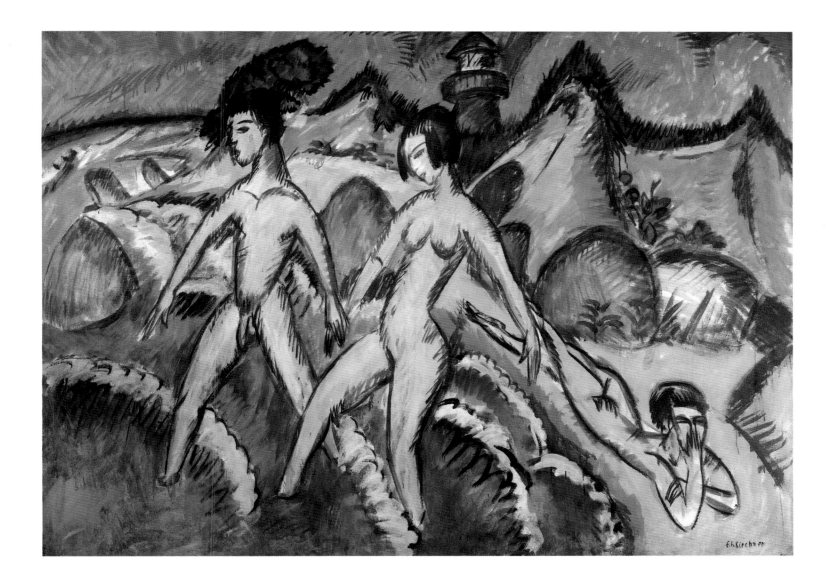

ists had to wait for years before comparable attention came their way. In his 1914 book on Expressionism, Fechter described Pechstein as the leader of the Dresden Brücke – a role that was never Pechstein's, no doubt, but the difficulty was that Kirchner saw it as his own role, and his alone. He had even inscribed a photograph with the fact, as we have seen. Conflict lay ahead, but in 1911, when Kirchner moved to Berlin, relations between the two men were still untroubled, and the new arrival sought closeness with the established presence.

In late September 1911, in one of his last letters from Dresden, written to Gustav Schiefler in Hamburg, Kirchner announced his intention of going to Paris. But three weeks later, on 17 October, he had changed his plans: "I am in the midst of moving – not to Paris, alas, but to Berlin. Things didn't work out." No other mention of Paris plans has come down to us, nor do we know exactly what it was that did not work out, or how serious the plans were. Given the defensive stance Kirchner invariably struck in public statements concerning the influence of Paris and French art on his work, regardless of how much he had profited from the example, it seems surprising that he should have so much as considered the move. It is also tempting, of course, to speculate on how Kirchner would have fared in the Paris of Matisse, Picasso and Braque, and how his life and art would have changed. Tempting, but fruitless – Kirchner went to Berlin.

Striding into the Sea, 1912
Ins Meer Schreitende
Oil on canvas, 146 x 200 cm
Gordon 262; Stuttgart, Staatsgalerie Stuttgart

Kirchner considered this the masterpiece among his paintings of open air nudes on Fehmarn. Looking back in the Davos journal, he wrote: "Work on the nude in Nature began in my Dresden days […] and continued into the Berlin period, culminating for the moment in the big Fehmarn pictures *Striding into the Sea* and *Three Bathers*." (The latter picture, Gordon 356, was painted in 1913. It is not reproduced in the present volume.)

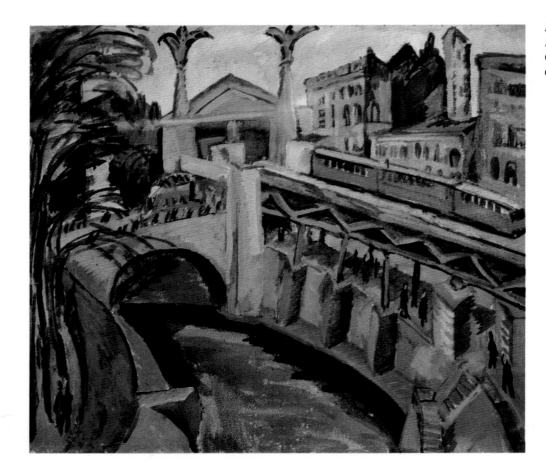

Halle Gate, Berlin, 1913
Hallesches Tor, Berlin
Oil on canvas, 70 x 78 cm
Gordon 305; London, private collection

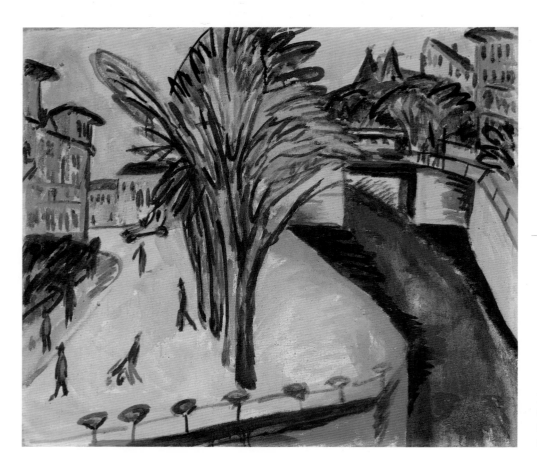

Yellow Angel Bank, Berlin, 1913
Gelbes Engelsufer, Berlin
Oil on canvas, 71.5 x 80.5 cm
Gordon 306; Mannheim, Städtische Kunsthalle

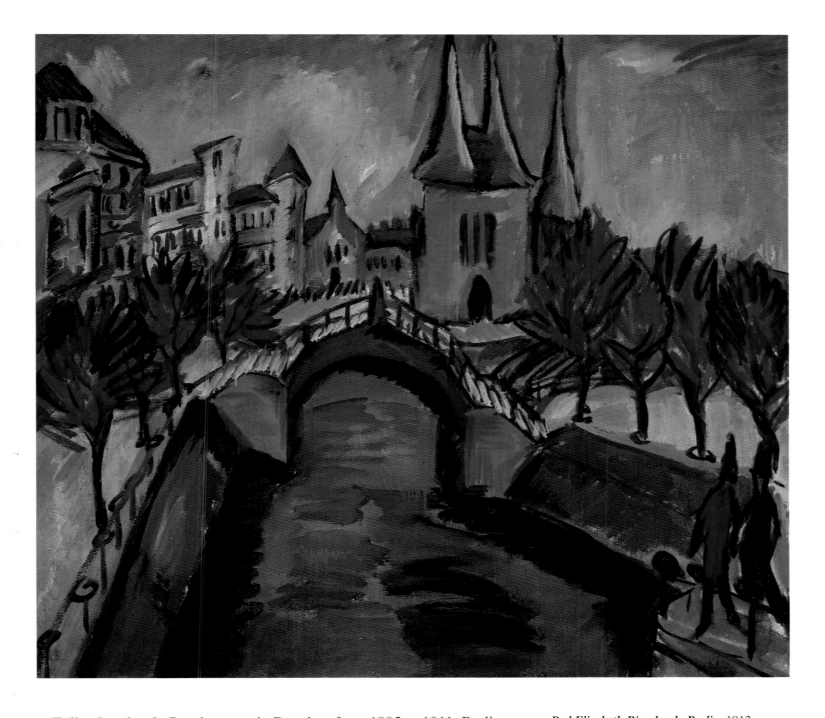

Following the six Brücke years in Dresden, from 1905 to 1911, Berlin now constituted a fresh challenge. "The struggle to get by is hard here, but the opportunities are greater", Kirchner wrote to the Schieflers in November, and went on, referring partly to the drawing school: "I hope that we shall be able to recruit sufficient numbers of followers, and win over many new friends to our cause." For Kirchner, the capital was a vast repository of new urban subject matter. He was catapulted from the isolation of the studio into the bustle of the real world, so to speak. To put it like this is, of course, to oversimplify, since he had taken subjects from the streets or the cabarets and circus when in Dresden. Nonetheless, the studio had been his preferred location there, or the secluded reedy ponds of Moritzburg. Berlin was different. Berlin was a vortex that drew him in – and within a very few years he had painted the works that assured him a special place in German art, as the grand master of the vibrant city scene.

As far as his everyday circumstances were concerned, Kirchner in Berlin

Red Elisabeth Riverbank, Berlin, 1912
Rotes Elisabethufer, Berlin
Oil on canvas, 101 x 113 cm
Gordon 275; Munich, Staatsgalerie für moderne Kunst

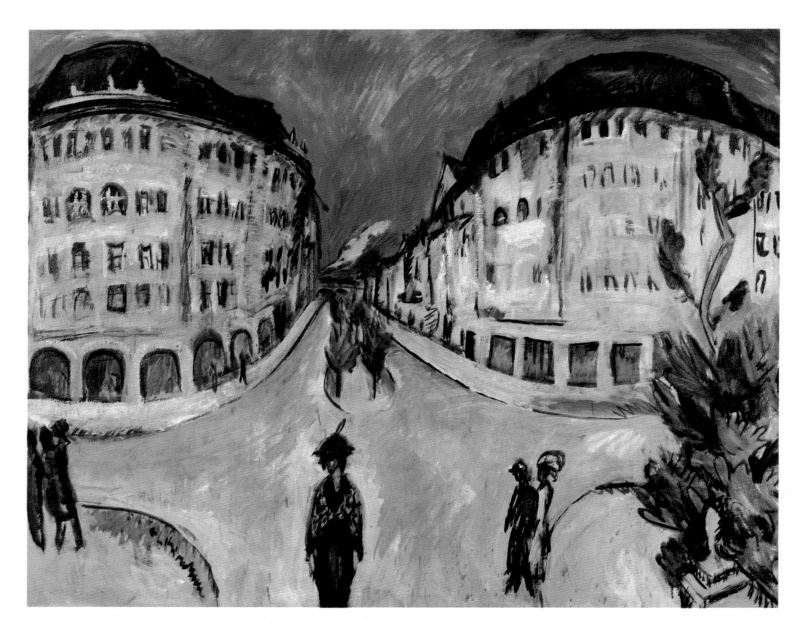

Street in Schöneberg City Park; Innsbruck
Street, 1912–1913
Straße am Stadtpark Schöneberg
Oil on canvas, 120 x 150 cm
Gordon 292; Milwaukee (WI), Milwaukee Art
Museum, Gift of Mrs. Harry Lynde Bradley

continued where he had left off in Dresden, setting up in a studio that could double as an apartment. To the props that had adorned his Dresden studio he constantly added new acquisitions. The Dresden studio had primarily provided a backdrop for people to move about naked and to be drawn and painted nude; the first Berlin studio became a place where friends could meet. During the first year, Kirchner produced pictures of a new type, which we might describe as scenes of conversation and friendship, scenes featuring two or three people talking in a corner of the studio, such as the 1913 *Gewecke and Erna* (p. 96).

The alternation of town and country continued and intensified. Where the Dresden summer destination had been Moritzburg, in Berlin it was now the Baltic island of Fehmarn, where Kirchner spent several weeks each pre-war summer from 1912 till 1914. He preferred the southern tip of the island, and stayed at the Staberhuk lighthouse near the town of Burg. He had already visited Fehmarn in 1908 with his partner of the time, Emmy Frisch (cf. p. 16), but now his expeditions there became a regular feature of his life in Berlin, and played an important part in his development as an artist. He lived in the lighthouse keeper's house and spent his days swimming, playing games, and painting on the beach beneath the Fehmarn crags. Again, as at

Portrait of Dr. Alfred Döblin, 1912
Oil on canvas, 50.8 x 41.3 cm
Gordon 290; Cambridge (MA), Courtesy of
The Busch-Reisinger Harvard University Art
Museums, Association Fund

Kirchner met the writer and neurologist Alfred
Döblin (1878–1957) in 1912. Döblin had just
moved to Berlin and frequented the literary
circles associated with Herwarth Walden's
periodical *Der Sturm*. His novel *Berlin Alex-
anderplatz*, published in 1929, is seen as the
modern masterpiece of city life and the urban
experience. Kirchner did a large number of
preliminary studies for the painting. He also
made five illustratory woodcuts for a novella
of Döblin's published in 1913 and illustrated a
play of his, now forgotten.

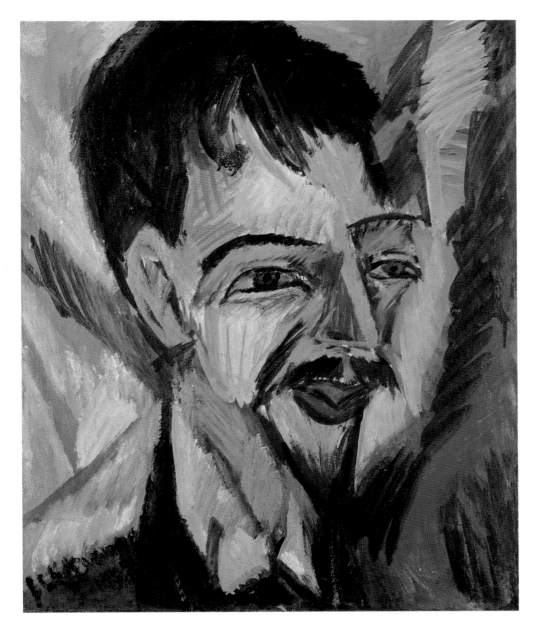

Moritzburg, his interest was in nudes in a landscape setting (pp. 76–79 and
92–95).

In Berlin Kirchner also entered what was a new realm for him – literature.
He met writers such as Alfred Döblin (1878–1957), who was later to pro-
duce one of the major novels of the city experience, *Berlin Alexanderplatz*,
or Simon Guttmann, a young author with many and varied interests and con-
tacts, who founded the periodical *Neue Weltbühne* in 1910 and smoothed
Kirchner's access to a club of Expressionist writers established in 1909.
Some of these men appear in portraits – Döblin, for instance, for whose
1912 likeness (p. 83) a large number of preparatory drawings were made.
And for the first time Kirchner worked as a book illustrator, producing
woodcuts for Döblin's novella *Das Stiftsfräulein und der Tod* and the same
author's play *Comtesse Mizzi*.

But it was the famous street scenes, painted rapidly in 1913 and 1914,
that marked the major achievement in Kirchner's Berlin years. It was an
extraordinarily productive time for him, but one that was to be abruptly ter-
minated by the outbreak of the First World War in August 1914. Kirchner
was called up just months later, in July 1915.

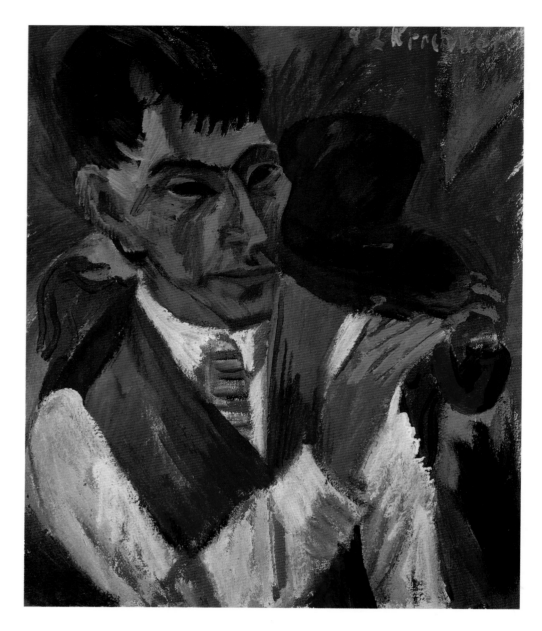

Otto Mueller with Pipe, 1913
Otto Mueller mit Pfeife
Oil on canvas, 60 x 50.5 cm
Gordon 296; Berlin, Brücke-Museum

Otto Mueller met Kirchner and the other Brücke artists in 1910, and joined the group. The friendship between him and Kirchner deepened, and was to be important to the latter during the dispute of 1913 over his chronicle of Die Brücke. In the summer of that year, Mueller visited Kirchner and Erna on Fehmarn. This portrait was probably done in Berlin.

The circumstance that Kirchner, Heckel and Schmidt-Rottluff all followed Pechstein to Berlin at about the same time in 1911 suggests that they had reached a joint decision. In other words, their move was a group move. And yet things turned out differently. The transfer to Berlin in fact marked the beginning of the end for Die Brücke and the artists' group identity. They began to drift apart. Each of them was more concerned with his own progress as an artist, and their paths took different stylistic directions. They also made different contacts amongst collectors and critics. So it could not be long till estrangement became conflict, and conflict led to the dissolution of the group. The breach was prompted in 1912 when Pechstein exhibited in a Berlin Secession show without consulting his fellows – despite the fact that in 1910, when the New Secession offshoot was formed, they had agreed that members would not go it alone. Pechstein was thereupon excluded from Die Brücke.

This first stage was followed in 1913 by a row between Kirchner and the others, and the final dissolution. With hindsight it seems difficult to take the occasion of their row very seriously – but we must assume that it was only a pretext, triggering an open confrontation that had been overdue. Die Brücke

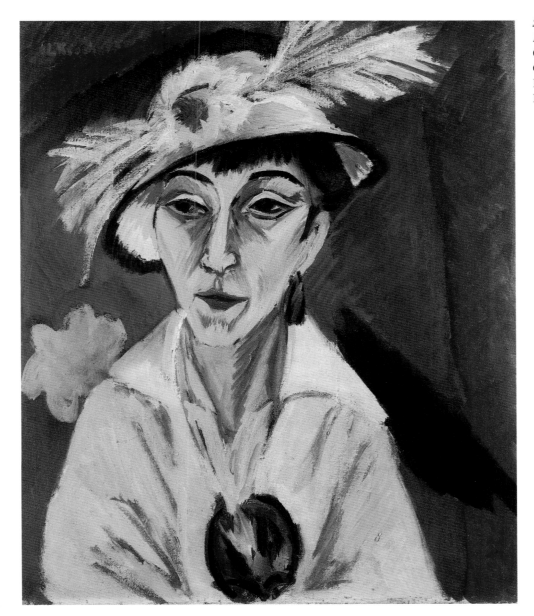

Sick Woman; Woman with Hat, 1913
Frau mit Hut, Kranke Frau
Oil on canvas, 71 x 60.5 cm
Gordon 298; Berlin, StaatlicheMuseen zu
Berlin – Preußischer Kulturbesitz,
Nationalgalerie

had existed for eight years, and in place of their usual annual portfolio for passive members they planned a chronicle of their work to date. Kirchner wrote it and made the title woodcut, while Heckel, Kirchner and Schmidt-Rottluff each made two small woodcuts to appear as vignettes alongside the text (cf. p. 195). The three-page document traced the movement from the first meeting of Kirchner and Bleyl in Dresden. The major points along the way were noted, at times dated wrongly, though in this context it hardly mattered. The problem was that Kirchner larded his account with phrases that assigned the initiatives and the leadership role to himself: "The group met to work in Kirchner's studio [...]. Kirchner introduced the woodcut technique from southern Germany [...]. Heckel was again carving wooden figurines. Kirchner went further in his own wood carvings by painting them, and in his stone and pewter work he sought the rhythm of unified form [...]. Meanwhile in Dresden, Kirchner was pressing on with unified composition. The Negro sculptures and carved beams from the South Seas, which he discovered in the Ethnological Museum, offered a parallel to his own creative work [...]. Kirchner created murals and batiks for his rooms, with Heckel's assistance [...]. In Dresden, Kirchner came up with hand-printed lithographs

[…]" – and so on and so forth. The others were understandably outraged. They "found the text offensive," as Heckel later put it. The group decided not to distribute the chronicle, whereupon Kirchner left Die Brücke and published the text anyway. This in turn led the other artists to decide on the formal dissolution of Die Brücke, in May 1913: "We beg to inform you that the undersigned, members of the artist group Die Brücke, are dissolving the organization. The members were Cuno Amiet, Erich Heckel, E. L. Kirchner, Otto Mueller, Schmidt-Rottluff. Berlin, 27 May 1913."

It was the end of Die Brücke. Kirchner subsequently tried his best to pretend it had never existed, and for years denied emphatically that the group had ever had any significance for him. Not until the late twenties, when he began to review his life and work, was he prepared to concede his former Brücke fellows a place in his recollections. In 1926–27, indeed, he even painted *A Group of Artists* (p. 172), which portrays Heckel, Mueller, Schmidt-Rottluff and himself at the time of the group's dissolution in 1913. In it he demonstratively shows himself holding a copy of the controversial chronicle.

When we trace the historical evolution of an artist, it is always tempting to associate stylistic changes with changes of location. In Ernst Ludwig Kirchner's case this has meant that various phases in his style have been associated with periods of residence in various places. Critics refer to his Dresden style, his Berlin style or his Davos style, implying that the developments were in some way a product of his moves. But this is not true of Kirchner, whatever may be the initial appearance. It is true that his subject matter changed when he moved, as we shall see most clearly when we come to his removal to Davos, but the changes and developments in his style proceeded independently of where he happened to be living. His style evolved according to other criteria. In the case of the move to Berlin, we have already seen (in the last chapter) that the colouring, the brushwork and the draughtsmanship in the figures – aspects that can appear to differentiate the post-move works from those Kirchner did in Dresden from 1909 to 1911 – were already undergoing change in Dresden during 1911. The large-format *Five Bathers at the Lake* (p. 66), inspired by Indian cave paintings, showed Kirchner in 1911, still in Dresden, beginning to articulate a new formal idiom. In place of the contrasts of strong complementary colours which had hitherto governed his approach, we now see much milder offsets of related shades. The flattened two-dimensionality that had served a radical clarity hitherto was now replaced by a more modelled, three-dimensional approach to the figures. The women's bodies not only have linear outlines, they also feature blue shading to produce a sense of volume. The same strategy is in evidence in *Half-Length Nude with Hat* (p. 67), also a pre-Berlin work of 1911. *Approach to the Altstadt Goods Station, Dresden* (p. 69), painted in green, violet and grey, might be read in this context of stylistic evolution as a statement on Kirchner's departure from Dresden to Berlin. With the typical Brücke style of the last couple of years before the move (cf. pp. 31 or 52–53) this painting no longer has anything whatsoever in common.

The works Kirchner painted in Berlin and on Fehmarn in 1912 continued this evolution. The figures in Berlin pictures of that year such as *Negro Dancers* (p. 72) or *Couple in Room* (p. 73) possess the same rounded proportions, and are done with the same outlines and blue hatched shading, as the figures in the Dresden *Five Bathers at the Lake*. The palpable difference lies

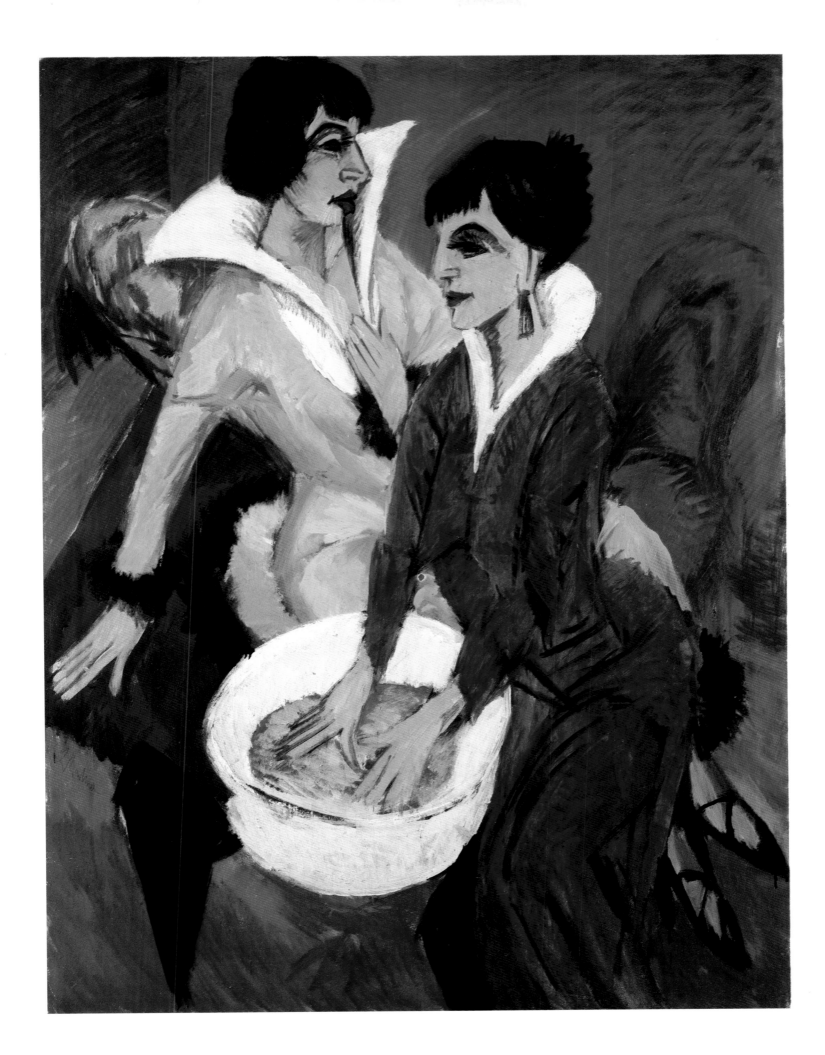

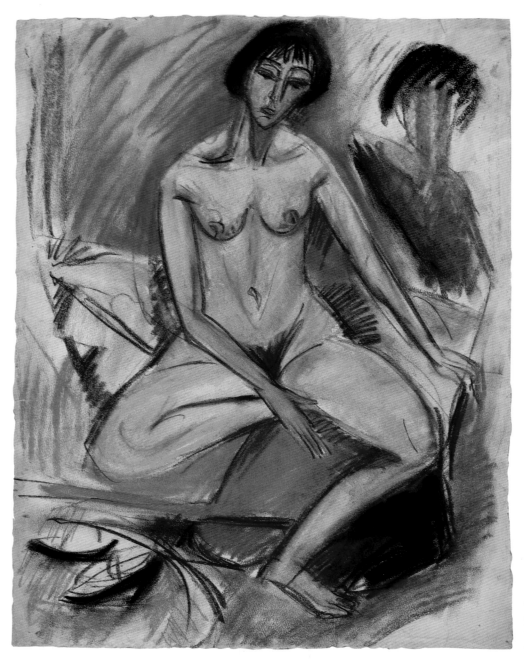

Seated Female Nude, 1913
Sitzender weiblicher Akt
Pastel, 67.7 x 50.7 cm
Hanover, Sprengel Museum

in the nature of the motifs and in their charisma. In Dresden, Kirchner had taken circus artistes (pp. 32–33) and Hungarian dancers (pp. 18–19 and 34) as his subjects – but Berlin had more risqué material to offer. Blacks performed erotic dances, for instance. In the capital, Kirchner had no qualms about painting a brothel scene featuring a lightly-clad prostitute and her correctly-attired client, and in the famous street scenes his eye was not just on anybody in the nocturnal bustle, but on women looking for customers. So of course it is true to say that the purely aesthetic criteria that governed the incipient changes in Kirchner's Dresden style (the Indian cave paintings) were supplemented in Berlin by the new subject matter offered by a major city, as his new style developed. In the process, Kirchner's work acquired a new artistic quality and substance.

It is difficult to gain a satisfactory purchase on the work Kirchner did during his first few months in Berlin. Most of the pictures reproduced in the present study make an astonishingly private impression. We see his new part-

PAGE 89:
The Toilette; Woman before the Mirror,
1913/1920
Toilette; Frau vor Spiegel
Oil on canvas, 101 x 75 cm
Gordon 311; Paris, Musée National d'Art
Moderne, Centre Georges Pompidou

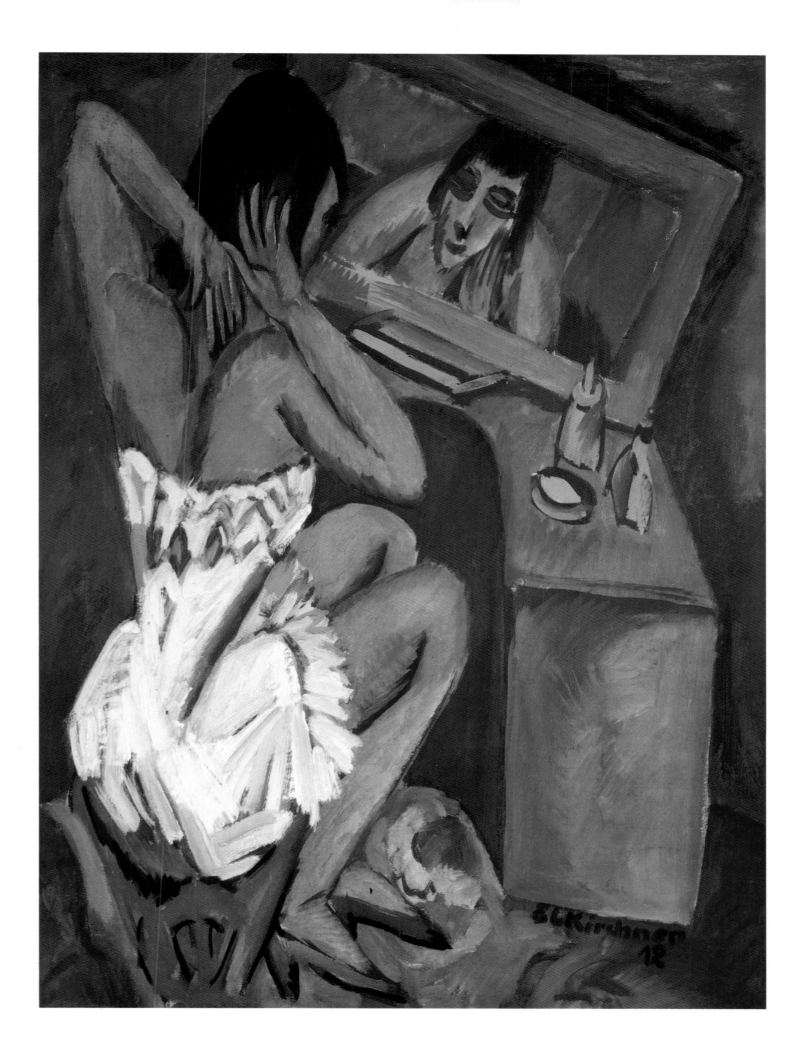

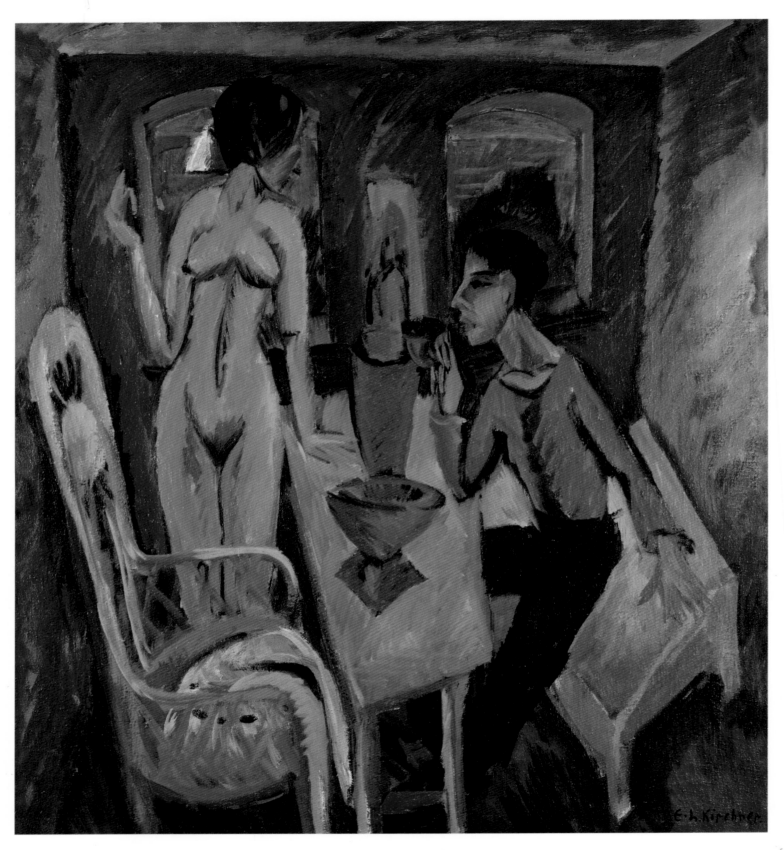

Tower Room; Self-Portrait with Erna, 1913
Turmzimmer, Selbstbildnis mit Erna
Oil on canvas, 91.5 x 82 cm
Gordon 312; Columbus (OH), Columbus
Museum of Art, Gift of Howard D. and
Babette L. Sirak

The tower room must have been the room
Kirchner and Erna rented in the lighthouse
keeper's house at Staberhuk on Fehmarn for
their summer stays.

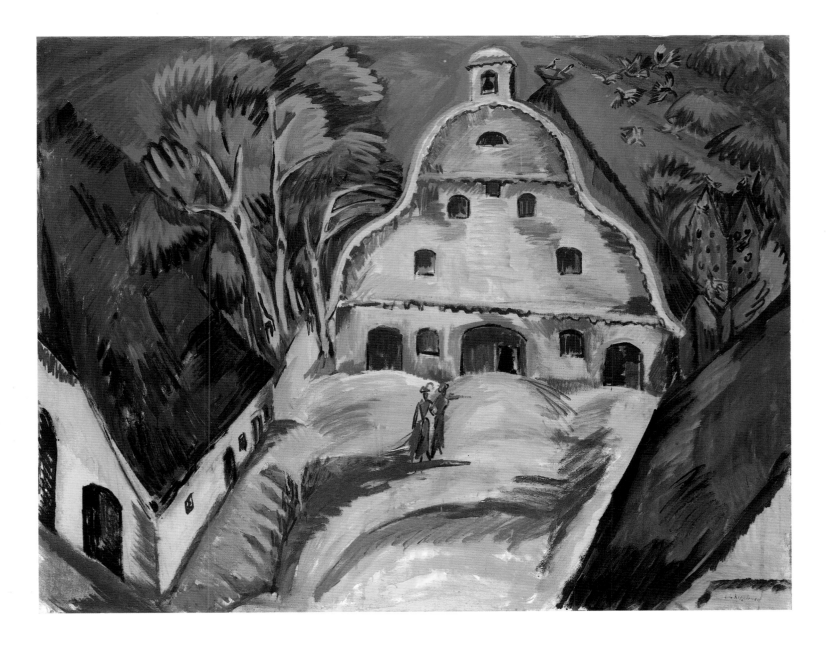

ner Erna as a *Seated Woman with Wood Sculpture* (1912; p.74) or *The Russian Girl*, a meditative woman in a morning robe (1912; p.75). It is only when we reach the Fehmarn pictures of summer 1912 that we can confidently identify a homogeneous group of works.

Shortly after his arrival in Berlin, Kirchner met the sisters Gerda and Erna Schilling. Unloved by their stepmother, they had left home as soon as they could and built up their own self-reliant lives. When Kirchner met them they were probably working as nightclub dancers. We see them in a number of 1912 pictures (pp. 74–79). Erna, the younger, became Kirchner's partner, and they remained together for the rest of his life. Gerda, the elder and more stylish, seems to have hit hard times later and to have vanished from Kirchner's circle completely. He spent summer on Fehmarn with the two sisters, and the three were joined there for a time by Erich Heckel and his girlfriend Sidi – though Heckel generally preferred Dangast, near Oldenburg, where he had stayed regularly with Schmidt-Rottluff since Dresden days.

The first summer on Fehmarn turned out to be both pleasant for Kirchner the man and productive for Kirchner the artist. He himself later enthused, in

Staberhof Country Estate, Fehmarn I, 1913
Gut Staberhof, Fehmarn I
Oil on canvas, 121 x 151 cm
Gordon 322; Hamburg, Hamburger Kunsthalle

Staberhof estate is close to the Staberhuk lighthouse on the southeast tip of Fehmarn. Kirchner painted this great baroque barn from the residence opposite.

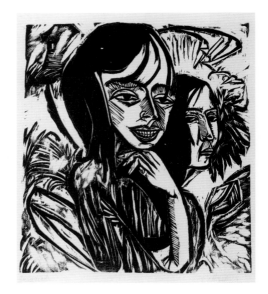

Fehmarn Girl, 1913
Fehmarnmädchen
Woodcut, 42 x 37 cm
Dube 219; Essen, Museum Folkwang

the article on his own work to which we have referred: "There I learnt how to create the ultimate oneness of Man and Nature, and completed what I had begun at Moritzburg." And in a letter to Gustav Schiefler in 1912 he wrote, "There I painted pictures that are absolutely mature, insofar as I myself can judge. Ochre, blue and green are the colours of Fehmarn, and the coastline is wonderful, at times with a South Seas opulence, amazing flowers with thick fleshy stems [...]." Was it only the place that sparked this response? Or was it his unrestrained life with his new partner and their mutual friends, in an Eden of sun and sea far from everyday restrictions? At all events, he painted a number of pictures conspicuous for their compositional assurance and their vivid lightness of touch. The rounded-out figures familiar from *Five Bathers at the Lake* (p. 66) and other works now became tauter, more elastic, more at ease. Major works of that summer of 1912 include *Bather between Rocks* (p. 78), a small and unusual painting done from a photograph Kirchner himself took of Erna; *Brown Nude at the Window* (p. 77), again showing Erna, at the window of a rented room in the Staberhuk lighthouse keeper's house, gazing out across fields and trees towards the sea; and another large-format master achievement, *Striding into the Sea* (p. 79). This picture confirms the importance of the aim Kirchner had set himself from the outset, in his artistic engagement with given reality: the human creature is seen in its purest essence when in movement, and the ideal must be to portray people in movement. In this big picture of two nudes wading into the waves, with the cliffs and lighthouse behind them, the compositional crux is their movement. That movement flows on through the waves of the sea and the lines of the landscape, imbuing the entire painting with immense, dynamic energy.

Up to a point, Kirchner's evolution during the Berlin years can be traced by looking at his Fehmarn summers. He returned to Staberhuk with Erna and Gerda in 1913, this time accompanied by their friends Gewecke and

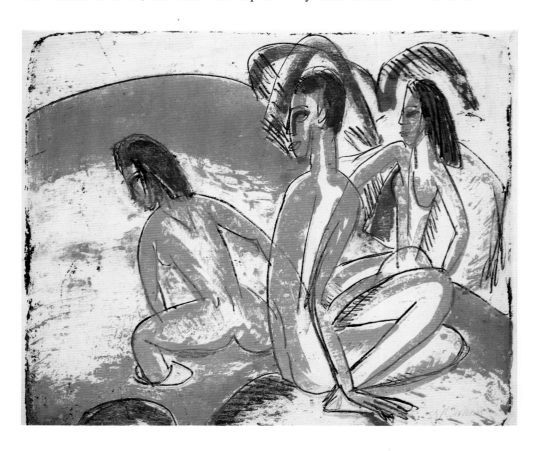

Three Bathers on Rocks, 1913
Drei Badende an Steinen
Coloured lithograph, 49.5 x 59.5 cm
Dube 235; Basle, Öffentliche Kunstsammlung
Basel, Kupferstichkabinett

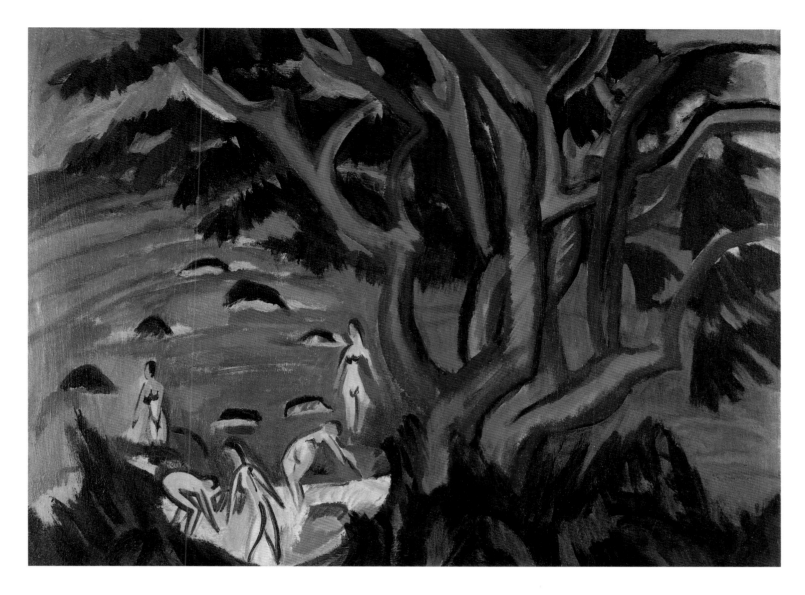

Gothein too, and visited for a while by Otto Mueller and his wife Maschka. And the sojourn was repeated in 1914 – before the First World War put an end to the relaxing but productive summer idylls on the Baltic. In August 1914, Kirchner and Erna returned to Berlin in a hurry when Fehmarn was declared a military restricted area, off-limits to the public. During the second stay, Kirchner's figures became slimmer and even more dynamic, and his technique changed again. Whereas before the outlined figures with hatched areas to lend volume had been treated quite differently from the flat blocks of colour in his paintings, now the entire canvas would be covered with hatching-like brushstrokes. In the paintings of 1913 and 1914, the brushwork recalls plumage – a dense covering of strokes packed onto the entire visual surface. He did more landscapes in those years, and fewer figure compositions.

But Kirchner's pictures of people on Fehmarn and the coastal landscape were only a part of his output before the war. From late 1912, he began his closer scrutiny of the city scene, painting conventional urban views of the kind he had already done in Dresden, though now his composition and colouring had less of the poster-like simplicity of the earlier works. Again his preferred motifs were non-picturesque streets, canals, bridges and railways (p. 80) – the everyday Berlin of tenement blocks and commercial sites.

In October 1913, Kirchner and Erna moved into a larger topfloor apart-

Red Tree on the Shore, 1913
Roter Baum am Strand
Oil on canvas, 75 x 100 cm
Gordon 359; private collection

Beach on Fehmarn, 1913
Fehmarnstrand
Watercolour and chalk, 46 x 59 cm
Stuttgart, Staatsgalerie Stuttgart

White Beach, 1913
Weißer Strand
Watercolour and coloured chalk, 46 x 56 cm
Bremen, Kunsthalle Bremen

Beach Scene on Fehmarn, 1913
Strandszene in Fehmarn
Watercolour and pencil, 46 x 58.5 cm
Berlin, Staatliche Museen zu Berlin –
Preußischer Kulturbesitz, Kupferstichkabinet

Fehmarn Coast, 1913
Fehmarnküste
Oil on canvas, 85.5 x 85.5 cm
Gordon 330; Darmstadt, Hessisches
Landesmuseum

Gewecke and Erna, 1913
Pencil drawing, 55 x 39 cm
Private collection

Kirchner's studio life with Erna produced a type of picture that occurred frequently in the Berlin years: scenes of friendship and conversation. In this drawing, Erna is seen with Hans Gewecke, one of two painters Kirchner met through the drawing school he tried to start – an everyday scene of private life.

PAGE 97:

Judgement of Paris, 1913
Urteil des Paris
Oil on canvas, 111.5 x 88.5 cm
Gordon 360; Ludwigshafen, Wilhelm-Hack-Museum

Here Kirchner is combining the private lifestyle of his studio world – the painter and his naked girlfriends and models – with the Greek myth of Paris choosing the loveliest of the goddesses Hera, Athene and Aphrodite. The Paris figure is Kirchner himself, cigarette in mouth. The naked goddesses are Erna and Gerda in various poses; Erna is the woman to the fore in a thin petticoat, head averted.

ment at 45, Körnerstraße in the suburb of Friedenau. There he set up his second Berlin studio, photographs of which have survived (p. 196). The rooms were shabby and could only be heated by means of rudimentary iron stoves. As in Dresden and Durlacher Straße, Kirchner painted the walls, fitted painted drapes, installed furniture he had carved and carpentered himself, and hung his latest paintings. Middle-class friends who visited at times would be startled by the couple's reduced circumstances but enchanted by the artistic character of the dwelling and the works they saw there: "Landscapes that would delight even the most hidebound academicians, figure compositions of the most intense impact imaginable", wrote one visitor in 1914. "I also witnessed a poverty such as I could not have imagined. And the man is so proud that, of course, he never makes any reference to his straits."

Kirchner's central achievement of the years from his move until 1915 was of course the street pictures we have already referred to, eleven paintings in all plus a number of crayon drawings and graphics (pp. 98–115). They were done in 1913 and 1914, all but a single one that dates from 1915. They constitute only one per cent of Kirchner's entire output of over a thousand paintings – but nonetheless, contemporaries and posterity have agreed in viewing these as Kirchner's most important works, the very heart of his art, and Kirchner too always rated them among his major creations. The street scenes have come to be seen as the very definition of neurasthenic modern city life before the First World War.

Unlike the other city pictures we have looked at, these paintings are not urban scenes; rather, they are portraits of people in city settings. Properly speaking, they are figure compositions – in conventional art history, a category rated higher in the pictorial hierarchy than landscape work. The tradition handed down from the Renaissance considered that figure composition for a mythological or historical scene demanded greater learning and greater powers of invention than the mere reproduction of a landscape or a sitter's appearance, and should therefore be classified on a higher level. Kirchner himself, it should be stressed, was no stranger to this traditional view, and indeed subscribed to it. It mattered very much to him that he should go down in history as a figure painter, not a landscape artist. After the First World War, for example, when the National Gallery in Berlin proposed acquiring three Kirchners for its new contemporary art section, the choice fell upon Fehmarn pictures or townscapes – *Fehmarn Coast* (a picture similar to that reproduced on p. 95), *Staberhof Country Estate, Fehmarn I* (1913; p. 91) and *Rhine River Bridge at Cologne* (1914; p. 115) – and the artist himself, who confided to his diary that he had no desire to be seen merely as a "tame landscape artist" but wanted recognition as a figure painter, felt obliged to insist that the foremost German collection of contemporary art take one of his street scenes, *The Street* (1913; p. 102). Under the Nazis the painting was subsequently branded as degenerate art and confiscated, and it is now in the Museum of Modern Art in New York.

The series begins with a 1913 painting now in Cologne, *Five Women on the Street* (p. 99). It shows five women in a street at night. To the right we can see what is presumably a display window, to the left the wheel of a vehicle, so that the women can be taken as standing on the pavement of a shopping street. The light from the window is spilling onto the street, and the women stand out like tall thin crows against the brightness. In their attitudes and stylish clothes they are deliberately striking poses, though they

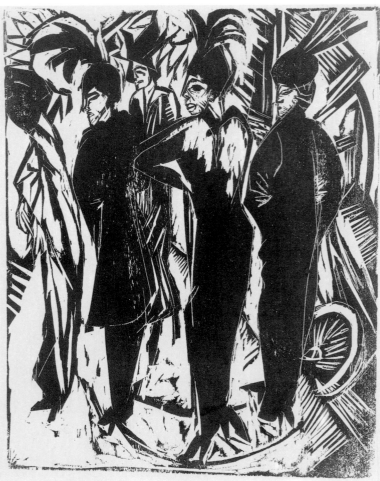

are just as deliberately looking aside. These are the coquettes or whores that frequented the downtown nightlife areas of Berlin around Friedrichstraße and Potsdamer Platz, attracting the attention of men by their own studied lack of interest. Kirchner catches the situation, the relations between the five and their charismatic presence by his presentation of their postures, their clothing, and particularly their gaze, pointedly averted from us and, in the case of the woman at right, directed entirely at whatever is in the window.

In this painting, the five women are on their own. There is no audience to witness the attitudes they are striking – or rather, *we* are the audience. Kirchner takes a different approach in the next of the street scenes, also painted in 1913: *Berlin Street Scene* (p. 100). The women at the centre of the composition, provocatively dressed in bright colours, with lace collars and fashionable bonnets, are seen in a crowded street. They are giving the men inviting looks; and the men have the choice to either look away or respond. In the background we see a horse-drawn cab and the sign for the number 15 tram. (In Kirchner's day, the 15 ran through the city centre via Hallesches Tor, Anhalt and Potsdam stations, the Brandenburg Gate, and on.) The snapshot quality of the scene is emphasized by the cropping of the two men in the foreground. The man to the right is looking away out of the picture, almost as if to draw our attention to something. In fact his gesture is almost certainly meant for the women, clearly the reference point of all responses, open or concealed, in the immediate vicinity.

Berlin prostitutes in search of clients, and the clients themselves, had to

Berlin Demi-Mondaines, 1913
Berliner Kokotten
Watercolour, 45 x 37 cm
Cologne, Museum Ludwig

Five Demi-Mondaines, 1914
Fünf Kokotten
Woodcut, 49.5 x 38 cm
Dube 240; Frankfurt am Main, Städtische Galerie im Städelschen Kunstinstitut

PAGE 99:
Five Women on the Street, 1913
Fünf Frauen auf der Straße
Oil on canvas, 120 x 90 cm
Gordon 362; Cologne, Museum Ludwig

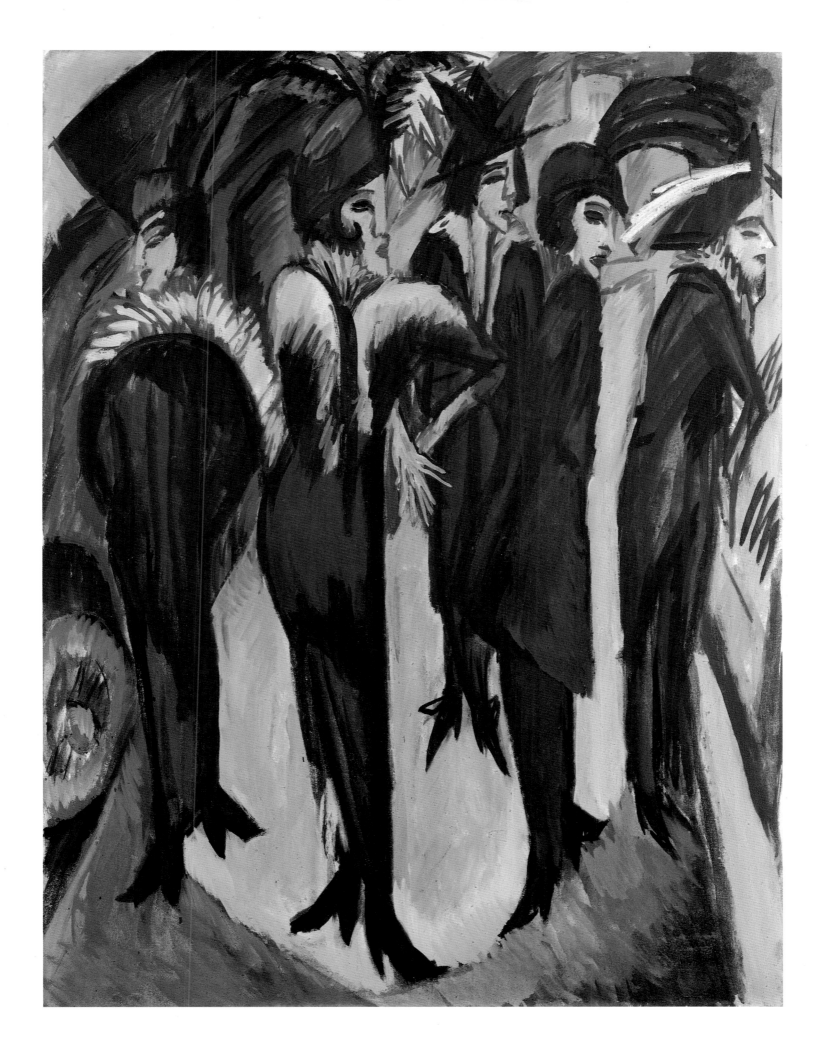

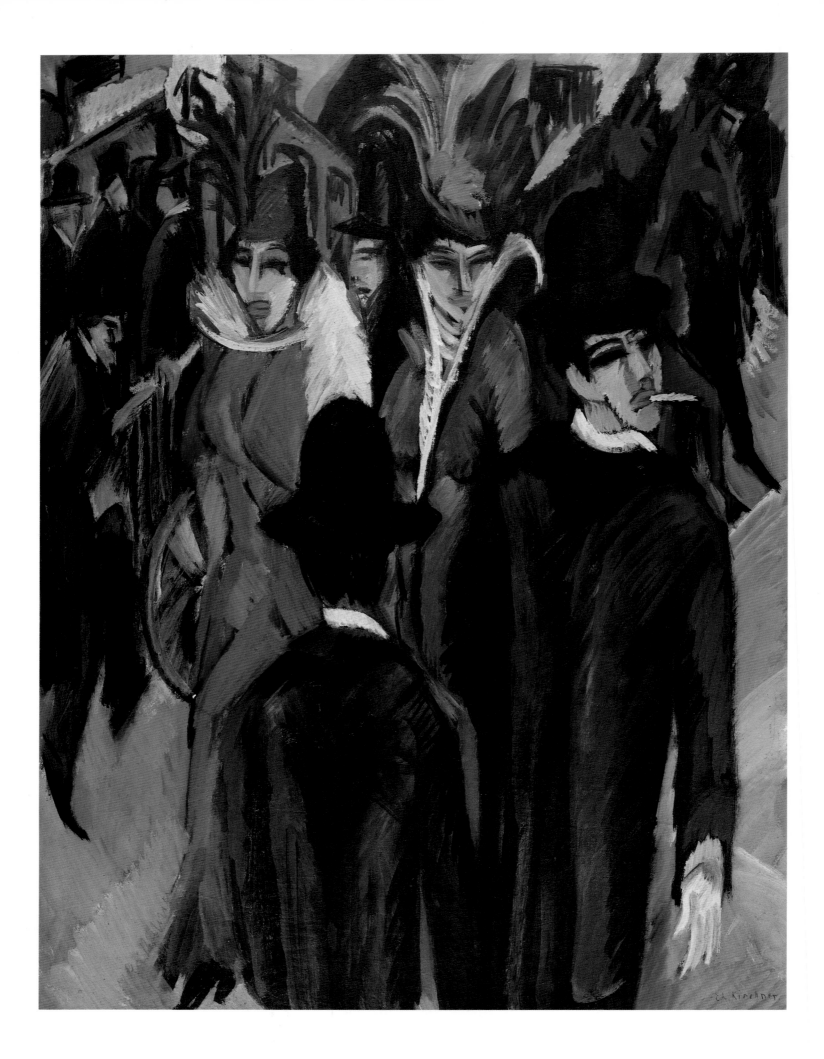

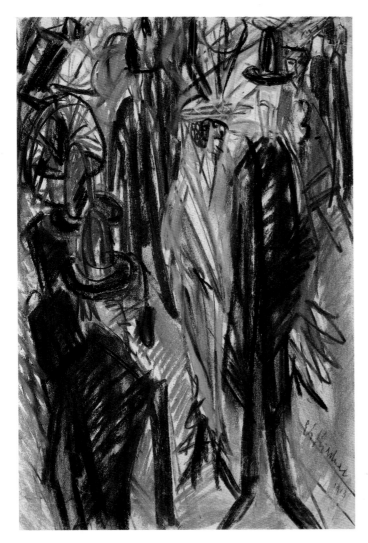 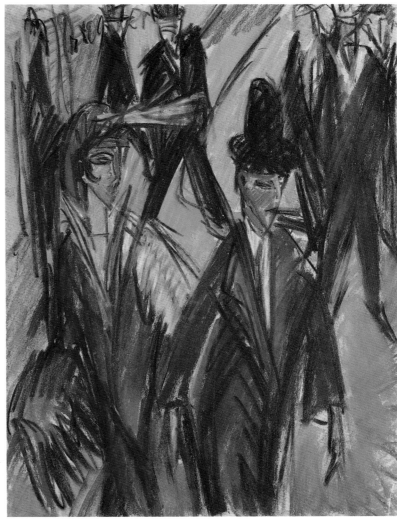

be wary. Writing on Kirchner's street scenes, critic Magdalena Moeller describes official policy on prostitution in Germany in 1910: "[...] the Berlin police proposed to turn a blind eye if prostitutes behaved with as much decorum as respectable women. What this meant was that the women of the night who frequented Friedrichstraße [...] had to avoid looking back, pausing at shop windows, lingering with men or indeed talking to them at all costs. They were expected to waft along the streets in a lady-like fashion, as untouchable as if they were surrounded by bayonets. The slightest lapse and a vice squad detective would materialize out of nowhere, write down the party's name – and she would be on her way to jail." It was a situation that enforced discretion in the making of contact between whore and client, and it is precisely that discretion that we see in Kirchner's street pictures.

Kirchner's compositional deftness in emphasizing figural groups within a picture and establishing confrontational interaction with other figures grew more confident as the series progressed, relatively brief though the total time span was. The third painting, simply entitled *The Street* (p. 102), was also done in 1913, and can safely be described as one of the most accomplished of them all. Again the composition is dominated by two women, seen full-length in the centre foreground, with men in black coats and hats at their backs. One man at right is pointedly looking aside into a display window, his gaze averted in a way we are now familiar with. To the upper left is

Street Scene, 1913–1914
Straßenszene
Pastel, 40 x 30 cm
Berlin, Brücke-Museum

Street Scene, 1914
Pastel, 47 x 29.5 cm
Berne/Davos, Sammlung EWK

PAGE 100:
Berlin Street Scene, 1913
Berliner Straßenszene
Oil on canvas, 121 x 95 cm
Gordon 363; Berlin, Brücke-Museum

PAGE 102:
The Street, 1913
Die Straße
Oil on canvas, 120.6 x 91.1 cm
Gordon 364; New York, The Museum of
Modern Art, Purchase.

PAGE 103:
Friedrichstraße, Berlin, 1914
Oil on canvas, 125 x 91 cm
Gordon 367; Stuttgart, Staatsgalerie Stuttgart

101

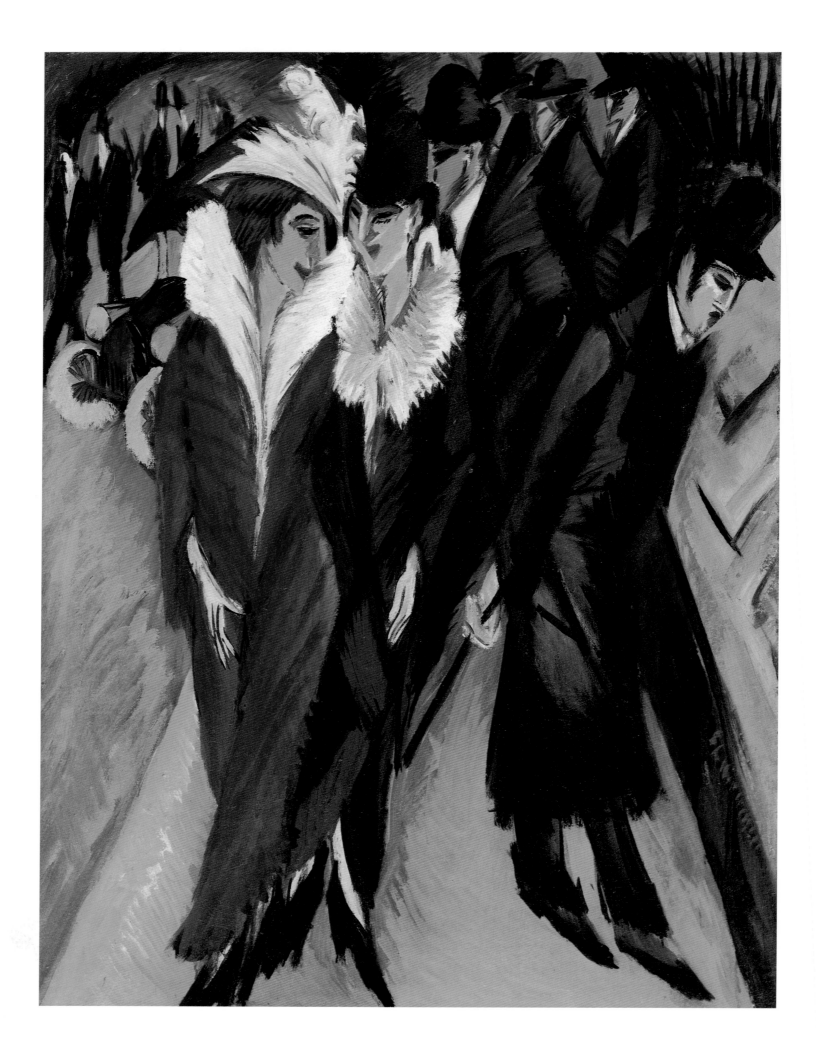

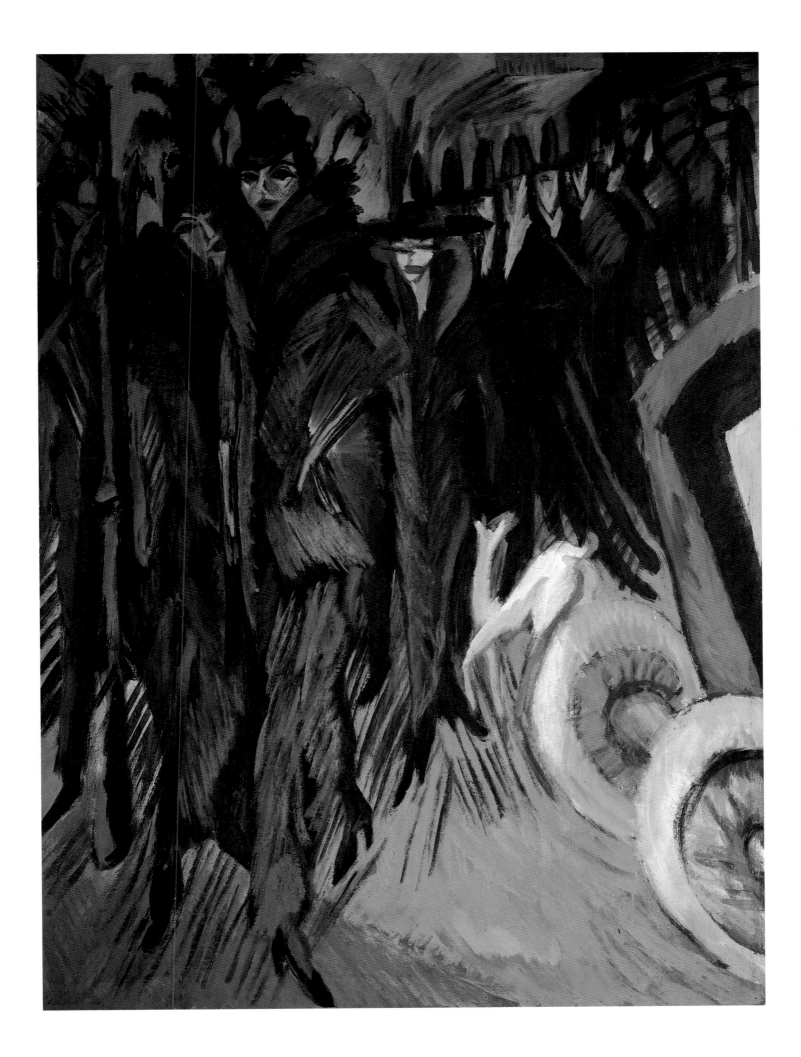

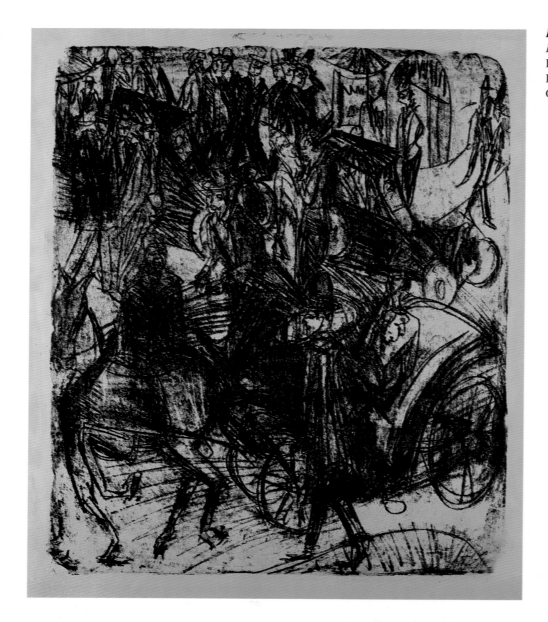

Leipziger Straße, Crossroads, 1914
Leipziger Straße, Kreuzung
Lithograph, 59.5 x 50.5 cm
Dube 250; Wichtrach/Berne,
Galerie Henze & Ketterer

a car, and beyond it people on the far side of the street. The two women, exchanging glances, seem deep in conversation. In this painting they are more subtly portrayed, and can less confidently be described as prostitutes. They might simply be fashionable women attracting the attention of men. There seems no doubt that they too are meant to be seen as whores, but in this case an unambiguous pointer is lacking. What interests Kirchner here is the sexual crackle in the air.

All of these street pictures are located on the pavement, between lit-up store windows and the street itself, where motorized traffic was increasing in pre–1914 Berlin. Two further paintings of the same type are the Stuttgart *Friedrichstraße, Berlin* (p. 103) and the Wuppertal *Women on the Street* (p. 112), the former done in 1914 and the latter, a final return to the motif, in 1915. In both we see a throng of passers-by, the individual figures scarcely distinguishable, headed by the usual two elegantly turned-out demi-mondaines. In the Stuttgart picture a car is disappearing off the canvas to the right, and a lone dog is straying hither and thither between it and the crowd.

The *Demi-Mondaine in Red* (p. 107) of 1914 is here reproduced in the crayon version only, since Kirchner overpainted the subsequent oil so heav-

ily in the 1920s that nothing now remains of its original jangling, edgy style. The drawing, however, is a tremendously exciting piece of work. It is done in the feathery manner of draughtsmanship that Kirchner had evolved in 1913 out of the looser brushwork he employed for the Fehmarn pictures. The crayon hatching fans out, radiating around the woman in her striking and provocatively cut scarlet dress. The street perspectives gather in to the centre at which she stands, and the men in black behind and before her are all attention.

By contrast, both the crayon *Two Demi-Mondaines* (p. 108) and its oil version, *Two Women on the Street* (p. 109), also works of 1914, are well worth reproducing. This is the only half-figure composition among the street scenes. Kirchner's full attention is on the two women in their over-the-top clothes and outrageous bonnets, and the men looking at them are mere shadowy presences in the background. Both the drawing and the oil have the assurance and directness that were Kirchner's at that time. Of the crayon drawings, some (pp. 107 and 108) were evidently preliminary sketches for oils, whereas others (pp. 101 and 106) appear to have been small-format compositions in their own right.

These are the major works in Kirchner's series of street scenes – all but the most important of them all, the 1914 *Potsdamer Platz* (p. 111). As we have seen before, Kirchner's strategy was to create a major work in any thematic complex he broached – the 1909 *Bathing Nudes in a Room* (p. 25) summarized his studio nudes; the Tate Gallery *Bathers at Moritzburg* of 1909 (not reproduced in this book because later overpainting ruined it) defined the Moritzburg open-air complex; the 1912 *Striding into the Sea* (p. 79) recapitulated the theme of the *plein air* nude; and the *Dresden*

Street Corner near the Winter Gardens, 1914
Ecke am Wintergarten
Etching, 25 x 20 cm
Dube 184; private collection

War Widows in the Street, 1914
Kriegerwitwen auf der Straße
Etching, 25 x 19.5 cm
Dube 185; Frankfurt am Main, Städtische Galerie im Städelschen Kunstinstitut

After the outbreak of the First World War, demi-mondaines in Berlin took to wearing widows' weeds as a kind of camouflage. See also *Potsdamer Platz, Berlin* (p. 111).

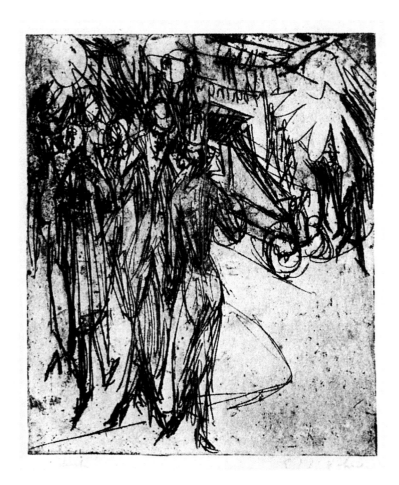

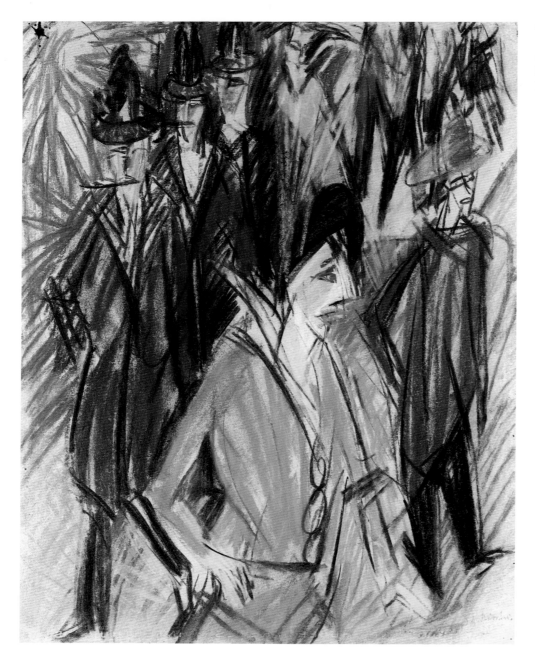

Street (p. 21), painted in 1908 and overpainted in 1919, was a first attempt
to define the street subject matter. These paintings were larger in format
and more complex in composition than other treatments of the same
themes. *Potsdamer Platz* is a major work of this kind, and furthermore
arguably possesses the greatest historical significance of Kirchner's paint-
ings, and has become the best known. In no other work are the key ele-
ments in the artist's style so completely married to a sense of city life
before the First World War. It shows two tall, slender demi-mondaines in
the Berlin setting named in the title. In Germany, the Potsdamer Platz
defined the metropolitan experience. It was a bustling intersection, one of
the busiest in Europe. Around it were Potsdam station, the terminus for
long-distance trains from western Germany as well as suburban trains, a
number of hotels (the Palast, Bellevue and Fürstenhof), pubs and wine bars
– in a word, the buildings one would expect on a central square in a capi-
tal city. A 1910 Berlin Baedeker mentions that some five thousand trams
crossed Potsdamer Platz daily (unsurprisingly, since the Berlin under-

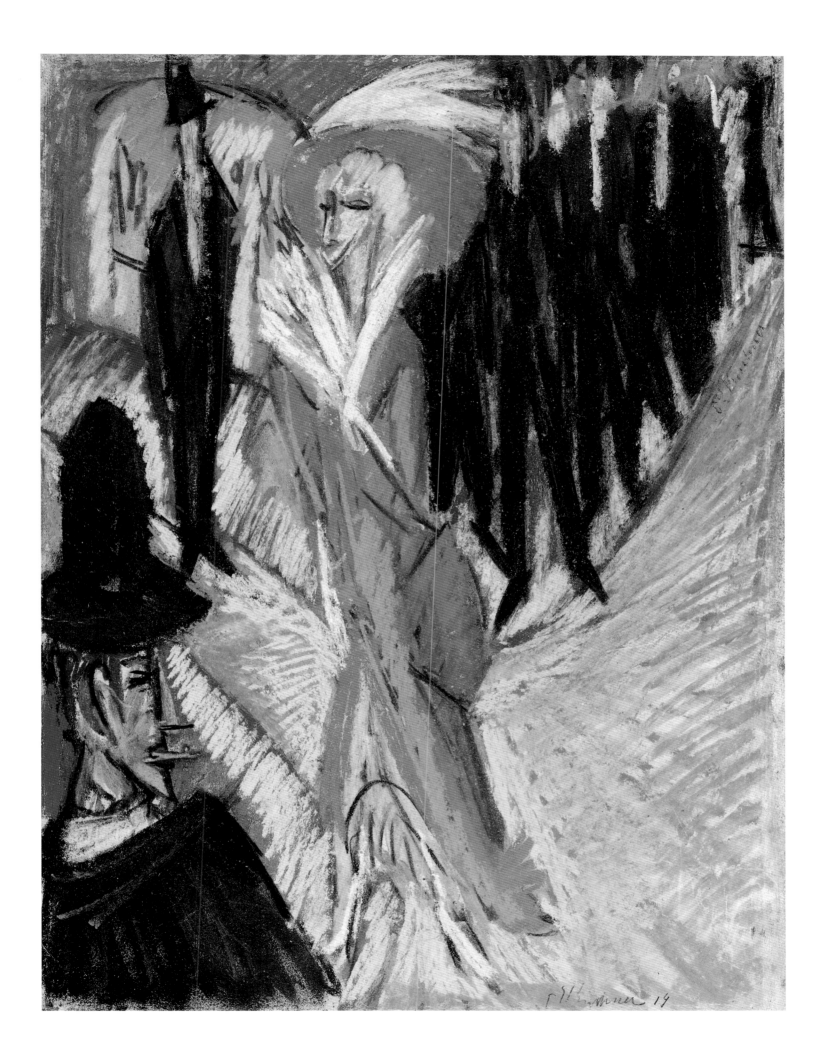

Two Demi-Mondaines, 1914
Zwei Kokotten
Pastel, 67.5 x 51 cm
Richmond (VA), Virginia Museum of Fine
Art, The Ludwig and Rosy Fischer Collection

ground, unlike the London, was still in its infancy). The two women stand isolated and close together on a tiny traffic island in the square. Once again, their gazes are fixed to avoid contact. One is positioned to the left of the centre vertical axis, staring straight out at us, while the other is crossing in front of her toward the left. Compositionally they belong together and indeed constitute an intimately connected group, but in any other terms they are altogether unrelated. Everything else in the picture is seen at a distance. The exaggerated perspective, academically "wrong", associates the various zones even as it keeps them far apart. Men clad in black are walking by housefronts, and one is stepping into the square, towards the women. The women are the focal point – though whatever interest the men take in them is evidenced only in a semblance of indifference. The grey traffic island the women are on seems to be afloat in the green sea of the square – a green applied in the hatched style so characteristic of Kirchner's work of this period. The brushstrokes radiate, demarcating a force field emanating from the women and dominating the entire visual arena. The other greys – the area outside the station where a man is striding out onto

PAGE 109:
Two Women on the Street, 1914
Zwei Frauen auf der Straße
Oil on canvas, 120.5 x 91 cm
Gordon 369; Düsseldorf, Kunstsammlung
Nordrhein-Westfalen

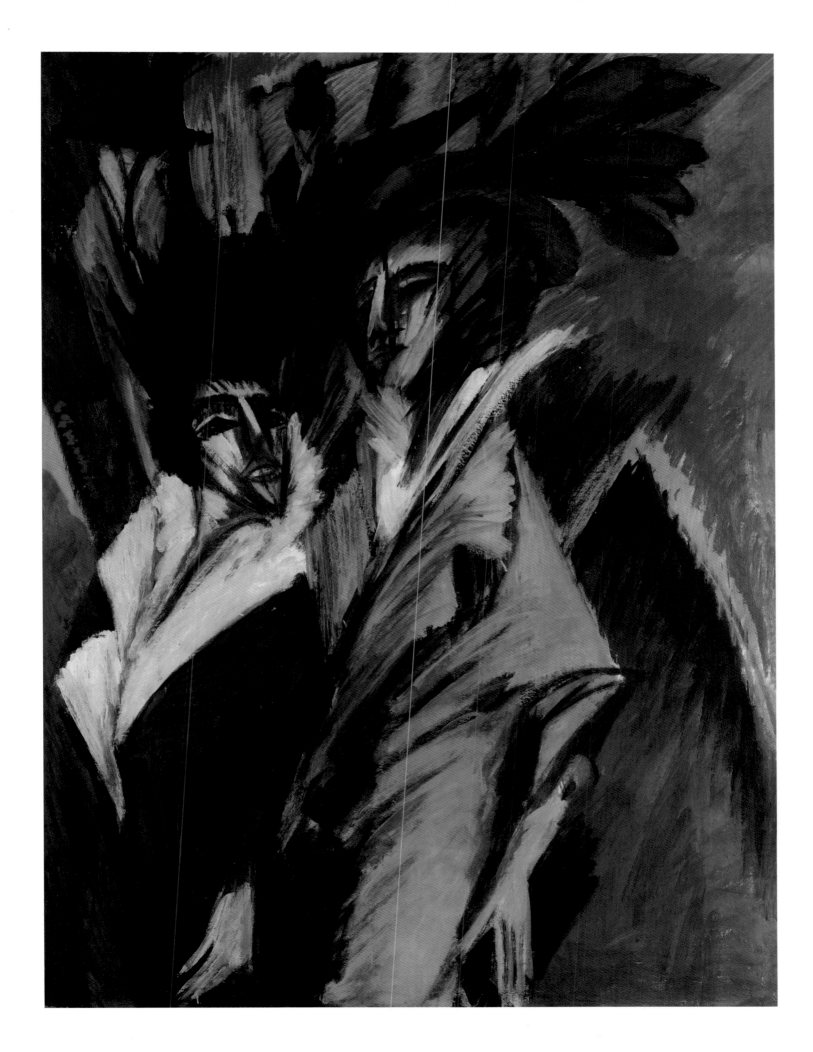

Potsdamer Platz, 1914
Charcoal on handmade paper, 67.5 x 51 cm
Private collection

Potsdamer Platz, 1914
Coloured chalk, 65 x 48.5 cm
Cambridge (MA), Courtesy of The Busch-
Reisinger Harvard University Art Museums,
Association Fund

PAGE 111:
Potsdamer Platz, 1914
Oil on canvas, 200 x 150 cm
Gordon 370; Berlin, Staatliche Museen zu
Berlin – Preußischer Kulturbesitz, National-
galerie, on loan from a private collection

the street, and the building at right with its narrow pavement – impinge aggressively on the green. Thus the composition replicates the same thrust and parry as obtains between the people it portrays.

Whereas the other street scenes are segments cropped out of an overall view, *Potsdamer Platz* presents the entire prospect. Beyond the two elegant women is a whole panorama, composed and structured down to the last detail. Two large preliminary sketches, one in coloured chalk and one in charcoal (p. 110), as well as a woodcut done from the painting later in 1914 (*Women at Potsdamer Platz*), afford a glimpse of the compositional changes the picture underwent. The position of the two main figures, and their spatial relation to the rest of the square, to the buildings and other figures, were transformed. Kirchner decided to render the contrast of large and small, near and far, foreground figures and background, in as emphatic a manner as possible in the painting. When he came to do the woodcut, he re-thought anew since the reversal of right and left that results in print graphics would create new compositional appearances. The two women were displaced now to the righthand side of the picture, and the woman who faces left *out* of the painting was revolved so that she was facing left *into* the centre of the composition in the woodcut.

At about the same time as Kirchner was creating these pictures in Berlin, August Macke (1887–1914) in Bonn was painting women gazing into store windows. We do not know whether either artist inspired the other. In certain senses one might well say there is no difference between Macke's paintings and Kirchner's – both artists show us groups of people in city streets. And yet they are worlds apart. Macke's figures are people out strolling, window-

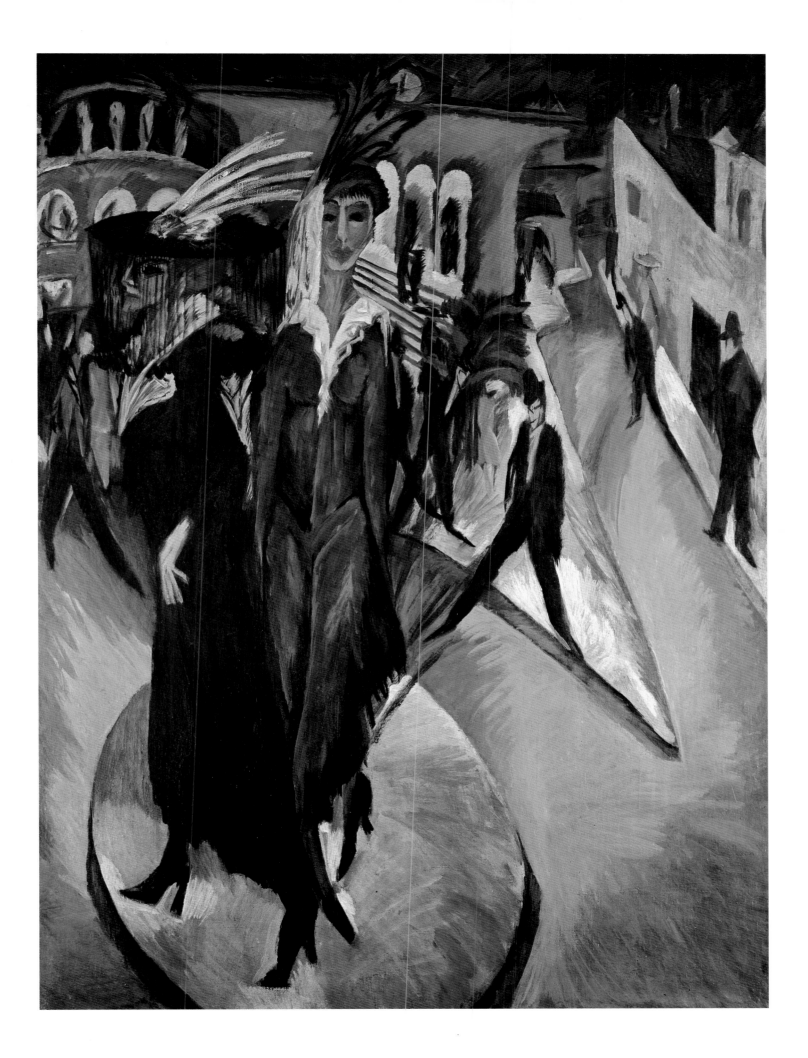

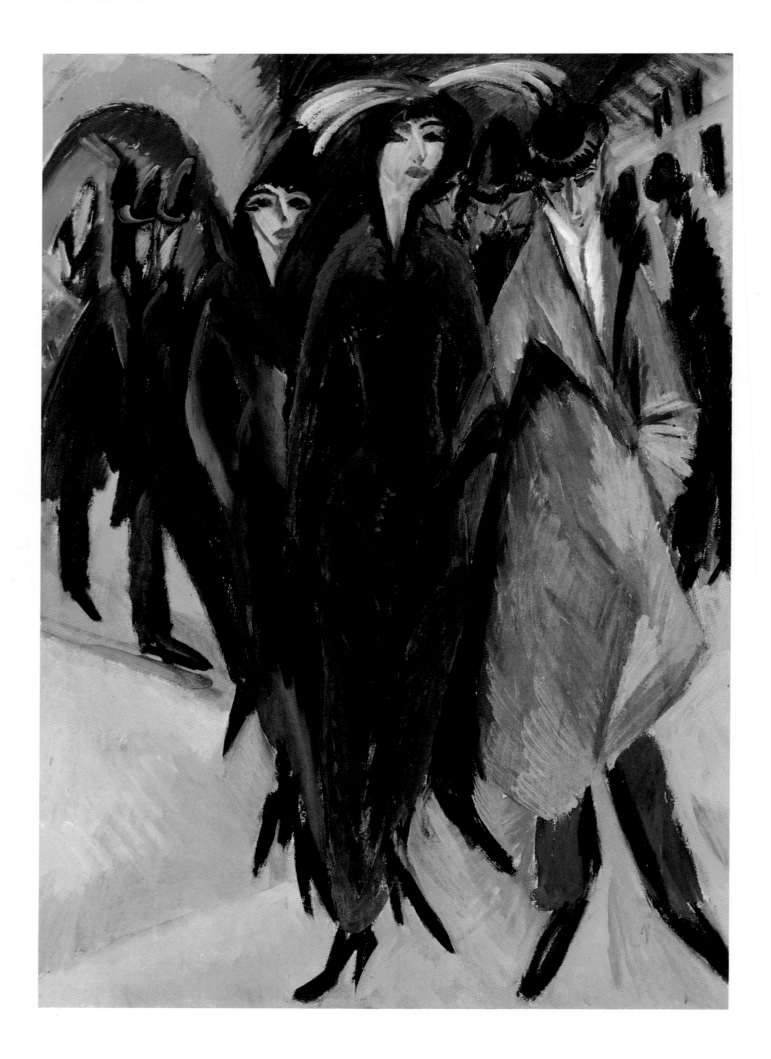

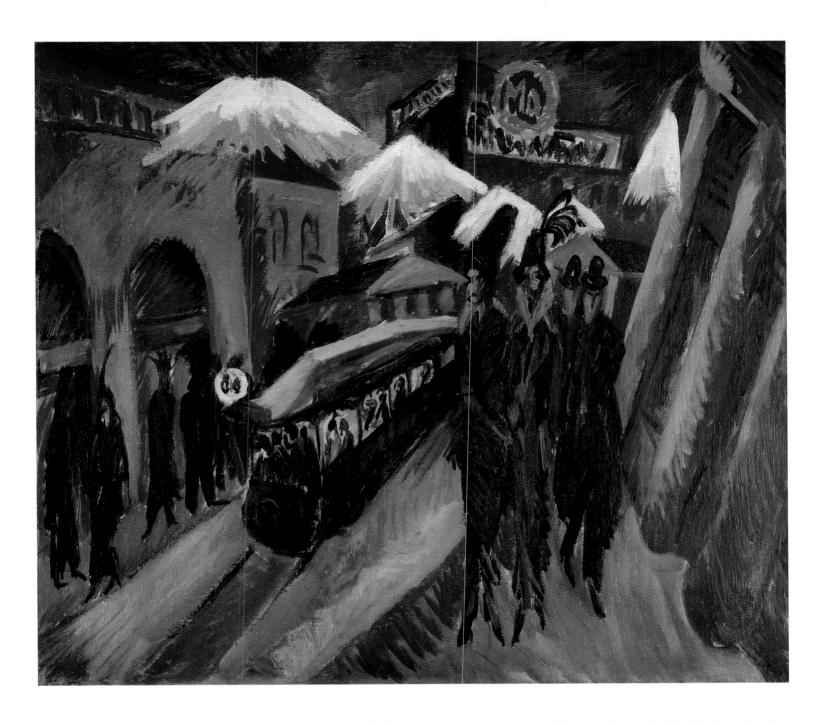

shopping, enjoying themselves in the sunshine, and it hardly matters
whether the street is in a city or a small town. Of the metropolitan bustle in
Kirchner's pictures, and especially of the tense balance of allure and menace
in Kirchner's demi-monde, Macke's art is innocent.

German critics have elevated Kirchner's street scenes to the status of
icons. They are seen as the very definition of the modern city experience,
with all its excitements and its destructive forces, thrilling and corrupt. They
present the modern metropolis entire – on the brink of the cataclysm that
was the First World War. But to see Kirchner's works in this light is to read
them in a metaphoric or literary manner that was alien to the artist and is in-
compatible with the pictures themselves. Of course, it is easy to see why
they have achieved this iconic standing. They hit the tone of the age, a note
sounded by much Expressionist literature about the city too. Nevertheless,
they were not painted as metaphors or literary compositions, but as realistic
representations of real situations. Everything we see in them was seen by the

Leipziger Straße with Electric Tram; Small
Street Scene, 1914
Leipziger Straße mit elektrischer Bahn
Oil on canvas, 69.5 x 79 cm
Gordon 368; Essen, Museum Folkwang

PAGE 112:
Women on the Street, 1915
Frauen auf der Straße
Oil on canvas, 126 x 90 cm
Gordon 427; Wuppertal, Von der Heydt-
Museum

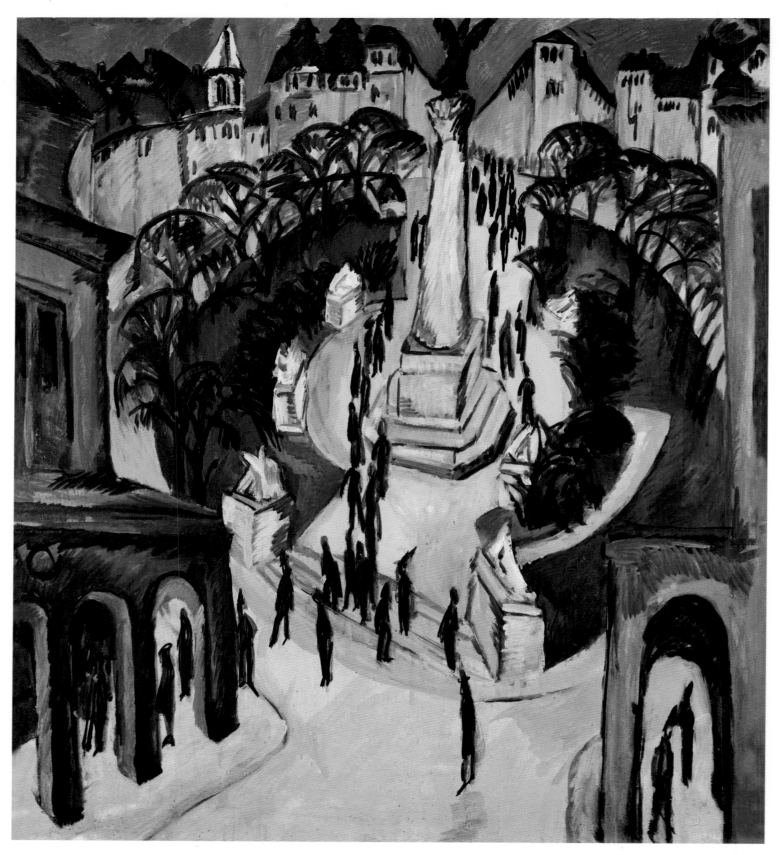

Belle-Alliance-Platz, Berlin, 1914
Oil on canvas, 96 x 85 cm
Gordon 371; Berlin, Staatliche Museen zu
Berlin – Preußischer Kulturbesitz,
Nationalgalerie

PAGE 115:
Rhine River Bridge at Cologne, 1914
Rheinbrücke
Oil on canvas, 121 x 91 cm
Gordon 387; Berlin, Staatliche Museen zu
Berlin – Preußischer Kulturbesitz,
Nationalgalerie

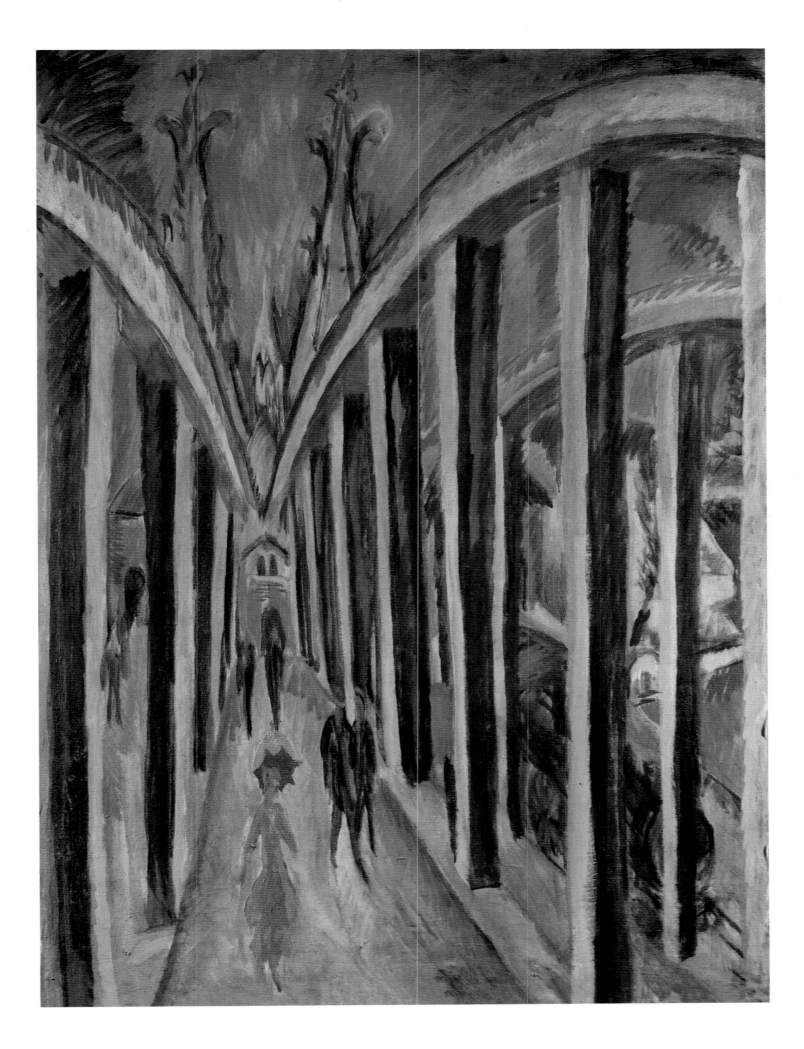

Circus Rider, 1914
Zirkusreiter
Brush and Indian ink, 67.3 x 51.1 cm
Private collection

artist at a specific moment in a specific place. Nothing in them has been artificially contrived. Neither the buildings nor the figures have been invented, imagined, or borrowed from a literary source. Even the most insignificant details, such as the numbers of tram lines (p. 100) or the trams themselves (p. 113), genuinely existed – and Kirchner took care to include them. We shall be returning to this issue in due course.

When the First World War broke out on 1 August 1914, Kirchner was at work on the street scenes, and the impact of the war quickly affected the paintings. In each of *Potsdamer Platz* (p. 111) and the oil version of *Two Women on the Street* (p. 109), both done in that year, one woman is wearing the black veil of a widow. There is also a 1914 etching titled *War Widows in the Street* (p. 105). In point of fact, prostitutes in the streets of Berlin very quickly took to dressing as war widows after the outbreak of war – whether by way of sophisticated camouflage for an outlawed profession or in order to add an extra, morbid thrill to the transaction is a moot point. In Kirchner's pictures, at any rate, the veils add a further erotic charge. The circumstance

PAGE 117:
Circus Rider, 1914
Zirkusreiter
Oil on canvas, 200 x 150 cm
Gordon 382; Saint Louis (MO), Saint Louis
Art Museum, Morton D. May Collection

This large-format painting is one of those that Kirchner considered a major piece even as he was working on them. The preliminary drawing was reproduced in Will Grohmann's 1926 study of Kirchner's drawings. The rapidly drawn piece is heavily hatched and extremely energetic, with an idiosyncratic sense of space.

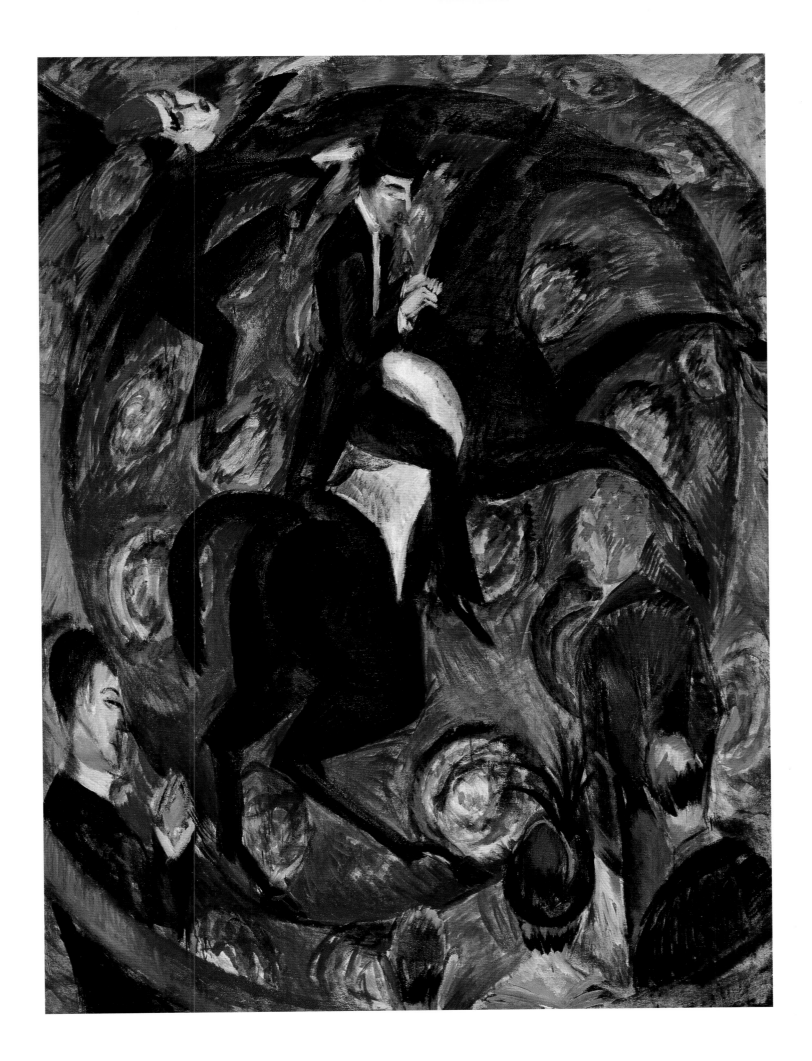

that the veils were not added until the oil stage of either work indicates that the basic composition was settled before the war began. We can thus date them to the summer and autumn of 1914.

That same year, Kirchner established contact with an art association that had been going strong in Jena since its foundation in 1903 and was among the most progressive in Germany. The contact was probably made through Hans Fehr, the law professor to whom reference was made as a supporter of Die Brücke in the first chapter of this book. A friend of Emil Nolde, Fehr had been one of the passive members. Until his appointment to the chair of law at Halle university in 1912, he taught at Jena, and was also the business manager of the art association, on an honorary basis. In 1911 he had arranged a Jena exhibition for Die Brücke. Fehr was succeeded in his association post by Eberhard Grisebach, a young philosophy lecturer with a taste for art, whose home was adorned with paintings by Munch and Ferdinand Hodler. In early 1914, following an exhibition of Heckel's work in 1913, he invited Kirchner to mount a solo show in Jena for the association. This was opened on 15 February 1914 with a lecture by Botho Graef, professor of archaeology and art history at the university of Jena and an influential advocate of the new art.

Eberhard Grisebach, who had contracted tuberculosis in his student years, had spent five years in treatment at Davos, finally leaving in 1909, a healthy man. He had married the daughter of his Davos doctor, Luzius Spengler, and settled in Jena with her. Contact with his wife's family in Davos remained close, especially with his mother-in-law Helene Spengler, and an extensive correspondence resulted. On 13 February 1914, Grisebach wrote to Davos describing his first meeting with Kirchner on the occasion of the Jena show: "Today was a busy and interesting day. I spent the morning hanging pictures by E. L. Kirchner. It was a pleasure, as they are very good. At one o'clock Graef came to view them, since he will be giving the opening lecture on Sunday at twelve. Fortunately he took a shine to them as well [...]. At two

Man and Girl Talking, 1914–1915
Mann und Mädchen im Gespräch
Pencil drawing, 52.5 x 39.5 cm
Kassel, Staatliche Museen Kassel,
Graphische Sammlung

Another of the studio scenes of friendship and conversation.

The Murderer, 1914
Der Mörder
Coloured lithograph, 50.1 x 65.2 cm
Dube 253; New York, The Museum of Modern Art, Purchase.

One of three illustrations Kirchner did in 1914 for the 1890 novel "La bête humaine" by Emile Zola (1840–1902). In the event, the lithograph was only ever published as an individual sheet.

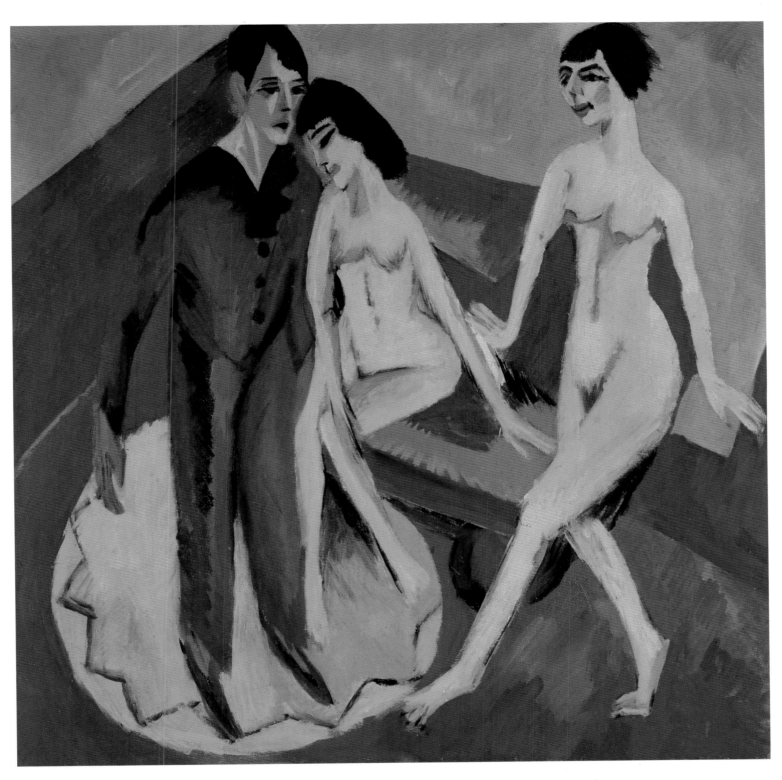

Dancing School, 1914
Tanzschule
Oil on canvas, 114.5 x 115.5 cm
Gordon 388; Munich, Staatsgalerie für
moderne Kunst

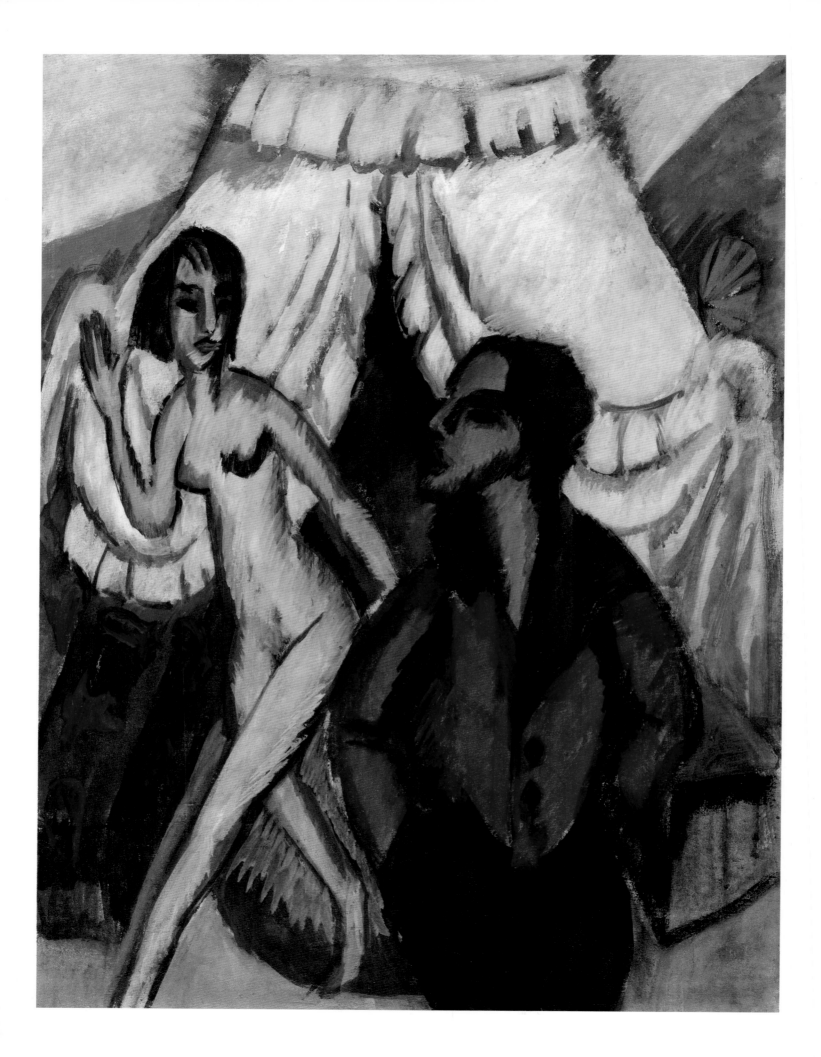

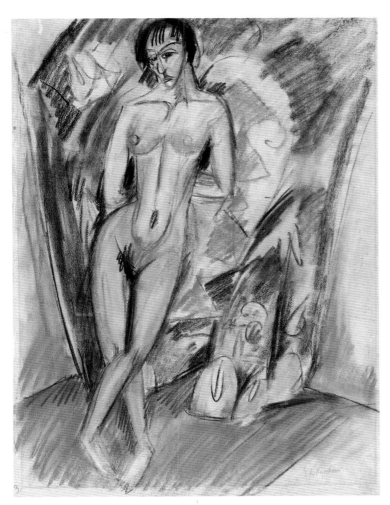 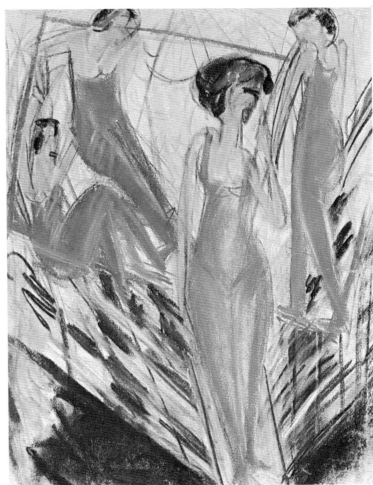

thirty Kirchner himself telephoned, having arrived from Berlin. At three he called in, looked at my pictures, I showed him the exhibition, and then we had a cup of coffee and talked about all kinds of things. He is an agreeably straightforward person, his hands rough from making woodcuts, which he does with great skill. Apart from wearing his hair long, as artists do, he is without affectation. Berlin may make metropolitans of these artists, but they see life there as simply a part of the whole universe, and stoutly uphold their independence. If Heckel tends to make the impression of a tailor, starting with his Saxon accent and manner, Kirchner is a regular cobbler, hard-headed and angular [...]. I am inclined to think him the most important of the Brücke artists, and I like some of his pictures very much. If I buy something myself, he proposes to make over a picture to the association, although he himself has not a penny [...]." Following a second meeting a few weeks later Grisebach wrote: "I liked him personally very much. He is only a painter, but he is intelligent and very honest. His world is not mine; that is to say, in his company I often feel too conventional and well bred. But his coarser experiences are conveyed powerfully and honestly in his art, and I find his form compelling [...]."

These meetings marked the beginning of a friendship that was shortly to acquire a special significance for Kirchner. The young lecturer's phrasing tells of the pleasure of meeting an eminent artist. Kirchner seemed to be at the height of his powers, and expectations of his work were great. Soon, however, the war and his call-up were to plunge the artist into a profound crisis, in which he would very much need the help of his friends.

Standing Nude with the Tent, 1914
Stehender Akt vor dem Zelt
Pastel, 67.5 x 51 cm
Düsseldorf, Kunstmuseum Düsseldorf im Ehrenhof

Artistes in Blue, 1914
Blaue Artisten
Pastel, 67 x 50.5 cm
Hamburg, private collection

PAGE 120:
The Tent; Interior in Berlin Studio, 1914
Das Zelt
Oil on canvas, 116 x 92 cm
Gordon 393; Munich, Staatsgalerie für moderne Kunst

The "tent" in this painting and the pastel above (left) was an area of Kirchner's Berlin studio at 45, Körnerstraße in the Friedenau district (to which he moved in October 1913) which was screened off with drapes.

The friendship linking the unconventional artist in Berlin with the rather more academic and middle-class art lovers of Jena quickly deepened, and extended to include others such as the philosopher Rudolf Eucken, winner of the Nobel Prize for Literature, and his wife Irene; the poet Karl Theodor Bluth; and Julius Schaxel, professor of biology at the university. Kirchner stayed at Botho Graef's Jena home on more than one occasion, and Graef reciprocated, visiting Kirchner's Berlin studio. The artist painted Jena motifs, portraits of his Jena friends, and a number of those more private pictures of friendship such as featured in his early Berlin period too – paintings such as the 1914 *Graef and Friend* (p. 125), showing the bearded scholar in a fatherly, protective pose with a young man. This work was long titled *Father and Son*; but Graef had no family, and the other man has been identified as Johann Ilmari Auerbach (1899–1950), nephew of the then famous Jena physicist Felix Auerbach (1856–1933). He later studied at the Bauhaus and became a sculptor. Botho Graef and his male circle of friends intrigued Kirchner. In the double portrait we find the artist viewing human affection

Interior, 1914
Interieur
Oil on canvas, 70 x 80 cm
Gordon 412; Munich, Staatsgalerie für moderne Kunst

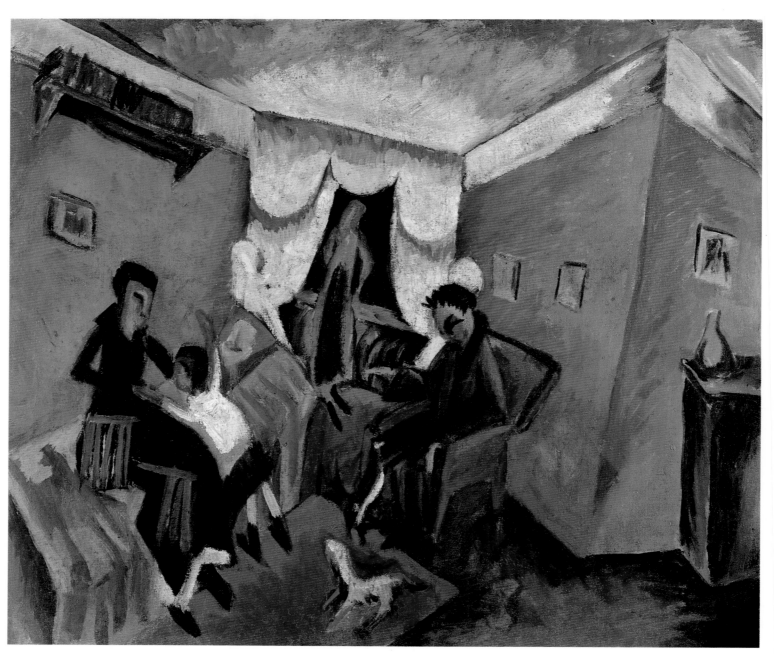

Self-Portrait; Double Portrait, 1914
Selbstbildnis, Doppelbildnis
Oil on canvas, 60 x 49 cm
Gordon 417; Berlin, Staatliche Museen zu
Berlin – Preußischer Kulturbesitz,
Nationalgalerie

One of Kirchner's studio self-portraits with
partner. As in the 1910 *Self-Portrait with
Model* (p.45), the artist is in his dressing
gown with a brush in his hand, the emblem of
his trade. Behind him is Erna. The proud, self-
assured stance of the artist in 1910, with his
lover on the bed, has become a portrait study
of two people sharing the same life. Kirch-
ner's situation had changed. In August 1914
war had broken out, he and Erna had curtailed
their stay on Fehmarn, and Kirchner was now
expecting to be called up.

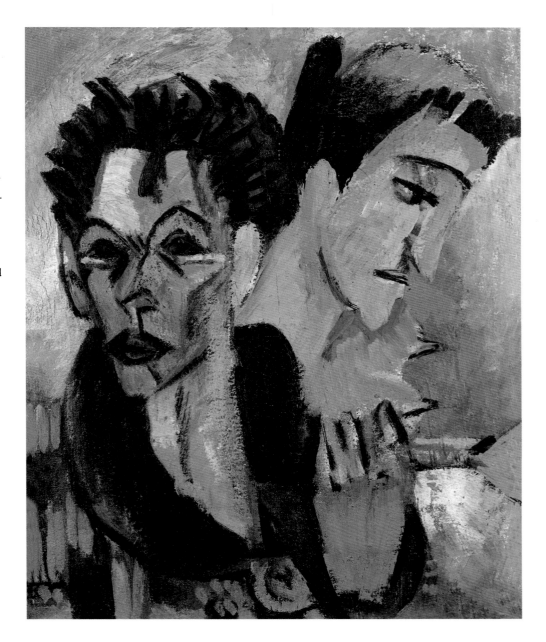

of a kind he had not experienced in his relations with women or with his
Brücke fellows, affection free of rivalry and distrust.

As we have seen, the outbreak of war on 1 August 1914 prompted Kirch-
ner to curtail his summer visit to the Staberhuk lighthouse on Fehmarn ab-
ruptly. He returned to Berlin. "It was hard to leave so suddenly," he wrote
afterwards to Gustav Schiefler, "because I had been devoting this year's stay
entirely to the scenery and the way of life there, and was working with
hardly any conscious effort." Now aged thirty-four, he was not among the
young men who were the first to be called up, but he was afraid of the day
he would be, and of "being a Landsturm cripple and having to dig trenches
somewhere". Those who volunteered at least had the choice of which ser-
vice they entered. And so in early 1915, as an "involuntary volunteer" (as he
put it), Kirchner volunteered to be an artillery driver. And in July 1915, aged
thirty-five, he was called up to join the mounted field artillery at Halle an
der Saale.

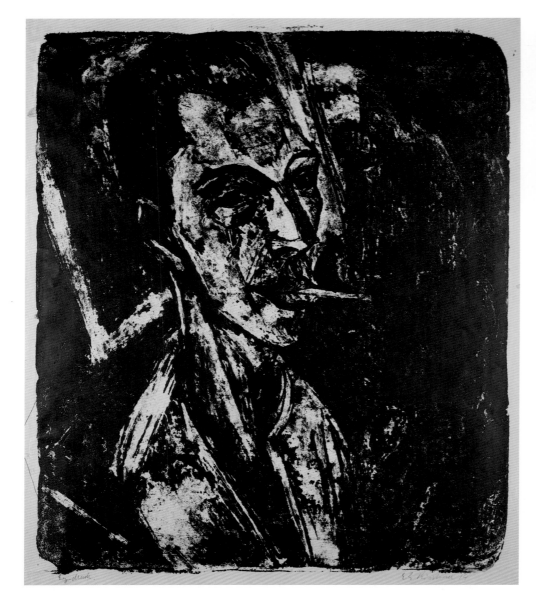

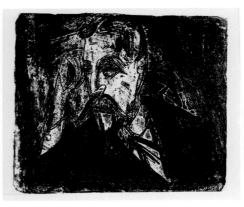

Professor Graef (horizontal format),
1914–1915
Kopf Professor Graef (Querformat)
Lithograph, 50 x 59.5 cm
Dube 284; private collection

Self-Portrait with a Cigarette, 1915
Selbstbildnis mit Zigarette
Lithograph, 59 x 50.5 cm
Dube 280; Frankfurt am Main, Städtische
Galerie im Städelschen Kunstinstitut

One of Kirchner's last self-portraits before he
joined the army for training in July 1915 –
and entered a critical phase.

PAGE 125:
Graef and Friend, 1914
Graef und Freund
Oil on canvas, 125 x 90 cm
Gordon 423; private collection

Botho Graef (1857–1917) was a professor of
archaeology and art history at the University
of Jena. From 1914 he became an important
friend and protector, one of a number of art
lovers in Jena who showed their concern for
Kirchner during the difficult war years. In this
picture, which was known for a time as
Father and Son, Kirchner presents Graef with
a young man from Jena, who later became a
sculptor, Johannes Ilmari Auerbach (1899–
1950) – the nephew of the famed physicist
Felix Auerbach (1856–1933), whose portrait
was painted by Munch in 1906.

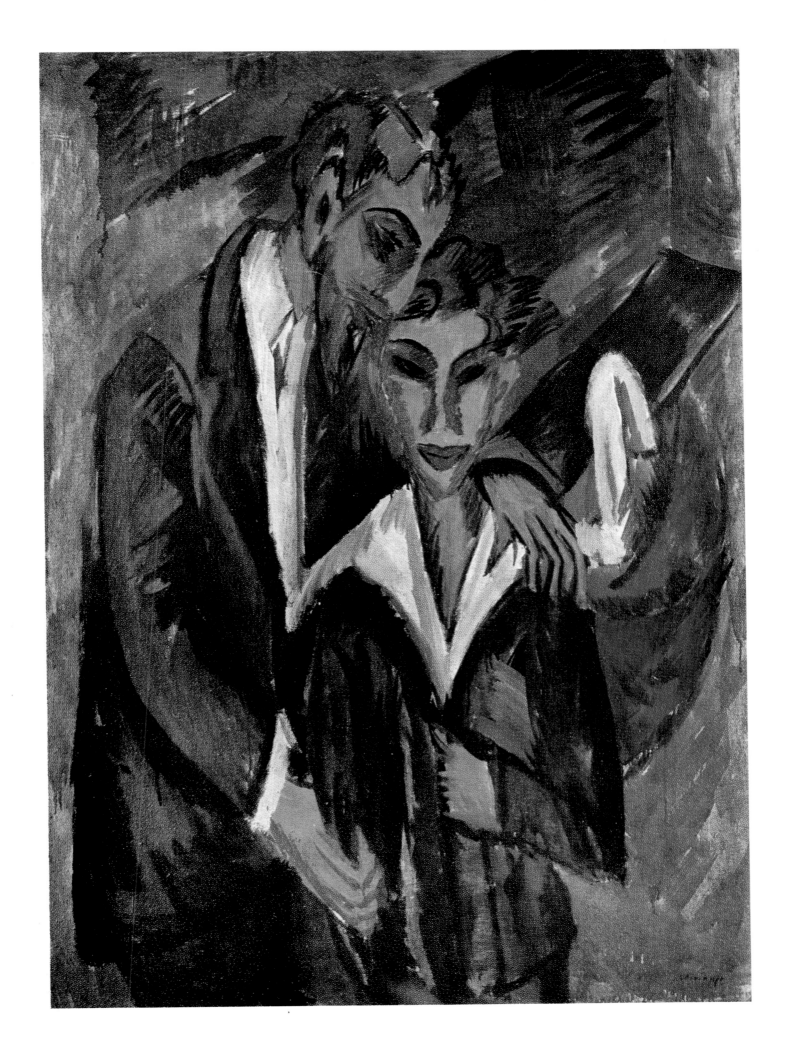

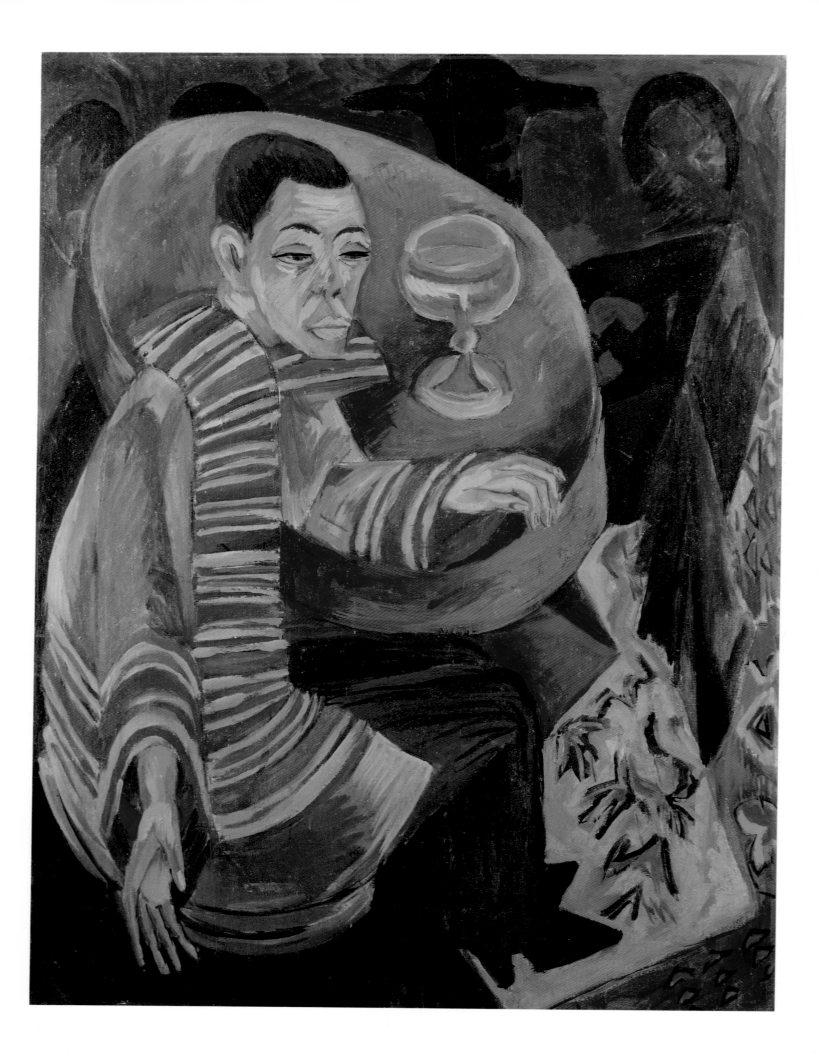

The Critical Years

In his Dresden years, Ernst Ludwig Kirchner was a radical innovator, a pioneer of new artistic form. In Berlin he was an artist with a new subject matter, the great city. With the outbreak of war he once again acquired a new role, one that may put us in mind of Vincent van Gogh – that of the sensitive artist threatened by an inhuman and destructive world. The likelihood that he would be sent to the front put Kirchner in an existential panic. It was his profoundest crisis. He himself portrayed that state of mind in a self-portrait presumably painted in the first half of 1915 in his Berlin studio, *The Drinker; Self-Portrait* (p. 126). The mood contrast between this work and the tranquil *Graef and Friend* (p. 125) or the buoyant lithograph *Self-Portrait with a Cigarette* (1915; p. 124), both done only months earlier, could scarcely be greater. There the artist sits, in the room of many colours he painted himself, wearing a resplendent jacket, an acid green glass beside him. His face is drawn and expressionless. The selfsame artist who presented himself with the tools of his trade, a self-confident young man with his lover, just five years before (*Self-Portrait with Model*, 1910; pp. 44 and 45) now sees himself as isolated, thrust upon his own resources, a prey to alcohol.

The green drink is absinthe, the famed ichor of the French bohemians of the fin de siècle, the existential emblem of the artist's self-destructive urges (and, incidentally, no longer made – the dangers absinthe poses to health led to a ban). Kirchner's original title for the painting was in fact *The Absinthe Drinker*, and it was under that title that it was first exhibited with the Jena art association in 1917, where his friend, the poet Karl Theodor Bluth, bought it. Absinthe drinkers of either sex had been written about (for example, by Rimbaud and Verlaine) and had also been a subject for painters, famously from Manet's hand but also from Toulouse-Lautrec's, van Gogh's and latterly Picasso's.

For the first time, Kirchner was painting a picture that represented more than direct experience. The motif was avowedly one drawn from art and literature. Plainly his existential fear demanded this move into the literary and metaphoric, and we shall see the same approach in other works of the period (cf. pp. 130–135). Equally, the fact is that Kirchner himself was a heavy drinker of absinthe at the time. One might say that he borrowed the subject not only in his art but also in his life.

In July 1915 he was called up and sent to Halle an der Saale to join mounted field artillery regiment 75 for basic training. Kirchner liked handling the horses, but military drill and barracks life terrified him. Then, as luck would have it, he met a friend who was in a position to help, and within two months Kirchner was granted leave on grounds of poor health – "a lung complaint and overall debility," as he put it in a letter. The coincidence is

Self-Portrait Drawing, 1916
Selbstbildnis zeichnend
Etching, 40.5 x 31 cm
Dube 218; Saarbrücken, Saarland-Museum in der Stiftung Saarländischer Kulturbesitz

Two wartime self-portraits clearly show the changes wrought in Kirchner by his tribulations. With the feared worst yet to come he portrayed himself as an absinthe drinker. A year later (above), after a period of basic training, his collapse, and his first experience of sanatoriums, he was looking haggard, wrecked by drugs.

PAGE 126:
The Drinker; Self-Portrait, 1915
Der Trinker, Selbstbildnis
Oil on canvas, 118.5 x 88.5 cm
Gordon 428; Nuremberg, Germanisches Nationalmuseum

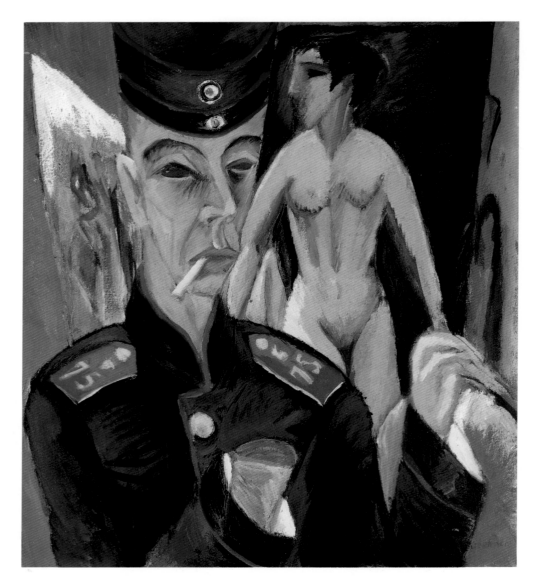

Self-Portrait as a Soldier, 1915
Selbstbildnis als Soldat
Oil on canvas, 69 x 61 cm
Gordon 435; Oberlin (OH), Allen Memorial
Art Museum, Oberlin College, Charles F.
Olney Fund, 50.29

Kirchner the involuntary volunteer, the artil-
leryman on leave in his studio, painted this
portrait of himself in uniform with a naked
woman – at once lover, partner, and personi-
fication of his art. The relations of man and
woman, a stable component of earlier works
though depicted in very various ways, have
been interrupted here. In his panic, the artist
even shows himself lacking a hand – the war
(he feared) would rob him of the one thing he
absolutely needed to pursue his art.

worth describing. It so happened that one of his instructors, in riding, was
none other than Hans Fehr, the Swiss professor of law who was now teach-
ing at the university of Halle. (As a full-time employee of the German educa-
tion system, Fehr, though a Swiss national, was considered a German citizen
too under the law of the time, and was thus eligible for military service.)
"And so he volunteered for the Prussian army," Fehr later recounted, writing
of himself in the third person, "and was accepted at the rank of lieutenant
and assigned to riding instruction. One morning a soldier appeared on the
riding field who should never have been put in uniform, as one could see
from a long way off. It was Ernst Ludwig Kirchner the painter. He went over
to the lieutenant, clicked his heels clumsily, and reported for duty. 'But what-
ever are you doing here, Herr Kirchner!' – 'I was called up suddenly. I shall
never be a good soldier. I know that if I'm sent to the front I'll be shot dead
in an instant.' […] He was evidently suffering. He was pale and was losing
weight. Anyone could see that he was destined to collapse, sooner or later."
Fehr got in touch with the captain of the medical corps, who in due course
issued the needed medical certificate.

 At some point during the two months he was with the army in Halle,
Kirchner appears to have been in Berlin on a short leave. A number of photo-
graphs show him in the uniform of an artillery soldier in his own studio

(p. 197). It will presumably have been at this time that he painted the famous *Self-Portrait as a Soldier* (p. 128) too. The picture strikingly documents Kirchner's panic, the fear that was driving him to the verge of physical and mental breakdown. Again he is seen in his studio, again with a naked woman in the familiar dual role of partner and personification of art (cf. pp. 24 and 44–45). Kirchner was precise in recording the details which one might call the attributes of his role as soldier: the uniform with the two cockades of Prussia and of the German Reich on the cap and the regimental number on the epaulettes. But all that is left of his right hand is a bloody stump. The war, he was saying, would rob him of the artist's most precious tool, the hand he needs to draw and paint. It was the second painting within a short space of time that imaged forth his immense fear in metaphoric terms that left realism behind.

Artillerymen in the Shower, 1915
Das Soldatenbad
Oil on canvas, 140.5 x 152 cm
Gordon 434; New York, Solomon R. Guggenheim Museum

One of the few pictures showing Kirchner's experience of basic training at Halle in 1915. The naked soldiers are supervised by a uniformed NCO. One soldier is stoking up the boiler.

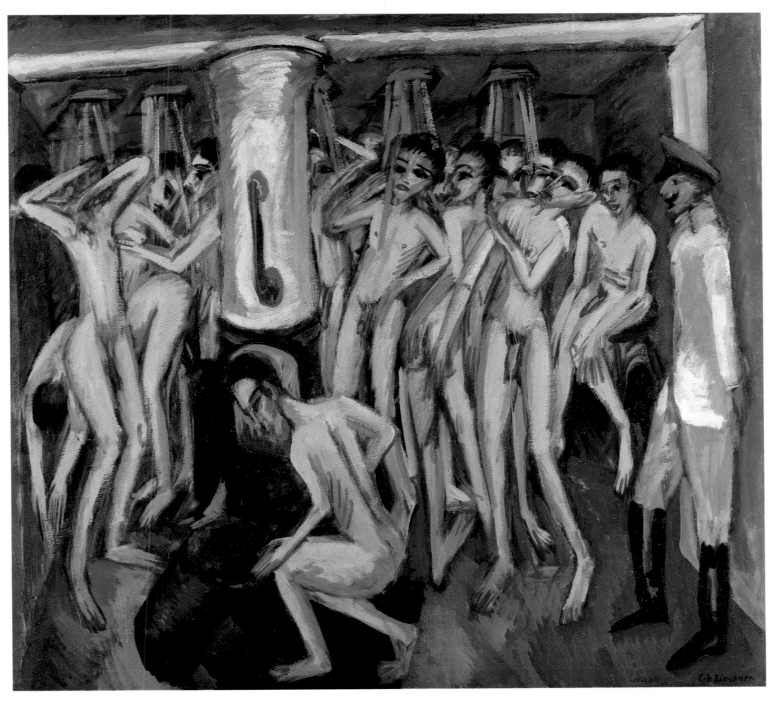

The Amazing Tale of Peter Schlemihl, 1915
Peter Schlemihls wundersame Geschichte
Title sheet
Coloured woodcut, 29.2 x 26 cm
Dube 262; Basle, Öffentliche Kunstsammlung
Basel, Kupferstichkabinett

Between his discharge and his entry into a
sanatorium in late 1915, Kirchner did a series
of coloured woodcuts illustrating *The Amazing Tale of Peter Schlemihl* (1814) by the German Romantic writer Adalbert von Chamisso
(1781–1838) – the story of a man who sells
his shadow. The copy reproduced here was
dedicated to his "dear wise" friend Botho
Graef. After Graef's death in 1917, Kirchner
added a second dedication, to the philosopher
Eberhard Grisebach – "who continues his
intellectual legacy in Jena".

PAGE 131:
Selling the Shadow, 1915
Der Verkauf des Schattens
Coloured woodcut, 32.3 x 21.9 cm
Dube 263; Basle, Öffentliche Kunstsammlung
Basel, Kupferstichkabinett

In a letter of 28 July 1919 to Gustav Schiefler,
who compiled the catalogue of the graphic
works, Kirchner gave the following account
of the Schlemihl sequence:
"The tale of Peter Schlemihl, once stripped of
its Romantic trappings, is the tale of a man
suffering from persecution mania. It is the
story of a man who suddenly, prompted by
some event, becomes aware of how infinitely
small he is, but also realises by what means
the world at large deceives itself and does not
accept this insight.
In sheet 1, filled with the longing that the
wealth around him has fired, he seizes the
opportunity that presents itself, although he
knows that in doing so he is selling his inmost
self, as it were, and thus his spiritual equilibrium. This is expressed symbolically by the
selling of his shadow.

Sheet 2 shows the attractive girl he falls in
love with.
Sheet 3 represents the troubles that that love
causes both him and her.
Sheet 4 shows his feverish self-analysis when
he is alone again in his room after the pursuit
by the street urchins.
Sheet 5 is the scene where the little grey man
on the country road loans his shadow to Schlemihl while they are together, and Schlemihl attempts to make off with it. As if of its own accord, the shadow slips back into the little
man's pocket. I have used a military uniform
because at the time I was in the army I felt in
a similar mental state. My own selling to the
little grey man was the act of volunteering, for
which I am entirely to blame myself.

Sheet 6 shows Schlemihl grieving in the fields
when suddenly, as the sun shines, a shadow
materializes. He tries to put his feet into the
shadow's footprints, thinking that in that way
he can again become himself. Analogous to
the mental state of a man discharged from the
army.
There is no sheet 7. It was to have shown the
process of reconciliation to this spiritual deficiency, and Schlemihl racing around the world
in his seven-league boots, as in Chamisso. But
I have not yet been able to find a way of
doing this picture."

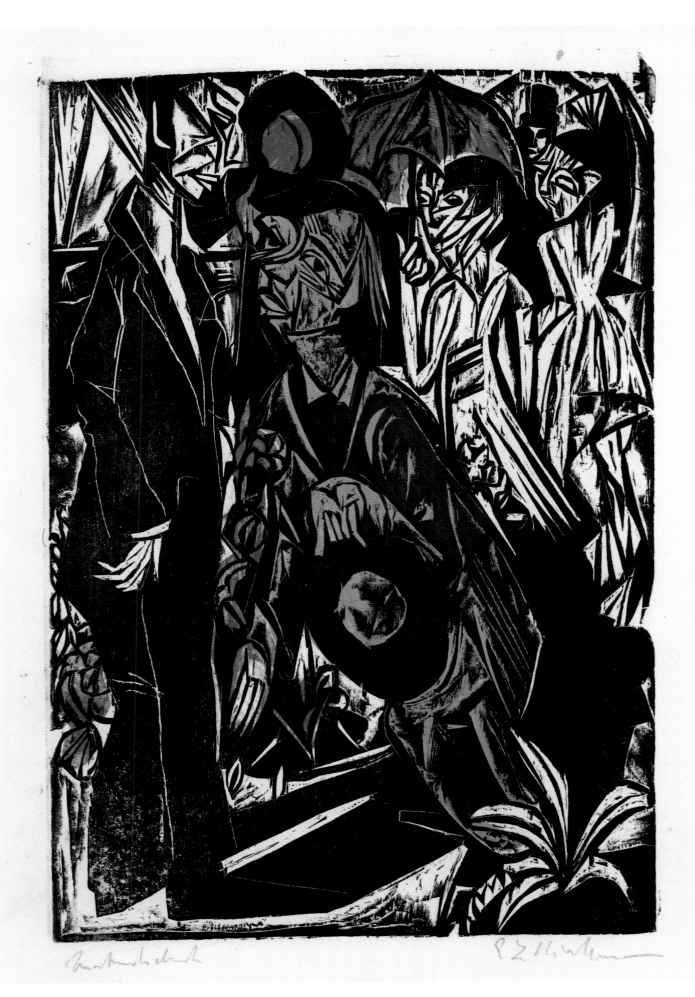

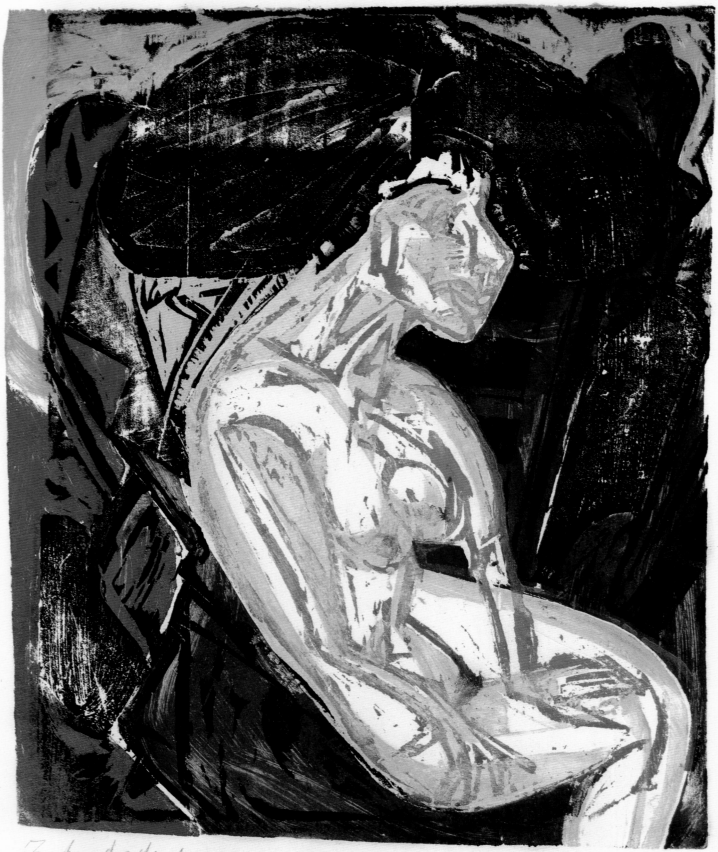

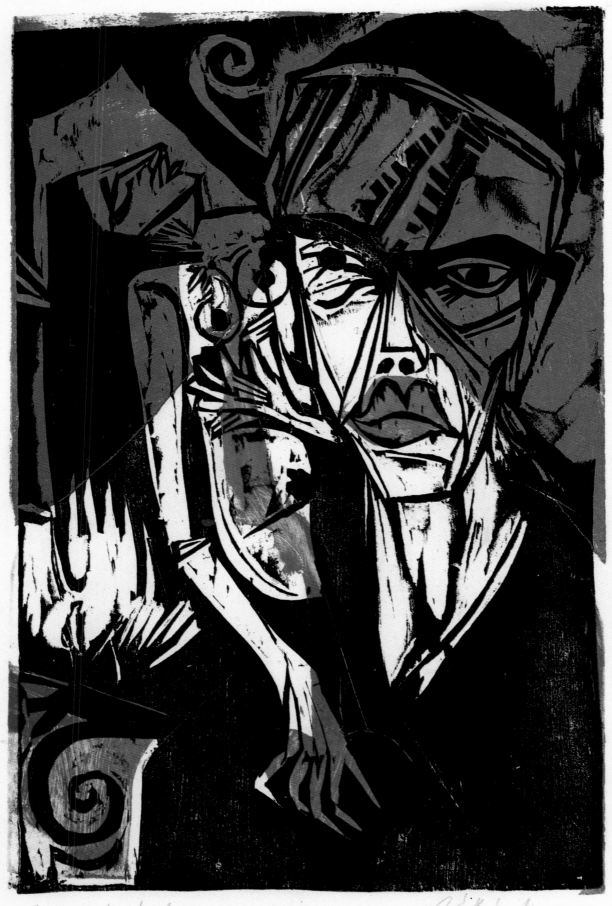

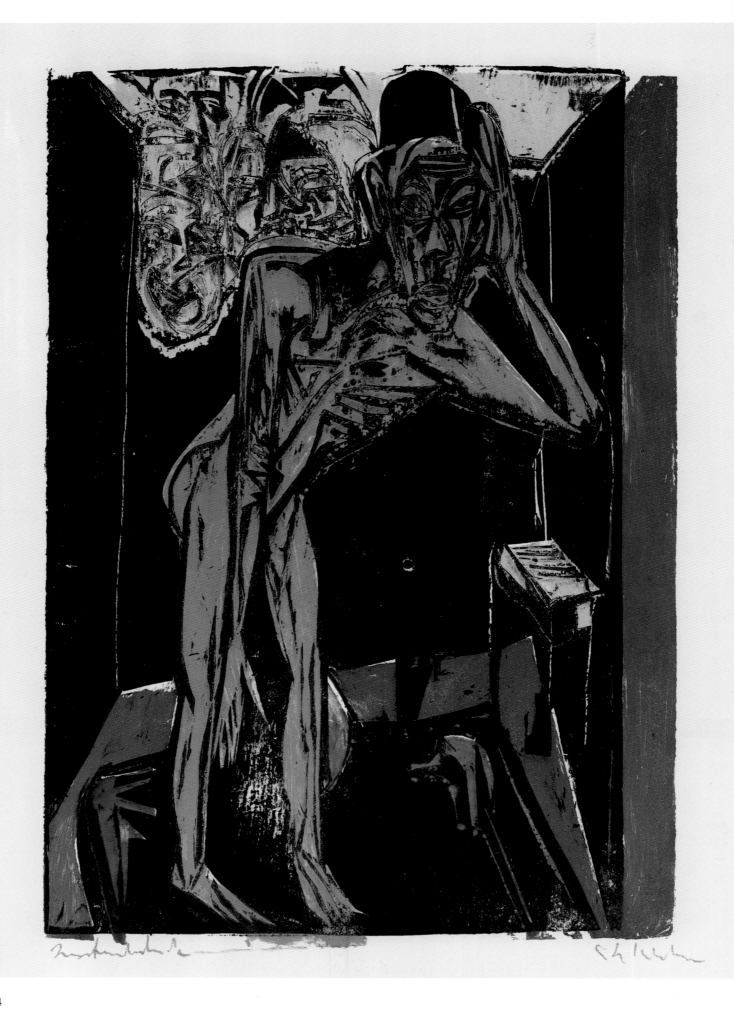

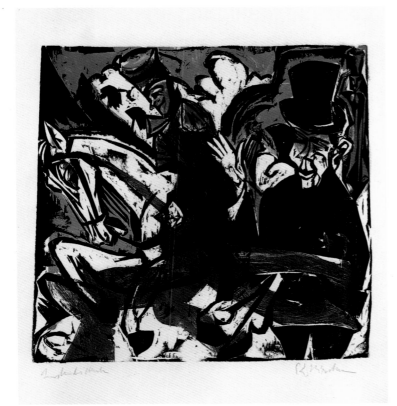

Artillerymen in the Shower (1915; p. 129) is a related picture. This large painting shows shower rooms in military barracks, and naked soldiers showering under the supervision of a uniformed NCO. One of them is stoking the boiler. For Kirchner, this was a realistic picture that showed the humiliations of the military life, in which the individual was reduced to a few physical functions. To a later eye informed with hindsight knowledge that the gas chambers in the Nazi death camps were disguised as showers, the associations the painting prompts may go further, of course.

Another painting of this period, even more heavily symbolic, is *Dance between the Women* (1915; p. 141). This is one of a number of paintings on the subject of man and woman that criticism has largely bypassed to date. Kirchner returned to the theme every year or so, as if to a problem he was worrying at. Back in 1905, in a manner still indebted to Art Nouveau, he had done a set of woodcuts entitled *Two People* which represented relations between man and woman as passing through the stages of attraction, union, estrangement, temptation, and separation. In a later set of woodcuts illustrating Petrarch, in 1918, the same themes recurred. And in his paintings Kirchner repeatedly tackled this central complex, which evidently carried a high personal charge. Besides *Dance between the Women* we need only think of *Man* (1915), *Black Springtime* (1923), and *Two against the World* (1924). The motif of a man dancing naked before naked women was one that Kirchner used frequently, in paintings, graphics and carved reliefs in wood. He appears to have used Berlin studio photographs taken between 1913 and 1915 (cf. p. 196) in the process, though this information is of little assistance in interpreting the pictures.

Kirchner was on sick leave till the end of October 1915, and of course his fear of being sent to the front to fight remained. Since his condition did not improve, however, his protector Fehr succeeded in having the leave papers altered to a discharge – "on condition that he enter a sanatorium immedi-

PAGE 132:
The Loved One, 1915
Die Geliebte
Coloured woodcut, 28.2 x 23 cm
Dube 264; Basle, Öffentliche Kunstsammlung
Basel, Kupferstichkabinett

PAGE 133:
Troubles, 1915
Kämpfe
Coloured woodcut, 33.3 x 21.4 cm
Dube 265; Basle, Öffentliche Kunstsammlung
Basel, Kupferstichkabinett

PAGE 134:
Schlemihl Alone in His Room, 1915
Schlemihl in der Einsamkeit des Zimmers
Coloured woodcut, 33 x 23.5 cm
Dube 266; Basle, Öffentliche Kunstsammlung
Basel, Kupferstichkabinett

TOP LEFT:
Schlemihl and the Little Grey Man on the Country Road, 1915
Begegnung Schlemihls mit dem grauen Männlein auf der Landstraße
Coloured woodcut, 29.9 x 31 cm
Dube 267; Basle, Öffentliche Kunstsammlung
Basel, Kupferstichkabinett

TOP RIGHT:
Schlemihl and the Shadow, 1915
Schlemihls Begegnung mit dem Schatten
Coloured woodcut, 30.4 x 28.6 cm
Dube 268; Basle, Öffentliche Kunstsammlung
Basel, Kupferstichkabinett

Brandenburg Gate, Berlin, 1915
Brandenburger Tor, Berlin
Oil on canvas, 50 x 70 cm
Gordon 437; Herford, Ahlers Collection

PAGE 137:
The Red Tower in Halle, 1915
Der Rote Turm in Halle
Oil on canvas, 120 x 90.5 cm
Gordon 436; Essen, Museum Folkwang

ately". Writing to the collector Karl Ernst Osthaus on 9 December 1915, Kirchner observed: "I have now been discharged from the army and am going to enter a sanatorium to regain my strength. I feel half dead from the mental and physical torment. And I have to reckon with the possibility of being called up anew. At present I can work only at night." Two days later he was writing to Gustav Schiefler, "away from the army for some time, I have now completed a set of woodcuts on Schlemihl [...]. I am no longer suitable for demanding military duties and intend to enter a sanatorium in a few days' time, so that my nerves and lung can mend. I have been half out of my mind, and even now I am a stranger to the physical sensations of human beings."

The set of woodcuts Kirchner refers to, made in late 1915 in the interval between his discharge and his entry into a sanatorium, was *The Amazing Tale of Peter Schlemihl* (pp. 130–136), based on the famous tale by the German Romantic Adalbert von Chamisso (1781–1838), first published in 1814. The seven coloured woodcuts in the portfolio, in which Kirchner again probes his own existential crisis, are now rated amongst the finest print graphics of the twentieth century. Fewer than ten complete sets are known to exist. Chamisso's Peter Schlemihl sells his own shadow to a man in a grey jacket for a bag of fortune that is permanently full of ducats. Soon, however, he realises that he has sealed a fateful bargain, for the want of a shadow excludes him from human society and even loses him his beloved. Kirchner

The Corner of Uhlandstraße, Berlin, 1915
Ecke Uhlandstraße, Berlin
Pen and Indian ink, 53 x 38 cm
Private collection

did not tackle his task in the spirit of an illustrator tracing major landmarks in the narrative; rather, he expressed existential situations that were far more palpably related to his own mental state than to the literary text he was working from. Later, in a letter of 28 July 1919 to Gustav Schiefler, he described his interpretation in the following terms: "The tale of Peter Schlemihl, once stripped of its Romantic trappings, is the tale of a man suffering from persecution mania. It is the story of a man who suddenly, prompted by some event, becomes aware of how infinitely small he is, but also realises by what means the world at large deceives itself and does not accept this insight." Kirchner himself, needless to say, was the man suffering from persecution mania – and there were indeed those among his friends who saw his self-pitying panic as precisely that.

In mid-December 1915 Kirchner entered a sanatorium at Königstein in the Taunus hills, run by the neurologist Dr. Oscar Kohnstamm – probably on

the recommendation of his Jena friend Botho Graef (now serving in the army himself and acting as an interpreter in prisoner-of-war camps), who was a long-standing acquaintance of Kohnstamm's. In the first half of 1916, Kirchner spent three periods each of several weeks' duration at the sanatorium. His constitution was found to have been wrecked by alcohol, cigarettes and excessive use of veronal, a sleeping draught. "Kirchner seemed to live on cigarettes and veronal," Kohnstamm's daughter later recalled; "the oppressive fear of warfare and the prospect of the front were wearing him away." In the intervals between stays, Kirchner returned to his Berlin studio or visited Botho Graef. And it was from Graef's Jena apartment that he

Café Interior, 1916
Café-Interieur
Reed pen and Indian ink, 54 x 34 cm
Frankfurt am Main, Städtische Galerie im
Städelschen Kunstinstitut

Two Girls Bathing in a Tub, 1915
Zwei sich badende Mädchen mit Badetub
Brush and ink, 54 x 35 cm
Stuttgart, Staatsgalerie Stuttgart

PAGE 141:
Dance between the Women, 1915
Der Tanz zwischen den Frauen
Oil on canvas, 120 x 60 cm
Gordon 443; Munich, Staatsgalerie für
moderne Kunst

One of Kirchner's few symbolic paintings,
and one which has by no means been exhaust-
ively interpreted. Relations between the sexes,
both as partnership and as struggle, are a
recurrent theme in Kirchner's work. The pos-
ture of the male figure was taken from a
photograph Kirchner took in his studio in
1915.

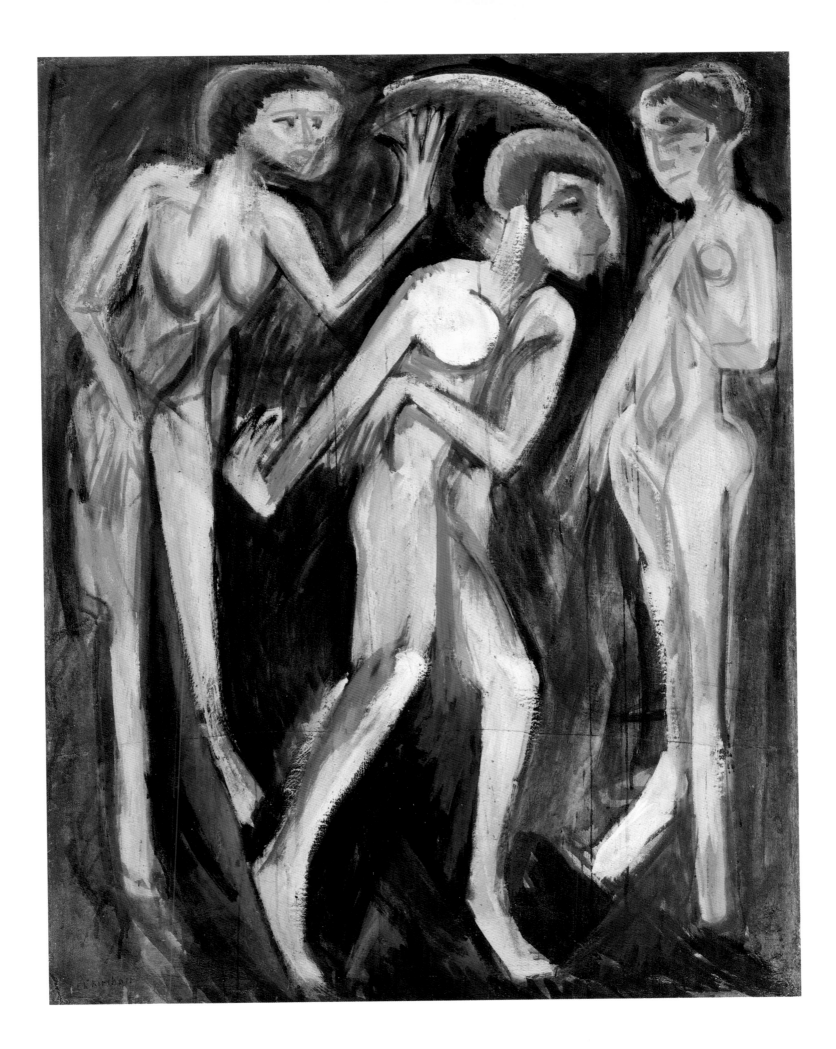

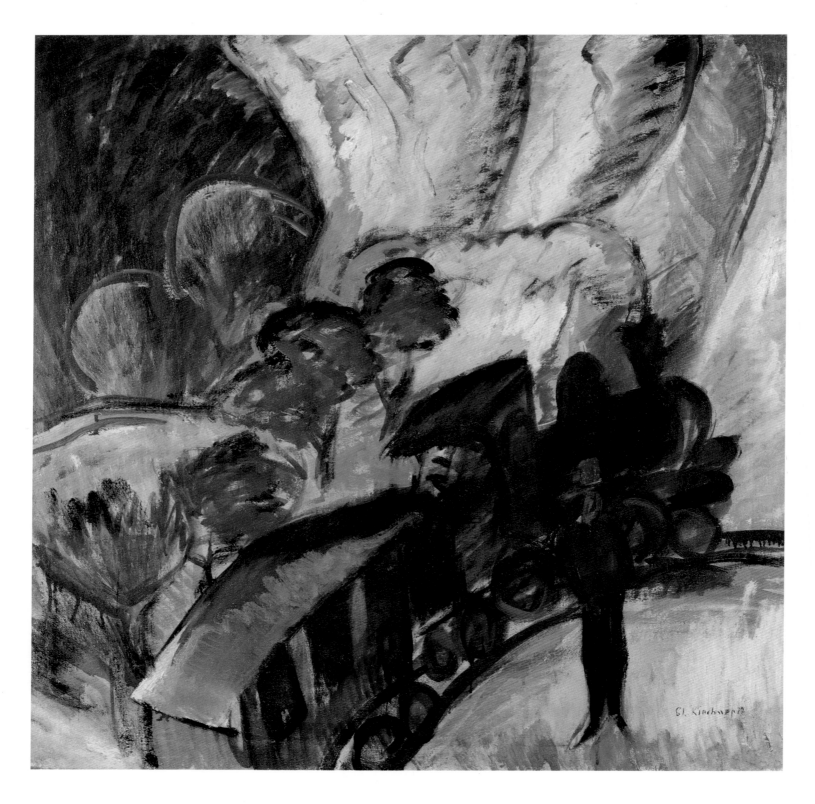

Train near Davos, 1917
Rhätische Bahn, Davos
Oil on canvas, 94 x 94 cm
Gordon 476; Frankfurt am Main,
Deutsche Bank AG

On 19 January 1917, in the bitterly cold depth
of winter, Kirchner arrived at Davos for the
first time, by rail. His first visit was for just
two weeks. He had apparently thought it was
in the south, beneath palm trees.

wrote a letter to Gustav Schiefler which is quoted time and again by the
critics: "I always have the sense that this is a bloody carnival. How will it all
end? One senses that the decision is in the air. All is in confusion. With a
bloated sensation, one totters to one's work, though work of any kind is in
vain and the onslaught of mediocrity is dragging everything down. One is
now oneself like the demi-mondaines I once painted. Brushed onto the
canvas down one moment, gone the next [...]."

Doubtless for therapeutic reasons, Kohnstamm suggested Kirchner paint a
room at the sanatorium; and so, during his third stay in summer 1916, he
painted murals inspired by the Fehmarn bathers on the walls of the pump

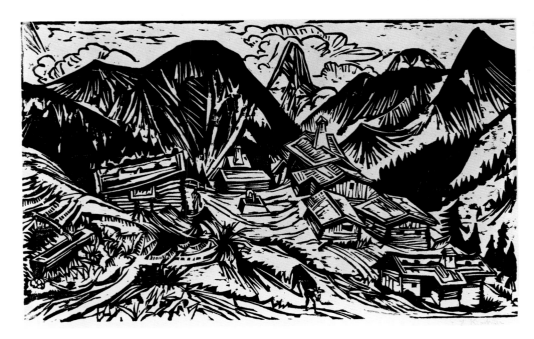

Stafelalp, 1917
Woodcut, 34 x 55.5 cm
Dube 301; Berlin, Staatliche Museen zu
Berlin – Preußischer Kulturbesitz,
Kupferstichkabinett

In May 1917 Kirchner visited Davos for the
second time. He soon left the town itself for
the greater seclusion of the mountains, taking
a peasant cottage at Stafelalp above the vil-
lage of Frauenkirch for the summer. There he
did his first drawings and woodcuts on the ex-
perience of the mountains – the landscape and
people that were to remain at the centre of his
art henceforth.

room at the Königstein sanatorium. In 1938, on the orders of the Nazi Gau-
leiter, the murals were destroyed.

Kirchner's friends were greatly concerned, and followed the changes in
his condition closely. They were afraid that he might never be capable of a
normal life again. Since the diagnoses were vague, speculation that Kirch-
ner's mind might have been unhinged as a result of syphilis has been rife,
but in fact he seems really to have been suffering a critical physical and men-
tal debility prompted by his extreme fears – and doubtless augmented, per-
haps deliberately, by misuse of alcohol and veronal and an intermittent re-
fusal to eat.

"Aside from the general weakness of his constitution," Kirchner's doctor
wrote to Karl Ernst Osthaus in April 1916, following the artist's second stay
at the sanatorium, "Herr Kirchner is in a state of extreme nervous agitation
that causes him insomnia and leads to abuse of sleeping drugs. This agita-
tion is kept lively by his recollections of military service and all that it in-
volved." Osthaus, together with a number of other friends, was covering
Kirchner's sanatorium costs. A letter of 1 December 1916 from Botho Graef
to Eberhard Grisebach shows just how concerned his friends were: "You are
aware that Kirchner is in a hopeless condition. I am writing to his patrons to
raise as much money as possible to have him undergo a cure, which might
perhaps be successful for a time. But it is to be expected, alas, that he may
spend years in a helpless state, like Nietzsche. In that case we shall have to
try to raise funds by selling his work." Graef goes on with detailed proposals
of how these sales might be organized.

In early December 1916, Kirchner voluntarily entered a sanatorium in
the Charlottenburg district of Berlin, run by one Dr. Edel. Botho Graef
visited him there and tried to discover what Kirchner's present condition
was. On 17 December he wrote to Gustav Schiefler: "He was very slack
and weak, but very calm too, and completely lucid. I still have no definite
word, though I expect it daily, of whether paralysis can unambiguously be
diagnosed and whether some long-standing syphilitic infection is behind it
or not [...]. K. has always denied to me and to any who understandably
come to that conclusion that he has had syphilis, but recently he appears to

Portrait of a Farmer (Martin Schmid), 1917
Sennkopf (Martin Schmid)
Woodcut, 50 x 40 cm
Dube 308; Berlin, Staatliche Museen zu
Berlin – Preußischer Kulturbesitz,
Kupferstichkabinett

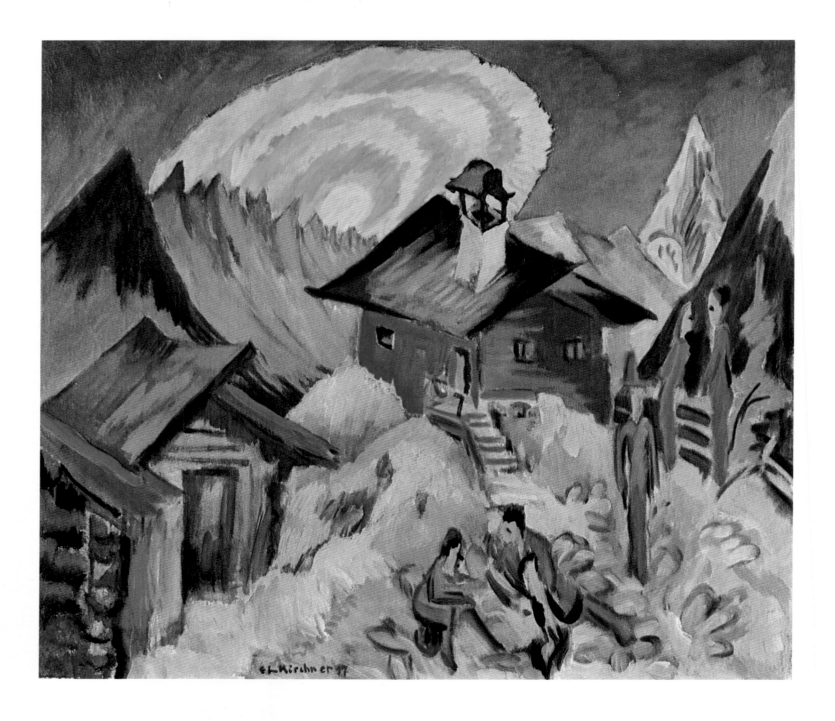

Rising Moon in the Stafelalp, 1917
Mondaufgang auf der Stafelalp
Oil on canvas, 80 x 90 cm
Gordon 561; private collection

One of the few oils Kirchner did during his first summer at Stafelalp. It was exhibited at the Zurich Kunsthaus in March 1918. His treatment of the peasant world in the mountains has the same vibrant sensitivity that Kirchner brought to bear on Berlin street scenes.

have admitted it to others. However, since his grasp of the connection between syphilis and intellectual work is distinctly confused, it is impossible to ascertain the truth of the case. If he is merely suffering from chronic veronal abuse, as some believe, there is still a gleam of hope. – There is no need to be advancing money. Two thousand marks turned up in his pocket, and beside that payments do arrive at intervals." The following day Graef was already writing in different tones to Karl Ernst Osthaus: "Today I learned that the doctors think he may have a growth in his head. They may be able to operate, and if he then recovers he would naturally need funds for his convalescence; and if he does not he will also be in need of money." Shortly, however, Kirchner's parents, not liking the thought that their son was in "a mental asylum", put a stop to this fourth sanatorium stay.

Eberhard Grisebach was similarly concerned about Kirchner. On 15 No-

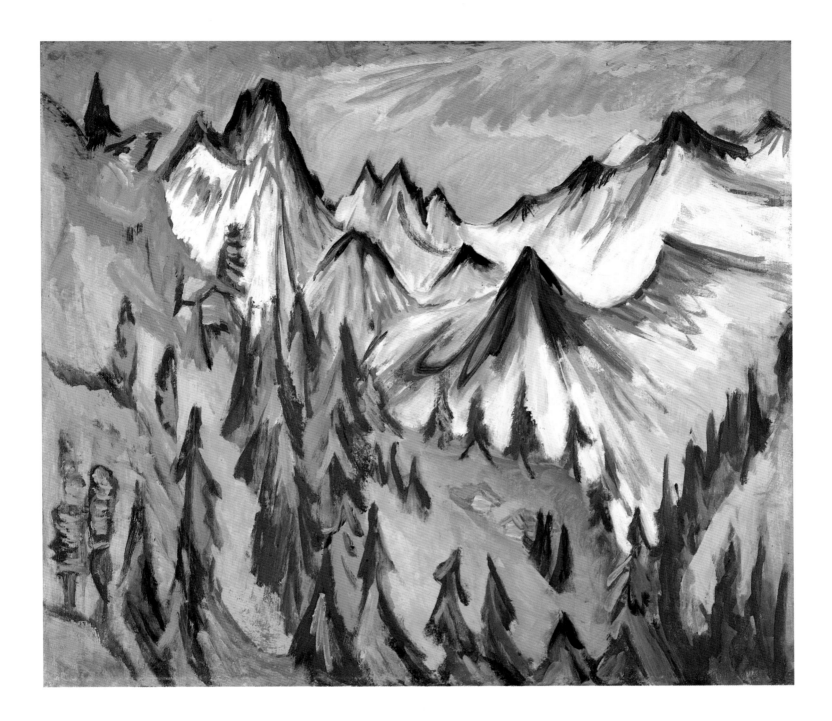

vember 1916, in one of his regular letters to his Davos in-laws, he wrote: "Kirchner has to be weaned from the veronal or it will be his destruction. But how?" His mother-in-law Helene Spengler responded immediately, replying on 21 November: "Kirchner, I presume, is not allowed to cross the border, otherwise I should be glad to have him here for six weeks after Christmas, to get him off the veronal if I can. He would sleep well here without it. If he is not an alcoholic, I should gladly try." To this, Grisebach replied on 25 November: "Your offer to have Kirchner is most generous-hearted – I am convinced that he cannot be rehabilitated into a society he has fled. For instance, he never sleeps in a bed, but simply curls up on a blanket. Graef's housekeeper has been driven to distraction by Kirchner. We cannot free him of his destiny – if he is to overcome it, as Munch did, it must be by his own endeavour. The neurologists in the Taunus accomplished nothing. His art grows the more, the more his body fails."

Mountain Peaks, 1918
Berggipfel
Oil on canvas, 79.5 x 90 cm
Gordon 512; private collection

In the winter of 1917, Kirchner left Davos and entered a sanatorium near Lake Constance and the Swiss-German border. This mountain landscape was probably painted there from drawings done at Stafelalp.

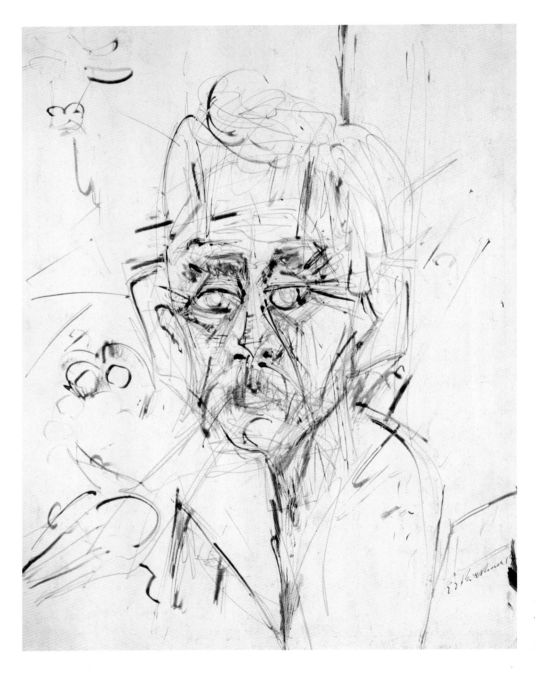

Old Farmer, 1917
Alter Bauer
Reed pen, ink and pencil, 50 x 38 cm
Private collection

And so it was that Eberhard Grisebach and Helene Spengler prepared the way for Ernst Ludwig Kirchner to leave Germany and travel to Davos. On 20 January 1917 Helene Spengler was writing: "Kirchner arrived here yesterday evening. Ady [one of her daughters] picked him up at the station." Two days later she reported: "This evening I spent an hour with Kirchner, who has a room with Frau Wijers next door. He is in bed and is not eating at present. All he takes is strong coffee and a little fruit that Ady and I took him. I made an appeal to him, but without success as yet. [...] I find him likeable, as far as I can judge, and feel very sorry for him. His soft, lost way of talking impresses me greatly. [...] With Papa [i.e. her husband, Dr. Luzius Spengler] he is still dissatisfied because he is not giving him any veronal, which they unwisely made him addicted to at the Taunus sanatorium." Kirchner remained at Davos for only a fortnight before he fled the rigours of winter there. On 1 February, Helene Spengler wrote: "Kirchner is returning. He had imagined Davos was in the south, amid palm trees! Honestly. [...] He is a wretched creature and one can only pity

him. And at times he is such an interesting talker that one feels sympathy twice over [...]."

A few months later, however, Kirchner resolved to return to Davos, and arrived there on 8 May. Dr. Luzius Spengler assumed charge of his treatment, and Helene Spengler looked after the artist's personal requirements. The choice of Davos was the product of chance; if Kirchner had had friends with good contacts elsewhere, he would have gone elsewhere. The name of Davos naturally prompts the association of tuberculosis, but Kirchner's move there had nothing to do with his lungs, despite the "lung complaint" already noted in 1915. What Spengler (himself a lung specialist) *did* diagnose was addiction not only to veronal, a barbiturate, but also to morphine, which Kirchner had plainly been given in one of the German sanatoriums. It was to take the Spenglers till 1921 to wean the artist from morphine. That aside, though, Kirchner had no serious organic complaints. It was purely his fear of fighting that had plunged him into psychotic states, which he had only made worse with alcohol, drugs and his refusal to eat.

A painting that marks the transition from Germany to Switzerland in Kirchner's life, as it were, is *Train near Davos* (p. 142), done in 1917. This was long thought to show the railway station at Königstein, but there is no sign of a station in the picture, only of landscape, trees, the train and a man. And a copy of the woodcut version of the scene bears a handwritten inscription assigning the correct title. It was in a train such as this, steam-drawn and with chestnut-coloured carriages, that Kirchner first arrived in Davos in January 1917, and that was the experience he was recording. The oil must either have been one of the first he did in Davos, or a painting done later remembering that first arrival. Interestingly, it is also the only work that might leave us in any doubt at all whether the subject is German or Swiss. In other works, Kirchner's rapid artistic adjustment to the new environment is palpable.

In Berlin, Kirchner had painted the whores and their clients in the streets. In Halle his subjects were soldiers. Now in Davos he turned his at-

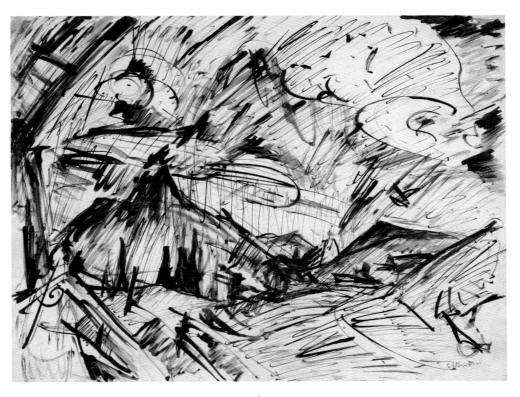

Mountains, 1917
Gebirge
Reed pen, brush and Indian ink, 38 x 50 cm
Munich, Staatliche Graphische Sammlung

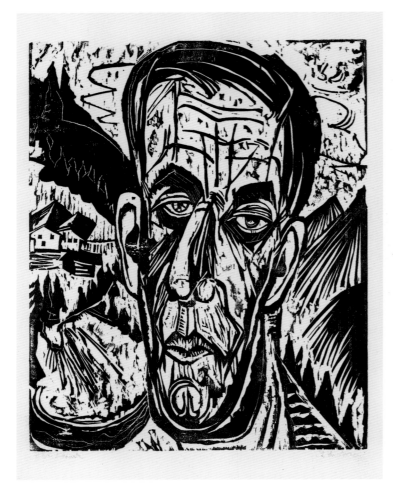
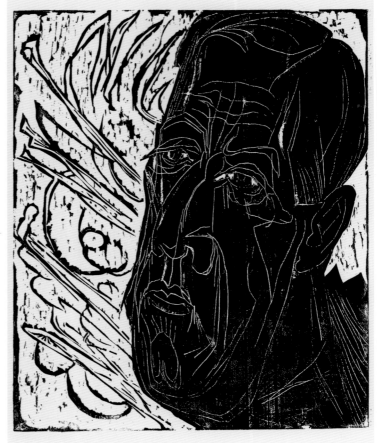
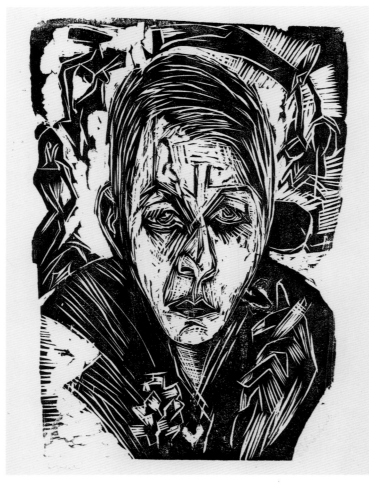
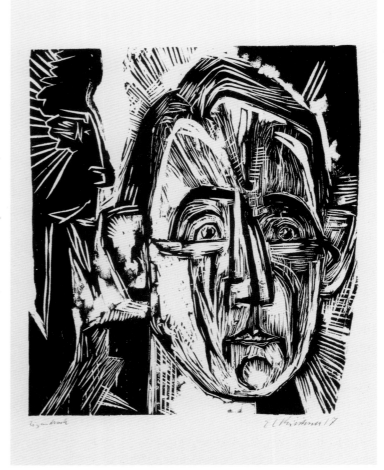

tention to his new surroundings: the mountain region, the people who lived there. The notion that he might continue painting scenes such as he set down in Berlin, here in the Swiss mountains, seems to have been far from his thoughts.

On his second journey to Davos, Kirchner was accompanied by a nurse, Sister Hedwig. Not long after his arrival he expressed the wish to live high up in the mountains in an Alpine cottage. A suitable accommodation was found at the Stafelalp above the village of Frauenkirch, a few kilometres south of Davos, and there Kirchner moved with Sister Hedwig in mid-June 1917. He spent two months there, amongst the local farmers tending their livestock on the mountain pastures. His health was poor and he was in pain, bedridden, and so little able to use his hands that Sister Hedwig had to write his letters for him. He did, however, manage to make eleven important woodcuts (such as *Stafelalp*, p. 143) and to paint a few oils.

One major fruit of his first stay at the Stafelalp cottage in 1917 was *Rising Moon in the Stafelalp* (p. 144). It shows a number of cottages and in the background the mountains beyond an intervening valley, with the peak of the Tinzenhorn, which was to be a regular feature of Kirchner's paintings henceforth, visible on the right. On the grass in front of the cottages are a group of people. It was a new motif in Kirchner's work, comparable neither with the Berlin street scenes nor with the *plein air* or studio nudes. In it, the new, dramatic setting which was to absorb Kirchner over the years ahead is combined with the theme of peasant life in the mountains, a life governed by the imperatives of the terrain and the seasonal cycle.

Though the subject may be new, however, Kirchner's technique retains the angular nervousness visible in the 1915 self-portraits drinking (p. 126) or as a soldier (p. 128). More clearly than before we can now see that a change of location, even if it shifted Kirchner's thematic concerns, had no impact at all on his style. The same can be observed in 1917 drawings such as *Old Farmer* (p. 146) or *Mountains* (p. 147) if we compare them with the last of the Berlin sheets, such as the 1915 *The Corner of Uhlandstraße, Berlin* (p. 138) or the 1916 *Café Interior* (p. 139). Kirchner transferred his neurasthenic sensibility entire, from Berlin to the Stafelalp, and it was through that lens that he viewed his new environment.

While Kirchner was in seclusion with Sister Hedwig near Davos (his partner Erna having remained in Berlin to look after the studio), his friends continued their endeavour to help him (though Graef was no longer of their number – he died in 1917). It happened that the great Belgian architect Henry van de Velde (1863–1957), who had headed the College of Arts and Crafts in Weimar for many years and so knew Kirchner's Jena friends well, was also spending the war years in Switzerland. He got in touch with the painter and visited him in Davos. "With my late friend Botho Graef in mind, the Jena art historian, I sought out Ernst Ludwig Kirchner in Davos," van de Velde later wrote in his memoirs, "a true victim of the war; the infernal fear of being sent into battle had tipped the balance of his mind. [...] In Davos I found him very thin, with a piercing and feverish gaze that appeared to see death approaching. He seemed appalled to have me at his bedside, and clasped his arms convulsively to his breast. He had his passport hidden inside his shirt like a talisman which, together with his Swiss residence permit, would protect him from imaginary enemies planning to hand him over to the German authorities. [...] In the course of several days I gradually won his confidence, at which point I asked my

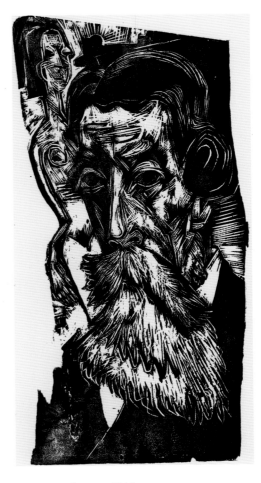

Ludwig Schames, 1918
Kopf Ludwig Schames
Woodcut, 56 x 25.5 cm
Dube 330; Frankfurt am Main, Städtische Galerie im Städelschen Kunstinstitut

PAGE 148:
Van de Helde, light, 1917
Kopf van de Velde, hell
Woodcut, 50 x 40.5 cm
Dube 311; Frankfurt am Main, Städtische Galerie im Städelschen Kunstinstitut

Van de Helde, dark, 1917
Kopf van de Velde, dunkel
Woodcut, 50 x 40 cm
Dube 312; Berlin, Staatliche Museen zu Berlin – Preußischer Kulturbesitz, Kupferstichkabinett

Girl with a Cigarette (Nele van de Velde), 1918
Junges Mädchen mit Zigarette (Nele van de Velde)
Woodcut, 43 x 29 cm
Dube 332; Frankfurt am Main, Städtische Galerie im Städelschen Kunstinstitut

Dr. Grisebach, 1917
Kopf Dr. Grisebach
Woodcut, 32 x 27.5 cm
Dube 310; Essen, Museum Folkwang

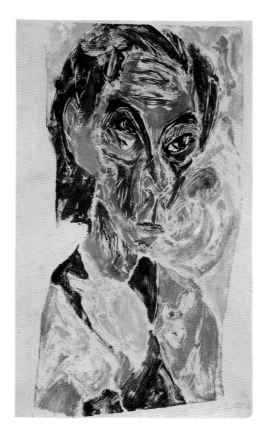

The Sick Man (Self-Portrait), 1917
Kopf des Kranken (Selbstbildnis)
Coloured woodcut, 57 x 27.5 cm
Dube 327; private collection

The colour version of this woodcut is a unique copy. As in monotype printing, Kirchner painted onto the wood plate and printed from it. All the other copies of this self-portrait were done in black. We know of only two woodcuts that Kirchner worked on in this way, the other being the 1914 *Women at Potsdamer Platz.*

friends the Binswangers in Kreuzlingen whether they would be prepared to take him in to their sanatorium. I was glad to read in their affirmative reply that they would be particularly interested in helping Kirchner, purely for humanitarian reasons."

Dr. Ludwig Binswanger, who ran the Bellevue Sanatorium in Kreuzlingen, also had contact with Kirchner's circles in Jena. He was from a family of psychiatrists, and a paternal uncle, Otto Ludwig Binswanger, headed the university psychiatric clinic in Jena. During the First World War, the Bellevue, which was located just inside Switzerland's German border, had become a sanctuary for artists and intellectuals who were unequal to the troubles which the war brought with it in Germany. When Kirchner arrived there in autumn 1917 after a summer at the Stafelalp cottage, he found his acquaintance Julius Schaxel, the Jena professor of biology, and the German writer Leonhard Frank (1882–1961) already in residence. His partner Erna was given permission to visit him, and various Swiss and German friends also went to see him.

The safety Switzerland afforded, and the well-regulated, healthy life he led in the sanatorium, led to an improvement in Kirchner's condition. He remained in Kreuzlingen until the summer of 1918. During that period he painted a number of oils, but above all he made a series of extraordinary woodcut portraits (pp. 148–149) that are now seen as among his most important works. On his departure he left a portfolio of seventeen of these woodcuts with the Binswangers as a gift to the Bellevue Sanatorium. Once again it comes as no small surprise to find that an artist who complained of crippling pains in his hands, and who required an attendant to write his letters for him, should have had so total a command of the tools and skills involved in making woodcuts.

In July 1918, accompanied this time by a male nurse from the Bellevue, Kirchner left Kreuzlingen and returned to the Stafelalp cottage. This had apparently come to seem the very heart and definition of the new world he had discovered in Davos. Then in the autumn he rented a house in Frauenkirch, intending to settle. If it had been chance that guided his steps to Davos originally, it was now his own decision to make it his home. And when the war came to an end in November 1918, the danger that he might still be expected to fight was over – and he was free to plan a future once again.

That October and November, Kirchner painted a self-portrait that exactly marks the threshold from the tense, fear-ridden years of the First World War to the new tranquillity of life in Davos: *Self-Portrait as a Sick Man* (p. 151). He had just moved into the new house, which was called "In den Lärchen" [The Larches]. He still felt ill, and his dependence on morphine continued to give him trouble – it took another three years till he was weaned from the addiction. Hence the self-portrait shows him bed ridden and anxious in the new home, wearing the blue tunic traditionally worn by the peasants of the region, a view of mountains visible through the window.

Stylistically the painting is closely related to the 1917 *Rising Moon in the Stafelalp* (p. 144), and for years the two works were thought to be companion pieces and the self-portrait to have been done at the Stafelalp cottage in 1917 too. But Eberhard W. Kornfeld, the critic, art dealer and collector, has shown that the carved peasant-style bed-frame was part of the furniture in the house Kirchner rented in 1918, and has proved when the picture was in fact painted. Thus the two works are a year apart, and are associated with

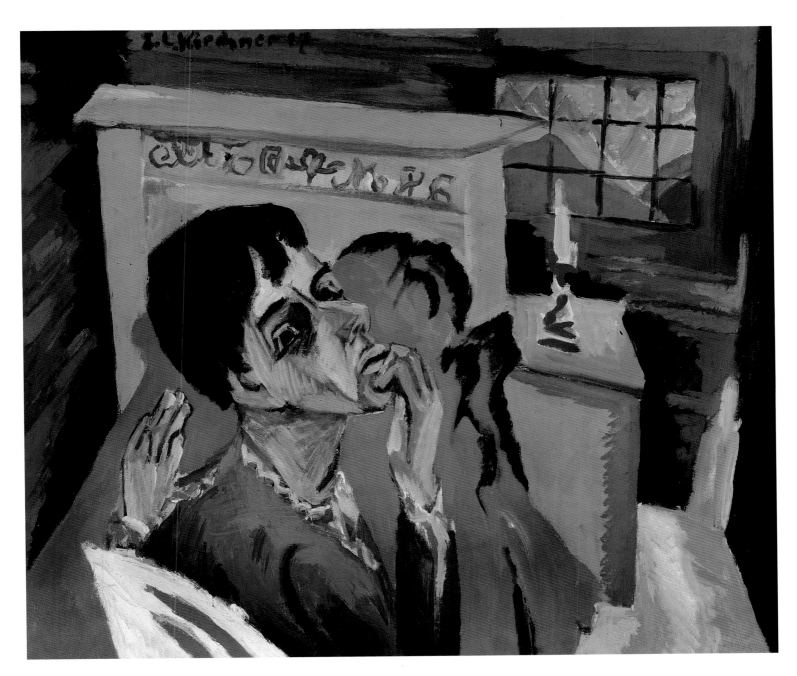

two different locations near Davos. The self-portrait has prompted a great deal of speculation and misunderstanding, but in reality, as so often, it is a realistic, faithful representation of a specific real situation – that of the artist in his new accommodation. And there, as previously in his Dresden and Berlin studios, he set about establishing an environment of his own, to suit his way of life and his art.

Self-Portrait as a Sick Man, 1917/1920
Selbstbildnis als Kranker
Oil on canvas, 57 x 66 cm
Gordon 496; Munich, Staatsgalerie für moderne Kunst

The first self-portrait Kirchner painted at "The Larches" in Frauenkirch near Davos, where he moved in late September 1918. The artist's subsequent dating (1917) was a mistake.

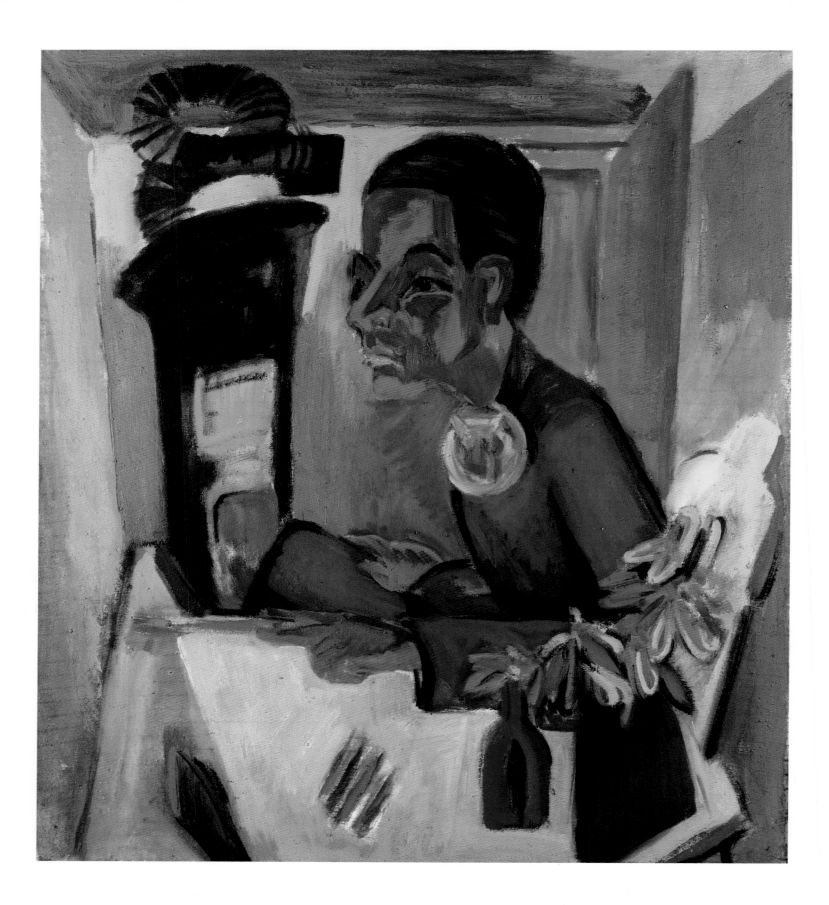

The Alpine Experience

The armistice of November 1918 certainly put an end to Kirchner's fear of being sent into battle and to his death, but it did not see him returning to Berlin. He had no intention of resuming his life where the war had interrupted it four years before. Chance and the intervention of friends had led him from basic training in Halle via sanatoriums in Königstein, Berlin and Kreuzlingen to an old farmhouse, "The Larches", in Frauenkirch near Davos – and there he plainly liked it best. "Dear Van de Velde writes today that I ought to return to modern life", Kirchner wrote to Helene Spengler on 3 July 1919. "For me, it is out of the question. Nor do I regret it. I have a vast scope in which to pursue my work here, so vast that I could scarcely cope if I had my health, let alone in my present state. The delights the world affords are the same everywhere, differing only in their outer forms. Here one learns how to see further and go deeper than in so-called 'modern' life, which is generally so very much more superficial despite its wealth of outer forms."

Two central concerns dominated the early years of Kirchner's new life in Switzerland: physical and mental recuperation (and, chiefly, the breaking of the morphine habit), and, more happily, the "experience of the mountains", as he himself referred to it later – his artistic engagement with his new home. The breathtaking landscape, the mountain farmers whose daily and seasonal rhythm he now shared, and his own division of the year between Frauenkirch and the summer weeks up at the Stafelalp, all cried out for expression.

Recuperation implied restoring normality to his life. Moving into "The Larches" put Kirchner back in a household of his own, and gradually it became possible for Erna (to whom he now frequently referred as Frau Kirchner) to join him in Switzerland, at first for periods of a few months of the year and later on a permanent basis. He also transferred the contents of his Berlin studio to Switzerland – his paintings, drawings and graphics, his sculptures, his carpets, and the press on which he printed his woodcuts and etchings himself. It also became increasingly possible for friends, collectors, dealers and publishers to visit him in his new home.

Dr. Luzius Spengler (who died in 1923) remained Kirchner's doctor for the first few years, and Helene Spengler, acting for her husband, monitored the reduction of Kirchner's morphine intake. He was withdrawn gradually and gave the drug up entirely in 1921 – a wearing process which exacted its price. Quotation from the letters between Helene Spengler, Eberhard Grisebach and his wife Lotte, and Kirchner will afford a glimpse of this process. "We all felt that he was in an exceptionally good frame of mind. My own belief is that he had boosted his spirits with a good dose of morphine", wrote Helene Spengler on 22 October 1918. Kirchner wrote to the Speng-

Dance between the Women, 1919
Tanz zwischen den Frauen
Etching, 15.3 x 8.7 cm
Dube 289; Saarbrücken, Saarland-Museum in der Stiftung Saarländischer Kulturbesitz

PAGE 152:
The Painter; Self-Portrait, 1919–1920
Der Maler; Selbstporträt
Oil on canvas, 91 x 80.5 cm
Gordon 576; Karlsruhe, Staatliche Kunsthalle

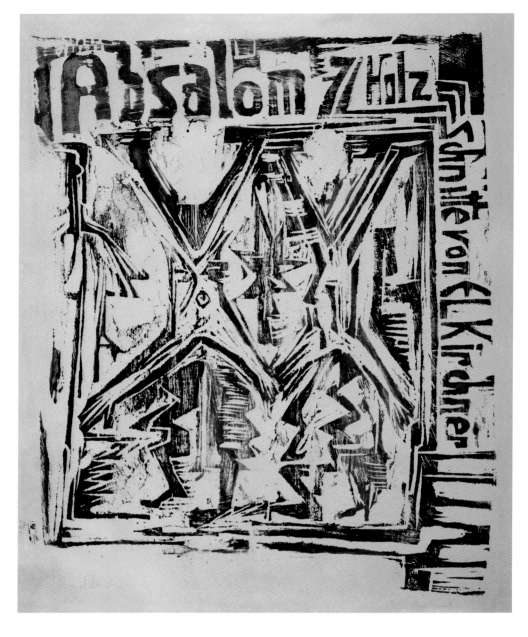

LEFT AND PAGE 155:
Absalom, 1918
Series of woodcuts (8 sheets), c. 36 x 40cm
Dube 358–366; Kassel, Staatliche Museen
Kassel

On 25 November 1919, Kirchner wrote his own account of this series to Gustav Schiefler (the biblical tale is in 2 Samuel, 13–18):
"The story of Absalom is that of a son of good parents. Absalom, the father's favourite son, wantonly foolish.
[Sheet 1] The father initiates the son into life.
[Sheet 2] Following a quarrel, Absalom is turned away by his father. The father sits beside his wife, who is urging him on. Absalom paces the carpet in a rage. In this rage, the decorations of the carpet and lamp are faces telling him to go.
[Sheet 4] Absalom violates the women. Absalom is kneeling before the woman in front, who is kissing him, while his father sits in the room writing by lamplight. Often a scholar attracts a number of women, who will then have affairs with his son. Absalom is sullying his father's venerable house.
[Sheet 5] Absalom passes judgement in his father's stead. In small towns, the wayward son often makes contact with bored industrialists or merchants, and so it happens that one Sunday, flirting and making clever conversation with the owner class, he drives past his parents taking their customary Sunday afternoon walk with their other children. Both parties feel uneasy and look away. I cannot put this very clearly, but the parallel exists."
It is clear that Kirchner's interpretation of the Old Testament story was strongly coloured by autobiographical concerns relating to his parents.

lers on 28 November that year: "I should dearly love to drop the injections, and would be the first to do so, simply to be rid of the addiction, but with these pains and pressure I think morphine does less damage to my nerves than putting up with the torment would." Requesting a new box of ampoules from Helene Spengler on 6 February 1919, Kirchner added: "My supply will be exhausted on Sunday. (I have had to take two extra once again, and I broke one, to my great annoyance. One goes on sinning.)" Writing to Grisebach on 28 April 1919, Helene Spengler reported: "At present Kirchner and I are disagreeing again over the morphine dosage. Yesterday Papa [Dr. Luzius Spengler] visited him with me, and he was astounded to see how the poor chap has changed; he was once a sick man, and now he looks very well." On 30 April, Kirchner wrote to Helene Spengler: "I shall certainly abide by the prescribed amounts, even if the initial period on the reduced dosage proves difficult." On 21 October, on the other hand, Helene Spengler noted in a letter to Eberhard Grisebach that "his eyes were gleaming, he must have taken one ampoule more than he was supposed to." Grisebach wrote to his wife Lotte on 11 April 1920: "Kirchner is amazingly well.

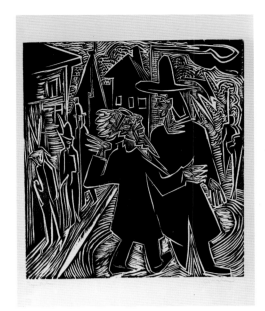

David Cautions His Son Absalom

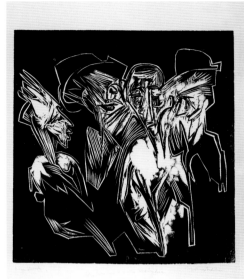

Absalom Violating His Father's Concubines

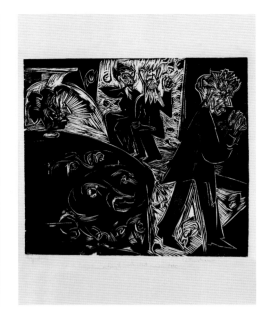

Absalom with His Counsellors

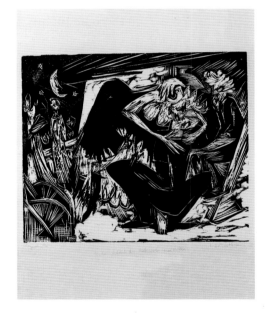

Absalom Breaks with His Father

Absalom Passing Judgement in His Father's Stead

The Death of Absalom

David Weeping for Absalom

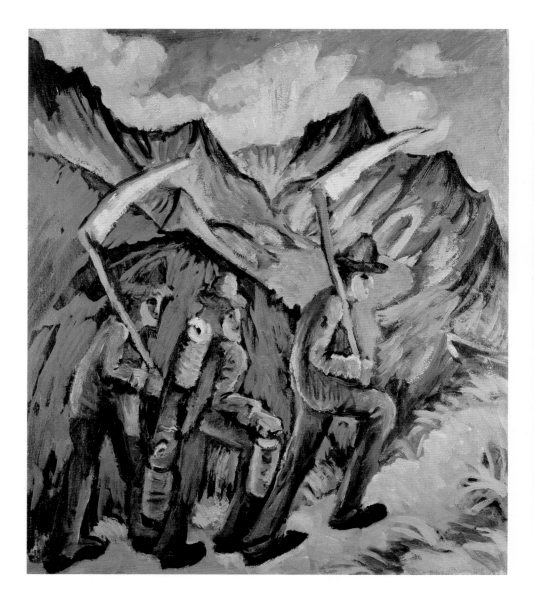
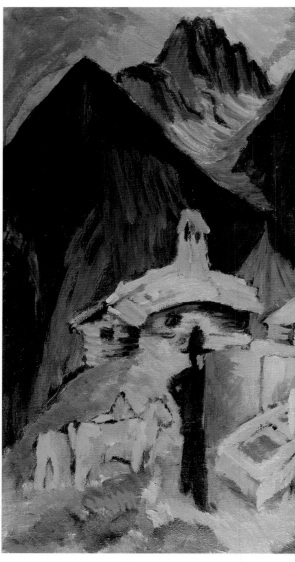

Life in the Alps, Triptych, 1918
Alpleben, Triptychon
Oil on canvas, 70 x 80/60 cm
Gordon 527; private collection

Kirchner spent his second summer at Stafelalp in 1918, spending several weeks among the mountain farmers. This triptych shows various everyday scenes – watering the animals, the men going up to cut grass, the woman with her hay rake and straw hat for protection against the summer sun. In choosing a form rich in tradition, Kirchner was asserting an importance and dignity beyond the merely everyday for his subject.

It is only his pursuit of morphine that gives Mama cause for concern, since she is trying to keep him on a smaller dosage." On 19 April, Helene Spengler wrote to her daughter Lotte Grisebach: "Kirchner and I are at loggerheads over the number of ampoules and the torment involved." To Eberhard Grisebach she reported on 3 May that year that "Kirchner came by unexpectedly, unfortunately in a bad mood and demanding morphine. I refused it, and had to keep watch on him." On 10 May she wrote to the same correspondent that she was now having Kirchner fetch his own ampoules from the chemist's every other day, adding, "I want him to value me as a human being and not as a supply of ampoules", and on 15 May she reported that she and Kirchner were again getting on, following a blazing row over ampoules. At long last, on 20 March 1921, Helene Spengler was able to write (to Lotte Grisebach): "If anyone should ask after Kirchner, you will be able to answer truthfully that life in a peaceful farming community has done him a world of good, that he is hard at work, and, all being well, will not be thinking of dying for a long time. He will have to live in quiet surroundings; his state of health would not be equal to the wear and tear of life in a city like Berlin. He himself has reduced his morphine dosage, which was in any case small, to a minimum, and in three or four weeks he will be free of it, thanks to his wonderful energy [...]."

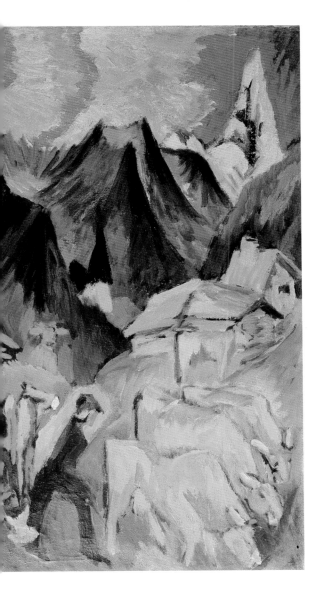
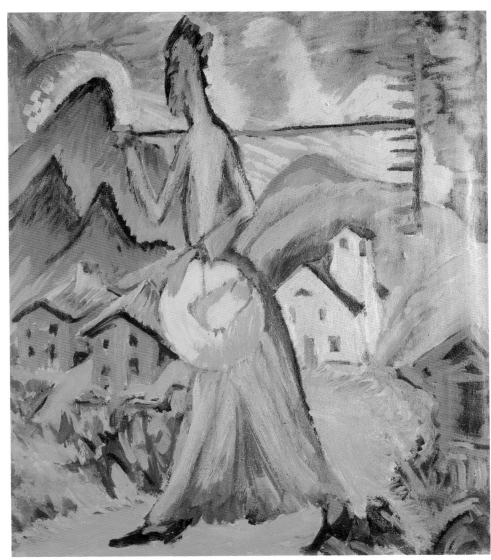

The Painter; Self-Portrait (p. 152), painted in 1919–1920, conveys a first
impression of the new calm and composure that were Kirchner's. His fea-
tures relaxed, the artist is sitting in home surroundings, with the tools of his
trade, beside him on the table a vase of Alpine roses. It is a warm painting –
even the stove suggests warmth, though the picture was painted in August
and September 1919 at Stafelalp, at a time when its heat would presumably
not have been needed. At this point, the new tranquillity was only an occa-
sional boon, and one that Kirchner achieved with the aid of injections. His
entries in the Davos journal, which he began in July 1919, tell a vivid tale of
the importance of those injections. "Tremendous pain in my every limb."
(7 July 1919.) "Who will stop this terrible illness that keeps returning and
wrecking my well-being. All afternoon, and the terrible night. Who will stop
it. I would give anything", he wrote on 10 July, and the next day: "I wait
with longing for Erna with the medicine." On 13 July we read again, "In a
very bad way", and on 9 August: "The injections were done at lunchtime,
and with their help I was able to do some drawings in the evening." Later
that month, on 27 August, Kirchner noted: "I am waiting most urgently for
Frau Doktor and the medicine. My life is one long wait and grief. There is
no peace in it any more." And on 11 September 1919: "I fight the agony in
vain. All my limbs hurt. Don't know what to do. No mental tricks or imper-

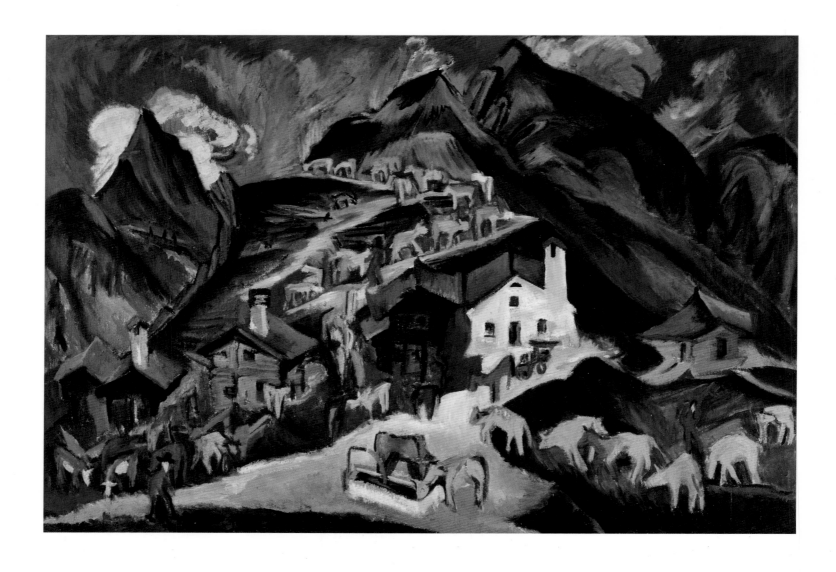

Ascending the Alps, 1919
Alpauftrieb
Oil on canvas, 139 x 199 cm
Gordon 539; St. Gallen, Kunstmuseum

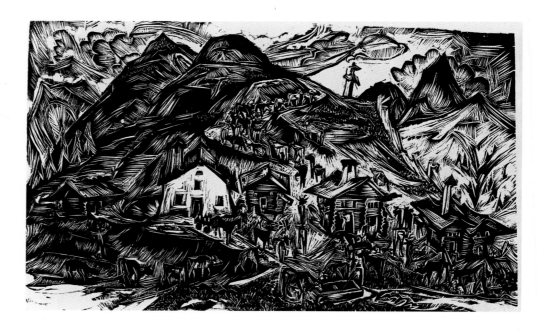

Stafelalp, 1919
Stafelalp, Gesamtansicht
Woodcut, 33.5 x 56.5 cm
Dube 379; Berlin, Staatliche Museen zu
Berlin – Preußischer Kulturbesitz,
Kupferstichkabinett

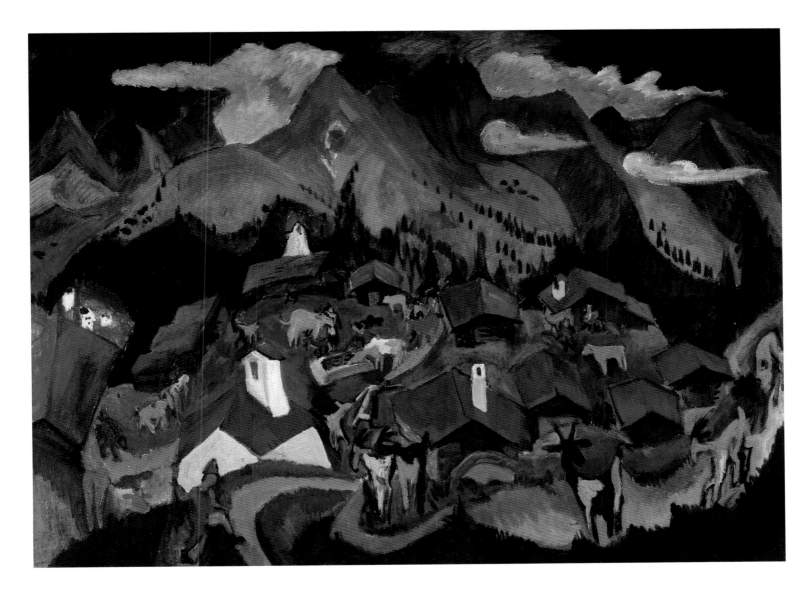

atives help. The body is simply failing." It is Kirchner the convalescent at this period in his life whom we see in another self-portrait, painted in the latter half of 1919: *Self-Portrait with a Cat* (p.171). It shows Kirchner and his cat in his new home, "The Larches".

In the summer of 1920, Kirchner began work on *Our House. House in Meadow* (p.174), which shows "The Larches", now the home he shared with Erna, from the outside. The title emphasizes his feeling that it was now home to them both as a couple. The style of the painting betrays new changes, to which we shall be returning presently.

Kirchner's first Swiss works were concerned foremost with himself and his state of health. Often they were self-portraits (pp.150, 151, 152 and 171) or portraits of the friends who had his well-being at heart: Eberhard Grisebach (1917; p.148, bottom right), art dealer Ludwig Schames (1918; p.149), Henry van de Velde (1917; p.148, top) and van de Velde's daughter Nele (1918; p.148, bottom left). In 1918 he also tackled his second literary cycle, following the Peter Schlemihl woodcuts of 1915: the Old Testament story of Absalom, the son of King David, who dies at odds with his father (p.155). For Kirchner, the subject invited autobiographical, existential responses: "The story of Absalom", he wrote to Gustav Schiefler, "is that of a son of good parents. Absalom, the father's favourite son, wantonly foolish." In several of the pictures he gave Absalom his own features.

Animals Returning Home, 1919
Rückkehr der Tiere
Oil on canvas, 120 x 167 cm
Gordon 577; Berne/Davos, Sammlung EWK

As in a baroque cycle, the artist presents the driving up of the animals in the morning, and their return in the evening, as parts of a natural and logical life cycle.

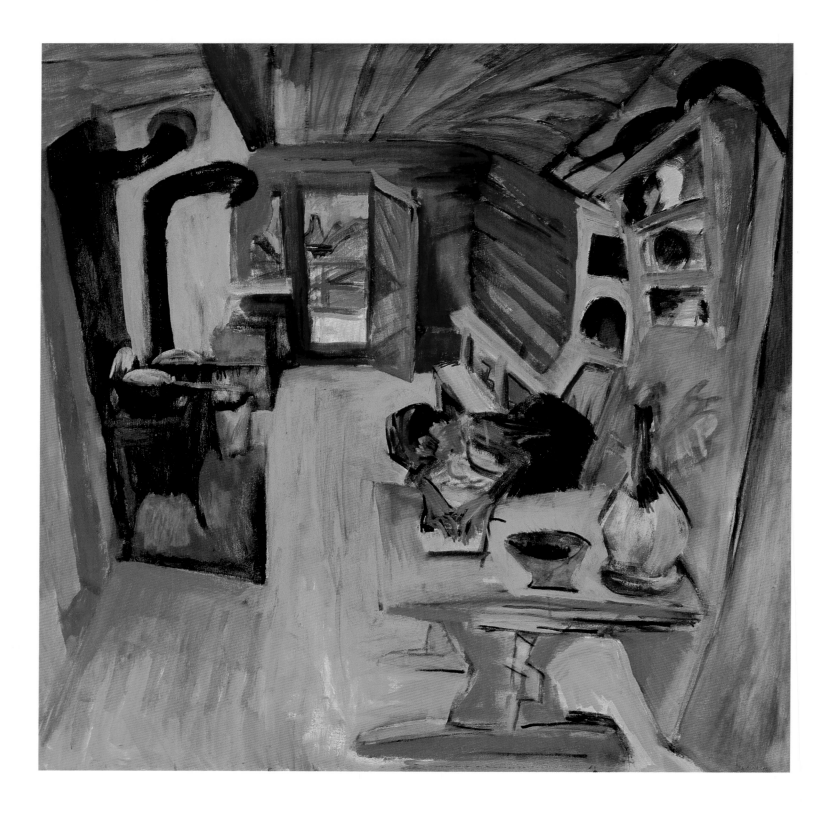

Alpine Kitchen, 1918
Alpküche
Oil on canvas, 120 x 120 cm
Gordon 518; Madrid, Fundación Collección
Thyssen-Bornemisza

This picture shows the interior of the cottage
in which Kirchner spent the summer of 1918
at Stafelalp.

Kirchner turned next to the setting he was now living in. We have already
looked at a picture painted in the first Stafelalp summer, 1917 – *Rising
Moon in the Stafelalp* (p. 144) – which shows the landscape, cottages, and
the people who live there. The farmers' lives rapidly became a principal sub-
ject in Kirchner's art, acquiring an importance comparable to that of the
nudes and street scenes of the Dresden and Berlin years. Kirchner saw the
life of the farmers and peasants as a harmonious life that had evolved out of
the specific conditions of the mountains and the seasons. His drawings,
paintings, lithographs, etchings and woodcuts did not record the mountain
idylls a tourist might happen upon so much as life as it was genuinely lived

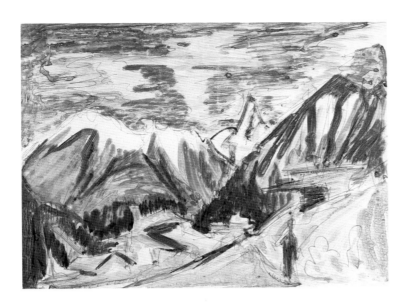

Stafelalp in the Autumn, 1919
Stafelalp im Herbst
Watercolour over pencil on paper, 38 x 50 cm
Lübeck, Museum für Kunst und Kulturgeschichte

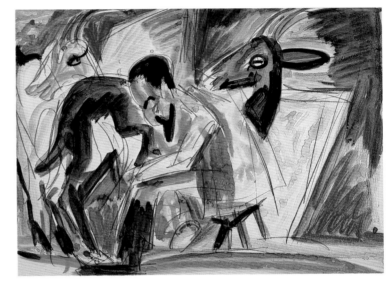

**Farmer Milking
(Goat Farmer Martin Schmid)**, 1918
*Melkender Bauer
(Ziegenmelker Martin Schmid)*
Watercolour, 39 x 51 cm
Private collection

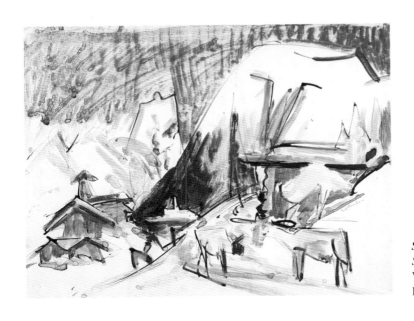

Snow at Stafelalp, 1918
Schnee auf der Stafelalp
Watercolour, pen and Indian ink, and pencil, 38 x 50 cm
Essen, Museum Folkwang

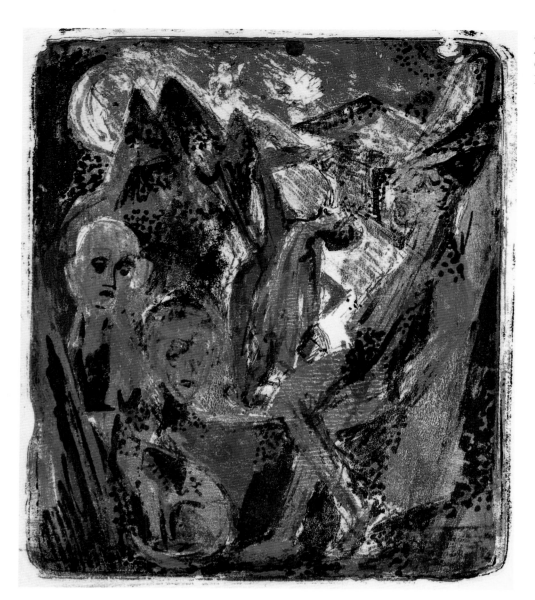

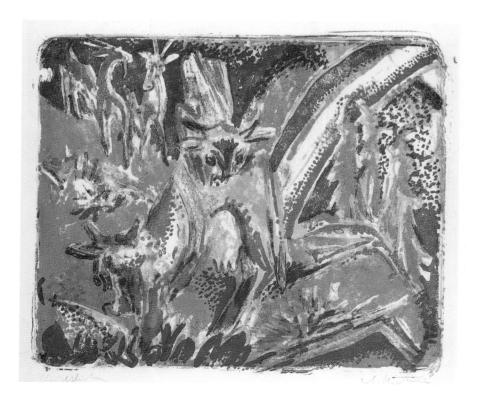

Cows in a Rainbow, 1919
Kühe im Regenbogen
Coloured lithograph, 28 x 33 cm
Dube 379; Frankfurt am Main, Städtische Galerie im
Städelschen Kunstinstitut

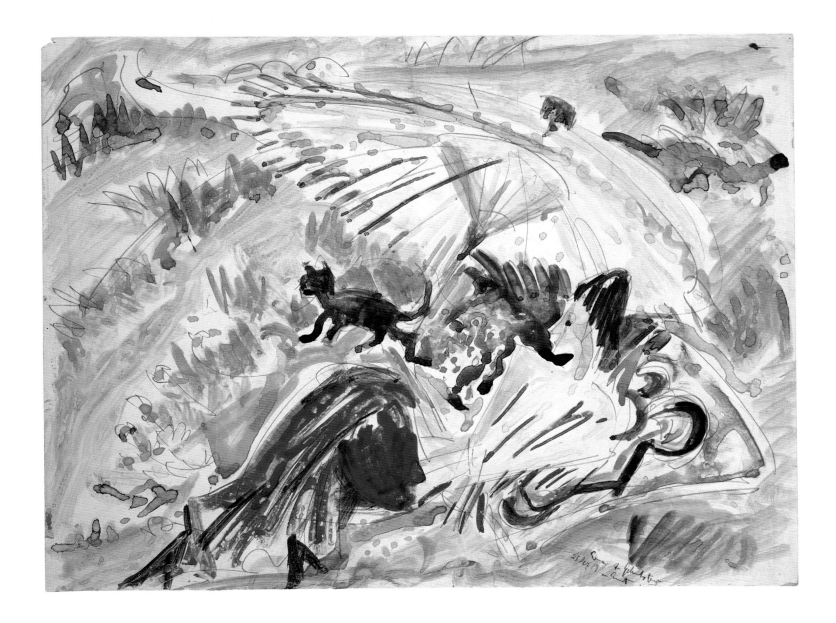

in the high-lying village communities: the farmers and their animals, season
following season, and age following youth, in a natural and organic form of
society.

In summer 1918 he painted a triptych on this subject: *Life in the Alps,
Triptych* (pp. 156–157). His use of this venerable form, which originated in
mediaeval altarpieces, indicates just how significant the subject was to him.
The centre section shows Stafelalp, high in the mountains, and in the midst
of the composition the well standpipe, the heart of life for humankind and
livestock in that tiny community. This centre picture is a landscape with
figures. The two wings, by contrast, strongly emphasize the figures. The left
composition shows three men tramping uphill with scythes and cans contain-
ing their rations for the day, while that on the right shows a woman with a
hay rake and straw hat. Summer in the Alpine pasture districts is devoted to
two principal agricultural duties: tending the livestock (driving the cattle up
to the pastures in the morning and back down in the evening, watering them,
and milking), and hay-making (the cutting, drying and turning of the grass,
and bringing the hay in to shelter). These activities are seen as a harmonious
way of life in Kirchner's triptych.

Emil Nolde also returned to the traditional form of the winged altarpiece

In the Sunshine, 1919
Im Sonnenbad
Watercolour and pencil, 38.5 x 50 cm
Hamburg, Hamburger Kunsthalle

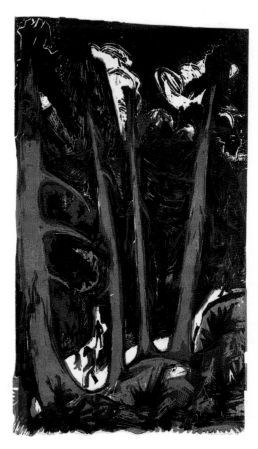

Pines, 1919
Wettertannen
Coloured woodcut, 62 x 34.5 cm
Dube 392; Basle, Öffentliche Kunstsammlung
Basel, Kupferstichkabinett

when he painted religious themes, as in *The Life of Christ* (1911–1912; Stiftung Ada und Emil Nolde, Seebüll) or *Blessed Mary of Egypt* (1912; Kunsthalle, Hamburg). Max Beckmann too, to whom we shall be turning in another connection, used the triptych in the 1930s and 40s for some of his most densely symbolic allegories of life – *Departure*, *Temptation*, *Acrobats*, *Perseus*, *Actors*, *Carnival*, *Blind Man's Buff*, *The Beginning*, *Argonauts* and *The Ballet Rehearsal*. In using the same form, Kirchner was stressing his sense that the everyday life of the farmers around him was of a higher order. Individually, the pictures present commonplace scenes of working life – but the sum, in the weighty form of the triptych, is altogether greater than the parts.

In 1919 Kirchner painted two more majestic scenes of Alpine farming life. Though they are not identical in format, and though they were indeed sold off separately to different collectors, they can be seen as companion pieces insofar as they register, like certain Baroque works, the stages of the day: *Ascending the Alps* (p. 158) and *Animals Returning Home* (p. 159). In the former we see the animals being driven up to the higher pastures in the early morning, and in the latter their return to the byres and sheds in the evening. Again the location is precisely defined: the Stafelalp cottages, the square and the white stone dairy building, the trough and the well standpipe.

In the same year, Kirchner also made a woodcut, *Stafelalp* (p. 158), after *Ascending the Alps*. And we might subsume under the general heading of peasant life all the scenes of work and the daily round that Kirchner did in various media (pp. 160–162). The Stafelalp appears in these pictures as more than a mere location; it is a social organism. Five years later, in 1923–24, Kirchner was to crown the ongoing series with a major work measuring a full four metres across, *Sunday in the Alps; Scene at the Well* (pp. 180–181).

In 1919 especially, Kirchner also painted pure landscapes alongside his scenes of farming life. Indeed, in a state of high agitation and acute sensibility, Kirchner created some of his most arresting landscapes, in oil and as woodcuts, the latter also to be numbered among the finest works in that medium. "This morning before sunrise," Kirchner wrote to Nele van de Velde, describing the night of 20 January 1919, "I witnessed a magnificent setting of the moon. The mountains were completely blue, the sky a reddish violet with pink clouds, and the moon a yellow sickle. It was simply wonderful, though terribly cold as well. Oh, if only one could paint that. Alas, one can never convey it with these frightful paints." Nele van de Velde was herself a painter, and her relation to Kirchner at the time was much that of a pupil. To Helene Spengler in nearby Davos Kirchner also described what he saw in that insomniac night: "This morning the moon set wonderfully – the yellow moon on little pink clouds and the mountains a pure deep blue, utterly majestic. I should dearly have loved to paint it." In fact he did paint it, in the well-known *Winter Moon Landscape* (p. 167), and he also recorded the experience in the still better known coloured woodcut *Moonlit Night in Winter* (p. 166), both done in 1919. In the painting and woodcut alike, the motif is presented exactly as Kirchner described it in his letters, "frightful paints" notwithstanding. In the coloured woodcut, Kirchner tried out a number of differently adjusted printings in order to establish different tonalities and moods, the variations being caused by changes in the sequence of colour application. Ten copies of this woodcut are currently known to exist, and not

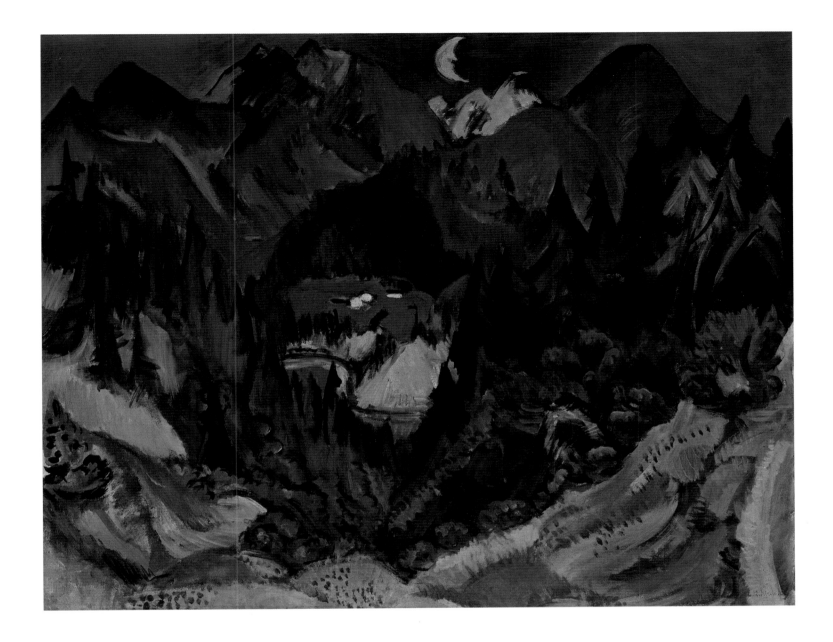

one looks like any of the others. They were the first colour prints Kirchner made on his own press after it had been delivered to him from Berlin in January 1919.

In the summer of 1919, at the same time as he was painting the scenes of Alpine toil (pp. 158–159), Kirchner began work on two extraordinarily dramatic mountain pictures. One was *Tinzenhorn; Mountain Gorge near Monstein* (p. 168). The Tinzenhorn is a striking peak south of Davos, which repeatedly features in Kirchner's mountain landscapes. The painting shows part of the village of Monstein on the left, and the deep valley that leads to the Tinzenhorn. The second was *Stafelalp by Moonlight* (p. 169). On 10 August 1919, Kirchner noted in his journal: "I dreamt of a picture of the Tinzenhorn in the red glow of evening, but with the mountain itself blue against a blue background, very simple. A lot of drawings for this." And again: "The three mountainside cottages by moonlight, 120 x 150, very delicate, olive green, pink, blue and black, shadows in violet-tinged brown and ochre." And, on 14 August he noted: "Tackled the Tinzenhorn in 120 x 120 format. A successful composition, the colours and shapes all of a piece."

Junkerboden, 1919
Oil on canvas, 95 x 120 cm
Gordon 569; Berne/Davos, Sammlung EWK

165

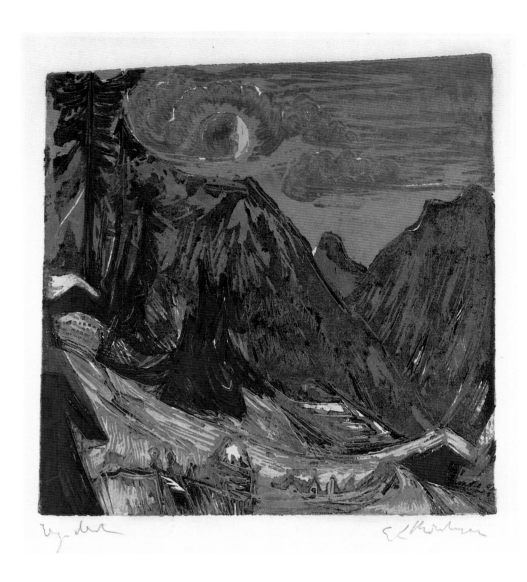

Related to *Moonlit Night in Winter* (p. 166) was *Pines* (1919; p. 164),
Kirchner's second superlative coloured woodcut of the early Davos period.
Kirchner was never out to be seen as a landscape artist, and in his Dresden
and Fehmarn work alike his pure landscape output was always eclipsed by
figure compositions, or landscapes with figures. In the early Davos period,
however, his mountain landscapes achieved an expressive power that gives
them a special status. As in the Romantic landscapes of a Caspar David
Friedrich, the sublimity of the natural world has fused intimately with the
personal wonder of the artist.

Kirchner's critics have not found it easy to accept that an artist who re-
sponded so arrestingly to the almost morbid thrills of metropolitan life in the
pre–1914 era should subsequently have entered with such wholehearted
sensitivity into the life and world of the mountains and the people who
dwelt there. It seems inconsistent. The result has been a split in the reception
of Kirchner's art. Most German critics tend to concentrate on the periods be-
fore the First World War – the Brücke years in Dresden and the street scenes
he painted in Berlin – and incline to treat his Swiss work as proof that he
had turned his back on the world in a mood of resignation. This interpreta-
tion has been consolidated by the passage of time, as those writing on Kirch-
ner were increasingly historians rather than friends or associates. In Switzer-
land, by contrast, Kirchner has been welcomed into the great tradition of
Alpine art. A line has been traced from the 18th century Alpine master

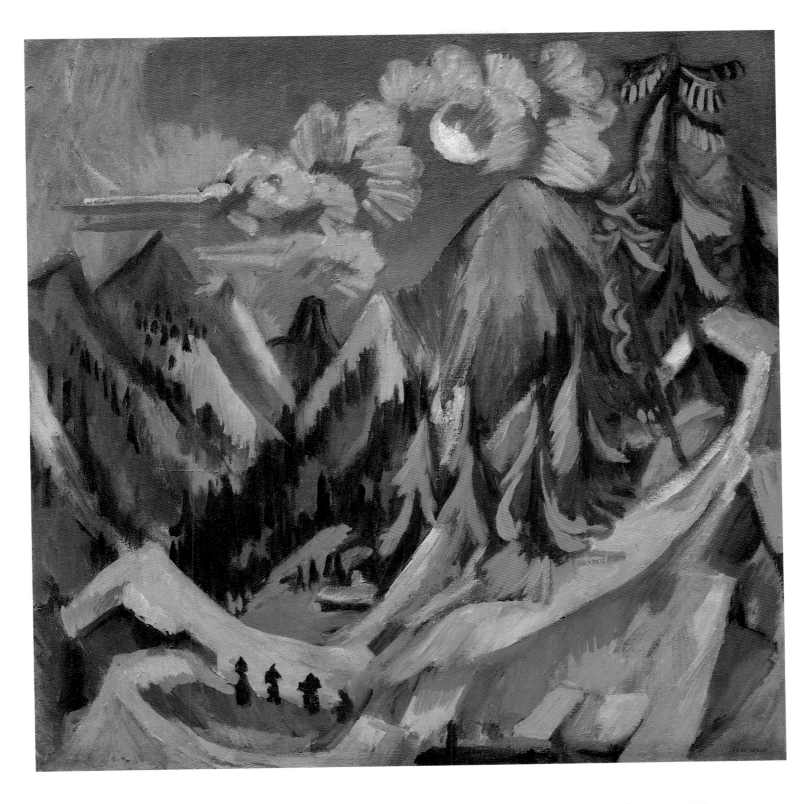

Caspar Wolf, via Joseph Anton Koch (1768–1839) and the Romantics, and on through Giovanni Segantini (1858–1899) and Ferdinand Hodler (1853–1918) and so to Kirchner. Sometimes Alberto Giacometti (1901–1966) is now included in this line. On either side of this reception, aspects of the artist's work are emphasized that seem hardly reconcilable with what is emphasized on the other.

But we do not do Kirchner justice unless we realise that the different phases and apparent irreconcilables in his evolution as an artist, far from requiring to be separated, in fact express one and the same artistic stance. What was Kirchner to do? Having endured his worst physical and mental

Winter Moon Landscape, 1919
Wintermondlandschaft
Oil on canvas, 120 x 121 cm
Gordon 558; Detroit (MI), Art Institute,
Gift from Curt Valentin in memory of the
artist on the occasion of the sixtieth birthday
of Dr. William R. Valentiner

hour, and having decided to settle near Davos, was he to go on painting Berlin street scenes? Art critics who treat those scenes as iconic, literary artefacts seem to think that precisely that might have been possible. After all, Lyonel Feininger continued to paint motifs drawn from the landscape of Thuringia and Mecklenburg even in Manhattan; they were a part of his repertoire, and had developed an autonomous existence within his art. Max Beckmann's visual universe absorbed the many and various existential and political experiences of his life, and its constituents remained with him throughout, adding up steadily to a poetic idiom which transformed the facts of life (personal crises, emigration, war, old age) into a quasi-literary set of forms. But it was this very constancy of idiomatic repertoire that Ernst Ludwig Kirchner was evidently incapable of, however much he may at times have wished to be. His art sprang directly from his own experience, which implied that his thematic range had to adapt to changed circumstances. He was acutely aware of the traditional hierarchies governing the genres and subjects of paintings, but nonetheless his subjects had to remain as given. What mattered to him in life must matter in art too – thus his implied view. The livestock and herdsfolk in the mountains near Davos were no less important as subjects than demi-mondaines or poets in the streets or salons of Berlin.

As his health stabilized and he gradually came off morphine, Kirchner's mental state also became calmer. He now began to give more thought to his own standing as an artist and in history. Back in Germany, the democratic Weimar Republic was trying to change its cultural profile, and Kirchner was

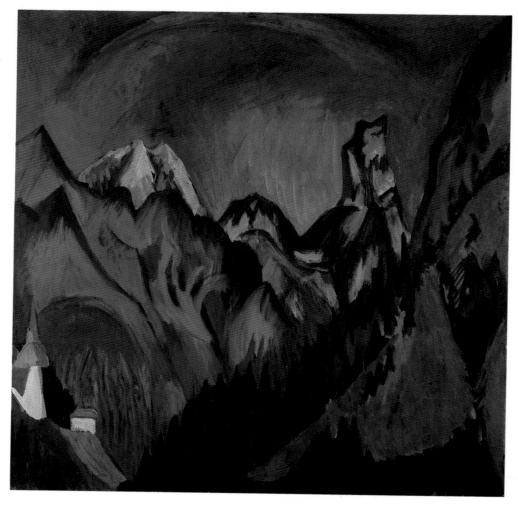

Tinzenhorn; Mountain Gorge near Monstein, 1919–1920
Tinzenhorn. Zügenschlucht bei Monstein
Oil on canvas, 119 x 119cm
Gordon 578; Davos, Kirchner Museum

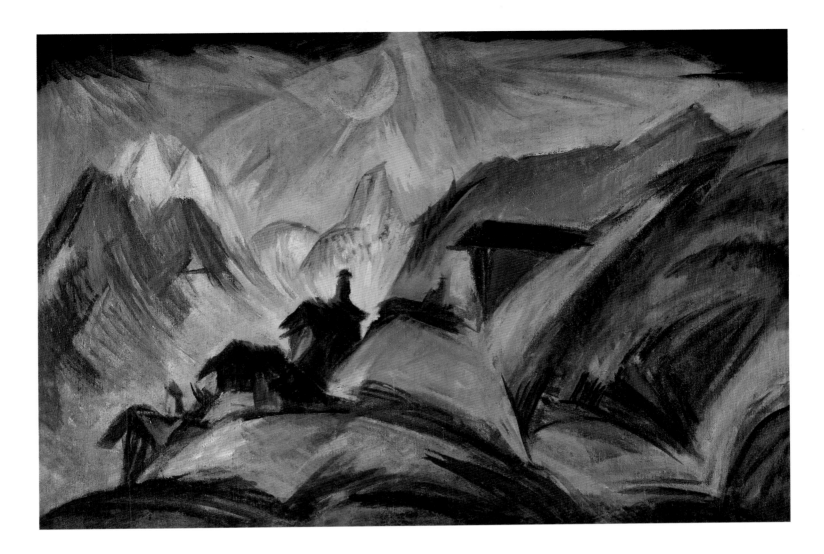

Stafelalp by Moonlight, 1919
Stafelalp bei Mondschein
Oil on canvas, 138 x 200 cm
Gordon 583; Dortmund, Museum am Ostwall

naturally one of the contemporary artists who were seen as playing a key role. Ludwig Justi, then director of the National Gallery in Berlin, established a section devoted to contemporary art, and for the first time in Germany art transferred direct from the studio to a major public collection. Kirchner and his Brücke associates were seen as important figures in modern German art.

In 1920 Edwin Redslob, a progressive art historian who had already done much on behalf of Kirchner and Die Brücke in his capacity as director of the Erfurt Museum, was appointed national director of the arts ("Reichskunstwart"), and in that position he tried to assign the new German art a key role in the image that newly democratic Germany was projecting within and without. Gustav Schiefler, one of the earliest collectors and patrons of Kirchner, began work on his catalogue of the print graphics in 1917, the two volumes finally appearing in 1926 and 1931. Publishers and periodicals gave their attention to contemporary German art, and Kirchner was invariably one of those they contacted. To all, he was one of the central figures in the new German art. And, of course, that was precisely how Kirchner saw himself.

Nonetheless, his suspicious nature, which had been aggravated by the mental troubles he had passed through, made it impossible for him to handle the demand he was now in with any lightness of touch. Every letter or visit, he took to be the product of intrigue. Many of those who expressed an interest were daunted by his excessive wariness. "Kirchner makes it inexpress-

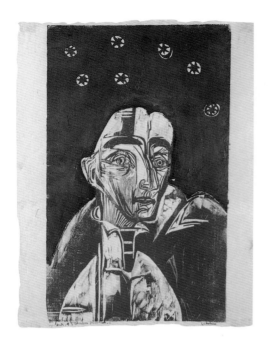

Woman at Night, 1919
Frau in der Nacht, 1919
Coloured woodcut, 58.8 x 34.5 cm
Dube 405; private collection

The woman is Marie-Luise Binswanger (1871–1941), second wife of the psychiatrist Dr. Robert Binswanger (1850–1910) and step-mother of Dr. Ludwig Binswanger (1881–1966), whose patient Kirchner was at the Bellevue Sanatorium in Kreuzlingen in 1917 and 1918. In October 1919 she visited Kirchner at Frauenkirch. The woodcut shows a slender, indeed elongated figure with mountains in the background. The dark night sky mantles her in a way that produces a strangely unreal feeling.

PAGE 171:
Self-Portrait with a Cat, 1919–1920
Selbstporträt mit Katze
Oil on canvas, 120 x 85 cm
Gordon 621; Cambridge (MA), Courtesy of The Busch-Reisinger Harvard University Art Museums, Museum's Purchase

Kirchner began one self-portrait, *The Painter*, at the Stafelalp in summer 1919, and may have finished it in 1920. During the winter he painted this second self-portrait, with a cat, at "The Larches". From letters we know that it was finished in the early weeks of 1920.

ibly difficult for everybody", Edwin Redslob wrote from Erfurt to Eberhard Grisebach on 30 June 1919. "He has behaved in a cruel and disappointing manner towards me too, on the basis of a misconception. […] It would be excellent if 'Genius' [an art periodical founded in 1919 by Carl Georg Heise, Hans Mardersteig and Kurt Pinthus] did publish a good deal about Kirchner, and it drives me to despair to see how hard Kirchner makes any such publication. He has flatly turned me down. I recently analysed a picture of his in 'Genius'. […] K. wrote me a very friendly note about it, but now he has suddenly announced that I do not understand his work at all and that he will never give permission for me to write about him or his pictures. […] I imagined I had taken his part in a friendly and honest manner – and now to be so distrusted and rejected by him!" Redslob's experience was typical. Anyone who proposed to write on Kirchner, no matter how well-disposed, had to have the artist's permission to reproduce pictures to illustrate the text, and Kirchner used the power this legal necessity gave him to the full. He would demand to see criticism prior to publication, and would censor it or, in extreme cases, veto publication.

At the same time, from 1919 on, Kirchner began penning criticism of his work himself, publishing essays under the pseudonym Louis de Marsalle. The fictitious de Marsalle was identified as a French army doctor stationed in a remote part of North Africa. To Gustav Schiefler, who was perfectly well aware that there was no such person, Kirchner described him as "my friend de Marsalle, who in my own opinion is a simply ideal critic. We struck up acquaintance during the war when we were sick. Until now, only you have brought such level-headed scrutiny and intense interest to bear on my work. I hope that with the help of this Frenchman I shall be able to prove that my work originated independently of French art and developed separately from it." The first of these self-penned essays, on Kirchner's drawings, appeared in *Genius* in 1920. Naturally it is vitiated by the fact that the artist wrote it himself. Nevertheless, it has to be said that it includes some of the most telling observations on the importance of Kirchner's draughtsmanship. Further self-penned pieces followed on the graphic work (in *Genius*, 1921), on his Swiss work (in an exhibition catalogue of 1922), and on his sculptural work (in the periodical *Cicerone* in 1925). This critical engagement with his own past creations was not without implications for Kirchner's future development.

With the return of a calmer state of mind, and the normalization of his life and circumstances at "The Larches", Kirchner's art also became calmer. The nervous agitation that had entered his work in Berlin and been exacerbated during the war years, that edginess with which he had first registered the Davos scene, steadily ebbed away through 1920. Compositionally, his pictures resolved into more even areas, in a manner that Kirchner himself likened to an oriental carpet. The angularity and elongation went out of his shapes, the proportions became steadier, and his colours intensified. Helene Spengler, who was invited by the artist to view his new pictures in February 1921, wrote: "The majesty of the colours is overwhelming; they are so wonderful that one no longer enquires after the subject – one merely gapes in admiration at the magnificent 'tapestry'." And this change, three years after the decision to settle in Switzerland, marked a real new departure in Kirchner's style.

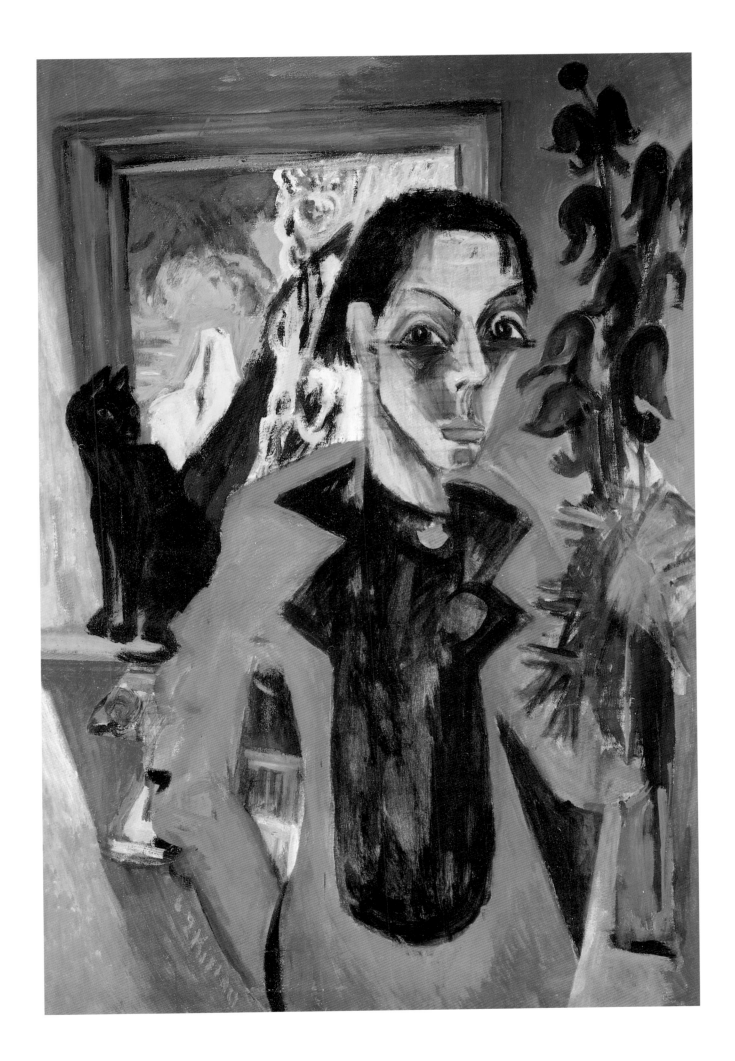

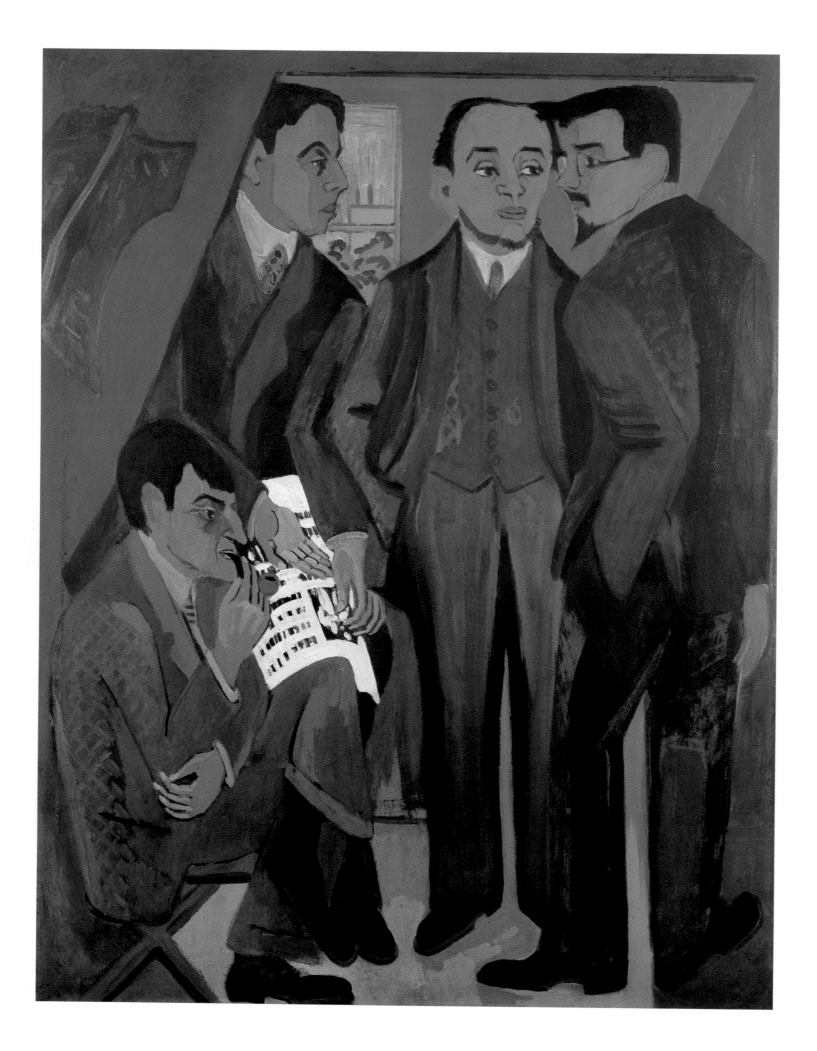

Self-Scrutiny and Style

The Davos where Ernst Ludwig Kirchner settled in 1918 was not the Davos of Thomas Mann's masterly novel *The Magic Mountain* (1924). Mann (1875–1955) described the world of the great tuberculosis sanatoriums in a health resort with an international, urbane profile where the wealthy and the affluent from countries throughout Europe constituted a closed sub-culture within the mountain community, a throng of sick decadents with a taste for the morbid, if Mann can be believed. Kirchner, by contrast, led his life in his Frauenkirch farmhouse amongst the Alpine peasant folk, and we have already seen how greatly he was fascinated by their way of life and how rich his sense of well-being was. That contentment marked the years after he had been weaned from morphine and restored to health, and continued into the 1930s. He lived at "The Larches" until 1923 and then moved into an old farmhouse on the other side of the valley, a slope known locally as the Wildboden, where he was to remain until his death in 1938.

From 1921 he led a less reclusive life than he had in recent years, though. He went into Davos itself more frequently, frequenting the cafés and participating in local life, and developed his contact with other artists and intellectuals in the area. He also played his part in the European art scene. Kirchner's correspondence was extensive, he exhibited in a variety of shows, and he published essays. Gustav Schiefler in Hamburg was at work on the graphics catalogue, the two volumes of which were published in 1926 and 1931. Will Grohmann in Dresden published a study of Kirchner's drawings in 1925, and the first monograph on the whole œuvre in the following year. Kirchner's Frankfurt dealer Ludwig Schames regularly mounted solo exhibitions, and these were continued after his death in 1922 by his nephew, Manfred Schames. Other galleries throughout Germany and Switzerland also exhibited Kirchner. There were a number of major museum shows, which met with varying responses – at the Berlin National Gallery in 1921, at the Basle Kunsthalle in 1923, at the Winterthur Kunstverein in 1924 (where Kirchner's painting was given an emphatically hostile reception), and at the Berne Kunsthalle in 1933. Fellow-artists repeatedly visited Kirchner – chiefly other German artists, but from the mid-twenties he also attracted a number of young Swiss artists from Basle, who found in him a father figure and mentor. Among them were Hermann Scherer (1893–1927), Albert Müller (1897–1926) and Paul Camenisch (1893–1970), who founded an artists' association by the name of Rot-Blau [Red-Blue] in 1925 under Kirchner's influence.

Kirchner had become reluctant to visit Germany, and was aware of a need to counter his wariness: "I must put an end to my fear of my fatherland", he wrote in a letter of October 1925. And so he went to Germany a number of times, in the winter of 1925, in the early months of 1928, and in late spring 1929, revisit-

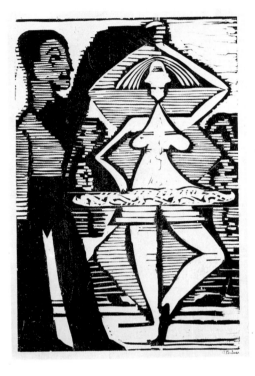

Dancer Pirouetting, 1932
Drehende Tänzerin
Woodcut, 84.5 x 54 cm
Dube 628; Stuttgart, Staatsgalerie Stuttgart

PAGE 172:
A Group of Artists, 1926–1927
Eine Künstlergruppe
Oil on canvas, 168 x 126 cm
Gordon 855; Cologne, Museum Ludwig

Following his first return visits to Germany in 1925 and 1926, when he sought out places where he had lived and met Karl Schmidt-Rottluff again, Kirchner painted this picture of the Brücke artists at the time when the movement was dissolved in 1913: Erich Heckel, the organizing power, is in the middle, with Schmidt-Rottluff to the right. Kirchner, to the left rear, is pointedly holding a copy of the Brücke chronicle he wrote. In the left foreground, seated, is Otto Mueller. Max Pechstein, who had been excluded from the group in 1912, is not in the painting.

173

ing the places where he had spent his earlier years. Naturally it was good to be welcomed in the country of his birth as a contemporary master. At the same time, however, his aversion to the metropolitan art industry was confirmed with every visit. In 1931 he became a member of the Prussian Academy of Arts in Berlin. Throughout, Kirchner repeatedly wondered whether he ought to return to Germany. If he had been called to the chair of a German art academy, it seems certain that he would have accepted the offer and left Davos. (If we can believe Kirchner's journal and various remarks in his private correspondence, he was considered for the professorship in painting at the Dresden Academy of Art in 1926, for instance. In the event, however, the choice fell upon Otto Dix.) Offers of other kinds, no matter how tempting, failed to induce Kirchner to return. And then in 1933, when Adolf Hitler came to power, Kirchner's friends and advocates at German galleries lost their influence, and a few years later his paintings were among those branded as degenerate art and removed from German collections, so there could no longer be any question of returning. It was at this point that Kirchner's final crisis set in. And this time he was not equal to the pressure, and it led to suicide.

There are various ways of considering Kirchner's development as an artist in the Swiss years after 1921. As he grew older, his art grew calmer. The radical and agitated qualities of the work he produced as a young man were superseded by greater balance. The older Kirchner was more concerned to harmonize with the traditions of art than to rewrite them. This led to a composure of style comparable to what we see in his erstwhile Brücke fellows Erich Heckel and Karl Schmidt-Rottluff too. In the case of Kirchner, however, the development was not a steady one towards a moderated Expressionism of old age, as it was in their cases; rather, there were a number of breaks. Kirchner was determined that in his maturity, in the latter part of his life, he would again scale the heights of his chosen art. At the age of forty he liked to compare himself with the greats of his generation – with Picasso and Braque, with Matisse and Fernand Léger, and also with Wassily Kandinsky and Paul Klee – while at the same time looking down on the other Brücke artists and

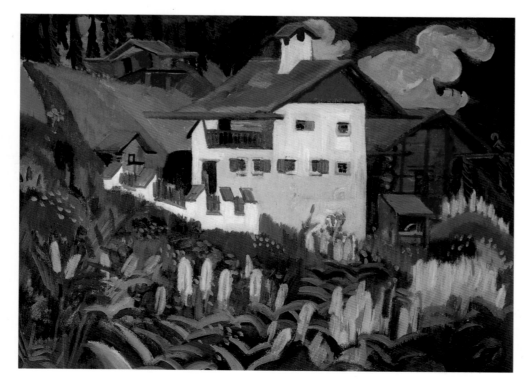

Our House. House in Meadow, 1920–1922
Unser Haus. Haus in den Wiesen
Oil on canvas, 90 x 120 cm
Gordon 631; private collection

"The Larches", the house at Frauenkirch near Davos into which Kirchner moved in September 1918. He had to move out again in autumn 1923 because the owner needed it for his own use. Kirchner then moved into an old farmhouse across the valley, on the Wildboden side.

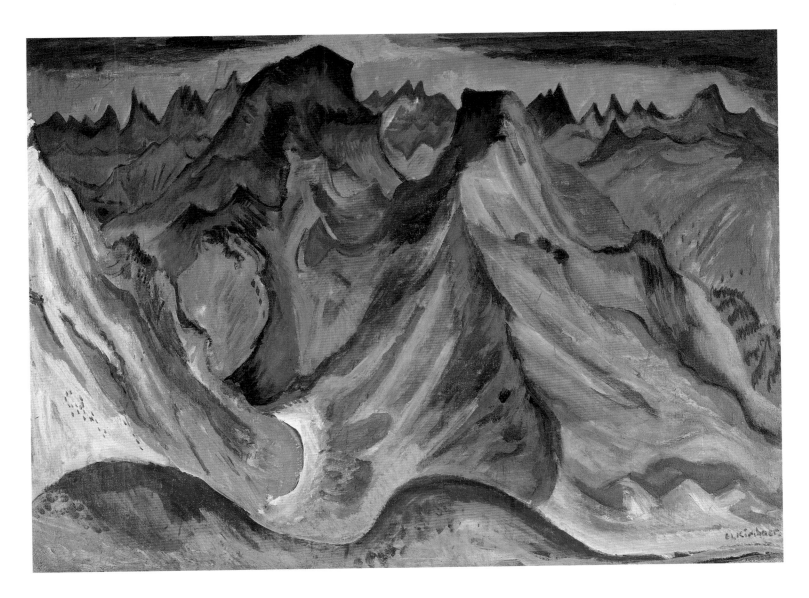

other German contemporaries such as Max Beckmann or Otto Dix. After a visit to the international art show at the Zurich Kunsthaus in 1925 he noted in his journal: "Nolde and Schmidt-Rottluff make the best impression. Can't bear to look at Dix, common and eclectic. Beckmann as senseless and revolting as Dix. Dirty colours and contrived composition. […] Heckel is looking bad. Nothing whatsoever of his former power remains, the pictures are fake and ugly, he imitates everything, particularly me."

We must add that Kirchner's development was also a part of the general trend towards the classical apparent everywhere in Europe in the twenties and thirties. Picasso, who had been in the forefront of Cubism from 1907, dissecting the evidence of the eyes and steering the movement through its analytic and synthetic phases, was the prime example. In 1920 he began painting large-scale nude figure compositions of classical proportions. If Kirchner made the odd gesture towards the monumental in his art of the twenties and thirties, that was altogether in the spirit of the age.

There is a further problem the importance of which must be stressed, one which is rooted in Kirchner's own personality and the view of the artist that he held. It is a problem we encounter in artists so conscious of history and style that they are forever squaring up to history in everything they do, artists who set out to secure a key position in history for themselves. Constantly glancing over their shoulders to check their impact on history, such artists not only lose

The Mountains, 1921
Der Berg. Weißfluh und Schafgrind
Oil on canvas, 124 x 168 cm
Gordon 676; Frankfurt am Main,
Deutsche Bank AG

One of Kirchner's few mountain landscapes painted not from the point of view of a local inhabitant but from that of an Alpine rambler. The Weißfluh is the highest peak in a popular skiing and walking region near Davos. "Since Hodler", Kirchner wrote of himself in 1927 (using the pseudonym Louis de Marsalle), "Kirchner has been the first artist to paint the mountains in a new way."

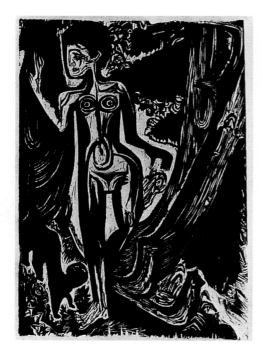

Nude Woman in the Wood, 1921
Nackte Frau im Walde
Woodcut, 57 x 39 cm
Dube 451; Düren, Leopold-Hoesch-Museum
der Stadt Düren

The Tree, 1921
Der Baum
Woodcut, 62.5 x 43 cm
Dube 440; Stuttgart, Staatsgalerie Stuttgart

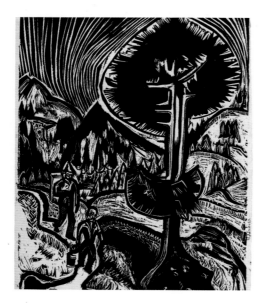

their artistic innocence but also end by doing things only in order to attain their historical goal. This is not, of course, a problem that we see in Kirchner alone. The dominance of historical awareness forces a heightened sense of history and style on all modern artists. But in Kirchner it took on a particularly acute form, and affected his development as an artist in twofold manner.

We have already seen that in 1919 Kirchner began to write about himself and his own art, using a pseudonym. Those essays (together with a variety of passages in the Davos journal or in his correspondence with collectors or writers) constitute a theory which Kirchner constructed as a retrospective systematic underpinning of an art he had created without any conscious theory at all. This theory might be summed up in the following manner. The artist takes a hold upon reality. His first tool in so doing is draughtsmanship. In the act of drawing, the artist translates the motif into a visual form – Kirchner refers to this as a "hieroglyph" – and this is then worked upon further, in painting or in print graphics. The hieroglyph, Kirchner's key term, was very probably borrowed from Max Liebermann's essay *Imagination in Painting*, published in 1916, but Kirchner used it very much in a sense of his own. For Kirchner, the hieroglyph was a single artistic form created when movement was "ecstatically" captured with the crayon, pen or brush. It is crucial to the meaning of the concept that the artistic form (the picture) be distinguished from the natural form (the given motif). The two forms are fundamentally different, and belong to different realms. The artistic form is not a reflection but the pictorial equivalent of the natural form, necessarily explicable by the logic of the picture. As a form in its own right it calls for its own conceptual definition. For Ernst Ludwig Kirchner, faced (like all his generation) with the express need to vindicate his abdication from naturalistic representation, this conceptual distinction was of the essence. It is important, incidentally, not to confuse Kirchner's hieroglyph with the written characters originally denoted by the word. "They are not hieroglyphs in the familiar sense of the word, whereby a particular shape is invariably used for the same object or concept", he wrote in his 1920 essay on his own drawings. The individual hieroglyph is given new meaning by the overall context it appears in. This is developed anew in every work, and in every work it has a new rationale behind it.

On the one hand, Kirchner's theoretical definitions aimed at a clear distinction between reality and its pictorial image, while at the same time insisting on a causal link between the two. It was important to emphasize the autonomous value of the artistic form over against the natural form. The hieroglyph must be seen as a pictorial form subject not to the rules of representation but to the rules of two-dimensional iconography. On the other hand, he always stressed that these hieroglyphs were rooted in experienced reality. Kirchner could not conceive of forms not so rooted. The idea of ecstasy was introduced into his theory in order to establish a plausible link between the two levels. Ecstasy was experienced in the act of drawing – or, to put it differently, drawing is the ecstatic act of translating the natural form into the hieroglyph.

In seeing a causal link between the experience of reality and pictorial conceptualization, Kirchner was adopting a fundamentally different theoretical position from that taken by other artists of his generation, principally Paul Klee. Klee advocated the complete autonomy of the pictorial; for Kirchner, this could never take priority over the rootedness of images in experienced reality. Quite the contrary, it was only by presenting its experiential credentials that an image earned a place, philosophically. In this respect, Kirchner's theory was a logical and consistent systematic account of his practice as an artist. He

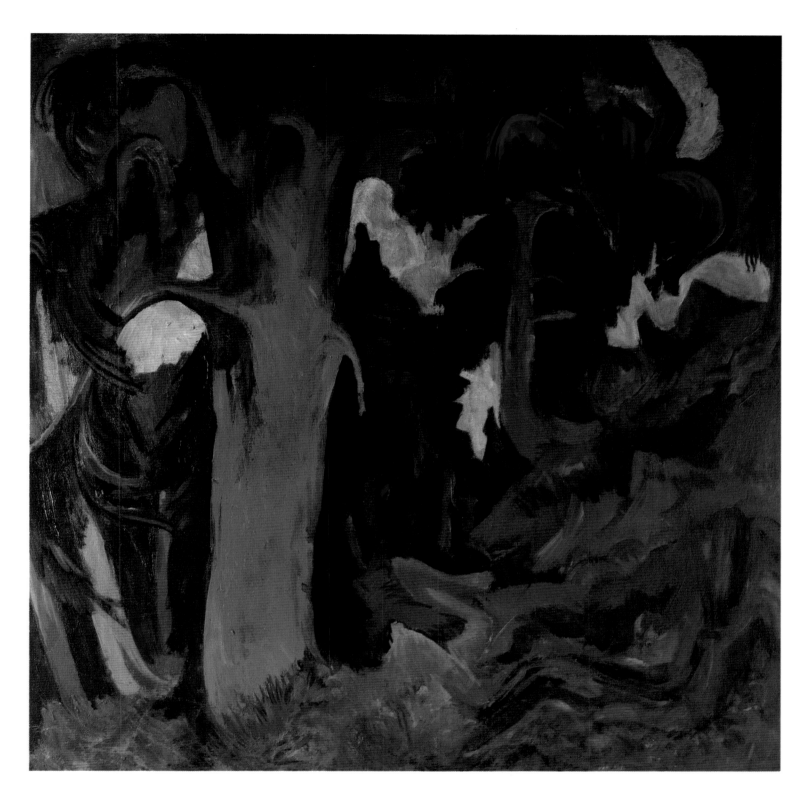

did, however, introduce a further consideration which signally upset the balance between theory and practice. A journal entry of 17 October 1919 reads: "I believe the painter must reach a point where he can work from the soul alone, without Nature. Only then can he produce his true works. Then, his earlier sketches will guide him to the experience, and the form will be achieved independently." The hieroglyph derived ecstatically from the experience of reality was to be intensified into a more exalted hieroglyph, a form based upon it which would be of higher aesthetic standing. It was to be the foundation of "free creations drawn purely from the imagination". Was Kirchner perhaps thinking of Picasso or Kandinsky, of non-representational art?

The Blue Tree. Mountain Forest, 1920–1922
Der blaue Baum. Bergwald
Oil on canvas, 120 x 120 cm
Gordon 651; private collection

Davos in the Snow, 1923
Davos im Schnee
Oil on canvas, 121 x 150 cm
Gordon 716; Basle, Öffentliche Kunst-
sammlung Basel

Kirchner's Wildboden home, to which he
moved in October 1923, commanded this
view of the valley and Davos.

This idea is even more clearly expressed in a later text. In 1925 Will
Grohmann, the Dresden art critic, having just published his study of Kirch-
ner's drawings, was at work on his large-scale comprehensive monograph,
the book which became *Das Werk Ernst Ludwig Kirchners*; and Kirchner
intervened with corrections to the text. That summer of 1925 he wrote a
lengthy piece titled *Das Werk* [The Work], which he subsequently appended
to his journal. The essay grouped all his work to date into six thematic areas:
"The Nude in Nature", "Street Scenes", "Relations with Woman", "The Ex-
perience of the Mountains", "Affection for Mountain Farmers" and "Free
Creations drawn purely from the Imagination". Kirchner emphasized that
this last group represented the proper aim of all his endeavours and were to
be the culmination of his development. In his youth, he wrote, he had begun
with symbolist pictures, but had then realised "that what mattered above all
was to locate a form that would enable him to articulate his dreams". For
this reason he had studied the natural world very closely. Now he had finally
got to the point where he had the form he needed and was in a position to
make art purely from the imagination. It now seemed to Kirchner that
pictures done from imagination were of greater historical importance than

pictures after nature. This preference recalls the conventional hierarchy of classifications once again. "This new approach", Kirchner wrote of his own art, "has of course been an obstacle to a full understanding of Kirchner's art, and has occasioned long years of misery and struggle. To this day there are only a few who truly understand his work."

Alongside his theoretical deliberations, and his concern to classify himself historically, Kirchner was introducing an autobiographical note to his art. We have already noted the group portrait of the Brücke artists which he painted in 1926–27, breaking a silence of many years' standing on this subject. He sketched people in the Davos cafés he frequented, and painted pictures he saw as a continuation of the Berlin street scenes, both on journeys to Germany or elsewhere in Switzerland (p.183, top) or at home in Davos (p.183, bottom). In the early 1920s he did a number of drawings, paintings and graphics of nude women bathing in a mountain stream, works that pick up the Moritzburg and Fehmarn line. His wife Erna and female visitors would pose naked on the rocks or amongst the trees (cf. *Nude Woman in the Wood*; 1921, p.176).

Kirchner's analytic self-scrutiny and his attempts to define his position inevitably influenced his development as an artist. Increasingly these considerations steered his style towards an abstraction that was planned according to theoretical criteria. The first change, apparent from 1920 on, has already been discussed. The agitated, hatched brushwork gave way to a more even compositional manner using a greater two-dimensionality and deploying colour to create an almost architectural sense of structure (cf. pp.177,

The Amselfluh, 1923
Die Amselfluh
Oil on canvas, 120 x 170.5 cm
Gordon 741; Basle, Öffentliche Kunst-sammlung Basel

The Amselfluh is a lofty rock face above Frauenkirch and the Stafelalp. Below it runs a well-loved path from Davos to Arosa. When he was living at "The Larches", Kirchner often had visitors who took that walk. This picture will in all likelihood have been painted before he moved to the Wildboden side of the valley. Kirchner variously dated it to 1922 or 1923.

Sunday in the Alps. Scene at the Well,
1923–1924
Alpsonntag. Szene am Brunnen
Oil on canvas, 168 x 400 cm
Gordon 734; Berne, Kunstmuseum Bern

This is Kirchner's most monumental painting
on the subject of mountain farm and peasant
life, a key subject in the first Davos years. He
began preliminary studies in 1920 and com-
pleted the painting in a workroom specifically
rented for the purpose, since the rooms in the
Wildboden house were too small. While at
work on the picture, Kirchner referred to it re-
peatedly as *Dimanche l'après-midi sur l'Alpe*
– an indication that he was thinking of
Georges Seurat's famous *Un dimanche après-*

178, 179, 180–181 and 182). The effect has been compared with that of tap-
estries, and the style dubbed Kirchner's tapestry style. The comparison is
apt, not least because Kirchner was in fact interested in tapestries and ex-
perimented with tapestry embroidery himself at this time. In 1922 he met
Lise Gujer, who had just begun familiarizing herself with the use of an old
loom in Davos, and she wove tapestries from his designs. Textile work had
always interested Kirchner – we need only recall the décor in his Dresden
and Berlin studios. Now, the flat simplicity of form that went with the me-
dium produced an architectural, monumental quality in his work (cf. *Mod-
ern Bohemia*, 1924; p. 182). From this it was but a small step to dissolving
distinctions between foreground and background, or between figures, and
the more two-dimensional, abstract visual idiom Kirchner evolved in this
way can well be seen in *Street Scene at Night* (1926–1927; p. 183) and *Café
in Davos* (1928; p. 183). Evidently the artist was striving for a monumental

form that would possess universal validity. The direct, "ecstatic" approach now seemed too individualist to him, and insufficient to meet the imperatives of history. Kirchner compared himself with Picasso and the abstract movements that had spread worldwide in the wake of all-triumphant Cubism, and wished his own art, grounded no less in intellectual theory, to stand beside the art of major contemporaries.

This led Kirchner to his own sense of abstract compositional structure, and the art that came out of this peaked after 1930. The subject matter, generally a situation drawn from everyday experience, was taken apart into component areas, as in a construction plan, and these were contoured with lines. The areas could be seen from a simultaneous multiple viewpoint, as in Cubism, and several stages in a movement could be rendered in a single picture. The use of line served to emphasize movement. The most arresting works Kirchner painted in this manner are two very large pictures, *The Rider*

midi à l'Ile de la Grande Jatte, generally seen as the French artist's masterpiece. It brought all the components of Seurat's art together; and similarly, Kirchner wanted his painting received as a grand synthesis.

Modern Bohemia, 1924
Moderne Bohème
Oil on canvas, 124.5 x 165 cm
Gordon 767; Minneapolis (MN), Minneapolis
Institute of Arts

Will Grohmann (1887–1968) from Dresden
published two studies of Kirchner (in 1925
and 1926). In April 1924 he and his wife paid
a first visit to Kirchner in Davos. The painting
shows Kirchner and Erna with their guests in
the Wildboden living room. Kirchner is at left
rear, drawing in a wing chair, while
Grohmann is at right, reading. Erna is reclin-
ing naked on a divan, while Frau Grohmann is
standing in the centre of the room, looking a
little out of place. Various items are identifi-
able. The wing chair has a back of carved
figures, there are figures on the side of the set-
tee at right and the floor is covered with the
oriental carpets Kirchner was so fond of. The
tapestry quality of the composition prompted
the tag "tapestry style" for Kirchner's manner
at this period.

(1931–1932; p. 186) and *Colour Dance II* (1932–1934; p. 187), while the
drawings and watercolours Kirchner did in 1928 and 1929 (pp. 184–185)
show him in the process of establishing this style. *The Rider* shows a lady of
Davos whom Kirchner occasionally met out riding when he himself took a
walk. *Colour Dance II* is a purely imaginary symbolic composition which we
must see in connection with a large mural project Kirchner was preparing in
the years from 1926 to 1934, but which was never in fact realised. The new
Folkwang Museum was under construction in Essen, and Kirchner had been
approached to paint the great hall. Though the commission had not been
defined in specific terms, Kirchner immersed himself deeper and deeper in
the work over the course of several years, finding it nicely suited his taste for
monumental form and for an art of high historical ambition. With the advent
of Nazi art policies in 1933, alas, all his plans came to nothing.

Kirchner was much concerned to interpret his own development as being
governed by logical historical imperatives, and it was in this spirit that he
underpinned his new sense of form with mock-scientific cognitive theory.
We see this at its clearest in the catalogue of the major Kirchner retrospect-
ive shown at the Kunsthalle in Berne in 1933. It includes an essay by Kirch-
ner's fictitious Louis de Marsalle – the last, as it happened, since the name
carried a cross to indicate that the writer was now deceased. Every syllable
of this essay asserted the inevitability (in Kirchner's eyes) of his evolution

Street Scene at Night, 1926–1927
Straßenszene bei Nacht
Oil on canvas, 100 x 90 cm
Gordon 852; Bremen, Kunsthalle Bremen

This may be a recollection of the visit to Germany in 1925 or of trips to Zurich or Basle. The subject matter is a reminiscence of the Berlin street scenes.

Café in Davos, 1928
Davoser Café
Oil on canvas, 72 x 92 cm
Gordon 918; Kassel, Staatliche Museen Kassel, Neue Galerie

During the twenties, Kirchner explored the urban features of Davos – the cafés and other attractions. His style became simpler, starker, and semi-abstract, with Cubist influences apparent. In the catalogue of the 1933 Berne exhibition, Kirchner described this painting as follows: "Five figures at tables with lamps, a waitress in the background, shelves with bottles and a mirror. A rich, tonally varied painting."

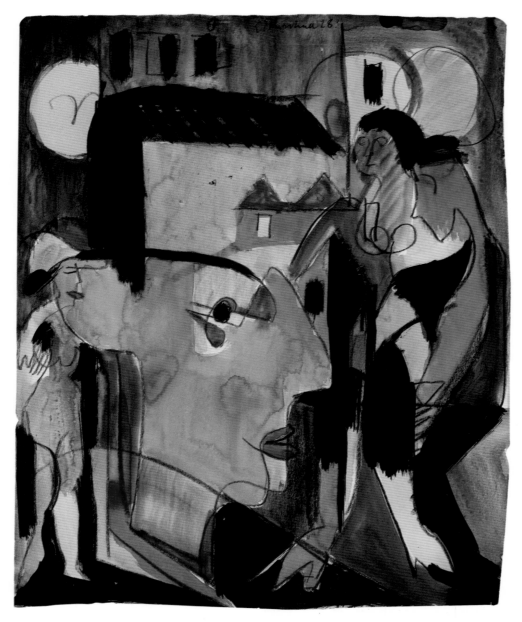

Self-Portrait, 1928
Selbstbildnis
Watercolour and chalk, 46.5 x 37.5 cm
Chevy Chase Maryland, Ruth and Jacob
Kainen Collection

Kirchner's work betrayed a variety of Cubist
influences in the late twenties, such as
multiple point of view, the overlapping of
motifs, and the use of lines that continue re-
gardless of the limits of individual shapes. In
this watercolour the self-portrait is combined
with recollections of women, lights and build-
ings.

Head of a Woman (Erna), 1929
Frauenkopf (Erna)
Watercolour and chalk, 28 x 24.5 cm
Saarbrücken, Saarland Museum in der Stif-
tung Saarländischer Kulturbesitz

Kirchner's partner is crying here, in a com-
bined frontal and profile portrait. The entire
composition is covered with decorative circles
and rhombuses – and one of each is on each
of Erna's eyes. An oil on the same subject was
described by the artist, in the Berne exhibition
catalogue, as follows: "The head, seen in
profile and *en face*, is resting in the hand of
one propped arm. The strong pattern of the
gown continues into the background, intensi-
fying the psychological impact."

from the Expressionist paintings recording experienced reality in direct
terms to the higher monumental form of the later work: "At the turn of the
century, when Kirchner, then a young student of architecture and painting,
saw pictures by Leo Putz and Fritz Erler at the Munich Secession, he real-
ised that only a new study of nature, and a new attitude to life, could inject
new energy into German art. For his own purposes he devised the study of
movement rather than the study of a model at rest then normal in the acad-
emies." This passage is followed by an outline of Kirchner's development,
from the Brücke days via Berlin to Davos, and then the essay continues: "In
about 1926, Kirchner once again gathered his powers for a new achieve-
ment, distilling all he had hitherto accomplished into a technique the sim-
plicity of which approached that of his early works, and with which he cre-
ated visionary works. The 'hieroglyphs', his non-naturalistic presentations
of the inner image of the visible world, developed and took on forms gov-
erned by optical laws that had not previously been used in this way in the
visual arts, such as those of reflection, interference or polarization, etc. Only
an eye as trained and sensitive as Kirchner's could bring to this visionary

Agitated Heads, 1929
Erregte Köpfe
Pencil drawing, 34 x 46cm
Düsseldorf, Kunstmuseum im Ehrenhof

Typical of Kirchner's Cubist-influenced, supposedly abstract later style is the use of shared line in this picture of states of agitation. Kirchner had wanted from the very start to catch people in moments of movement, and in this spirit he saw the line, indicating movement but at the same time independent of the subjects, as a visual translation of movement.

imagination a degree of intensity never yet seen in German art. To find an apt comparison one would have to go back to Dürer, whose achievement in his own time was similar in leading German art out of its Gothic confines into the life that was the Renaissance. In the same way, Kirchner, using means that are original to him and still his alone, is giving German art today its proper connection with the international sense of style in his latest works. In the process he has lost none of his originality or power. Quite the contrary, the work he is producing today is the logical culmination of his work of the past thirty years. Nietzsche's words well describe his art: 'do not aim to reproduce but to achieve higher things'."

This passage includes all the arguments Kirchner liked to advance in defence of his claim to be a leading figure. Even as a young man he had realised what was needed if German art was to be revitalized, and it was he who had devised the means to do it. In his maturity he went beyond what he had formerly accomplished and reached an exalted level in art. His path to that goal was signposted by laws. Only Dürer, the uncontested master of German art, had achieved comparable things. It was Kirchner who had originated the ways in which German art could go forward – he had been influenced and inspired by no one, and his entire development was dictated by historical logic. Thus Kirchner's view of himself.

He staked his claims unambiguously, and on the surface the argument did not lack consistency. But responses were divided, and Kirchner's own subsequent development effectively rescinded much that he had asserted. What Kirchner wanted critics to interpret as higher and abstract form in fact remained a contrived monumental rendering of the individual and arbitrary. The seemingly abstract, with its claim to be an eternal constant, is vitiated time and again by perfectly non-abstract details. In *The Rider* (p. 186), for example, though the horse's body is rendered as overlapping colour zones seen against a landscape as part of an overall patterned complex, in masterly fashion, the figure of the horsewoman and the horse's head are too detailed

PAGE 186:
The Rider, 1931–1932
Reiterin
Oil on canvas, 200 x 150cm
Gordon 962; Davos, Kirchner Museum

Kirchner, in the 1933 Berne catalogue: "In bright sunlight, shadows seen far off acquire a certain autonomy of form, and merge with simplified outlines to create new forms. The various views obtained by walking around are here combined into a single form."

PAGE 187:
Colour Dance II, 1932–1934
Farbentanz II
Oil on canvas, 195 x 148.5cm
Gordon 968; private collection

This was a motif Kirchner planned to include in the unrealised murals in the Folkwang Museum, Essen: "'Colours are the joy of life.' Their birth from light and their re-combination to make white. In the shadow contours of the three dancing figures, the prime colours: blue, red, yellow. To halfway up, the lines of reflection of the green meadow. The light and the colours enclosed by black." Thus the artist himself.

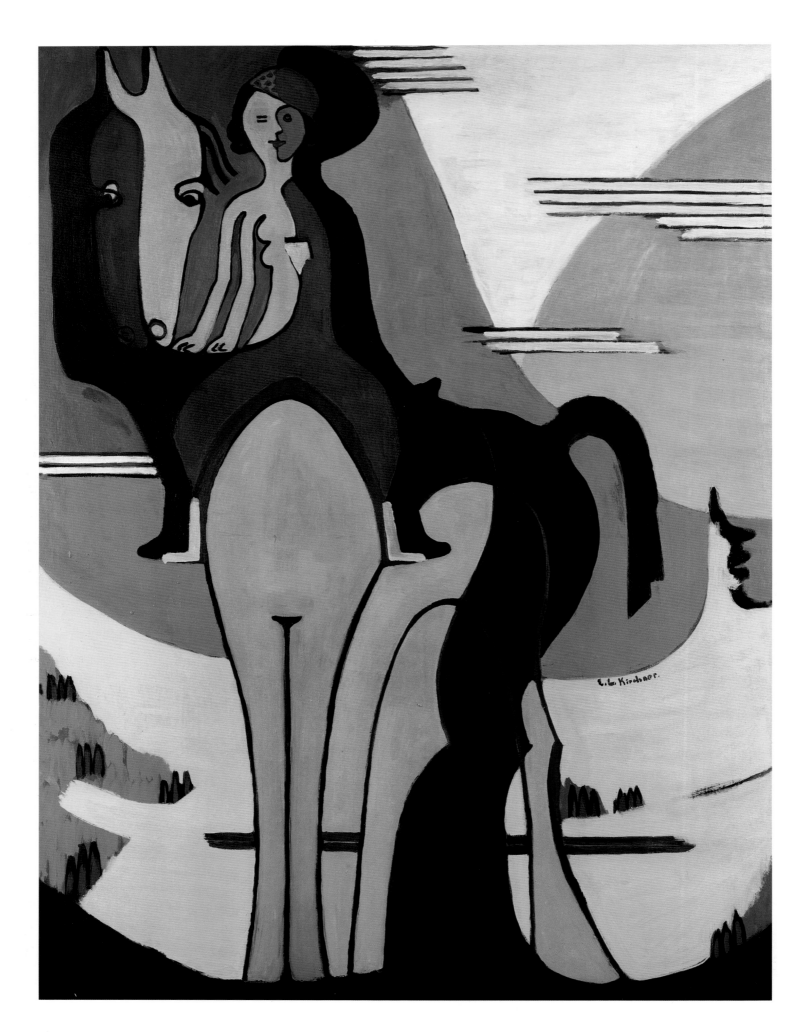

Dr. Bauer, 1933
Kopf Dr. Bauer
Coloured woodcut, 50.5 x 35 cm
Dube 633; Frankfurt am Main, Städtische
Galerie im Städelschen Kunstinstitut

Dr. Frédéric Bauer was Kirchner's most
important collector and supporter in Davos
after 1922.

to be effective. The eyes, lips, hair, riding hat, arms and breasts are too anec-
dotal to be abstract – they would properly belong in caricature. Similar in-
consistences can be seen in *Colour Dance II* (p. 187).

The fact is that Ernst Ludwig Kirchner was not a Wassily Kandinsky,
thinking and making compositions in a fully abstract way. Nor was he a
Pablo Picasso, who always remained within the circumscribed zone of art
and its traditions and who recorded experience of reality only indirectly. And
least of all was he a Paul Klee, exploring with ludic grace the poetry of form
and the power of association. Concrete, experienced reality kept insisting on
a hearing.

Kirchner's claim that he was producing free creations drawn purely from
the imagination also seems far-fetched. It is true that his art moved towards
the symbolic at times, as in the 1915 *Dance between the Women* (p. 141) or

the various pictures of man and woman. But these works lack the consistency and conviction of his works done from given, observed reality – from the Brücke days in Dresden through the Berlin street scenes to the mountain landscapes and peasant scenes painted in Davos in the twenties. The artist was talking himself (and his audience) into believing he was doing something that he was not.

The clearest proof that the development towards the abstract in Kirchner's art up to 1934 was *voulu* and arguably an affectation can be found in his own later development. The artist himself broke off the excursion into abstraction in the mid-thirties, and painted a number of naturalistic though still monumental figures and landscapes that retained certain formal features from the abstract phase but in essence abandoned the aim to achieve an abstraction that went beyond the representation of the real. The 1937 *Herdsmen in the Evening* (p.190) and *Grisons Landscape with Sunrays* (p.191) are paintings of this kind. They may no longer be stylistically innovative, nor would they have pleased the "international sense of style" Kirchner had written of in 1933, but at least he was doing what came naturally and had ceased pretending to be a painter different from what he was. The pictures are beautiful, no doubt, and they also possess an unmistakable dimension of melancholy and resignation.

When an artist commits suicide, speculation is inevitable. The clichés of the desperate artist driven by an uncomprehending fate to madness and self-slaughter are legion. Whether intentionally or not, Kirchner contributed his share to these clichés. His despair must have been profound, apparently for various reasons. There are indications that he may have been seriously ill. In the 1960s, large quantities of ampoules were found buried near his Wildboden home. These ampoules originally contained a morphine-based pain killer that he seems to have been injecting in the last years of his life. It is possible that he had cancer of the stomach or intestines. Another contributory factor was the Nazi regime in Germany, which had begun its persecution of modern artists and their work. In 1937 Kirchner, like many other contemporaries, was called upon to resign from the Prussian Academy, of which he had been made

Woodland Cemetery, 1933
Waldfriedhof
Coloured woodcut, 35 x 50 cm
Dube 644; Basle, Öffentliche Kunstsammlung
Basel, Kupferstichkabinett

This park-like woodland cemetery was laid out in the early years of the century on the Wildboden side of the valley where Kirchner lived from 1923. With hindsight the sheet seems almost prophetic, since it was here that the artist wanted to be buried after his suicide five years later.

Herdsmen in the Evening, 1937
Hirten am Abend
Oil on canvas, 120 x 90 cm
Gordon 1008; private collection

After 1935, Kirchner abandoned his post-Cubist abstract leanings and took to painting in a naturalistic manner. His colours and brushwork retained a monumental quality. This painting shows the influence of Oskar Schlemmer and of his Swiss friend Otto Meyer-Amden. Schlemmer, whose portrait Kirchner had painted in 1914, regularly visited him in Davos in the thirties. These upright, plastically modelled figures recall the geometrical exactions of Schlemmer the Bauhaus master.

a member in 1931. That same year, every one of his works in a German museum was confiscated as "degenerate" and offered for sale abroad or earmarked for destruction. Everything Kirchner had achieved in German art was swept away overnight. Only a few friends and collectors remained in Germany, and he did not feel he had a proper place in Swiss art. Then, at an exhibition at the Basle Kunsthalle in 1937, he sold not a single painting. And he received no congratulations at all on his fifty-eighth birthday on 6 May 1938. In March 1938 the German army had entered Austria, the border of which was just twenty-five kilometres from his home as the crow flew. The approaching war was almost literally on his doorstep. Everything that had once placed him in mortal jeopardy and fear, everything that had exiled him to the new home he had laboriously made his own, had become a real threat once again.

There were doubtless reasons rooted in his own sense of himself as artist, too. In turning to a less ambitious kind of painting, even if it was more in line with his own personal and artistic preferences, Kirchner had lost his

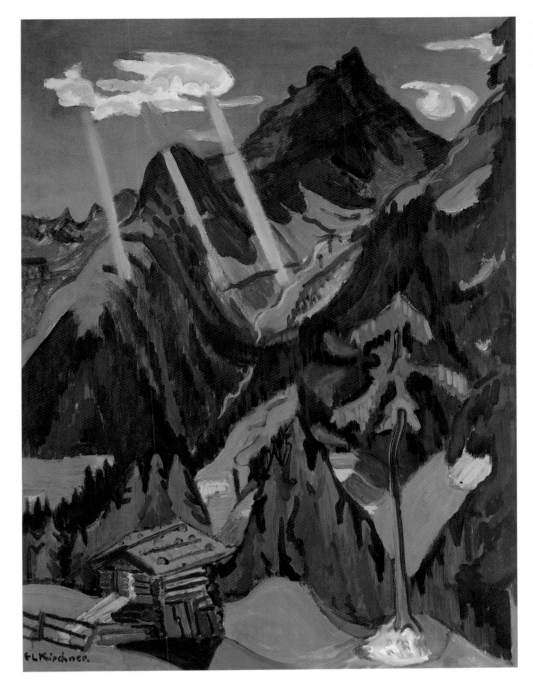

Grisons Landscape with Sunrays, 1937
Bündner Landschaft mit Sonnenstrahlen
Oil on canvas, 119 x 90 cm
Gordon 1014; private collection

A painting representative of the last phase in Kirchner's development, when he had cast off all ambition to evolve a new, contemporary form. Now, he merely wished to savour the mighty wonder of the landscape.

sense of a future he might be working towards. Although his work of the past two years was of high quality, it did not point the way forward in the way his historical rationale demanded. His awareness of this plunged him into depressions and sapped his will to live. But, of course, we cannot account for Kirchner's suicide in artistic terms alone. The point of no return was reached in a deep depression triggered by illness, political events and personal disillusionment working in conjunction (it is a moot point whether a more optimistic artistic outlook would have countered this). On 15 June 1938, Ernst Ludwig Kirchner shot himself through the heart with a pistol, outside his Wildboden house, not far from the woodland cemetery at Davos where he wished to be buried. "For the past few months," Erna Kirchner wrote to Helene Spengler a few days later, "a tragedy has been quietly enacted here. The defamations broke him. In the last few weeks he was a tormented soul, so that one can be relieved that he is at rest."

Ernst Ludwig Kirchner: A Chronology

1880 Ernst Ludwig Kirchner is born in Aschaffenburg on Thursday 6 May.

1882 Birth of his brother, Hans Walter (1882–1954).

1886 The family moves to Frankfurt am Main.

1887 Ernst Kirchner (1847–1921), a successful chemist in the paper industry, is appointed deputy director of the paper factory at Perlen, near Lucerne, Switzerland. The family moves there in early 1887, remaining until late in 1889.

1888 Birth of another brother, Ulrich (1888–1950).

1890 The family moves to Chemnitz in Saxony, where Ernst Kirchner is appointed to the chair of paper research. Ernst Ludwig goes to school in Chemnitz.

1892 At Easter he enters the royal humanities grammar school.

1894 Changes to another grammar school in October, where he remains until his school-leaving exams. His parents nurture his talent, but oppose his wish to be an artist.

1895 and 1898 With his father in Berlin, he meets his father's old friend Otto Lilienthal, the pioneer aviator, and is impressed by his "genius".

1901 29 March: school-leaving exams. 15 April: on his father's wish, Kirchner matriculates for the summer semester at the Technical College of Saxony in Dresden, to study architecture. He lives at 56, Schnorrstraße, in Dresden's "American quarter". At college he meets Fritz Bleyl (1880–1966) from Zwickau, another student of architecture who wants to be a painter. They draw together and keep up their studies only as a way of training in art. Kirchner's college teachers include art histor-

Ernst Ludwig Kirchner, c. 1912–1913

ian Cornelius Gurlitt (1850–1938), for the history of architecture, and architect Fritz Schumacher (1869–1947), for draughtsmanship and architectural design.

1903–1904 30 April: sits his preliminaries for the architecture diploma. Now living at 23, Lindenaustraße. Spends the winter semester of 1903 to 1904 at the Royal Bavarian Technical College in Munich, living at 6, Forstenrieder Straße. Attends a private studio run by Wilhelm von Debschitz (1871–1948) and Hermann Obrist (1862–1927), where he takes life drawing classes and a class on graphic art taught by Hugo Steiner-Prag.

1904 Returns to continue his architecture studies at the Technical College in Dresden. Living on the third floor of 25, Lindenaustraße. Meets Erich Heckel (1883–1970) from Chemnitz, whose elder brother Manfred was at school with Kirchner. They become friends. Heckel is also studying architecture, and joins Kirchner and Bleyl in their pursuit of art. Summer: drawing in the country near the baroque hunting lodge at Moritzburg near Dresden for the first time, with Bleyl. At the end of the year, Kirchner moves to 15, Ostbahnstraße, again taking a third floor apartment.

1905 After Easter, Karl Schmidt (1884–1976) from Rottluff near Chemnitz, an old school friend of Heckel's, starts studying architecture in Dresden and joins the art-minded group of friends. 7 June: they found Die Brücke. 1 July: Kirchner passes his final exams in architecture and is awarded his diploma in engineering. November: the first group exhibition by the Brücke artists, in Leipzig at P. H. Beyer & Sohn (a bookshop), includes watercolours, drawings and woodcuts by Bleyl, Heckel, Kirchner and Schmidt-Rottluff. Kirchner meets a cabaret dancer named Line.

1906 An exhibition of Emil Nolde's work at the Ernst Arnold gallery in January prompts Schmidt-Rottluff to write on 4 February inviting the artist to join Die Brücke.

Nolde (1867–1956) agrees, but leaves again eighteen months later. Die Brücke draws up a programme which is published in typographical form and as a woodcut by Kirchner. Max Pechstein (1881–1955) becomes a member in May, and Cuno Amiet (1868–1961) in September. The first annual Brücke portfolio for the passive members appears, containing one woodcut each by Bleyl, Heckel and Kirchner. 24 September: opening of the first Brücke exhibition in Dresden, at Karl Max Seifert's lamp factory at 17, Gröbelstraße in the Löbtau district. It runs till the end of October. 3 December: opening of a group show of printed graphics at the same location, including work by invited guest artists such as Wassily Kandinsky. This exhibition runs till 31 January 1907.

1907 In the summer, Kirchner and Pechstein paint at Goppeln, near Dresden. The second annual Brücke portfolio includes woodcuts by Cuno Amiet and the Finnish painter Axel Gallén-Kallela (1865–1931), recruited as a member that year, as well as an etching by Nolde and a lithograph by Schmidt-Rottluff. Kirchner carves the first roll-call of members in wood. He moves into former shop premises in a building where Schmidt-Rottluff has a third-floor apartment, at 60, Berliner Straße in the Friedrichstadt district of Dresden, and converts it into a studio apartment. Heckel's nearby apartment at number 65 is Die Brücke's business address. 1 to 21 September: Brücke exhibition at Emil Richter's art salon, 13 Prager Straße, Dresden. Kirchner does the lithograph poster. Journalist F. Ernst Köhler-Haußen (1872–1946) writes enthusiastically on the show and a subsequent visit to Kirchner's studio, and becomes a passive member of Die Brücke and a personal friend of Kirchner.

1908 January: Kirchner exhibits with Karl Schmidt-Rottluff at August Dörbrandt's art salon in Braunschweig. In the summer he makes his first visit to the Baltic island of Fehmarn together with Emmy Frisch (later Schmidt-Rottluff's wife) and her brother

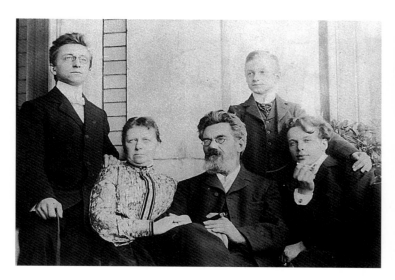

Ernst Ludwig Kirchner and his family, 1904

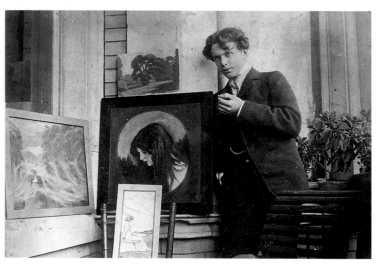

Ernst Ludwig Kirchner in Chemnitz with the works he had done in Munich, 1904

Hans. The third annual Brücke portfolio appears, including a woodcut each by Heckel, Kirchner and Pechstein. 1 to 23 September: the second Brücke exhibition at Emil Richter's includes paintings by Amiet, Heckel, Kirchner, Pechstein and Schmidt-Rottluff. Kirchner paints his first street scene, *The Street*.

1909 January: Kirchner visits Pechstein at the latter's Berlin studio, at 152, Kurfürstendamm. They go to the first German show of Henri Matisse's work, at the Paul Cassirer gallery at 53, Viktoriastraße – as recorded by a postcard sent by Kirchner and Pechstein to Heckel on 12 January. April to May: the 2nd graphics exhibition of the German Artists' Association is held at Ernst Arnold's gallery in Dresden, and Kirchner, Heckel, Schmidt-Rottluff and Nolde all have work in it. The fourth annual Brücke portfolio appears, with two lithographs and an etching by Schmidt-Rottluff. Kirchner does a woodcut portrait of Schmidt-Rottluff as a title sheet. From this point, the portfolio focusses on one individual member every year. 15 to 30 June: the third Brücke exhibition at Emil Richter's in Dresden. Kirchner lives with Doris Große, known as Dodo. Stays at Moritzburg, north of Dresden, with Heckel in the summer. In August Heckel joins Schmidt-Rottluff near Oldenburg and Kirchner returns to Dresden. In November he sees a major exhibition of Cézanne at the Paul Cassirer gallery, together with Schmidt-Rottluff. 1 November: moves to other shop premises at 80, Berliner Straße, and converts this apartment to studio use too.

1910 Heckel meets Marzella and Fränzi, sisters who become models for the Brücke artists. March: lengthy stay, together with Heckel, at Pechstein's Berlin studio at 14,

Durlacher Straße. The fifth annual Brücke portfolio features two woodcuts and an etching by Kirchner, with a title sheet by Heckel. In Berlin the New Secession separates from the established Secession group, and the Brücke artists join. In May, at the opening of the new group's first show at the Maximilian Macht gallery, Kirchner meets Otto Mueller (1874–1930). Summer at Moritzburg with Heckel, Pechstein, Marzella and Fränzi. 1 to 30 September: Brücke exhibition at the Ernst Arnold gallery at 34, Schloßstraße in Dresden – under the directorship of Ludwig W. Gutbier it is now Dresden's foremost venue for contemporary art. A catalogue is published, for the first time, illustrated with woodcuts done by the artists after their own paintings. Kirchner does a coloured woodcut for the poster. October: visits collector Gustav Schiefler (1857–1935) and art historian Rosa Schapire (1874–1954), both passive members of Die Brücke, in Hamburg. December: Schiefler visits Dresden and sees the Brücke artists in their studios. Kirchner joins the German Artists' Association. In the Dresden Ethnological Museum he draws sculptures and carved beams from the Palau Islands in the Pacific.

1911 January: in Berlin, seeing Pechstein and Otto Mueller. February to March: major Brücke exhibition at the Art Association, Jena. Archaeologist and art historian Botho Graef (1857–1917) reviews the show in the *Jenaische Zeitung* (26 February) and counts Kirchner, with Pechstein, among the group's "strongest talents". July: stays at Mnischek in Bohemia with Otto Mueller. They visit the painter Bohumil Kubista in Prague. With Heckel at Moritzburg. The sixth annual Brücke portfolio appears, including three sheets by Heckel and a title woodcut by Pech-

stein. October: Kirchner moves to Berlin, taking a studio in the Wilmersdorf district at 14, Durlacher Straße, in the same building as Pechstein. With the latter he starts a drawing school; the only students are Hans Gewecke and Werner Gothein, who become friends. Kirchner meets the poet Wilhelm Simon Guttmann, and through him contact is established between Die Brücke and the Neuer Club, a progressive literary association founded in 1909. Kirchner meets his future lifelong partner Erna Schilling (1884–1945) and her sister Gerda.

1912 The Brücke artists exhibit at the second Blauer Reiter show in February at the Hans Goltz gallery in Munich. The show moves to the "Sturm" gallery in Berlin, from 12 March to 12 April. 2 to 27 April: major Brücke exhibition (with catalogue) at Fritz Gurlitt's in Berlin. This show is seen at Commeter's in Hamburg later in the year, from 18 August to mid-September. Pechstein is excluded from the group. The Brücke artists are invited to show at the international Sonderbund exhibition in Cologne (25 May to 30 September). Kirchner and Heckel paint the Sonderbund chapel. Kirchner meets Edvard Munch (1863–1944). In the summer, a long stay on Fehmarn, near the Staberhuk lighthouse, with Erna and Gerda Schilling, and a visit from Heckel. The seventh annual Brücke portfolio appears, with three sheets by Pechstein and a title woodcut by Otto Mueller, but it is not distributed because of Pechstein's exclusion. Kirchner is asked to write and produce a Brücke chronicle for the following year. In the autumn, Die Brücke shows in a Prague artists' association exhibition. Kirchner meets writer Alfred Döblin (1878–1957) and paints his portrait during the winter.

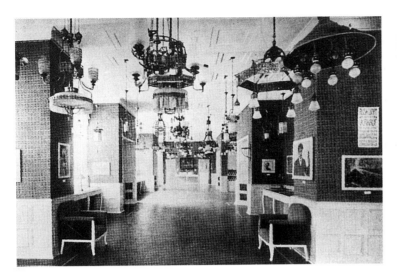

Exhibition at Seifert's lamp factory in Dresden, 1906/1907

Brücke exhibition at Emil Richter's art salon, 1909

1913 January: Brücke exhibition in the Neuer Kunstsalon, Munich. One of Kirchner's pictures from the Sonderbund exhibition is included in the Armory Show in New York, Chicago and Boston. Kirchner writes the Brücke chronicle, but the other artists reject it for its one-sidedness. 27 May: the group is formally dissolved. Kirchner publishes the chronicle under his own name, including two further texts on painting and on graphics. Summer on Fehmarn with Erna, Gewecke and Gothein. Otto Mueller visits. October: Kirchner moves into a spacious top-floor apartment in the Friedenau district of Berlin, at 45, Körnerstraße. First solo show at the Folkwang Museum in Hagen (October), and at Fritz Gurlitt's in Berlin (November). Begins painting his street scenes.

1914 Solo exhibition with the Jena Art Association, opened on 15 February with a lecture by Botho Graef. Kirchner makes new friends in Jena: Botho Graef and his friend Hugo Biallowons, Eberhard Grisebach (1880–1945), Karl Theodor Bluth, and Rudolph and Irene Eucken. Summer on Fehmarn with Erna. August: on the outbreak of the First World War, Kirchner and Erna return to Berlin. Kirchner reports as an "involuntary volunteer" to the artillery.

1915 The war causes a profound panic in Kirchner. In July he is called up for basic training at Halle an der Saale. By chance, law professor Hans Fehr is his riding instructor there. When Kirchner proves unequal to the pressures put upon him, Fehr intervenes

to secure leave for him in September and then his discharge, conditional on his being treated at a sanatorium. In mid-December Kirchner enters Dr. Oscar Kohnstamm's sanatorium at Königstein in the Taunus region, probably on the recommendation of Botho Graef in Jena.

1916 In the first half of the year, three stays at the Königstein sanatorium (mid-December 1915 to c. 20 January, c. 20 March to c. 18 April and early June to mid-July). Otherwise in Berlin. During his third stay he paints Fehmarn bathing scenes on the hallway of the pump room (destroyed after 1933). In the latter half of the year in Berlin, with Botho Graef in Halle, and in Jena. First contact with Frankfurt art dealer Ludwig Schames. At the

Chronicle of Die Brücke, 1913, woodcut

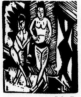

Im Jahre 1902 lernten sich die Maler Bleyl und Kirchner in Dresden kennen. Durch seinen Bruder, einen Freund von Kirchner, kam Heckel hinzu. Heckel brachte Schmidt-Rottluff mit, den er von Chemnitz her kannte. In Kirchners Atelier kam man zum Arbeiten zusammen. Man hatte hier die Möglichkeit, den Akt, die Grundlage aller bildenden Kunst, in freier Natürlichkeit zu studieren. Aus dem Zeichnen auf dieser Grundlage ergab sich das allen gemeinsame Gefühl, aus dem Leben die Anregung zum Schaffen zu nehmen und sich dem Erlebnis unterzuordnen. In einem Buch "Odi profanum" zeichneten und schrieben die einzelnen nebeneinander ihre Ideen nieder und verglichen dadurch ihre Eigenart. So wuchsen sie ganz von selbst zu einer Gruppe zusammen, die den Namen "Brücke" erhielt. Einer regte den andern an. Kirchner brachte den Holzschnitt aus Süddeutschland mit, den er, durch die alten Schnitte in Nürnberg angeregt, wieder aufgenommen hatte. Heckel schnitzte wieder Holzfiguren; Kirchner bereicherte diese Technik in den seinen durch die Bemalung und suchte in Stein und Zinnguss den Rhythmus der geschlossenen Form. Schmidt-Rottluff machte die ersten Lithos und sich dem Stein. Die erste Ausstellung der Gruppe fand in eigenen Räumen in Dresden statt; sie fand keine Anerkennung. Dresden gab aber durch viele landschaftliche Reize und seine alte Kultur viele Anregung. Hier fand "Brücke" auch die ersten kunstgeschichtlichen Stützpunkte in Cranach, Beham und andern deutschen Meistern des Mittelalters. Bei Gelegenheit einer Ausstellung von Amiet in Dresden wurde dieser

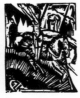

zum Mitglied von "Brücke" ernannt. Ihm folgte 1905 Nolde. Seine phantastische Eigenart gab eine neue Note in "Brücke", er bereicherte unsere Ausstellungen durch die interessante Technik seiner Radierung und lernte die unseres Holzschnittes kennen. Auf seine Einladung ging Schmidt-Rottluff zu ihm nach Alsen. Später gingen Schmidt-Rottluff und Heckel nach Dangast. Die harte Luft der Nordsee brachte besonders bei Schmidt-Rottluff einen monumentalen Impressionismus hervor. Währenddessen führte Kirchner in Dresden die geschlossene Komposition weiter; er fand im ethnographischen Museum in der Negerplastik und den Balkenschnitzereien der Südsee eine Parallele zu seinem eigenen Schaffen. Das Bestreben, von der akademischen Sterilität frei zu werden, führte Pechstein zu "Brücke". Kirchner und Pechstein gingen nach Gollverode. Im Salon Richter in Dresden fand die Ausstellung der "Brücke" mit den neuen Mitgliedern statt. Die Ausstellung machte einen grossen Eindruck auf die jungen Künstler in Dresden. Heckel und Kirchner versuchten die neue Malerei mit dem Raum in Einklang zu bringen. Kirchner stattete seine Räume mit Wandmalereien und Batiks aus.

an denen Heckel mitarbeitete. 1907 trat Nolde aus "Brücke" aus. Heckel und Kirchner gingen an die Moritzburger Seen, um den Akt im Freien zu studieren. Schmidt-Rottluff arbeitete in Dangast an der Vollendung seines Farbenrhythmus. Heckel ging nach Italien und brachte die Anregung der etruskischen Kunst. Pechstein ging in dekorativen Aufträgen nach Berlin. Er versuchte die neue Malerei in die Sezession zu bringen. Kirchner fand in Dresden den Handdruck

der Lithographie. Bleyl, der sich der Lehrtätigkeit zugewandt hatte, trat aus "Brücke" 1909 aus. Pechstein ging nach Dangast zu Heckel. Im selben Jahre kamen beide zu Kirchner nach Moritzburg, um an den Seen Akt zu malen. 1910 wurde durch die Zurückweisung der jüngeren deutschen Maler in der alten Sezession die Gründung der "Neuen Sezession" hervorgerufen. Um die Stellung Pechsteins in der neuen Sezession zu stützen, wurden Heckel, Kirchner und Schmidt-Rottluff auch dort Mitglieder. In der ersten Ausstellung der N.S. lernten sie Mueller kennen. In seinem Atelier fanden sie die Cranachsche Venus, die sie selbst sehr schätzten, wieder. Die sinnliche Harmonie seines Lebens mit dem Werk machte Mueller zu einem selbstverständlichen Mitglied von "Brücke". Er brachte uns den Reiz der Leimfarbe. Um die Bestrebungen von "Brücke" rein zu erhalten, traten die Mitglieder der "Brücke" aus der neuen Sezession aus. Sie gaben sich gegenseitig das Versprechen, nur gemeinsam in der "Sezession" in Berlin auszustellen. Es folgte eine Ausstellung der "Brücke" in sämtlichen Räumen des Kunstsalons Gurlitt. Pechstein brach das Vertrauen der Gruppe, wurde Mitglied der Sezession und wurde ausgeschlossen. Der Sonderbund lud "Brücke" 1912 zu seiner Cölner Ausstellung ein und übertrug Heckel und Kirchner die Ausmalung der darin befindlichen Kapelle. Die Mehrzahl der Mitglieder der "Brücke" ist jetzt in Berlin. "Brücke" hat auch hier ihren internen Charakter beibehalten. Innerlich zusammengewachsen, strahlt sie die neuen Arbeitswerte auf das moderne Kunstschaffen in Deutschland aus. Unbeeinflusst durch die heutigen Strömungen, Kubismus, Futurismus usw., kämpft sie für eine menschliche Kultur, die der Boden einer wirklichen Kunst ist. Diesen Bestrebungen verdankt "Brücke" ihre heutige Stellung im Kunstleben. E. L. Kirchner.

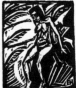

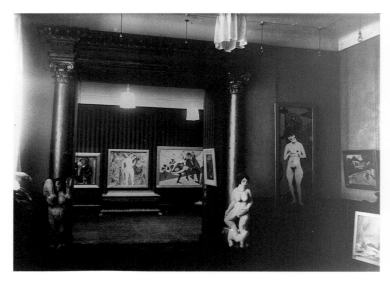

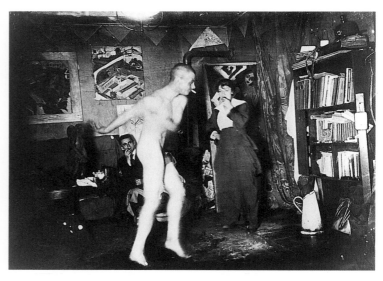

Brücke exhibition in Galerie Gurlitt, Berlin, 1912. The wooden sculptures in front of the pillars, by Kirchner, are lost.

The Berlin studio at 45, Körnerstraße, 1914–1915 (Kirchner or another man dancing naked).

end of the year he enters another sanatorium in the Charlottenburg district of Berlin. Eberhard Grisebach in Jena and his mother-in-law Helene Spengler in Davos set up a convalescent stay in Switzerland.

1917 19 January to 4 February: first stay in Davos. Returns to Berlin. March: solo show with the Jena Art Association. The unexpected death of his friend and supporter Botho Graef on 9 April deepens Kirchner's crisis. In early May he visits Davos for the second time. His doctor, Dr. Luzius Spengler, diagnoses addiction to the barbiturate veronal, which Kirchner was given in the German sanatoriums, and to morphine. Belgian architect Henry van de Velde (1863–1957), who is in Switzerland, gets in touch with Kirchner and recommends the Binswanger sanatorium at Kreuzlingen on Lake Constance. Kirchner spends July and August in a cottage at Stafelalp above Frauenkirch, near Davos. He does his first paintings and woodcuts on subjects drawn from Alpine farming life. September: enters the Kreuzlingen sanatorium.

1918 At Kreuzlingen until July. Despite his physical weakness, Kirchner does a large number of woodcuts, chiefly portraits of those who visit him or of other patients. In summer he returns to the Stafelalp. There he does a series of woodcuts after Petrarch. In the autumn he rents "In den Lärchen" (The Larches), a house in Frauenkirch, and settles there. He is gradually weaned from his morphine addiction by Helene Spengler (who reduces the dosage under instructions from her husband, Dr. Luzius Spengler) and comes off the drug in 1921. Kirchner writes "A Painter's Creed" and makes the *Absalom* series of woodcuts. In December he makes the famous woodcut portrait of Ludwig Schames, which

the Frankfurt Art Association distributes to members – Kirchner's only print graphic work to achieve a high edition.

1919 In January, Kirchner's printing press reaches Davos from Berlin. He does his coloured woodcuts *Moonlit Night in Winter* and *Pines*. His major themes are now mountain life and landscape. He also carves furniture for his home, including a bed for Erna and two reliefs for the studio door. February–March: major exhibition at the Ludwig Schames gallery in Frankfurt am Main. 11 and 12 May: Henry van de Velde visits. On 5 July Kirchner begins his Davos journal. 7 August to 16 September at Stafelalp. In the autumn he writes an essay on his own drawings, the first under the pseudonym of Louis de Marsalle; it is published in 1921 in the German periodical *Genius* (volume date 1920). Illustrates *Umbra vitae*, a collection of poems by Georg Heym (1887–1912) which is published in 1924.

1920 January-February: exhibition of graphics at the Ludwig Schames gallery in Frankfurt am Main. The catalogue features an essay on Kirchner's graphic work by Eberhard Grisebach. Kirchner paints backdrops for amateur theatricals in a Frauenkirch restaurant. Summer at Stafelalp. Painter Nele van de Velde (1897–1965), the architect's daughter, visits Frauenkirch from late September till early November and works with Kirchner. In the winter, fifteen important works from public and private collections in Germany are exhibited at the National Gallery in Berlin.

1921 Kirchner finally overcomes his morphine habit. April: exhibition at the Ludwig Schames gallery in Frankfurt am Main. 11 to

14 May: visits Zurich. Meets Nina Hard, a dancer, and invites her to Davos, where she stays from May to September and acts as a model. Kirchner writes a second essay under the Louis de Marsalle pseudonym, on the graphic works; it is published in the 1921 volume of *Genius*, which appears in 1922.

1922 January: exhibition of Kirchner's Swiss work at the Ludwig Schames gallery in Frankfurt am Main. The catalogue includes an essay written by Kirchner under his Louis de Marsalle pseudonym. Travelling to Zurich, he meets the painter Otto Meyer-Amden (1885–1933). Kirchner gives up his Berlin apartment at 45, Körnerstraße for good. The paintings stored there arrive in Frauenkirch in early March, and he begins reworking them. 3 July: death of Ludwig Schames. His nephew Manfred Schames takes over the gallery. In Davos Kirchner meets the poet Jakob Bosshart (1862–1924) and his wife Elsa Bosshart-Forrer; Lise Gujer (1893–1967), who weaves tapestries from his designs; and Dr. Frédéric Bauer (1883–1957), who becomes a regular buyer and committed collector. Woodcut illustrations for a book by Bosshart published the following year.

1923 Following the death of Dr. Luzius Spengler on 12 February, Kirchner and Helene Spengler fall out, and this important friendship is at an end. A periodical, "Das Kunstblatt", edited by Paul Westheim, does a special Kirchner issue. June: solo exhibition at the Kunsthalle, Basle. Kirchner meets the Basle artists Hermann Scherer (1893–1927) and Albert Müller (1897–1926) and makes the friendship of Georg Schmidt (1896–1965), then librarian with the Basle Art Association and director of the Basle Museum of Art from 1939. In June and July, Gustav

Schiefler and his wife visit Davos for several weeks, to work on the catalogue of the print graphics. Hermann Scherer visits. In October Kirchner has to move out of "The Larches" because the owner needs the house for his own use, and takes an old farmhouse on the Wildboden side of the valley. November–December: exhibition at the Paul Cassirer gallery in Berlin. Hermann Scherer visits again in December.

1924 Albert Müller visits for the first time in May or June. 22 June to 13 July: solo exhibition with the Winterthur Art Association. Winterthur, which possesses famous collections of French art (Reinhart, Hahnloser, Bühler), is unanimous in being unimpressed by Kirchner. Georg Reinhart buys *Davos in the Snow*, intending to give it to the Association, but the museum committee turns the gift down; twenty years later, Reinhart donates it to the Basle Museum of Art. Hermann Scherer and Albert Müller visit Kirchner at Frauenkirch. Begins assisting Will Grohmann in the latter's work on a study of Kirchner's drawings, which is published in 1925. September: Edwin Redslob, appointed national director of the arts in Germany in 1922, visits from Berlin.

1925 Kirchner's painting *Junkerboden* is awarded the Prize of the Republic in the spring exhibition at the Prussian Academy of the Arts in Berlin. Under his pseudonym Louis de Marsalle, Kirchner publishes an essay on his own sculptures in the periodical *Cicerone*. Assists in preparation of Will Grohmann's second book, a full-scale monograph. September: visits the international art show with Albert Müller. Kirchner, like Paul Klee, is not included in it himself as he is now considered a Swiss artist. On 18 December he begins his first return visit to Germany, via Zurich and Basle, staying in Frankfurt am Main (21 to 30 December) and in Chemnitz for the following three weeks.

1926 From 19 January Kirchner is in Dresden, staying with the Grohmanns at 84, Wormser Straße. There is talk of Kirchner's being called to a professorship at the Dresden Academy of Art (but in the event the chair goes to Otto Dix in 1927). Hans Posse, director of the Dresden Gallery of Modern Masters, invites Kirchner to curate a room of recent Swiss art at an international exhibition planned for the summer. Kirchner selects Albert Müller, Hermann Scherer, Fritz Pauli (1891–1968), Paul Camenisch (1893–1970), Philipp Bauknecht and himself. On 17 February he travels on to Berlin, where he stays with his brother Walter at 16, Wilhelmstraße, in the district of Grünau. He meets Schmidt-Rottluff and Max Liebermann. Kirchner

begins the return journey via Frankfurt on 5 March, reaching Davos on 11 March. He makes a second short trip to Germany in June, with Albert Müller, to see the international exhibition in Dresden. From July to September the Basle painter Paul Camenisch is staying with Kirchner in Davos, and shortly afterwards the painter Hans-Rudolf Schiess (1904–1978) visits. Will Grohmann's full-length study, and the first volume of Gustav Schiefler's catalogue of the graphic work, are published. November–December: exhibition at the Fides gallery in Dresden, and a retrospective of the first ten Davos years with the Davos Art Association. On 14 December his friend Albert Müller dies suddenly.

1927 Prompted by the reunion with Schmidt-Rottluff in Berlin, Kirchner paints *A Group of Artists*, showing the Brücke artists at the time of the group's dissolution in 1913. On 13 May Hermann Scherer dies. 10 June to 12 July: exhibition at the Aktuaryus Gallery in Zurich. The catalogue features an introduction by Kirchner himself, writing as Louis de Marsalle. Hans-Rudolf Schiess visits Davos for several weeks. The director of the Folkwang Museum in Essen, Ernst Gosebruch, proposes that Kirchner paint murals in the great hall of the new museum then under construction. Kirchner does numerous preparatory designs and paintings toward this project over the next few years. Commissioned by collector Carl Hagemann in Frankfurt, Kirchner designs a large tapestry titled *Life*.

1928 Kirchner's style becomes more abstract as an offshoot of the Essen project.

1929 Third trip via Zurich to Germany in the latter half of June, to Berlin, Essen (where he views the great hall of the Folkwang), and again to Berlin.

1931 Fourth journey via Zurich and Basle to Germany, from mid-June to early July. Kirchner visits Frankfurt and Berlin. The second volume of Gustav Schiefler's catalogue of Kirchner's graphic work is published.

1932 Prepares a major retrospective to be held in Berne the following year. Alarmed at political developments in Germany, where the rise of Adolf Hitler and the Nazis seems likely to lead to their being in power.

1933 5 March to 17 April: exhibition at the Kunsthalle in Berne. Kirchner contributes one last essay under the Louis de Marsalle pseudonym to the catalogue. Kirchner is satisfied with the show, the catalogue and the response in Switzerland and Germany. Various museum curators see it, and numerous collectors buy pictures. The Berne Museum of Art acquires *Sunday in the Alps. Scene at the Well*. The Nazi seizure of power in Germany on 30 January begins to affect the arts, and on 16 May Kirchner receives a letter from the Prussian Academy of the Arts in Berlin suggesting he withdraw and present himself for election again. Kirchner's dealer Manfred Schames emigrates to Palestine. Kirchner meets the French surrealist René Crevel (1900–1935) when the latter is staying at Dr. Frédéric Bauer's sanatorium.

1934 Ernst Gosebruch loses his position in Essen, spelling an end to the plans for mural paintings in the Folkwang Museum. Oskar

Self-portrait as a soldier, 1915

Self-portrait, 1919

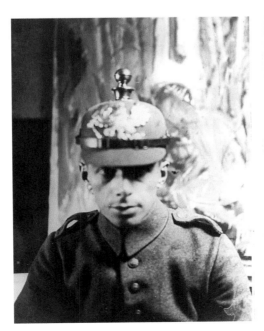

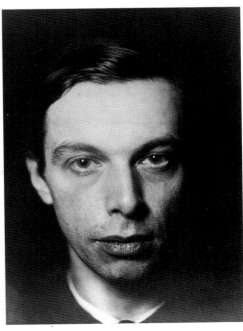

Schlemmer (1888–1943) visits Davos in March. In Berne in June, Kirchner meets Paul Klee.

1935 March: visits Berne to see an exhibition of Klee at the Kunsthal!e. Paints Berne city scenes. Kirchner abandons his Cubist-inspired abstract manner. The graphics section of the Basle Museum of Art exhibits Kirchner watercolours and drawings.

1936 Kirchner works on plans to paint the interior of the village church in Frauenkirch (these plans are never realised) and is commissioned to carve a relief for a new school building in Frauenkirch, which he does. The German Artists' Association is dissolved. Political reprisals against modern art are increasing in Germany. Kirchner's health deteriorates. He complains of intestinal trouble and loss of weight, and probably takes morphine-based medicines again. Art dealer Curt Valentin of the Buchholz gallery makes contact with Kirchner, visiting Davos shortly before emigrating to the U.S. William (Wilhelm) R. Valentiner, director of the Detroit Institute of Art, writes from America inviting Kirchner to exhibit. The Basle Kunsthalle also offers a show. Lise Gujer puts Kirchner in touch with the English writer Llewelyn Powys (1884–1939), who is living near Davos.

1937 January: exhibition at the Detroit Institute of Art. On 30 June the Nazi regime in Germany pronounces modern art to be degenerate and begins removing works from museums. 639 paintings, sculptures, drawings and graphics by Kirchner are confiscated and sold off abroad or destroyed. The Munich ex-hibition of "Degenerate Art" travels throughout Germany. The Prussian Academy of the Arts in Berlin demands that Kirchner resign his membership. He replies: "If my name is so troublesome to the Academy, strike it out" – and is excluded. Kirchner endeavours to consolidate his position in Switzerland by taking Swiss citizenship, for himself and for Erna. In the summer, Curt Valentin visits to prepare the Buchholz Gallery show in New York that autumn (29 September to 27 October). October–November: exhibition in the Kunsthalle, Basle.

1938 The Anschluß of 13 March – the German annexation of Austria – prompts fears that German troops might turn up on his doorstep. Davos is a bare thirty kilometres from the German border. Kirchner begins destroying the plates of his woodcuts and some of his carved sculptures. Newspapers report that he has taken to shooting at his pictures. His 58th birthday on 6 May passes without congratulations. On 10 May he goes to Davos town hall to have the banns read, intending to marry his long-standing partner Erna and so assure her legal status after his death, but on 12 June he cancels them. Erna realises that Kirchner's crisis is deepening and seeks the help of friends, but it is too late. On 15 June, shortly before ten in the morning, Kirchner shoots himself through the heart with a pistol. On 18 June he is buried in the woodland cemetery at Davos. Erna Schilling is granted the legal right to use the name of Kirchner and lives in the Wildboden house until her own death on 2 October 1945.

Ernst Ludwig Kirchner on his deathbed, 1938

Bibliography

A comprehensive and meticulous bibliography up to 1979, compiled by Hans Bolliger, is included in *Ernst Ludwig Kirchner: Zeichnungen und Pastelle*, ed. Roman Norbert Ketterer and Wolfgang Henze, Stuttgart and Zurich, 1979.

Writings by Kirchner

Louis de Marsalle (Ernst Ludwig Kirchner): 'Zeichungen von Ernst Ludwig Kirchner', in *Genius*, 1920, no. 2 (published 1921), pp. 216–234*

Louis de Marsalle (Ernst Ludwig Kirchner): 'Über Kirchners Grafik', in *Genius*, 1921, no. 2 (published 1922), pp. 190–194*

Louis de Marsalle (Ernst Ludwig Kirchner): 'Über die Schweizer Arbeiten von E. L. Kirchner', in *Ausstellung von neuen Gemälden und Grafik von E. L. Kirchner 1916–1921*, Ludwig Schames Gallery, Frankfurt am Main, 1921*

Louis de Marsalle (Ernst Ludwig Kirchner): 'Über die plastischen Arbeiten E. L. Kirchners', in *Der Cicerone*, 1925, no. 14, pp. 695–701*

Ernst Ludwig Kirchner: 'Die Arbeit E. L. Kirchners', written in 1925 or 1926, printed complete in Eberhard W. Kornfeld: *Ernst Ludwig Kirchner. Nachzeichnungen seines Lebens*, Berne, 1979, pp. 331–345

Ernst Ludwig Kirchner: 'Die neue Kunst in Basel', in *Das Kunstblatt*, 1926, vol. 10, no. 9 (September), pp. 321–330*

Louis de Marsalle (Ernst Ludwig Kirchner): contribution to *Ernst Ludwig Kirchner* (exhibition catalogue), Kunsthalle, Berne, 1933

Ernst Ludwig Kirchner: 'Anfänge und Ziele', in *Kroniek van hedendaagsche Kunst en Kultuur*, 1935, vol. 1, no. 1, pp. 5–9

Ernst Ludwig Kirchner: 'Ein paar Worte zur Arbeit', in *Kroniek van hedendaagsche Kunst en Kultuur*, 1937, vol. 2, no. 10, p. 306

* Asterisked items are reprinted in Lothar Grisebach: *E. L. Kirchners Davoser Tagebuch*, Cologne, 1968

Letters and Journals

Lothar Grisebach: *Maler des Expressionismus im Briefwechsel mit Eberhard Grisebach*, Hamburg, 1962. Paperback reprint as *Von Munch bis Kirchner. Erlebte Kunstgeschichte in Briefen aus dem Nachlaß von Eberhard Grisebach*, Munich, 1968

Lothar Grisebach: *E. L. Kirchners Davoser Tagebuch.*

Eine Darstellung des Malers und eine Sammlung seiner Schriften, Cologne, 1968

Gertrud Knoblauch: *Ernst Ludwig Kirchner. Briefwechsel mit einem jungen Ehepaar 1927–37. Elfriede Dümmler und Hansgeorg Knoblauch*, Berne, 1989

Wolfgang Henze, Annemarie Dube-Heynig and Magdalena Kraemer-Noble: *Ernst Ludwig Kirchner. Gustav Schiefler. Briefwechsel 1910–1935/1938*, Stuttgart and Zurich, 1990

Catalogues raisonnés

Gustav Schiefler: *Die Graphik E. L. Kirchners. Band I: bis 1916*, Berlin, 1926

Gustav Schiefler: *Die Graphik Ernst Ludwig Kirchners. Band II: 1917–1927*, Berlin, 1931

Annemarie and Wolf-Dieter Dube: *E. L. Kirchner. Das graphische Werk* (2 vols.), Munich, 1967

Donald E. Gordon: *Ernst Ludwig Kirchner. Mit einem kritischen Katalog einer Gemälde*, Munich, 1968

Lise Gujer. Wirkereien nach Entwürfen von E. L. Kirchner. Catalogue by Fritz Dürst and Eberhard W. Kornfeld, essays by Margrit Mattli, Hans Bolliger, Fritz Dürst and Eberhard W. Kornfeld, Berne, 1974

Secondary literature, in chronological order

Will Grohmann: *Zeichnungen von Ernst Ludwig Kirchner*, Dresden, 1925

Will Grohmann: *Das Werk Ernst Ludwig Kirchners*, Munich, 1926

Ernst Ludwig Kirchner. Exhibition catalogue, Kunsthalle, Berne, 1933

Will Grohmann: *E. L. Kirchner*, Stuttgart, 1958

Hans Bolliger and Eberhard W. Kornfeld: *Künstlergruppe Brücke. Jahresmappen 1906 bis 1912. Mit einem kompletten Verzeichnis der Mitgliedskarten, Jahresberichte, Kataloge, Plakate*. Exhibition catalogue issued by Kornfeld and Klipstein Gallery, Berne, 1958

Annemarie Dube-Heynig: *E. L. Kirchner. Graphik*, Munich, 1961

Donald E. Gordon: 'Kirchner in Dresden', in *The Art Bulletin*, no. 48, 1966, pp. 335–366

Ernst Ludwig Kirchner. A Retrospective Exhibition. Exhibition catalogue of the Seattle Art Museum, Pasadena Art Museum and the Museum of Fine Arts, Boston, 1968–1969

Adalbert von Chamisso: *Peter Schlemihls wundersame Geschichte*. With coloured woodcuts by Ernst Ludwig Kirchner. With essays by Lothar Lang (on the woodcuts) and Werner Feudel (on the text), Leipzig and Düsseldorf, 1974

Georg Reinhardt: *Die frühe 'Brücke'. Beiträge zur Geschichte der Dresdner Künstlergemeinschaft 'Brücke' der Jahre 1905 bis 1908*, Brücke-Archiv vols. 9/10, 1977/78, Berlin, 1978

Christian Lenz: *Das Leben. Ein Teppich-Entwurf*, Berne, 1978

Roman Norbert Ketterer and Wolfgang Henze (eds.): *Ernst Ludwig Kirchner. Zeichnungen und Pastelle*, Stuttgart and Zurich, 1979 (with an introduction and commentaries by Klaus Zoege von Manteuffel, and bio/bibliography by Hans Bolliger)

Eberhard W. Kornfeld: *Ernst Ludwig Kirchner. Eine Nachzeichnung seines Lebens*, Berne, 1979

Ernst Ludwig Kirchner 1880–1938. Exhibition catalogue of the Haus der Kunst, Munich, the Museum Ludwig, Cologne, and the Zurich Kunsthaus, 1979–1980

Karlheinz Gabler: *E. L. Kirchner* (2 vols.), Aschaffenburg, 1980 (vol. 1: documents, vol. 2: drawings, pastels and watercolours)

Günther Gercken: *Ernst Ludwig Kirchner. Holzschnittzyklen. Peter Schlemihl. Triumph der Liebe. Absalom*, Stuttgart and Zurich, 1980

Volker Wahl: 'Ernst Ludwig Kirchner und Jena', in *Staatliche Museen zu Berlin. Forschungen und Berichte*, vol. 20/21, Berlin, 1980, pp. 473–501

Bernd Hünlich: 'Die erste Dresdener 'Brücke'-Ausstellung im Bau von Wilhelm Kreis', in *Dresdener Kunstblätter*, 1982, vol. 26, no. 2, pp. 39–41

Bernd Hünlich: 'Ernst Ludwig Kirchners 'Russisches Tanzpaar'– und seine Entstehung', in *Dresdener Kunstblätter*, 1983, vol. 27, no. 1, pp. 21–25

Bernd Hünlich: 'Heckel und Kirchner auf der Berliner Straße in Dresden', in *Dresdener Kunstblätter*, 1983, vol. 27, no. 4, pp. 115–121

Horst Jähner: *Künstlergruppe Brücke*, Berlin, 1984

Annemarie Dube-Heynig: *Ernst Ludwig Kirchner. Postkarten und Briefe an Erich Heckel im Altonaer Museum in Hamburg*, edited by Roman Norbert Ketterer with Wolfgang Henze, Cologne, 1984

Stephanie Barron (ed.): *Skulptur des Expressionismus*, Munich, 1984

Wolfgang Henze: 'Ernst Ludwig Kirchner', in Stephanie Barron (ed.): *Skulptur des Expressionismus*, Munich, 1984, pp. 107–122

Bernd Hünlich: 'Wohnstätten und Lebensumstände der vier 'Brücke'-Gründer in Dresden', in *Dresdener Kunstblätter*, 1985, vol. 29, no. 3, pp. 80–90

Volker Wahl: *Jena als Kunststadt*, Leipzig, 1988

Wolfram Gabler: *Ernst Ludwig Kirchner als Illustrator*, doctoral thesis, Berlin, 1988

Bernd Hünlich: 'E. L. Kirchners Dresdener Freundin Dodo – Doris Große', in *Dresdener Kunstblätter*, 1988, vol. 32, no. 5, pp. 137–147

Ernst Ludwig Kirchner. Werke 1917–1923. Exhibition catalogue issued by the Ernst Ludwig Kirchner Museum, Davos, 1988–1989

Magdalena M. Moeller (ed.): *Die Jahresmappen der*

'Brücke' 1906–1912, Brücke-Archiv, vol. 17, 1989, Berlin, 1989

Bernd Hünlich: 'Moritzburger Ortsmotive der Künstlergruppe Brücke', in *Dresdener Kunstblätter*, 1990, vol. 34, no. 6, pp. 170–182

Volkmar Billig: "'Künstlergruppe Brücke' im Moritzburger Teichgebiet (1)", in *Dresdener Kunstblätter*, 1990, vol. 34, no. 6, pp. 183–193

Volkmar Billig: "'Künstlergruppe Brücke' in Moritzburg (2). Zu einigen Figurenkompositionen von Ernst Ludwig Kirchner", in *Dresdener Kunstblätter*, 1991, vol. 35, no. 1, pp. 15–20

Magdalena M. Moeller (ed.): *Expressionistische Grüße. Künstlerpostkarten der 'Brücke' und des 'Blauen Reiter'*, Stuttgart, 1991

Hubertus Froning: *E. L. Kirchner und die Wandmalerei. Entwürfe zur Wandmalerei im Museum Folkwang*, Recklinghausen, 1991

Figures du Moderne. L'Expressionisme en Allemagne. Dresde, Munich, Berlin 1905–1914. Exhibition catalogue of the Musée d'Art Moderne de la Ville de Paris, Stuttgart, 1992

Albert Schoop: *Ernst Ludwig Kirchner im Thurgau. Die 10 Monate in Kreuzlingen 1917–1918*, Berne, 1992

Ernst Ludwig Kirchner. Von Jena nach Davos. Exhibition catalogue of the Göhre Municipal Museum in Jena, Leipzig, 1993

Magdalena M. Moeller: *Ernst Ludwig Kirchner. Die Straßenszenen 1913–1915*, Munich, 1993

Gabriele Lohberg: *Kirchner Museum Davos. Katalog der Sammlung* (Vol. 2 of the catalogue, covering photographs, portraits, landscapes, interiors), Davos, 1994

The publishers wish to thank the museums, private collections, archives and photographers who granted permission to reproduce works and gave support in the making of this book, particularly Dr. Wolfgang and Mrs. Ingeborg Henze of Wichtrach near Berne. In addition to the collections and museums named in the picture captions, we wish to credit the following:

Artothek, Peissenberg: 70; Blauel 56, 81, 119, 120, 122, 141, 151; Blauel/Gnamm 26, 87; Edelmann 60; Bildarchiv Preußischer Kulturbesitz, Berlin: Jörg P. Anders 2, 30 bottom right, 48 right, 63 top, 71, 85, 94 bottom, 111, 114, 123, 143 bottom, 148 top right, 158 bottom; Klaus Göken 13 top, 115; Fotoarchiv Bolliger/Ketterer, Wichtrach/Berne: 4, 50 bottom, 74 bottom, 192, 194, 195 top, 196, 197, 198; Ute Brunzel, Staatliche Museen Kassel: 9, 10, 22 top, 41, 43 right, 48 top, 110 left, 116, 138, 146, 155; Martin Bühler, Öffentliche Kunstsammlung Basel: 92 bottom, 130–135, 164, 166, 178, 179, 189; Courtesy of The Busch-Reisinger Museum/Harvard University Art Museums, Cambridge: 83, 110 right, 171; Christie's Images, London: 80 top; Ursula Edelmann, Städelsches Kunstinstitut Frankfurt/Main: 15, 50 top, 98 bottom, 124 left, 139, 148 top left and bottom left, 149; The Solomon R. Guggenheim Foundation, New York © photograph by Lee B. Ewing: 129; Colorphoto Hinz, Allschwil-Basel: 68, 191; Jürgen Karpinski, Dresden: 53; The Museum of Modern Art, New York © photograph 1994: 21, 102, 118 bottom; Rheinisches Bildarchiv, Cologne: 23, 55, 67, 75, 98 top, 99, 172; Elke Walford, Kunsthalle Hamburg: 14 bottom, 45, 76, 91, 163.